AFRICA EXPLORES

AFRICA EXPLORES
20TH CENTURY AFRICAN ART

Susan Vogel
assisted by Ima Ebong

Contributions by

Walter E. A. van Beek
Donald John Cosentino
Ima Ebong
Bogumil Jewsiewicki
Thomas McEvilley
V. Y. Mudimbe

The Center for African Art, New York
and Prestel, Munich

AFRICA EXPLORES: 20th Century African Art is published in conjunction with an exhibition of the same title organized and presented by The Center for African Art, New York.

The exhibition is supported by grants from the National Endowment for the Humanities, the Rockefeller Foundation, the New York State Council on the Arts, the City of New York Department of Cultural Affairs, the Forbes Foundation, the Aaron Diamond Foundation, the Anne S. Richardson Fund, and the Andy Warhol Foundation.

EDITOR'S NOTE

Quoted passages from books and articles have generally been given in English even if the original was in a foreign language. Unless otherwise noted, translations have been made by the authors and editors of the essays in this book.

Legends written by the artist on artworks have been treated as titles, and where works of art have been given a name by the artist, that name has generally been given in the original language, accompanied by an English translation, if necessary, in parentheses; but in the interest of brevity, only translations have been given for the names of some of the works illustrating the essays.

Unless otherwise noted, the place names referred to in the book are the current ones, even though at the time of the events discussed other names may have been in use. With respect to the names of persons, the sequence of given name and family name varies from place to place in Africa; in some areas, the family name normally precedes the given name.

Publication director: Stephen Benjamin
Text editor: David Frankel
Design: Kiyoshi Kanai, Inc.
Typesetting: U.S. Lithograph, typographers, New York

Trade edition distributed by Prestel-Verlag, Mandlstrasse 26, D-8000 Munich 40, Federal Republic of Germany, Tel:(89)38-17-09-0; Telefax:(89)38-17-09-35. Distributed in continental Europe by Prestel-Verlag, Verlegerdienst München GmbH & Co. KG, Gutenbergstrasse 1, D-8031 Gilching, Federal Republic of Germany, Tel:(8105)2110; Telefax:(8105)55-20. Distributed in the USA and Canada on behalf of Prestel-Verlag by te Neues Publishing Company, 15 East 76th Street, New York, NY 10021, USA, Tel:(212)288-0265; Telefax:(212)570-2373. Distributed in Japan on behalf of Prestel-Verlag by YOHAN-Western Publications Distribution Agency, 14-9 Okubo 3-chome, Shinjuku-ku, J-Tokyo 169, Tel:(3)208-0181; Telefax:(3)209-0288. Distributed in the United Kingdom, Ireland, and all other countries on behalf of Prestel-Verlag by Thames & Hudson Limited, 30-40 Bloomsbury Street, London WC1B 3QP, England, Tel:(71)636-5488; Telefax:(71)636-4799.

Library of Congress catalogue card no. 90-26683
Clothbound ISBN 3-7913-1143-3
Paperbound ISBN 0-945802-09-9

Front cover: all illustrations are from the catalogue.
Back cover: cat. 39.

Printed and bound in Japan.

AFRICA EXPLORES by **Susan Vogel**

Walter E. A. van Beek is an associate professor of cultural anthropology at the University of Utrecht, the Netherlands. His research includes the Kapsiki/Higi of northern Cameroon and northeastern Nigeria (fieldwork 1971, 1972-1973, 1979, 1988) and the Dogon of Mali (fieldwork 1979, 1980-1981, plus short stays each year up until the present). His publications include *The Kapsiki of the Namdara Hills*, 1987; a coauthored book on the Dogon, *Masked Dancers of West Africa: The Dogon*; and, as editor, *The Quest for Purity: Dynamics of Puritan Movements*, 1988, as well as various articles.

Donald John Cosentino is an associate professor in the Department of English/ Folklore and Mythology Program, the University of California, Los Angeles. He is the cocurator and major catalogue author for an upcoming exhibition at the University's Museum of Cultural History, "Sacred Arts of Vodoun." He is also a coeditor of *African Arts* and an editorial-board member of *African Studies Review*.

Ima Ebong received her M.A. in art history from Brown University in 1988, and she has conducted research on contemporary art in West Africa. As Exhibition Coordinator at The Center for African Art, she has worked on the past exhibitions "ART/artifact," "Africa and the Renaissance," and "Yoruba: Nine Centuries of African Art and Thought." Over the past three years she has also assisted in the preparation of various Center publications.

Bogumil Jewsiewicki is a professor of history at Université Laval in Quebec. He has conducted extensive historical, economic, and social research in Zaire and has published over fifty articles on African history, including urban painting. He has edited several publications on African historiography, including *African Historiographies: What History for Which Africa?*, with D. Newbury (1986). His own publications include *Marx, Afrique et Occident: les pratiques africanistes de l'histoire marxiste* (1986).

Thomas McEvilley has written extensively about art and philosophy, and has contributed to establishing a global discourse involving representatives of the first and third worlds in both the East and the West. His polemical critique of the "Primitivism" show at the Museum of Modern Art, New York, in 1984 prepared the ground for the 1989 exhibition "*Magiciens de la terre*" at the Centre Georges Pompidou, for which he contributed a catalogue essay.

V. Y. Mudimbe, professor of romance studies and comparative literature at Duke University, has published some seventy articles, three collections of poetry, four novels, and several books in applied linguistics, philosophy, and social science. His publications include *L'Odeur du Père* (1982) and *The Invention of Africa* (1988). Forthcoming are *The Surreptitious Speech* (1991) and *Parables and Fables* (1991). His interests are in phenomenology, structuralism, and semiotics, with a focus on the logic of mythical narrative and the practice of language.

THE CENTER FOR AFRICAN ART

"What are we going to do about contemporary African art," asks the October 1990 issue of *African Arts*. ". . . Quite certainly for many the hope is that it might just go away, rather as when a child who knows a monster is lurking in the closet pulls the sheets over his head, on the comforting thesis that what one doesn't recognize isn't there. . . . But owing to the inherent creativity of African artists, the issue of contemporary art will not go away" (John Povey, p. 1).

"Africa Explores: 20th Century African Art," by revealing the visual richness and intellectual depth of contemporary African art, dramatically illustrates not only why it won't go away but also why it is so rewarding to study. This exhibition challenges two widely held misconceptions about twentieth century Africa: that its celebrated traditional art belongs to cultures glorious but extinct, dead upon contact with the West; and that there is no modern Africa or African art, merely second-hand Western culture.

Examining the multiple visual, intellectual, and historical dimensions of contemporary African art, "Africa Explores" is squarely within the Center's mandate "to increase public understanding and appreciation of the richness and variety of African culture." To achieve this goal the Center initiates two travelling exhibitions each year, publishes a substantive catalogue for each exhibition, and develops educational programs related to the themes of the exhibitions and to African arts, history, and cultures generally. "Africa Explores," our sixteenth exhibition, also falls within our own brief tradition, begun in 1984, and defined by our charter, of producing exhibitions "broad in scope, educational in subject, and of the highest aesthetic quality."

Within these guidelines the Center's exhibitions range widely across the spectrum of African art, exploring themes and ideas about Africa's artistic traditions and cultural heritage. Some Center exhibitions have explored the art of single ethnic groups, and others have examined selections from single preeminent collections, such as the Musée de l'Homme, Paris, and the Staatliches Museum für Völkerkunde, Munich. "Africa Explores" falls among those of our exhibitions that have examined themes in African art that cut across many ethnic groups and draw broadly from major museum collections in Africa, Europe, and the United States, from private collec- tions, and—in the case of this exhibition—from the artists themselves ("Africa and the Renaissance," "Wild Spirits," "Yoruba"). Several exhibi- tions have addressed issues related to the realtionship between the art and audience—intepretation, looking, collecting, and asethetics in the case of this exhibition—("African Aesthetics," "Perspectives," "ART/artifact," "Close- up"). Some , like "Africa Explores" are curated by Center staff; others by guest curators ("Likeness and Beyond," "Sets, Series and Ensembles"). Common to Center exhibitions are thematic and visual coherence, innova- tive presentation, aesthetic excellence, and the highest standards of scholarship.

Characteristically, each exhibition opens in New York and then embarks upon a national tour. Center exhibitions have travelled to over twenty major museums in the United States, including the Art Institute of Chicago, National Museum of African Art, Kimbell Art Museum, Cleveland Museum of Art, New Orleans Museum of Art, Denver Museum of Natural History, Dallas Museum of Art, Virginia Museum of Fine Arts, Worcester Art Museum, Carnegie Museum of Art, Cincinnati Art Museum, Museum of Fine Arts, Houston, San Diego Museum of Art, Columbus Museum of Art, and other art and natural history museums.

"Africa Explores" is not the final statement about contemporary Africar art—far from it. This is rather a beginning, as this young museum makes its first exploration of a new field.

Gerbrand Luttik
Vittorio Mangio
Mr. & Mrs. Thomas Marill
Latia Martin, Esq.
Barry D. Maurer
Anne & Jacques Maus
Lloyd & Mary McAulay
Balene McCormick
Scott McCue
Dr. Margaret McEvoy
John A. McKesson
Genevieve McMillan
Ann Meschery
Edwin Michalove
Nancy & Peter Mickelsen
Sam Scott Miller
Virginia & Fred Miles
Kolani Miyapo
Richard Monsein
S.J. Mostade & E.J. Nilson
Prof. Marshall Mount
Brigitte & Bernard Muhlack
Judith Nash
Marie S. & Roy R. Neuberger
Teruko & Albert Neuwalder
Austin Newton
Jack Odette
Mr. & Mrs. Richard Ohrstrom
David T. Owsley
Margaret Pancoast
Prof. & Mrs. John Pemberton
Linda C. Phillips
Mr. & Mrs. Joseph Pulitzer, Jr.
Mr. & Mrs. Cecil A. Ray, Jr.
Sieglinde Reynolds
Beatrice Riese
Warren M. Robbins
John Rosenthal
Mr. & Mrs. Phillip Rothblum
Mr. & Mrs. David B. Ross
Mr. & Mrs. Arthur Rovine
Barbara Rubin
Mr. & Mrs. Stephen Rubin
William Rubin
Arthur & Joan Sarnoff
Robert H. Schaffer
Richard H. Scheller
Victor Schenk
Stephen Scher
Franyo Schindler
Sydney L. Shaper
Glenda Shapiro
Mr. & Mrs. Ralph Shapiro
Mary Jo Shepard
Michael Siems
Barbara Spector
Gilda Carmel Spielberg
Gary Spratt
Mr. & Mrs. Dixon Stanton
Arnold Syrop
Howard Tanenbaum
Ellen Napiura Taubman
Farid Tawa
Frederieke Taylor
Mr. & Mrs. William E. Teel
Dr. & Mrs. Saul Unter
Kathy van der Pas
Anthony & Margo Viscusi
Nils Von der Heyde & Silke Gerlach

Dr. & Mrs. Bernard M. Wagner
Berverly Waldergrave-Knight
Lucille & Fred Wallace
Stewart J. Warkow
Margaret Wells
George F. Wick
Samuel Wiener & Maureen Gaffney

INSTITUTIONAL DONORS

City of New York, Department of
 Cultural Affairs
The Aaron Diamond Foundation
The Forbes Foundation
Hoechst Celanese Corporation
Charles E. Culpeper Foundation, Inc.
National Endowment for the Arts
National Endowment for the Humanities
New York State Council on the Arts
New York State Council on the Humanities
Pace Primitive
Puget Sound Fund of the Tides Foundation
Anne S. Richardson Fund
Sotheby's
Michael & Judith Wahl Foundation
Andy Warhol Foundation

Current as of January 31, 1991

BOARD OF DIRECTORS

Adrian Mnuchin
Chairman
Susan Vogel
Executive Director
Kathryn McAuliffe
James J. Ross
Robert Rubin
Sheldon H. Solow
Vice Chairmen
Marc Ginzberg
Secretary
Irwin Smiley
Treasurer
Corice Canton Arman
David Attenborough
Charles B. Benenson
William Brill
Sidney Clyman
Ekpo Eyo
Richard Faletti
Lawrence Gussman
Marian G. Malcolm
Carlo Monzino
John Morning
Don H. Nelson
Robert Nooter
William Rubin
Daniel Shapiro
Paul Simon
Donald M. Suggs

Ernst Anspach (Emeritus)

VOLUNTEERS

Stephen Benjamin
Nancy Blume

Patrice Cochran
Diane Feldman
Denyse Ginzberg
Selbra Hayes
Regina Humanitzki
Jeanne Mullin
Kirsten L. Scheid
Shira Sofer
Beverly Siegel
Kimberly M. Scott
Delia Sullivan
Karen Weinstein

Ralph Baxter
Lofton Holder
Betty Holloway
Stephenie Ricks
Beatrice Riese
Dorothy Robbins
Vivian Walker
Barbara Welch
Beverly Williams
Niki Wright

STAFF

Susan Vogel
Executive Director

Thomas H. Wilson
Deputy Director

Polly Nooter
Senior Curator

Albert Hutchinson
Comptroller

Carol Thompson
Education Associate

Ima Ebong
Exhibition Coordinator

Kyrin Ealy
Registrar

Mufutau Oledele T.J.
Membership Coordinator

Carol Braide
Administrative Assistant

Johanna Cooper
Building Manager

Linus Eze
*Chief of Security/
Admissions*

Carole Moore
Education Assistant

Muniania Lubangi
*Education Assistant/
Security*

Carolyn Evans
Security/Admissions

ACKNOWLEDGEMENTS

An undertaking of this size and complexity, involving Africa, Europe, and the United States, would not have been possible without the generous cooperation of artists, scholars, dealers, museum professionals, and collectors, as well as the entire staff of The Center for African Art. I thank them all most warmly.

Financial support for this exhibition was provided by the National Endowment for the Humanities, the Rockefeller Foundation, the New York State Council on the Arts, the City of New York Department of Cultural Affairs, the Forbes Foundation, the Aaron Diamond Foundation, the Anne S. Richardson Fund, and the Andy Warhol Foundation. We are most grateful for their confidence in The Center for African Art.

Ima Ebong, Exhibition Coordinator, has been a valuable ally in developing the conceptual aspects of this exhibition, though the final responsibility for oversights and errors rests with me. I deeply appreciate her partnership in this project and all her efforts to amass information on our behalf. Her thanks are joined to mine in many of the following acknowledgements. I warmly thank the scholars who have allowed us to publish their original research, for if this book has lasting merit it will be substantially due to their contributions. The Center's Board of Directors was unfailingly supportive, especially Charles Benenson, Robert Rubin, William Rubin, and Ekpo Eyo, who provided advice on various aspects of the exhibition. Stephen Benjamin, publication director, mastered and brought to order the many whirling elements of the book. I am most grateful for the long hours he devoted to it and for his painstaking commitment to high standards. David Frankel, as text editor, was both kind and rigorous, ensuring the book's consistency and logic in the face of countervailing tendencies. Kiyoshi Kanai, assisted by Stefanie Krieg, designed the book, bringing creative solutions to its multifaceted challenges; Christine Kristen and Carole Moore assisted in the completion of the mechanicals.

From the very start, this has been a collective project, involving the professional skills of the entire staff at The Center. I only wish I had the space here to describe all the ways they lent their expertise and energies to the success of this book and exhibition. I am especially indebted to Carol Braide, Administrative Assistant and serene commander of the office, whom everyone relied upon to keep track of everything. Her ability to deliver whatever we needed whenever we wanted it was so awesome even the computers became submissive.

I am grateful to all the lenders, listed on page 296, for parting with their works of art, and especially to the following individuals and institutions, sometimes for multiple loans: Erna Beumers, Museum voor Volkenkunde, Rotterdam; Mr. and Mrs. Chaim Gross of The Renee and Chaim Gross Foundation; David Pilbeam, Peabody Museum of Archaeology and Ethnology, Harvard University; Doran H. Ross, Fowler Museum of Cultural History, UCLA; Thierry Raspail, Musée d'Art Contemporain de Lyon; Dr. Théophile Obenga, Centre Internationale des Civilisations Bantu, Libreville; Jay Gates and Pam McClusky, the Seattle Art Museum; Julia Brown Turrell, the Des Moines Art Center; Lewis Sharp and Richard Conn, the Denver Art Museum; Kathleen Berrin and Thomas Seligman, The M.H. De Young Memorial Museum, San Francisco; Michael Bell, Agnes Etherington Art Centre, Queen's University, Kingston; Anthony Ralph Gallery, New York; and Akira Ikeda Gallery, Nagoya. We are thankful for the swift response of Michel Renaudeau of Agence Hoa Qui, and Thierry Schluck of Canal +.

For facilitating loans, I especially appreciate the cooperation of: Mr. Moustapha Ka, Minister of Culture and Communication, Republic of Senegal; Leslie High, United States Information Agency, Dakar; Jan Hart,

Cultural Counselor, United States Embassy, Libreville; Miriam Guichard, United States Information Service, Brazzaville; Ruth Schaffner, Watatu Gallery, Nairobi; David Court, Rockefeller Foundation, Nairobi; Annina Nosei Gallery, New York; Vrej Baghoomian and his gallery assistant, Janet Kraynak; and Jean-Marc Patras, Patras Galèrie, Paris, who was unfailingly helpful. Fredrick Lamp of The Baltimore Museum of Art, Jean Pigozzi, André Magnin, Hans Schaal, and Mark Rosenberg all generously supplied information and photographs. I am grateful to Ulli Beier, Iwalewa-Haus, as a lender, and for generously sharing his insightful opinions with me during my visit to Bayreuth. In connection with Ima Ebong's work in Dakar, she and I thank: Alioune Lo; Aissa Djionne; Ousmane Sow Huchard; Kalidou Sy, National School of Fine Arts; Issa Samb; El Hadji Sy; Souleymane Keita; Viye Diba, Senegalese National Fine Arts Association; and Claude Ardouin, West Africa Museums Project.

I am equally grateful for photographs and information generously provided by: Hans-Joachim Koloss, Keith Nicklin and Jill Salmons, Judith Bettelheim, David Gamble, Cynthia Siu, Christopher Roy, Bill Dewey, Hélène Leloup, Stuart Wrede, Christine Kristen, and Nancy Nooter, among others. Jerry L. Thompson photographed many of the loans with his usual skill and professionalism.

An essential element of the exhibition has been contact with artists in Africa, Europe, and the United States. In particular I would like to thank Joseph Aubin, Fodé Camara, Sokari Douglas Camp, Acha Debela, Tapfuma Gutsa, Souley Keita, Koffi Kouakou, Iba N'Diaye, Malangatana Valente Ngwenya, Leandro Mbomio Nsue, Bruce Onobrakpeya, Ouattara, Cheri Samba, and Gerard Santoni for stimulating conversations and, in some cases, for loans of their works. Conversations with many of them were invaluable in shaping the ideas presented here.

I am grateful to the following colleagues for information and insightful discussions or correspondence: Christraud Geary, National Museum of African Art, Smithsonian Institution; Jean Kennedy, California College of Arts and Crafts; Sidney Kasfir, Emory University; Grace Stanislaus, Studio Museum in Harlem; Roland Abiodun, Amherst College; Freida High-Tesfagioris, University of Wisconsin-Madison; Janet Stanley, National Museum of African Art Library, Smithsonian Institution; Mrs. De Sosa, UNESCO library, New York; Johanna Agthe, Museum für Völkerkunde, Frankfurt; H. Kammerer-Grothaus, Übersee-Museum, Bremen; Bennetta Jules-Rosette, University of California at San Diego; filmmaker Carol Blue; artist and writer David Hecht; Salah Hassan, SUNY, Buffalo; Charles Bordgna, African Art Museum of the S.M.A. Fathers, Tenafly, N.J.; John Nunley, Saint Louis Art Museum; art critics Kim Levin, Amadou N'gom, and Jack Flam; Bill Karg, Contemporary African Art Gallery, New York; members of the artists' Groupe Bogolan of Mali; Francesco Pelizzi, Editor, *RES*; Margit Rowell, Centre Georges Pompidou, Paris; and the artists Ismael Diabate and Abdoulaye Konate, Bamako.

I am deeply appreciative to my friends and colleagues who read parts of the text, helping me sharpen my discussion and avoid egregious errors: Ivan Karp, National Museum of Natural History, Smithsonian Institution; Enid Schildkrout, American Museum of Natural History; Doran Ross; Jerome Vogel; Bogumil Jewsiewicki; Frederick Lamp; Simon Ottenberg, University of Washington, Seattle; Philip Peek, Drew University; and Marilyn Houlberg, School of The Art Institute of Chicago.

Early in the planning of "Africa Explores" we were fortunate to be joined by The New Museum of Contemporary Art in this exhibition. We greatly appreciate the support we have received from Marcia Tucker, Director, France Morin, Curator, and the entire staff of the New Museum.

Susan Vogel, *Executive Director*
The Center for African Art, New York.

FOREWORD

Six years ago, the Centre Internationale des Civilisations Bantu (CICIBA) invited me to be a judge at the first Biennale of Contemporary Bantu Art, even though traditional art was my main specialization.[1] My interests were redirected by the days I spent looking at many hundreds of contemporary works, and especially in listening to my two fellow judges, Leandro Mbomio Nsue, sculptor and minister of culture of Equatorial Guinea (fig. 2, page 179), and Joseph-Aurélien Cornet, the art-historian expert in Zairian art who was then director of the Institute of National Museums of Zaire. Those passionate polyglot conversations, and my contact with the many artists attending the biennale, convinced me that while my back had been turned studying traditional African art, contemporary African art had become a large and fascinating domain, one that condensed both ancient and new traditions and tasted of both Africa and the West. The first CICIBA biennale included work by academically trained artists and by artists called —with a certain degree of disdain—"autodidacts." The relationship between these two branches of contemporary painting, and their interaction with traditional art of the past and of living communities, became the subject of this book and exhibition.

The continuities and discontinuities in the many different strains of African art are enormously complex and still being shaped.[2] But I was impelled by curiosity, and by a sense of the ferment and excitement in twentieth-century African art, to try to find out what could be learned from a broad overview. The continuities were in fact hard to see. They turned out to lie in an African sensibility that is more philosophical and aesthetic than immediately obvious in visual styles. Like most works of synthesis, mine has concluded with caveats and qualifications—the understanding, for example, that there are many exceptions to the tendencies I have described; and the sharp discomfort of knowing that the information on which my emphases are based is only partial, and that my conclusions are drawn in the face of much that remains unknown.

This work is drawn in part from the substantial literature on traditional art that has accumulated over the past century, little of which

deals explicitly with art in change; on the considerable, rather recent literature on "popular" art, which addresses that art mainly as a social document; and on a small but growing literature on "contemporary" art, most of which is tightly focused. What the main issues are in the larger picture, where the connections lie, who the important artists, teachers, and other actors are, what the criteria for quality might be, and who might judge—these questions are still being sorted out. This is why I felt the need for a substantial book with contributions from many authors who would reflect different —even contradictory—approaches. The book is not a survey, and cannot pretend to offer answers. Instead we hope to advance critical discussion, and to carry the debate forward by broadening the scope of inquiry, by offering some new terminology, and by helping to frame the important questions.

Some of the issues that have been most discussed—such as the debate about authenticity, or "Africanness"—seem more distracting than critical. Others are freighted with political and emotional weight: issues of marginalization; notions of taste and quality; the very words "tradition," "modern," "change," and "history," which are charged and contested. Loss, painful struggle, great aspirations, and involuntary changes that challenge our honesty and sympathies are part of this story. Politics and emotions of many sorts have shaped assumptions and distorted the available data, even in the long-studied field of traditional art. What Herbert Cole (1988:54) has sensitively confessed may be true of many scholars: "I mistakenly established an 'ethnographic present' of those bygone years, noting but somewhat suppressing the changes evident during fieldwork in 1966-67. . . . It was as if I did not really want to fully acknowledge the changes . . . since the 1930s." My own deep attachment to art styles and to a way of life that are doomed to pass into history had to be put aside before I could turn to a study of the present. Knowingly or not, we are all partisans on one side or another, and we all speak for our moment in time. If these texts had been written ten years ago, or ten years hence, they would tell a different story.

"Africa Explores" seeks to focus on Africa, its concerns, and its art and artists in their own contexts and in their own voices. Western perceptions of Africa, and Western uses of African art, are entirely secondary here, as are isolated African uses of Western ideologies and artifacts. It was repeatedly suggested or assumed that this book would consist mainly of objects that showed the influence of Western goods and ideologies: that it would trace the Africanization of Christianity, for example, or show African depictions of Western goods such as clothing and bicycles. This view, however, seemed to reflect a narcissistic Western fascination with images of whites or of Western things recast amusingly or incongruously, to Western eyes, in exotic settings. Instead of attending primarily to Western ideologies and objects, we preferred to try to understand Africa's experience of this century from the African perspective—from a point of view in which Western things and ideas are particles in a matrix of preexisting

African styles and philosophies, in which images of whites do not take pride of place, and in which it is perfectly natural, even expected, for an artist to paint in acrylic, or for a mask costume to include a digital watch (if, of course, it is a high-status mask).

Nonetheless, this book is mainly the work of Western writers who speak as intimate outsiders. There is nothing specifically African about this kind of study; we are aware that the whole exercise is typical of late-twentieth-century Western scholarship. The use of the category "art" to describe the objects included here—like the category "museum"—can be defended on grounds of theory and of convenience, but this concept is in no way inherent in all of the African objects under discussion. It is a strictly Western category that we employ here only as a useful tool.

My working procedure began with looking at hundreds of paintings, sculptures, photographs, and objects of all kinds, and with reading or listening to as many African artists and critics as possible. I looked for artists who had produced a significant body of work, passing over many interesting artworks that were singular successes. My African colleagues considered content or meaning at least as important as form in their assessment of art, leading me to a selection and grouping of works according to both form and content. Five loosely defined strains emerged that run through this century. Though the strains themselves are clearly distinguishable and describable, they converge and overlap at times, and individual artists occasionally move from one to another. No single criterion (such as relationship to a market) can define or explain the similarities and differences in African works of art. Instead the strains are characterized by clusters of traits. Three of the strains are familiar, though their conventional names require reexamination in the context of all African art. The names used here single out their most salient traits.

The first strain discussed here (because it is the oldest, and because it underlies all the rest) is **traditional art**. Contemporary writers specializing in such work often try to avoid the word "traditional," preferring simply "African art," or sometimes "regional art"—a meaningless term for our purposes. In some measure, all art everywhere is traditional (and regional). We use the word in the narrower sense of an art that emphasizes its connection to received forms more than the invention of the individual artist. To note this characteristic of traditional African art is not to ignore its makers' long-standing appreciation of innovation, and their willing adoption of new ideas and forms.

Traditional art is village based, and is made by artists who work mainly for members of their own ethnic group. They have been trained through a relaxed form of traditional teaching—usually apprenticeship—and make works that serve old functions, if sometimes in an updated style using new materials, such as enamel paint. The forms of traditional art, almost always sculptures, are resolved, self-contained, and unitary; their subjects are humans and animals, often highly stylized. These works are functional in the sense that they serve some concrete purpose (they are made to be worn as masks

for example, or, sat upon), or they are intended to be displayed or manipulated in the course of some event to which they are essential (such as the installation of a chief, or the performance of a divination). Traditional artists often also work for the tourist market.

A second strain, **New Functional art**, is art that will become traditional if it continues to be made by the next generation. This art is not usually identified with single ethnic groups. It is generally made on commission in rural villages and small towns it serves newly felt purposes in its community and is generally used in public contexts, often performances that are not a continuation or an updating of older practices. Sometimes this art serves Christian or Islamic cults, often of a syncretic nature. The artists tend to be self-taught innovators experimenting with an eclectic mix of materials and motifs. The artistic forms are striking and aggressive, and conspicuously different from traditional art. These new kinds of art can reach a wide market, making the artist famous.

Urban art, commonly called "popular" art, is made by artists who make signs and other commercial images for small businesses such as restaurants, market record shops, or barber stands. They also make paintings as "art to look at," which they sell to urban workers and to Europeans. Their art must be extroverted and must have an immediate impact, and it should be engaging, amusing, or ornamental. The enormous volume of work these artists create may be quite repetitive. They are rather like craftspeople, making art to earn a living. Most have only a primary school education and rarely travel, but some have attracted attention in the West, and have visited Europe or have been guided by a European mentor.

International art is made by artists who are academically trained or who have worked under the guidance of a European teacher/patron. These artists live in cities, often represent their governments in international gatherings, are more widely traveled than other artists, and have a higher standard of living. Their works are shown in exhibitions, and may be sold to foreigners and international businesses as well as to the governments and the elite of their own countries. Their works can be concerned with issues of form, and the meanings can be obscure to the uninitiated.

"Extinct" art has a strong presence in Africa today: this is traditional art of the past, now stored in museums, and in the collective memory, or living on in contemporary reproductions neither made nor used for the objects' original function. In some cases the original art form may still be used in its old context, but in the national consciousness it is treated as a popular symbol divorced from its original associations. Extinct art is a glorious legacy—both a burden and an inspiration for contemporary artists. It is often appropriated as a symbol of national unity, and treated as a reservoir of forms for popular images, conferring prestige and signaling African identity. Its forms are often harmonious, defined, completely resolved, and calculated to produce a transcendent emotion.

This book is organized according to these strains, which should be considered conceptual tools rather than sequential or developmental

phases, for they provide not a history of twentieth-century African art but an interpretation of it. Nor are they rigid or exclusive, since it is clear that some artists and some works can pass from one strain to another, and rarely is a trait limited to only one category.

During the long period I worked on this book and exhibition, many people influenced my views, though the selection of works and the conceptual framework for the exhibition—along with any shortcomings or inaccuracies—are finally my own. As the exhibition developed, it became evident that the selection was necessarily going to be arbitrary and personal because the body of work is so enormous and so difficult of access, and because there are so few earlier choices upon which to build. If this selection neglects some well-known and deserving artists, it also certainly overlooks obscure but talented artists whose work I never encountered. Public attention to artists and trends has been grossly uneven and often unrelated to the intrinsic interest of the works of art. Most of the writing on contemporary African art has been in English, and it typically displays an emphasis on artists working in Anglophone Africa. The present overview may be seen as weighted in favor of artists from the Francophone countries.

The problem of equal representation of women artists remains regrettably unsolved here. For a variety of familiar social and economic reasons, Africa claims only a fraction as many professional women artists as men—in many places there are literally none. The number grows, however, with each generation, and there are more women artists at the beginnings of their careers today than there are in their maturity. I hope future exhibitions will be able to show more work by African women than has been possible here.

This study was affected by two related exhibitions that appeared during the period in which it developed. The Studio Museum in Harlem's widely seen "Contemporary African Artists: Changing Tradition," of 1990, featured the work of nine generally well-established International artists. I decided not to duplicate any of those choices, some of which were shown not only in New York but also at the 1990 Venice Biennale.[3] And the Centre Pompidou's courageous and provocative "*Magiciens de la terre*," of 1989, showed traditional and Urban African artists, three of whom had already been selected for this exhibition.[4] In some respects this exhibition is an answer to that one, which underscored the importance of placing contemporary African art in the context of African art, history, and culture, if only by failing to do so.

As a first attempt at synthesis, "Africa Explores" is in the nature of a working proposal. It invites elaboration and improvement—and indulgence of its oversights and errors. I hope it will prove useful to those who will deepen and extend our understanding.

NOTES

1. The biennale was held in Libreville, Gabon, in April 1985, and included some of the works by Trigo Piula, Moke, Cheri Samba, and Sim Simaro that CICIBA and the artists have lent to this exhibition. I am grateful to CICIBA and its director general, Théophile Obenga, for also inviting me to the third biennale, held in Libreville in July 1989.

2. This study examines art from sub-Saharan Africa only. It does not include art from north Africa, Ethiopia and Sudan, which belong to other art traditions, or, for practical reasons only, from South Africa. We hope in the future to devote an entire exhibition and book to South Africa's rich and complex twentieth-century art.

3. They were El Anatsui (Ghanaian, living in Nigeria), Youssouf Bath (Ivoirian), Ablade Glover (Ghanaian), Tapfuma Gutsa (Zimbabwean), Rosemary Karuga (Kenyan), Souleymane Keita (Senegalese), Nicholas Mukomberanwa (Zimbabwean), Henry Munyaradzi (Zimbabwean), and Bruce Onobrakpeya (Nigerian), all living in Africa.

4. They are S. J. Akpan, Kane Kwei, and Cheri Samba.

Susan Vogel

DIGESTING THE WEST

Contact with the West has been the determining experience—though certainly not the only influence—for African art in the twentieth century. European military and political domination during the colonial period enforced countless changes, some overwhelming, others imperceptible, leaving virtually no one untouched, and repercussions from these changes have continued to echo through the quarter century since most African nations became independent. The lives of ordinary people everywhere on the continent have been affected by the advance of Islam and Christianity, urbanization, Western-style education, the introduction of a money economy, and other developments in the wake of colonialism. Throughout the century, Africa has been engaged in a continuing pursuit of real economic and political freedom, and in an effort to negotiate its proper relationship with the West and with the Arab world. African peoples' efforts to situate themselves and their traditions in relation to Europe and Islam have framed the work of almost all twentieth-century African artists.

African art during the colonial period was shaped by a period of enforced peace. Throughout the century, rapid social change has deepened the need for spiritual solace, satisfied in part by new and expanding syncretic churches and healing cults, which often promote the creation of artworks. Countering these favorable conditions for ritual activity and artmaking has been the destruction or removal of art by white soldiers, missionaries, African converts to Christianity or Islam, and a seemingly insatiable world art market. This century has also been marked by the availability to African artists of an unprecedented range of media, techniques, patrons, and ideas.

Contradictory conditions like these have changed African art and artists profoundly in the twentieth century. There is reason to believe that earlier masquerades and cults were reinvigorated every generation or so by the introduction of new gods or powers, new cult requirements, new mask personae with new names, and new music, dances, and sculptures; these new cults often closely resembled earlier forms, but they nonetheless renewed artistic traditions without altering underlying structures or values. Furthermore, political and social upheavals periodically produced radical changes and discontinuities in art well

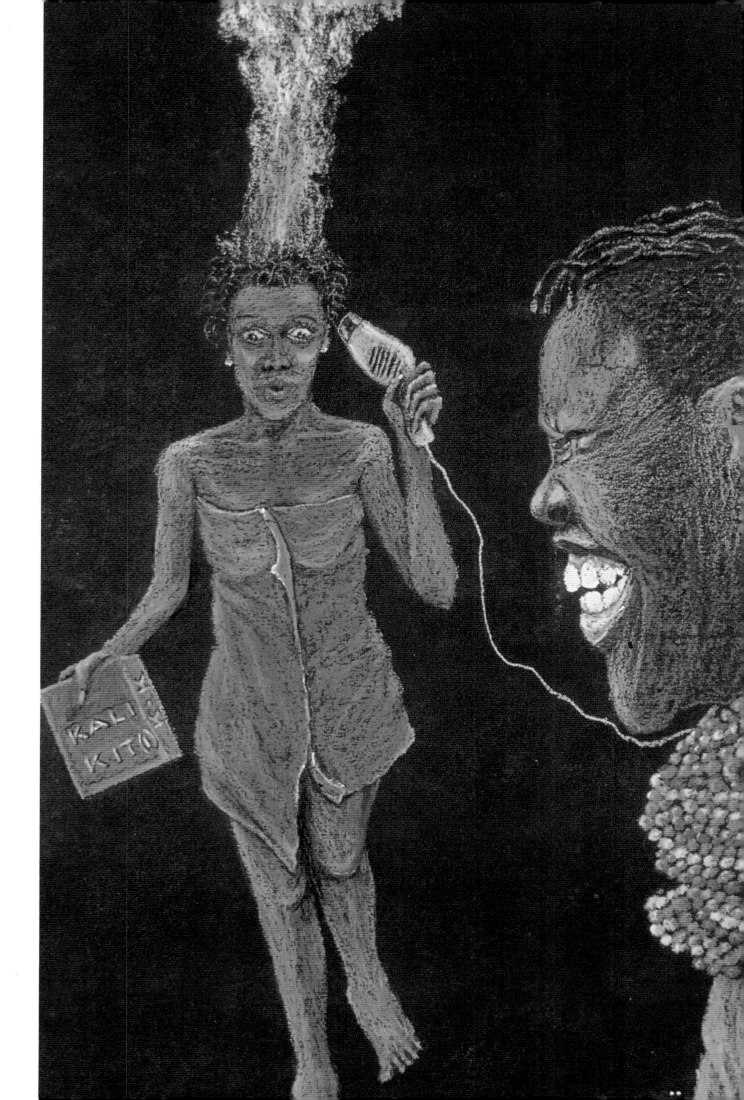

before 1900. But the current century has seen change of a different sort: the creation of entirely new art forms that respond to social and cultural situations peculiar to twentieth-century Africa.

Continuities

Visual links between current and past African art are surprisingly hard to find. Contemporary artists generally avoid the older African medium of wood sculpture, and echo its forms no more than do many Western artists. The exception is contemporary traditional art, which is a direct continuation of earlier art. The discovery that traditional sculpture in this decade compared to the beginning of the century in fact seldom shows radical changes in form contradicts common assumptions that it had remained unchanged for millennia, then suddenly lost its character completely on contact with the West. More usual than a radical change in form is the complete elimination of a genre of sculpture, or its waning in favor of other forms of expression. Both objects made for utilitarian contexts and those used in fervently felt religious cults obey this general rule.

A remarkable continuity in artistic vision was an unexpected finding of this study. A similar conception of art—one notably different from Europe's—unites African artists from the beginning of the century until the present: we find similar ideas about the purpose of art, the artist's role, his or her interaction with clients, and the way he or she works, even among African artists living in Europe or America. Content, for example, is of prime importance for African artists, critics, and audiences, who tend to share an expectation that works of art will have a readable message or story. African art of all kinds is likely to be explainable in terms of a narrative or a religious, social, or political text known to both artists and audiences. These explanations, however, are fluid, varying from circumstance to circumstance and even from individual to individual. This has long been recognized of traditional and Urban art, but is a less acknowledged part of International art, where the narrative may be more obliquely stated.[1]

That all forms of contemporary African art are seen as functional, or as serving some common good, was one of the most surprising findings of this study. While I expected contemporary traditional art to show this similarity to nineteenth-century traditional art, and knew that Urban art was in some respects utilitarian, I did not anticipate it in International art. The emergence of the strain I call New Functional art underscores the continuing communal use of art in African societies. As in the past, most kinds of African art (except some Urban art) seem to have a kind of seriousness, a higher mission than pleasure or decoration alone.[2] The general consensus is that it must honor, instruct, uplift, clarify, or even scold, expose, and ridicule to push people to be what they must be. Even at its most lighthearted, it is never trivial.

African art is seldom strictly private. It is almost always displayed today in relatively public places; even in the home, art, including portrait photographs, is seldom kept in the bedroom or other private areas of the house. Urban art is displayed in living rooms, or, when it is created as advertisement, in the streets or in public areas such as

Fig. 1. *Kali Kit* (Sharp kit), 1985, by Etale Sukuro (Kenyan, b. 1954). This satirical look at African appropriations of Western gadgets was painted not for sale but for display, to radicalize the people at local art fairs. Sukuro is one of Kenya's more prominent artists and has received numerous important commissions. (One of his murals was made for the United Nations' General Assembly Hall in New York.) Here a large woman in traditional Turkana necklaces and clayed hair laughs at her small citified sister, who has foolishly attempted to Westernize her appearance by using an appliance without being able to read the instructions (Agthe 1990a:418). Collection: Museum für Völkerkunde, Frankfurt. Photo: Maria Obermaier.

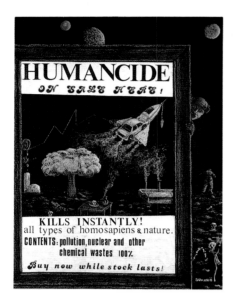

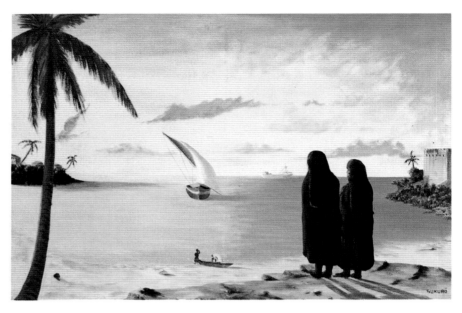

Figs. 2. a) *Humanicide on Sale Here*, 1985, pastel and collage, 63 x 51 cm. b) *Shore scene*, painted for Gallery Watatu, 1989. Both by Etale Sukuro. Sukuro has had considerable success with the attractive landscapes he paints for white collectors in Nairobi. Meanwhile he works in a different style for himself. In a style one might call imaginary realism, he paints biting political statements that he displays at the art fairs he helped to establish in markets, streets, and rural areas. These sophisticated renderings of cartoonlike subjects are designed to raise the political consciousness of the people (Agthe 1990a: 418). a) Collection: Museum für Völkerkunde, Frankfurt. Photo: Maria Obermaier. b) Courtesy Gallery Watatu, Nairobi.

restaurants. Other strains of art are routinely commissioned by associations or corporate groups for display in public settings ranging from a national bank to a village funeral. Because twentieth-century African art is functional and in some measure public, its interaction with its audience is of capital importance—another continuity with the past. The audience is not only the "receiver" of art (as the designated "receiver" of a folktale must be present for it to be told[3]) but also the respondent and in some ways the animator of the work. (The call-and-response pattern of African music, where the soloist sings or drums a segment and the group or orchestra produces an answering passage, is particularly analogous). Just as it would have been senseless and incomprehensible to hold a traditional masquerade performance without an audience, the idea of the artist in a garret creating works in isolation, for no one or for him- or herself alone, seems quite peculiar in Africa. In a traditional context it might even suggest madness or witchcraft. In modern settings we occasionally find artists making art for themselves, and not for sale, but such work is usually spiritually meaningful, or has a function as decoration or instruction.[4]

The audience also exerts the only control on innovation. In the past, the expectation was that each work of art would reprise a familiar theme, and any piece that innovated too much was no longer recognized as a version of the prototype. Not only the human commissioners and spectators of works of art fulfilled the role of audience, but also the ancestors and spirits, who could refuse to accept a work that deviated too far from the norm.[5] That role is now filled by the audience and the market, those who commission works of art and those who buy.

Repetition or Reprise

The interaction between artist and audience may involve a kind of repetition or reprise of themes familiar to both. This is an important characteristic of African art and music.[6] One aesthetic criterion of African traditional art is the artist's ability to hold in tension creation and the audience's expectations, in other words the opposed forces of

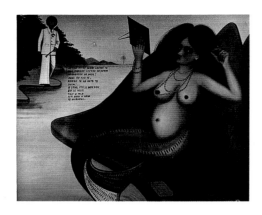

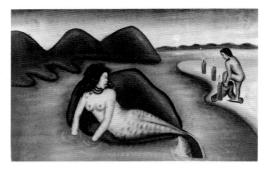

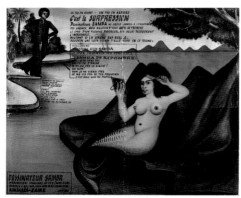

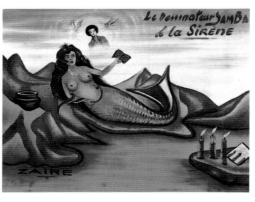

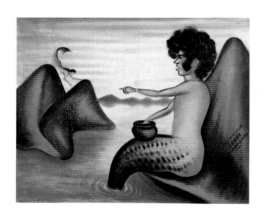

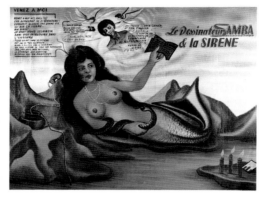

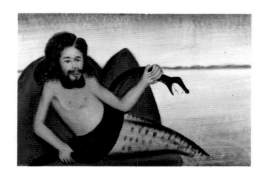

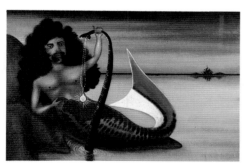

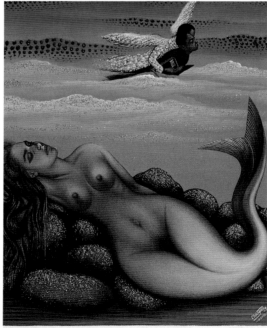

innovation and repetition. What James Snead says of music holds equally true of African art: "Black music sets up expectations and disturbs them at irregular intervals: that it will do this, however, is itself an expectation" (1990:222). Each traditional sculpture is seen against the ground of people's expectations about the type of art being created, and their memory of other versions. "Without an organizing principle of repetition, true improvisation would be impossible, since an improviser relies upon the ongoing recurrence of the beat" (ibid.:221). Like a jazz player's, the artist's variations on the theme rely on the audience's familiarity with the basic format. The interest and the surprise lie precisely in what is omitted or altered in comparison with that model.

The seeming repetitiousness of contemporary African art of all kinds—from glass paintings to coffins and academic painting—can be troubling to those who define creativity in Western terms that put a premium on originality. Joseph-Aurélien Cornet writes of a fundamental continuity through time that is "above all linked to the deep psychology.... There exists... a sort of cultural parallel to the desire for security, a real satisfaction in repetition, which is so different from modern Western art's spirit of adventure. This refuge in repetition can be seen even in the most recent Zairian arts. African art is more an art of stereotypes than of creation" (Cornet et al. 1989:55-56).[7] African artists characteristically develop a personal idiom (or more than one) early in their careers and then change it little over their lives.

One of the insights gained from an overview of African art is that the idea of the artwork as a reprise of familiar themes lies deep in the African conception of creativity. Where originality, the ability to create something never before known, remains a fundamental concept, however strongly contested, in the Western idea of the artist, the African artist is more likely to be seen as part of a continuum or community of artists drawing on preexisting forms. (Since all artists re-use existing forms, this distinction between the Western and the African artist may be more a matter of emphasis than a real difference.) The African artist is never solely an imitator, never literally repeating an earlier form (as craftspeople do), nor can the work be called stereotypical, since it always changes. The work should rather be called a reprise. Where repetition in European art is often directed toward perfecting the model, the African reprise is an end in itself, designed not to develop or improve on the basic theme but to embody it in a given instance or to play off it. One might say that, like a Western theater performance of a Shakespeare play, an African work of art is never seen as a culminating statement, is never definitive; the model is never exhausted or perfected, and therefore does not have to be discarded. (This idea of perfection is rooted in the Western notion of progress.) Magdalene Odundo's sensuous pots return again and again to the millennial African round-bottomed, swell-bodied form without ever exhausting or repeating it (cat. 105-107).

A particular kind of creativity inheres in this conception of art. African verbal art, scholars say, "has a prior existence, which the verbal artist [the storyteller] makes manifest in performance.... 'a

Fig. 3. These nine paintings on the subject of Mami Wata and Papi Wata, all by Cheri Samba (Zairian, b. 1956), were painted around 1979 in Kinshasa, with the exception of the last one, painted in Paris in 1989. Cheri Samba has worked and re-worked this popular theme many times, but he never quite repeats himself. The theme is always varied and has an ongoing life. The artist can cut back to it whenever the market or his own preoccupations suggest it. Photos: courtesy Bildnachweis, Übersee-Museum, Bremen, and Jean-Marc Patras Galerie, Paris.

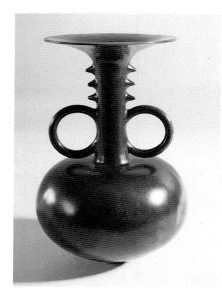

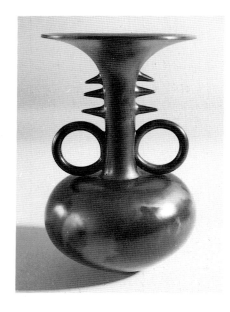

narrative is permanent and eternal'. . . . verbal artists bring something into being during a performance which did not have existence in that time and place before" (Peek 1981:30-31, partially quoting LaPin). Traditional African sculptors often say they are freeing a form they see in the uncarved wood; it may be justifiable to postulate that in the visual arts as in the verbal, creativity consists in materializing something that already exists. Originality, then, would lie in the ability to improvise, to create interesting variations, rather than in claiming to invent something completely new. As in music, the artist can cut away from an ongoing rhythm or melody—or form—to improvise against it, then can cut back to the waiting or ongoing form. Over a fifteen-year period, Cheri Samba has frequently cut back to the theme of Mami Wata, repeating it in many guises, including one conceived in Paris. No two are identical.

Artists and audiences alike value the creativity involved in the particular instance—in the making of an individual object or in the invention of a particular model. A painting or sculpture that an artist has copied from his or her earlier work because it is particularly successful is likely to be a more desirable purchase for the client than a work that is original— in our Western sense—but less popular. A certain kind of repetition, such as that seen in Kane Kwei's coffins (cat. 34-38), is thus the sign not of a failure of imagination but of success. Urban artists like Moke or Tshibumba (cat. 65-75) repeat their own best themes and compositions (but never exactly—such a commission would cost extra). Lesser artists are limited to copying the successes of other, more popular artists.

In addition to reprise·of earlier forms, rhythmic repetition of forms within the same work is a minor aesthetic trait of African art. Photographers all over Africa enjoy multiple printings of the same negative for aesthetic effect. Fodé Camara repeats pairs of hands down the side of his canvas (cat. 102); Mode Muntu repeats his stick figures in nearly identical postures (cat. 90-92); hosts of costumed Dogon dancers wearing similar *kanaga* masks create a stunning effect; rhythmically spaced, virtually identical metal bands create the forms of Sokari Douglas Camp's sculptures (cat. 100-101). Repeating patterns or motifs are used by painters as different as Pilipili and Twins Seven-Seven. On the streets, in churches, and in homes, visitors to Africa are always amazed to see groups or families dressed alike for special occasions, a popular expression of the same taste for rhythmic repetition.

Client Driven Art

Like nineteenth-century traditional art, virtually all strains of twentieth-century African art are client or market driven. Recent art forms as diverse as sign painting, easel painting, and cement tomb figures are made and sold by professional artists who must satisfy the changing demands of clients or customers. In response to current events and market demand, the Kinshasa artists who paint in volume for sale through street vendors can add current topical subjects to their repertoire with lightning speed. A relatively high proportion of International artists create works on commission for businesses or government

Fig. 4. Three pots, 1990, by Magdalene Odundo (Kenyan, b. 1950). Odundo makes few pots each year, but her repetition of their pure forms seems to spring from a desire to delve ever deeper into something inexhaustible. She does not always work in series and no two of her pots are alike. Like other African artists' work, hers seems to lack the Western kind of linear repetition—the drive to perfect a mode, then to discard it and an advance to another. All her works are simultaneously precious objects and simple pots. Photos: courtesy Anthony Ralph Gallery, New York.

Fig. 5. Portrait by an unknown Ivoirian studio photographer, Yamoussoukro, 1970s. The rhythmic repetition of the girl's head, printed from a single negative, is a popular device among studio photographers and their clients. Private collection.

agencies. The size, subject matter, materials, and [...] aspects of these works are commonly part of the clie[...] who work for the tourist art market are also notorious[...] the demands of their customers (see chapter V).

Today, the interaction between African artist and patro[...] continues the traditional relationship between artist and clie[...] between the artist and the work. It is an underlying assumptio[...] traditional artist's role that the client is a collaborator in the ma[...]g of the work, which will reflect his or her ideas as much as or more than the artist's. Further, the practice expresses the essential role of the audience in the creation of art. The relative absence of personal subjects in *any* strain of African art is explained by the importance of the client, and by the essentially functional nature of African art— which exists, on the whole, not to express the individual but to answer some larger collective purpose.

Twentieth-Century Aesthetics
Between the early and the late twentieth century, African aesthetic

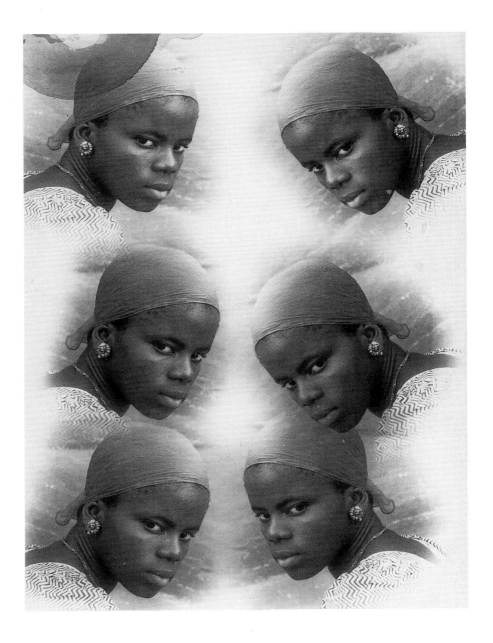

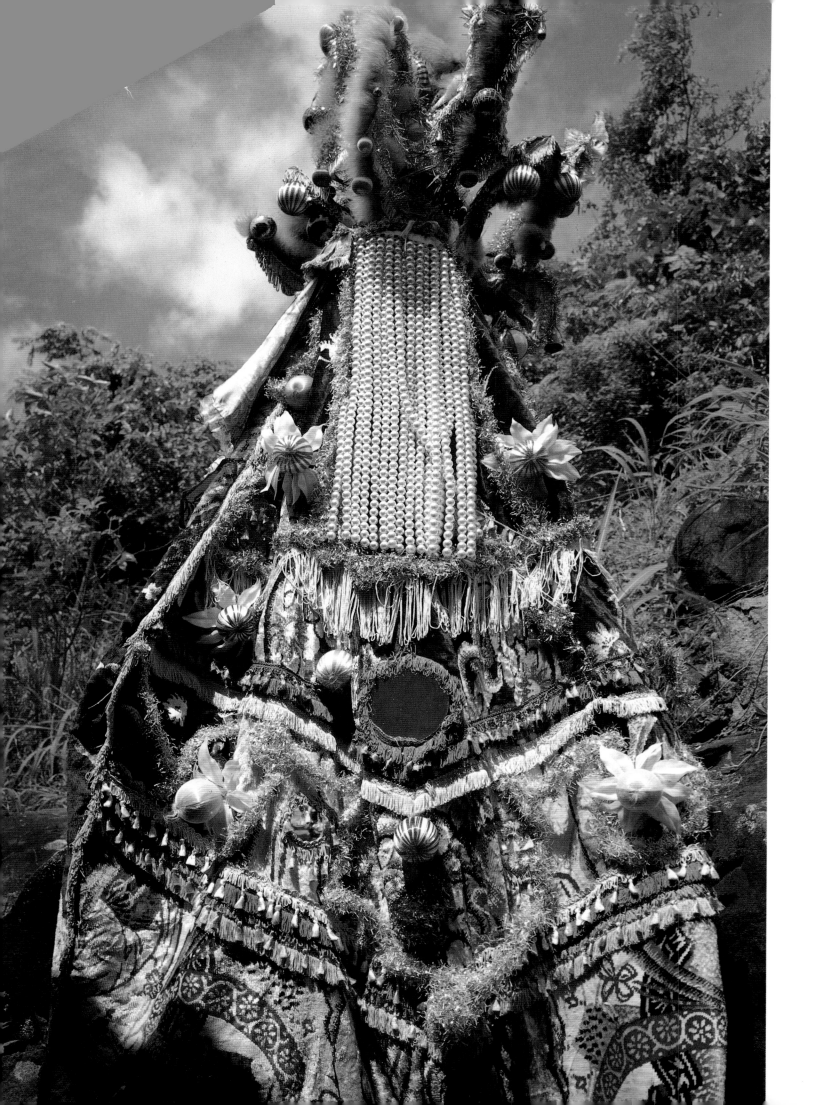

Fig. 6. Ode-lay costume by the Sierra Leonian artist Ajani (b. 1950s), Freetown, 1979. Seeking to produce an effect of dazzling luxury and complexity, the artist has combined an assortment of bright, shiny imported materials: Christmas ornaments, fake pearls, upholstery fringe, feather boas, tinsel, plastic flowers, mirrors, and various showy fabrics. The pearl face-screen derives from the bead veils of Yoruba Egungun masks. The costume exemplifies the late-twentieth-century taste for heterogeneous, confusing, often unstable compositions, an aesthetic preference that may reflect the uncertainties of contemporary existence in the booming cacophony of cities, with their jumble of ethnic groups. Photo: Hans Schaal.

intentions moved in a consistent direction. The forms of the earlier work were most often harmonious, resolved, classical. The work was magisterial, and conveyed a sense of overriding order—or else it produced a sense of disquiet and threat by playing on the viewer's familiarity with that aesthetic of order. There was a close relationship between form and meaning, often embedded in the very materials used: Zairian Kongo figures (cat. 127-129), for example, along with various other kinds of sculpture, could be understood partly through puns on the names of their materials, or through color symbolism.[8] Form and meaning were closely related to function: Kota reliquary guardian figures (cat. 120-122) have polished metal surfaces that not only reflect light but cast back the evil intentions of intruders.

As the tumultuous twentieth century advanced, aesthetic intentions changed, just as they did in other parts of the globe. African art— again with exceptions—became less definitive in its attitude, less unified in its composition, and more visually complex. Many works became heterogeneous in manufacture and in effect: where earlier sculptures might have been carved from a single piece of wood, new works began to be made of miscellaneous ersatz materials, often from disparate sources, combined in visually and sometimes physically unstable compositions. The Ode-lay masks of Freetown (cat. 31-33), for example, have wobbling superstructures made of wire covered with materials that convey no complex meanings: fabrics, fringe, plastic flowers, Christmas ornaments, porcupine quills, and cowrie shells. The Sibondel and al-Barak headdresses made by the Baga of Guinea have markings on the sides invented by the originator of the art form, and made with his son's school compasses and protractors (cat. 17-18).

These new works do not strive for the majesty of the earlier sculptures; they aim instead to stun. They are loud, surprising, exciting, disturbing, active. Colors are strong, with high contrasts. The scale is often large and the tone brassy. The work is not without complexity or nuance, but its subtlety is not of the old, classically restrained kind. To be successful, Kane Kwei's coffins (cat. 34-38) need their bright colors and surprising forms.

The compositions of late-twentieth-century art sometimes look fragmentary and confused compared to earlier art, but they express the complexities and confusions of the modern world. The uncertainties that have pervaded life in urban Africa, and increasingly since mid century in rural Africa as well, are mirrored in the continent's new art. The relationship between form and meaning is tense now. Meanings are no longer embedded in the materials of the works themselves, or in coded but familiar symbolic systems known to the intended audience; they are often newly invented, and must be explained. Messages may be ambiguous, personal, and situational, less universal than before. Audiences have become so diverse and interpretative systems so decentralized that Cheri Samba and other Zairian painters write titles and explanations on their paintings—some in two languages (cat. 63-83). Even then, the content of the works is so far from universal that a viewer in Dakar or Nairobi might be at pains to understand it.

The single most striking change is the new reliance on color. This

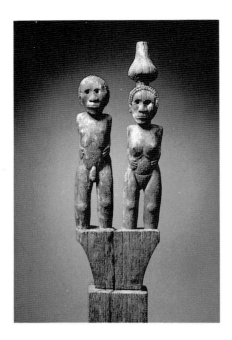

Fig. 7. Malagasy grave post from the second half of the nineteenth century. The memorial is fully sculptural and stylized, presenting a generic image of the deceased. Color does not seem to have been essential to the aesthetic. Collection: Carlo Monzino. Photo: Mario Carrieri.

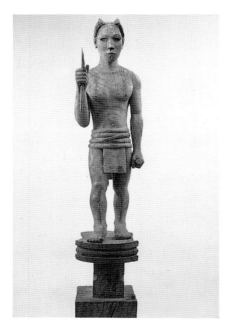

Fig. 8. Malagasy grave post from the 1920s. The figure is more naturalistic and individualized, and is animated by the walking stance. Collection: The Paul and Ruth Tishman Collection of African Art, Walt Disney Co., Los Angeles. Photo: Jerry L. Thompson.

change is accompanied by a corresponding deemphasis on plasticity—by the replacement of sculpture with two-dimensional art.[9] This movement from volume to color is found in the widest possible assortment of contexts. Nigerian Hausa builders used to decorate the facades of important houses with linear patterns in mud relief, but now use brightly colored patterns painted on a flat surface.[10] Malagasy sculptural tomb posts, which at the turn of the century stood unpainted on rock tombs, are now not only routinely brightly colored but are sometimes replaced by depictions of the old posts, and of other things, painted on the walls of the small cement house like structures now sometimes used as tombs. Bobo mask dancers of Burkina Faso used to wear fiber costumes in the natural buff color, or else dyed black and deep magenta. With the availability of new dyes, Bobo audiences now fancy emerald green, bright purple, orange, and yellow costumes. New gourds in the market are likely to be enameled in brilliant colors, where once they were engraved. No matter when they were carved, masks and all kinds of sculptures in use today are almost always freshly painted with sharp bright colors.

The introduction to Africa of imported paints and dyes is an obvious explanation for this interest in color as a medium of expression; the long-standing admiration for clean, freshly painted sculptures is another. In fact, the preponderance of brightly painted traditional objects now in use reminds us that the traditional works we know from collections (especially the vast majority that were not brought straight to museums from the field) are not representative of African art as it was expected to appear. Not only was the original, fugitive paint originally much brighter than it is today, but in all likelihood whole categories of objects we think of as dark, polished, unpainted wood were normally colored. These include Senufo helmet and face masks, all Yoruba sculpture, Djimini and Guro masks (see p. 33), Bamana marionettes, the Baga Nimba (cat. 13), Kongo masks, and dozens of other object types.

The early traditional use of paint on sculpture was almost invariably secondary to plasticity as an aesthetic medium, and was used mainly to emphasize sculptural form. Almost never is color used as a vehicle for expression in itself. In nineteenth-century sculpture, changes in color are almost invariably bounded by changes in relief (at least a groove but often much more), or by changes in material. Color is often used in such a way as to underscore the main sculptural volumes, or to draw attention to shallow-carved detail.

The recent use of color intersects with another stylistic tendency of twentieth-century African art: the desire for a new kind of verisimilitude. Both traits reflect a changed relationship to the visible world. A new desire to depict the surrounding world has been felt by artists working in every mode and can be said to be a central impulse in twentieth-century African art. This tendency is most marked in traditional sculpture, which has become progressively more naturalistic throughout the century. Anatomical details have appeared—clavicles, age lines, modeled muscles, the softness of flesh—and figures may now be shown in motion, as nineteenth-century examples almost never

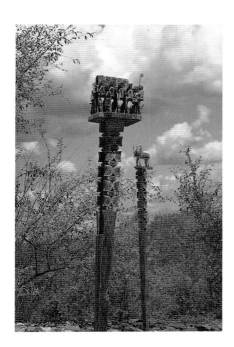

Fig. 9. Malagasy grave post (in a different regional style from the previous two), 1940s-1960s. The image depicts a scene of activity—the carrying of the coffin. The tomb also includes a depiction of a bus, as well as the traditional birds and cattle. The sculpture was probably painted; those made in 1989 for the "*Magiciens de la Terre*" exhibition at the Centre Pompidou, Paris were painted bright colors. Color had become essential to the total effect of the sculpture. Photo: Susan Vogel, 1979.

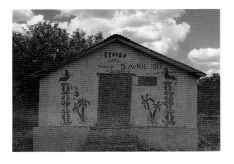

Fig. 10. Malagasy tomb structure with a painting depicting grave posts, 1977. Color and a two-dimensional image have replaced sculpture here. Photo: Susan Vogel, 1979.

were. Urban paintings from Zaire gain authority from the accumulation of naturalistic detail, which the artists use to prove that their moral tales are true, and that the historic events they depict really happened.[11] International art has a more ambiguous relationship to the visible world: International artists virtually never depict it as such, though they are often trained in the observation of nature. Typically they mix naturalistic with nonnaturalistic elements. Trigo Piula (cat. 114-116), for example, builds mystical scenes out of realistic elements; Mbuno (cat. 87-89) uses naturalistic shading to model stylized figures on a flattened ground; and Fodé Camara (cat. 102-104) traces the actual outline of his shadow. Nonetheless, many artists, like Malangatana (cat. 108-109), scarcely allude to their visible surroundings at all.

Western images, especially photographs, are usually proposed as the source of the new naturalism, especially in traditional and Urban art. I would dispute this. Photography has been a presence in Africa since the late nineteenth century, and has clearly been absorbed into the culture. Portrait photos can be seen in the remotest villages; in conversation, villagers will frequently compare photographs to their traditional sculptures as vehicles of representation. But African photographers don't necessarily use photography naturalistically. They often improve on the visible world, creating arresting effects through stylized poses, manipulated negatives, and painted backdrops (cat. 58-62). Furthermore, the kinds of artistic solutions photographs propose are pictorial, and are hardly useful to traditional wood carvers—whose work still shows the trend toward naturalism. Africans hardly needed the realism of European photographs to validate changes in their traditional imagery. Nor, obviously, did they need photographs to conceive of a naturalistic art.

Urban painters clearly use photographs in parts of their work, especially for faces. Certain Senegalese paintings on glass are based on photographs—notably the widely diffused portrait of the Mouride leader Sheikh Amadou Bamba (Chapter III). And the face of the Zairian patriot Patrice Lumumba that appears frequently in Tshibumba's work is based on a photograph (cat. 67). Nonetheless, Urban painters seldom describe space in a photographic way, and in general seem to have borrowed more from comic book drawing than from photography. It is tempting to say, in fact, that the reverse occurred and that Urban painters have influenced studio portrait photographers, who often use backdrops painted by local artists to create the unreal spaces in their images.

Something quite different from the influence of photography may be expressed in the interest in naturalistic art: a progressive lessening of confidence in the invisible world, and a new relationship to the visible one. Africa's defeat by colonial forces, and its subsequent inability to control its own affairs, may have conspired with the growth of Islam and Christianity and other factors to undermine the old faith in the powers, spirits, and ancestors who once were expected to protect believers. Simultaneously, a new materialism was increasing everywhere. The main focus and subject of traditional art had been the invisible. That art's famous stylization resulted in part from its concern

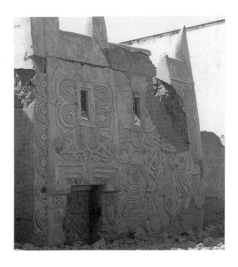

Fig. 11. House facade in Kano, Nigeria, 1990. This style of monochrome mud relief decoration is typical of the middle of the twentieth century. It has been replaced by two-dimensional, colored decoration in similar patterns painted on cement buildings. Photo: Robert Rubin.

with depicting not the visible but the other world, and the beings in it—or even with the materialization of new beings.[12] A nineteenth-century figure representing a chief is not a description of how a man looks but an expression of ideals of proper leadership; a mother-and-child figure, more than a woman with a baby, embodies ideas about increase, nurturing, and protection. Traditional African artists do continue to carve figures and masks for the old gods. But they also refer increasingly to the visible world.

The interest in verisimilitude is accompanied by a new interest in material things. Nineteenth-century traditional sculptures seldom depicted man-made objects—their main images were of living beings.[13] They depicted plants rarely and landscapes virtually never. But contemporary traditional sculptures of the human figure include man-made things formerly either absent or used only in the form of real attachments, such as cloth or beads. Garments, shoes, ornaments, weapons, seats, umbrellas, and so on are now carved as integral parts of traditional art. Late-twentieth-century African artists working in various strains still follow the old subject-matter conventions and focus on the human figure, but with a new interest in manufactured things. The gleaming garments in Sunday Jack Akpan's cement portraits have a preternatural immediacy almost greater than the small faces (cat. 39-41). Objects become decorative motifs, and sometimes the entire subject—as in Kane Kwei's coffins (cat. 34-38), Koffi Kouakou's sculpted suits, shoes, and computer (cat. 84-86), and Sokari Douglas Camp's bed and boat (cat. 100-101). Landscapes still attract almost no attention, but objects, mostly man-made, have taken on some of the value, power, and fascination that formerly belonged only to living beings.[14]

Ethnicity and Individuality

A desire to make "nonethnic" art runs through all kinds of twentieth-century African art except traditional art. Ethnicity, or "tribalism," has consistently been seen as divisive in contemporary Africa, and as a sort of throwback to an earlier form of social structure. The wearing of modern (we call it Western) dress has been one way of expressing a commitment to a multiethnic state. Artists have taken their inspiration from objects not identifiable with specific ethnic groups, or have deliberately mixed elements from several ethnic traditions. Nonetheless, ethnic ties are probably still the single most important determining factor in political, social, and economic relations in African villages and cities. Contemporary African art's avoidance of strong ethnic identifications is remarkable, for it is created in countries where ethnic tensions have, if anything, worsened since independence. The silence of artists on this issue can be taken to show that they are in agreement with the consensus that art should express not actual personal experience but socially useful ideals. The inhibition on "ethnic" art may be least felt by artists living farthest from Africa's ethnic divisiveness: Sokari Douglas Camp, working in London for a largely European audience, does not hesitate to draw upon the specific art forms of her own Kalabari people.

Though their art is not particularly inspired by personal experi-

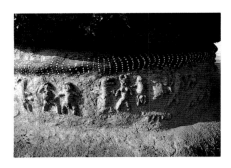

Fig. 12. Senufo painted relief, Niofoin, Côte d'Ivoire, 1982. Though the relief is painted, the color is secondary, serving only to emphasize its plastic qualities. International painters often use lines and dots like those seen here. Photo: Susan Vogel.

Fig. 13. Bobo masquerader in Yegueresso village, near Ouagadougou, Burkina Faso, 1990. The dancer is wearing a conservatively carved mask with a fiber costume of the traditional design, but the raffia has been dyed emerald green where it was formerly buff or black. This use of strong color is a late-twentieth-century phenomenon understandable in these monochromatic villages where streets, walls, and all structures are made of the same buff-colored earth. The area has seen relatively little economic development. Photo: Boureima Tiekoroni Diamitani.

ences, artists of all kinds have begun to seek personal recognition for their works. Traditional artists of the past were often willing to be relatively anonymous, but artists patronized by Europeans began signing their works as early as the 1910s.[15] Today some, especially cement sculptors and Urban painters, sign works with names and addresses as a marketing strategy, in the hope that this will bring them clients, and because certain names sell. Cheri Samba explains his autobiographical paintings (cat. 79) as a way to introduce himself to his public. He keeps one on display in his shop-cum-studio, and says he puts one or two in each of his exhibitions (Jacquemin 1990:82).

Patrons too have wanted to be represented in a more individualized way than they did in the past, to have their particular features recorded in portraits, and to have their names written on works of art. This desire to be individually named or depicted can be found in artworks as different as the studio portrait photograph (cat. 55-62) and the traditional *flali* mask with the owner's name written upon it (p. 33, fig. 1). An interest in recording a person's physical features intersects with the new verisimilitude, taking several different forms. It has created a flourishing market for portrait photographs since the early part of this century. Such photographs are used to achieve the best possible likeness of the deceased in cement sculpture. These photographs have also been copied in two ancillary art forms: painting on glass, and enlarged, colored portrait paintings by Urban artists.[16]

Distinctive new memorials to the dead have come into existence and new kinds of funeral arts have appeared in answer to this desire to be individually remembered. Traditional graves were usually unmarked

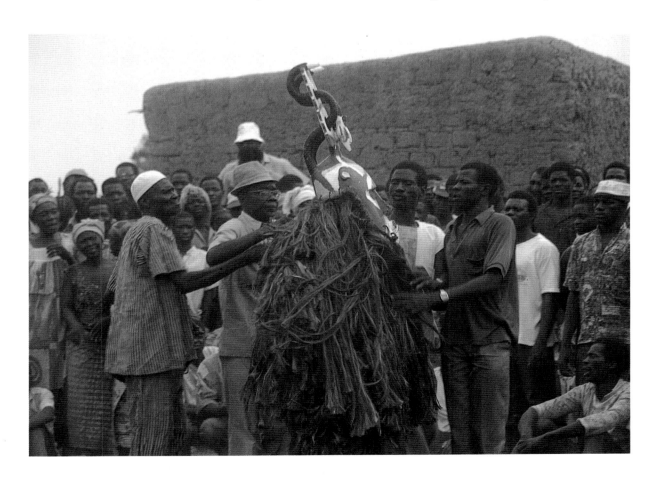

and located in rarely visited places, and cemeteries, if they existed at all, were small and simple; memorials to the dead were usually in or near the village, away from the place of burial.[17] Increasingly in the twentieth century, conspicuous cement or tile tombs have been built, individualized by the photograph or at least by the written name of the deceased. Traditional funerals of important people were always elaborate, well attended, and expensive; commemorations (which were often performances, frequently mainly verbal) underscored group history and family connections to other persons living and dead. In the past, a person's greatest importance lay in belonging to a group, or in fulfilling certain social roles.[18] To these elements have been added the dimensions of personal history, character, appearance, and individual achievements, as exemplified by the naturalistic cement grave statues of Sunday Jack Akpan (cat. 39-41) and the referential coffins invented by Kane Kwei (cat. 34-38).

The changes in twentieth-century African art—the attempt to fuse divisive ethnicity into national identity, the interest in the visible world and in depicting the particularity of individuals, the emphasis on color, and the aesthetic of immediate impact—are not only remarkably consistent all over Africa, they resemble changes apparent in the arts of other parts of the world, such as India, Mexico, and Indonesia.[19]

Westernisms

African artists and their clients who have assimilated foreign elements are often described as "Westernized." The word has been used as a kind of accusation, and a pretext for dismissal. What Helena Spanjaard writes of Indonesian art is equally true in Africa: "Western criticism often states that modern Indonesian art has become Westernized, is not oriental enough and [is] therefore plagiarism" (1988:131). "Westernization" seems too sweeping a term for the phenomena we have observed, and too monolithic in its suggestion that there is a single process at work. What is happening is actually far more subtle and less random than the blanket term "Westernization" suggests: African artists select foreign ingredients carefully from the array of choices, and insert them into a preexisting matrix in meaningful ways. Foreign formal elements—including those from other African groups—are virtually never adopted into works of art unchanged; they are reinterpreted and assimilated into local styles and structures. To regard the entire resulting work as "Westernized" is to ignore the substantial part that is African. Artists using foreign themes and techniques in their work do so not as a sign of their domination by the West, or of their repudiation of their African heritage, but in terms of their own culture.

A more useful approach to describing this process might be to locate "Westernisms" in African art. This conceptual term allows us to distinguish among the constituent parts of a work and to discuss them clearly. Westernism is not an art style or movement like European "primitivism," its mirror image; there is in fact no African movement that can be called by the name. Rather, a Westernism is a discrete element such as a motif, a style, a technique. Like primitivism and orientalism, however, Westernisms are a projection: they reflect an

Fig. 14. Portrait of a man by an unknown studio photographer, Yamoussoukro, Côte d'Ivoire, 1970s. Photography is not treated as a particularly naturalistic medium in Africa. Painted backdrops (often wrinkled, and not necessarily realistic), standard equipment from the earliest days, are used to provide a symbolic presence rather than an illusion. This photograph was taken in the open air by a town photographer on tour in the villages. His subject, seated on a local carpenter's chair, wanted to be portrayed surrounded by Western-isms: a radio on his lap, an airplane at his back. Private collection.

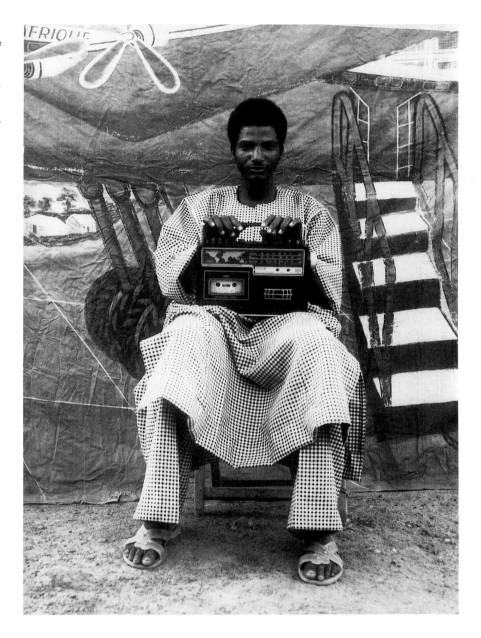

attitude. They are African visions and fantasies of Western culture, they may or may not correspond to Western culture's readings of itself. Like primitivizing European artists, African artists borrow foreign elements that answer their own needs, and that may have little relationship to events and ideas in the West itself.[20]

Westernisms are used self-consciously to make a statement; they are not every Western element we may see. When Christian or Muslim Yoruba parents replace carved figures with photographs in the twin cult, the photographs are Westernisms, proclaiming a different kind of relationship to the traditional cult (cat. 22-26). Portrait photos made as parlor decorations are not usually Westernisms (cat. 55-62) but simply a normal part of the decor. Iba N'Diaye's use of Velázquez's portrait of the black man Juan de Pareja is a Westernism: it asserts N'Diaye's connection to a classical European painting tradition, and makes a statement about the position of blacks in a white world (cat. 113). His use of the medium of oil on canvas does not seem to be a Westernism here, though in other circumstances it could be. Trigo Piula uses

Westernisms systematically to comment upon the cultural predicament of his people. The nursing Kongo mother in his *Materna* (cat. 114) feeds her child with imported, canned evaporated milk; as the slang expression goes, we can see where her head is: it has become the head of a white woman.

Many Western idioms and objects visible in African art must simply be considered assimilated parts of the culture of the Africans who use them—much as Americans use Japanese electronics unthinkingly as part of American culture. This study demonstrates the ability of non-Western peoples to apprehend, digest, and appropriate parts of Western culture without losing themselves. For too long we have regarded this process from a strictly Western point of view, and have been unwilling to surrender ownership of our own material culture after it has been permanently borrowed by others. At what point will suits and ties, or the medium of oil on canvas, for example, cease to be seen as borrowed—even stolen—expressions? When Europeans and Americans acquire African masks, hang them on their living room walls (never wearing them in rituals), and interpret them according to their own cultural categories (home decor, or objets d'art), those masks become part of the culture of the West. Their owners haven't compromised their Western cultural identity, nor do they think of themselves as "Africanized," or, worse, as "unmodern" or traditional.

The widespread assumption that to be modern is to be Western insidiously denies the authenticity of contemporary African cultural expressions by regarding them a priori as imitations of the West. This book and exhibition contradict that assumption by showing that African assimilations of imported objects, materials, and ideas are selective and meaningful; that they are interpretations grounded in preexisting African cultural forms, and that they contribute to a continuous renovation of culture.

NOTES

1. Babatunde Lawal, a prominent Nigerian critic, dismisses the widely admired art of the Oshogbo school because he finds a lack of content in it. This art, he argues, is "essentially an exercise in color doodling and simplistic representation," and Nigerians regard it "as a kind of fodder for the tourist." To Lawal, the art's claim to project Yoruba myths and folklore is an afterthought more closely bound up with the works' titles than with their imagery (Lawal 1977:147).

2. In many respects, traditional nineteenth-century African societies were exceptionally aestheticizing compared to Western societies—they showed a strong impulse to decorate or create aesthetically satisfying environments, architecture, and utilitarian objects. A great deal of ritual sculpture was made as "art to look at," virtual decoration, for example in shrines where the significant ritual focus was on some nonaesthetic object. Though Africans clearly value decoration and the pleasures of aesthetic surroundings, the impulse to create such surroundings seems to have diminished in recent times and in modern settings.

3. I am grateful to Philip M. Peek for bringing this to my attention.

4. The Kenyan artist Etale Sukuro (figs. 1,2) is an interesting case: Sukuro paints attractive stylized landscapes for sale to white collectors at Gallery Watatu in Nairobi at the same time that he works in a different style for himself, producing paintings and pastels in a style one might call imaginary realism. Yet these works, biting political statements, are still intended for an audience: Sukuro exhibits them at local art fairs

to raise the political consciousness of the people (Agthe 1990a:92).

5. At least theoretically, spirits who "refused" a work would refuse sacrifices and would not grant the benefits sought by their devotees. In reality, the potential for rejection seems more important than the practice; I have found almost no actual instances of a work being rejected by a client—human or otherwise.

6. James A. Snead's "Repetition as a Figure of Black Culture" (1990), which deals mainly with literature and music, is full of interesting ideas applicable to African visual art.

7. Most writers on traditional art allude to this repetitiousness, though few have put it so tartly. Most are concerned with the interplay between the individual artist and the regional style (e.g., Kasfir 1987; Brain 1980:261ff), and have argued for the creativity allowed the artist (e.g., Vansina 1984:45ff) without considering the nature of African creativity or of the inherited styles. The best definition of the situation I have found is by Denis Williams, who separates and discusses "type-motif," "stereotype" (which I call "type" in this text), "archetype" (which I call "form"), and "icon" (1974:20-24).

8. Wyatt MacGaffey cites a violent power figure with charcoal attached to it that could be interpreted by a pun on the Kongo word for charcoal *(kalazima)* and the words meaning "to be alert" *(kala zima)*; a parrot feather helped the figure to speak magically—as parrots seem to do (Koloss 1990:30).

9. For an extended discussion of traditional art's emphasis on sculptural volume over all other artistic devices, see Vogel 1990:76-77.

10. The change from building in mud to cement has been offered as the explanation for this change, but given similar shifts all across the continent, a change in taste seems a more likely explanation. The mud decorations were made with a reed armature, which was then plastered over with clay; cement buildings could be provided with a similar armature, perhaps of metal attached with nails, to preserve the element of relief if that were a priority.

11. Personal communication from Bogumil Jewsiewicki, December 1990.

12. I have argued that most traditional masks and figures are carved to bring into the world a new, named being in much the way that a birth brings a new person into the world (Vogel 1990:80-81).

13. There are rare exceptions. Baule artists carved wooden replicas of gongs and beaters, bottles, knives, kerosene lamps, hats, and shoes, and covered them with gold leaf for display at funerals with other gold. See p. 236, fig. 6a.

14. For further examples, see Bogumil Jewsiewicki's essay below, "Painting in Zaire."

15. Ivory carvers and gourd engravers in the Mangbetu area signed their works almost as soon as they began selling to Europeans; the Azande potter Mbitim, who worked in the 1930s, assiduously signed many of his distinctive figurative pots (Schildkrout and Keim 1990:230-231).

16. See Borgatti 1990 for a discussion of traditional African portraiture.

17. Graves were not necessarily clustered to form cemeteries. The dead were sometimes buried in the courtyard or under the house, or in isolated places in the wilderness.

18. Ivan Karp points out that contemporary Africans have not abandoned collective forms, but "the change is that they are using new collective forms such as the nation-state, as well as using old forms, such as clans, in new ways" (personal communication, January 1991).

19. Though they are beyond the scope of this book, these parallels are provocative. The 1988 exhibition and book "Art from Another World," at the Rotterdam Museum of Ethnology is a first synthesis.

20. Robert Goldwater emphasizes that "primitivism is not an immanent artistic movement, self-born and self-borne, but. . . grows from the general social and cultural setting of modern art" (1967:265).

Susan Vogel

ELASTIC CONTINUUM

All traditions were invented or brought into being; all traditions change. This discussion is predicated upon these two self-evident facts. A standard dictionary definition of "traditional" reads "based on an order, code or practice accepted from the past."[1] African artists have always drawn upon ideas, symbol systems, and art styles received from forebears both near and remote. But they have also always digested contemporary events and adapted to change. Traditional African art forms and styles all began somewhere, obviously, and new ones are always in the process of being established. The word "traditional," then, is used here to denote an elastic heritage.

The word needs no apologies, no quotation marks or prefixes. Recently scholars have realized that "tradition" has been used to connote an art impossibly static and unchanging, and one now finds writers diluting the term with qualifiers, or advocating that it be abandoned altogether. Some factual qualifiers can be helpful, but the practice seems otherwise unnecessary and self-defeating: there is simply no better word available for Africa's village arts, especially when they are considered in conjunction with other strains of African art. Nor is there significant disagreement among specialists about the true nature of traditional African arts. Eric Hobsbawm writes, "Where the old ways are alive, traditions need be neither revived nor invented" (Hobsbawm and Ranger 1983:8). The distinction between "invented traditions," which bear a factitious relationship to a historic past (ibid.:2), and "genuine" or "old" traditions (ibid.:8, 10) seems to lie partly in the self-conscious and deliberate process of creating an invented tradition; "invented traditions" are portrayed as rigid and unchanging, and "genuine traditions" as flexible and mutable.[2] "Genuine" traditional art is certainly alive today, especially in rural Africa, though not necessarily in the old familiar forms.

In some measure, of course, all art everywhere is traditional, including the art of our own time. New generations cannot and do not invent styles, media, techniques, and systems of meaning that have no relation to the art that has gone before. The origins of traditional African art styles are typically portrayed as anonymous and remote in time, even those that we can document as relatively recent. In

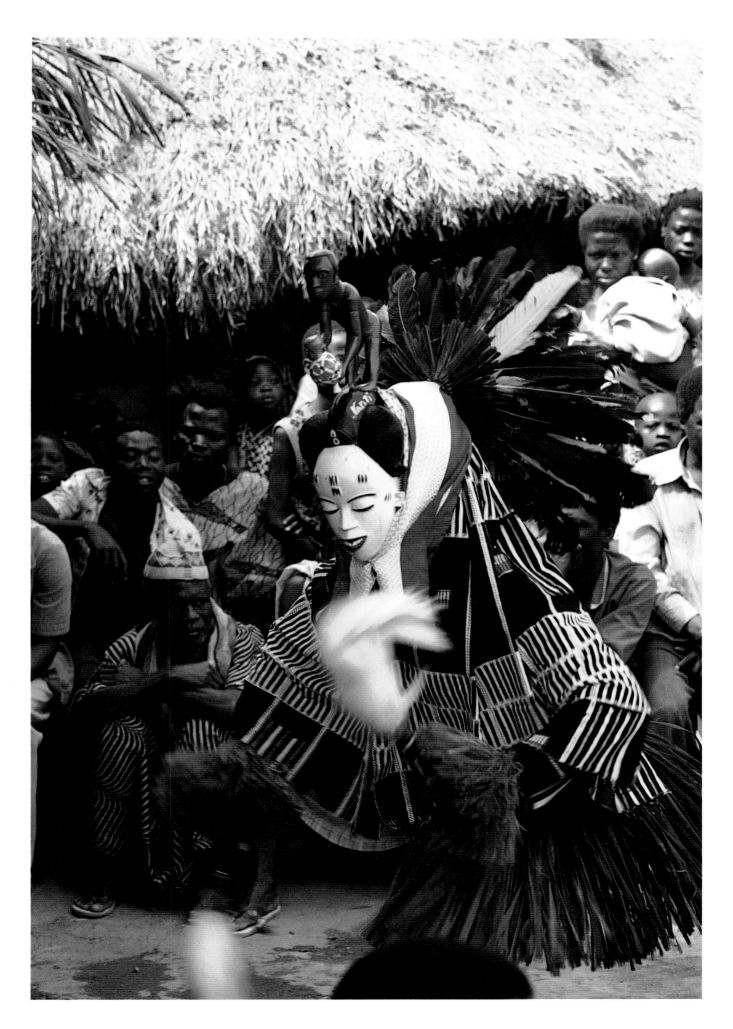

Fig. 2. Ndebele decorative shelves, South Africa, 1979, molded and painted by women to decorate house interiors. Though the shapes are inspired by Welsh dressers and by patterned shelf paper with scalloped edges, the geometric, high-contrast aesthetic is typically mid-twentieth-century Ndebele. Assorted factory-made objects frame the small, locally made, beaded doll placed dead center—the star of this stage. Photo: Susan Vogel.

◄ Fig. 1. *Flali* mask carved by the Guro artist Saou bi Boti of Tibeita village for dancers in Bangofla village, Côte d'Ivoire. The new aesthetic intention is to stun the viewer with bright colors, perfect carving of the delicate features, and an arresting motif—a smartly dressed musician playing the percussion gourd that is typical of *flali* bands. The only Westernism is the writing on the coiffure—the name of the mask's owner, not of the artist. Boti is the highest-paid sculptor of the region, and admired for having introduced numerous novel subjects in his masks. Of his carving of a trio of acrobats from the unrelated Dan ethnic group he explains, "People talked about them for a long time in the village so, I thought, I am going to carve these dancers because they please everybody" (Fischer 1985:32). Photo: Lorenz Homburger, 1983.

traditional African art, the age of a practice and its continuity with the past are valued to the point where they are often exaggerated; in the West, what is emphasized is the artist's originality or inventiveness, his or her break with the past. But the individual artist's experience of balancing imitation and innovation may in fact be quite similar in the two cultures.

There is a broad consensus today that traditional African art has never been static or unchanging, and was never a rote reiteration of inherited forms; that the societies that produced it were not closed to the world outside; that its styles were never homogeneous; and that events and individuals have periodically changed its history. At the same time, it has long been recognized that African art is also strongly rooted in repetition, and in the production of objects that correspond to predetermined types. As Joseph-Aurélien Cornet has written, "African art is more an art of stereotypes than an art of creation" (Cornet et al. 1989:56). Traditional art is a continuum of many small incremental changes, along with occasional sudden halts, fresh starts, and radical shifts in direction. Traditions do not survive unless they can respond to changes in the surrounding world. Long-distance trade, migrations, and the formation and dissolution of states in past centuries required large-scale transformations in African art. The long survival of core African cultures, both in Africa and in the countries of the diaspora, might be taken as evidence of their adaptability.

Fifteen years ago, Arnold Rubin wrote, "The entire body of inherited cultural patterns, representing the accumulated experiences, accomplishments, and wisdom of the past [in Africa] is typically evaluated in each generation and reinterpreted or adjusted where deemed desirable in the light of available options and altered circum-stances" (Rubin 1975:39). Innumerable other scholars have also recognized that a particular kind of change is integral to traditional African art.

Traditional, "Traditional," Transitional, Neo-, or Post-?

The view that the word "traditional" does not suit the art of African villages today rests upon a belief that traditional arts are static. Only if immutability is a defining trait of these arts do they need a new name as they change. But traditional art does evolve, and does have a history. The word "traditional," then, can (and often should) be qualified with a temporal designation: nineteenth-century traditional art is different from eighteenth-century or twentieth-century traditional art.

Traditional works that show the conspicuous use of Western imagery or materials have sometimes been called "transitional," without any reference to when they were made. This witless designation is peculiarly dismissive, because it arbitrarily relegates certain works to an ill-defined limbo between "pure" tradition and some presumably more fully realized (Westernized?) art of the future. Elsewhere, contemporary traditional art—that made today—has been called "neotraditional," or "post-traditional," to distinguish it from art of the precolonial era. This preference is based on the false assumption that "traditional" denotes an era. There is of course no moment when traditional art ends and "neo-" or "post-traditional" begins. Complete ruptures with the artistic practices of the past are rare, even in the twentieth century. Recently, rural Africans have lived with social changes faster and larger than any previous, but they often do not seem to have experienced these changes as different in kind from earlier transformations.

In fact, this book is filled with instances that suggest Africans have not regarded contact with the industrialized West as fundamentally different from contact with other alien cultures. Typical is the experience of a Yoruba elder who stated, as television arrived in Nigeria, that "television is the European's version of *apepa* [a form of sorcery in which one gazes into a pot of water, summons a person's image, then pierces the water with a knife]. The difference is that they can summon images from a great distance and use theirs for more good. We can only call images from about 200 miles away [the extent of Yorubaland]." This elder felt that the Yoruba would have invented television "if only we would have had the technology. We had the idea long before the Europeans had it" (Houlberg 1988:5).

It has been argued that the changes in African village arts today are fundamentally different from those of the precolonial past, for they involve influences from a dominant culture radically alien to Africa. This argument ignores the fact that contacts with the Mediterranean, Europe, and the Islamic world have long made those cultures available to African artists and thinkers, who have drawn from them what they have found useful. Further, conquest and domination are hardly a new experience in Africa, though previously they were mostly intra-African.

The argument that Africa's contact with industrialized nineteenth- and twentieth-century Europe eclipses all previous contacts with outsiders may rest on nothing firmer than the West's conviction of its own cultural superiority. There is ample evidence that in a traditional

Fig. 3. Engraved gourd (top) and engraved plastic cups and bowl (bottom) of the Wodaabe, Niger. Without missing a beat, Wodaabe artists have engraved their traditional designs on new, industrially made plastics. Plastic vessels have taken their place alongside gourds—which now are sometimes painted with enamels to give them a more modern look. Identical in function to the gourds, and, like them, received "ready made," the soft-plastic vessels can be worked with the same tools. This is a traditional art in a new medium, rather than a Westernism. Collection: Mette Bovin, Copenhagen. Photos: courtesy Labelle Prussin.

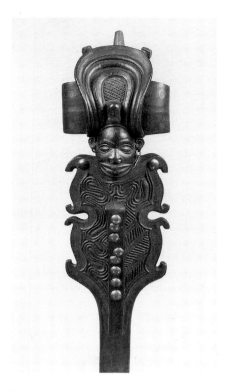

Fig. 4. The curvilinear outline of the panel below the face on this beautiful old Chokwe staff from Angola is debatably derived from European scroll ornaments (Bastin 1988:52). The staff, collected in 1875, is considered a masterpiece central to the canon of traditional art. Nonetheless, it incorporates European materials and influence, and was purchased from a trader outside the Chokwe area—factors that might qualify a more recent work as "transitional" or "nontraditional." It is time to acknowledge that traditional art includes such works, new and old. Collection: Berlin Museum für Völkerkunde.

context, Africans have consistently regarded Europeans as uncivilized and ignorant, if powerful, and have considered the sources of European power as no different in kind from their own. (When automobiles first were seen in Mali, around 1900, people in Sansanding and Segou, ten hours apart by foot, compared automobile travel to the exploits of Moussa Traoré, who was known to visit both towns in rapid succession, though nobody had ever seen him traveling between them.[3]) African perceptions of their contact with the West are often so different from the Western versions they seem almost humorous. But if a culture or epoch may validly interpret experience in terms of its own world view and values, African readings of Western culture and artifacts cannot be dismissed as ignorant or naive. Parallels between television and *apepa* must be considered seriously.

In the past as now, Africans have so thoroughly digested and interpreted foreign forms in terms of their own value systems and visual codes that the foreign origins of those forms have become virtually unrecognizable. The adoption of a foreign element without modifying it is rare. Certain nineteenth-century Chokwe chiefs' staffs (fig. 4) from Angola use a European scroll for the outline of their tops. Around 1900, when the Kuba of Zaire first saw a bicycle, they immediately found it useful for their own concerns: the pattern its tires made on the ground could be added to their repertoire of textile designs. Should a Chokwe staff with a scroll profile, or a Kuba textile embroidered with a tire pattern, be differentiated from every other example? What other art forms would then also have to be relabeled "post-" or "neotraditional"? Some of the impulse to distinguish current contacts from earlier ones comes from a sense that African culture is being contaminated by Western culture in a new way. Descriptions of contemporary traditional art are laced with words like "decadent" and "corrupted," words that presume a fall from a prior state of purity—as if Africa had been untouched until the arrival of transistors, *Dallas*, and mirror sunglasses. Ultimately this argument rests on an ideal of cultural purity that persists as a dream even when it has been exploded as romantic nonsense.

In its place should come a recognition that African societies have a long history of contact both with each other and with cultures abroad, and have long demonstrated a readiness—even an eagerness—to appropriate art forms, objects, and ideas from remote sources. In every case we see them exercising great selectivity in the traits they adopt. Writing and the wheel, for example, were available to Africans for centuries but, unlike gunpowder and alcohol, were not widely adopted until colonialism made it expedient to acquire them.[4] Seldom in traditional African culture is a foreign element simply imitated or borrowed unchanged. Forms appropriated in the nineteenth century and earlier are usually so completely digested and translated into African cultural expressions that they are hardly separable as borrowed or imported. The architectural style of Sudanese mosques, for example, which combined North African and Sahelian forms beginning in the twelfth century; the bronze vessels modeled on Islamic ones that were made by the Akan in Ghana from at least the fifteenth

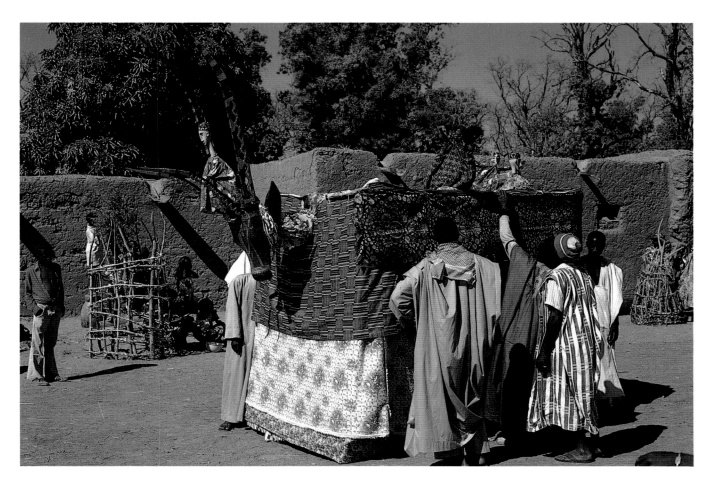

Fig. 5. Bamana marionettes performing in Kiranko village, Mali, in 1986. The marionettes, part of a performance adopted by the Bamana from a neighboring group in the first decades of this century, have changed little in style aside from a slightly more organic treatment of the angular face and the use of bright enamel paints in new colors. The puppets traditionally depict notable humans, animals, and birds. Newly added subjects conform to the earlier repertoire—one portrays a white researcher carrying a pen and notebook; another represents the nation as the "Great Bird of Mali," in a form similar to many other bird puppets. Even the rudimentary rod-and-string mechanism used to move the puppets remains unchanged. Photo: Susan Vogel.

century (Silverman 1983:11-14); the rectangular plaques of Benin (cat. 117-119) that echo Renaissance pictures in their shape and pictorial mode—these and many other cultural expressions show a will to recast the foreign trait in an African mold.

Researchers have described traditional cultures in a mode of discourse known as the ethnographic present, generally repudiated in recent years because of its misleading implication of timelessness. It is revealing, however, to consider how much the ethnographic present was jointly constructed by researchers and their informants. Because traditional African cultures received truths from forebears, and because legitimacy often rests on the presumption that present beliefs and practices are the same as those of the past, change is often suppressed or denied. Informants generally describe art forms and their meanings as very old, indeed as constants, and have often represented a replacement object as the original one—because, for their purposes, the two are indistinguishable. My own experience among the Baule of Côte d'Ivoire accords with what Allen Roberts found among the Tabwa in Zaire: "History is not absolute. Knowledge is not immutable. Rather, understanding is an ongoing process. People have no history with a capital 'H'; instead, they engage in 'historization'. . . . Personal past and collective 'tradition' are invented as the need arises, despite what inside informants and outside observers may say to the contrary" (Roberts 1988:123). Because the ethnographic present continues to be used by informants, it has proven hard to avoid.[5]

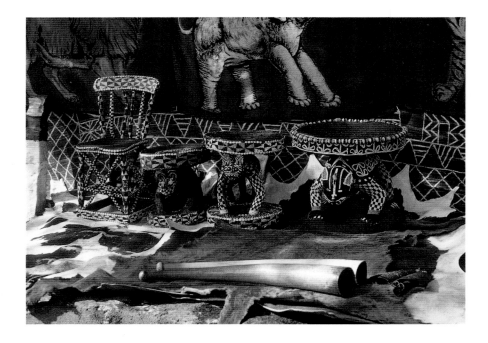

Fig. 6. The regalia of a Cameroon grasslands king, including beaded stools, ivory horns, and cloth hangings, late 1970s. A beaded kitchen-type chair has joined the assemblage. Prestige textiles include locally dyed indigo and imported hangings with images of the leopard and the elephant, animals associated with the king. Glass beads, made in Venice and Poland, and cowrie shells from the distant Indian Ocean were essential to the creation of traditional Cameroon grasslands art long before the arrival of Europeans. Photo: Hans-Joachim Koloss.

Traditional Art Today

Traditional African art is any art that continues either the form (object or performance type) or the function of a received art, or both.[6] Also traditional are art forms that recast formulas received from the past. Some newly invented art forms may become traditional in the twenty-first century if they are continued by the next generation. Even a relatively new art form should be considered traditional if it is communally recognized as a continuation of an older practice, and is accompanied by a complex structure of use and belief. Style seems a much more variable factor than form or function, and cannot be traced as a constant over time. As discussed in the Introduction, however, there is a clear, continent-wide drift toward certain well-defined stylistic features, though the causes for this are obscure. What, then, is traditional art today?

Traditional art has thrived through most of the twentieth century, nurtured in the early decades of colonial rule by the availability of new tools, the imposition of peace, and a new degree of prosperity. The destruction and removal of works of art by colonial forces, missionaries, and collectors both stimulated and inhibited the making of art. Social and political shifts, and some redistribution of wealth, created a need for new art objects, including many that served to allay anxiety and explain change. The introduction of new materials, motifs, and ideas must also have encouraged the creation of new works. It is impossible to estimate how many works of art were made in the twentieth century compared to the nineteenth, but it seems likely that much more than half of the traditional African art in collections today was created in this century, during what was certainly one of the great expansive flowerings of the arts anywhere.

In the last decade, however, creativity in the traditional arts has diminished, and the extinction of art types has been noticeable. As the old cults wane in the face of Islam, or of Christianity, or through their simple inability to protect their devotees from new dangers,

fewer resources are dedicated to creating elaborate new shrines or to maintaining old ones. New avenues to prestige and visibility have come into favor among Africans who grew up in the second half of the twentieth century: they prefer to buy a motorbike, or Western-style clothing, for example, rather than commission new shrines, sculptures, or masks. Furthermore, as the powers of traditional rulers are usurped by national governments and police forces, some royal courts and the artworks that expressed their prestige and authority have become less imposing. There are exceptions: as Doran Ross has pointed out, "Traditional royal regalia is thriving among the Akan, Yoruba, and at the Benin and Kuba courts. Traditional leaders are protecting their status through the only outlet left to them, which is public display during traditional festivals."[7]

Traditional art is most vigorous today in conservative, relatively isolated, rural communities, where it is patronized mainly by those with the least formal schooling. It is also found among leaders of kingdoms such as those Ross mentions above. Traditional art is also made and used by some residents of every town and city in Africa, and city-dwellers join their rural relatives in many village art events, especially funerals and healing rituals. In general, the arts that were once the most political and secret seem to have fared less well in recent times than the arts of entertainment, and those that help people to cope with personal problems. Healing and divination cults have frequently expanded, almost always becoming "modernized" in some way. The old secret cults and activities that bolstered political power suffered most, for they attracted the suspicion of colonial administrators, who often tried to suppress or exterminate them. Ironically, many of the art forms that have survived best are precisely those entertainment performances that mock or challenge authority. In the past, they sparked change, as they were the traditional means to unveil hypocrisy, to express skepticism about power, and to question the status quo—as they still do.[8] Many arts that had other primary functions in the past have become entertainments in recent years.

Many African art forms and cults strove to be continually and visibly up to date long before the twentieth century brought its dramatic changes. It can be important for diviners and healers to advertise their familiarity with the outside world, for they often claim to use the ancient powers of their cults to deal with modern problems. One of the most successful Yoruba diviners now has a televised weekly divination session that is followed closely by hundreds of thousands of people (see fig. 7). The association of what is new with vigor, youth, and strength is well documented in African art, and is often expressed as a preference for freshly painted or newly made sculptures and costumes. To sustain a following, a cult had to maintain its effectiveness in dealing with current problems, or people would say it had "lost its power" and would discard it for another.[9]

Ibibio Idiong diviners of Nigeria, and members of the more recent Mami Wata cult (which began in the 1920s or earlier), in the 1970s used a Westernism to signal their connection to today's world. A Mami

Fig. 7. Cover of a Nigerian guide to television programs showing the diviner Yemi Eleburur-Ibon. It has always been important for diviners to be able to deal with current problems, and in earlier years they "advertised" their special skills with remarkable behavior, buildings, garments, and impressive performances. Yemi Eleburur-Ibon has successfully adapted these traditional practices to modern times: since about 1985, he has performed traditional Ifa divination—essentially unchanged—on a weekly television series. (Nigerian Television Authority Ibadan TV Guide, Jan.-March 1987. Collected by Marilyn Houlberg.)

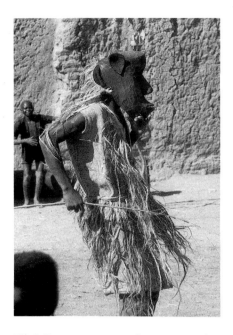

Fig. 8. Bamana masquerader accompanying the marionettes (fig. 5) in Kiranko village, Mali. He plays an archetypal buffoon role in mask performances, not dancing but behaving as an antiideal character, kicking over water buckets, rolling in the dirt, making lewd gestures, chasing women and children, and mocking anyone of importance. The masquerader acts as a crowd controller and provides comic entertainment between the appearances of the marionettes. The sculptural form of the mask is nineteenth century or older. Photo: Susan Vogel.

Wata diviner, for example, might put a "Mami Wata telephone" at the entrance to her or his compound. This was a tall pole with a small version of the shrine sculpture on top, connected to the house by a rope. Diviners said that the "telephone" warned them of any stranger entering the compound, and informed them of the reason for the visit (Salmons 1977:11). This old concern was fulfilled in the past by bundles of medicines and other items hung or buried at the entrances of houses and compounds. The telephone is only a new metaphor for the old powers.

Overall, traditional African artists today have more choices than in the past. Available to them now are more materials, more themes, more ideas, more disparate sources for inspiration than ever before. The living traditional arts today exist in every possible relationship to the arts of the past. We find: 1) arts that preserve traditional forms and functions, sometimes while serving a new purpose as well; and 2) arts that adopt new forms to serve traditional functions. We shall examine these types here, and in chapter II will deal with what may eventually become traditional art: new art forms that serve new functions.

Continuity of Form and Function

Among traditional arts that have preserved both the form and the function of older practices, masquerades with an entertainment aspect are the most conspicuous and widespread. Eberhard Fischer writes,

> There have also been passing fashions in Africa from the earliest times: a new song suddenly becomes popular, a new rhythmic combination or sequence of steps is specially admired and is copied on all sides, soon having its own name and its own "look." Within the last thirty years the *seri*, *uale*, *sauli*, *flali*, and many other solo dances have been in favor for a time, all associated with masks crowned by a particular emblem. Many of the dance styles are created by well-known personalities, they spread rapidly, remain popular for ten years or so and are then forgotten. In some cases, the masks survive the dances, for they are expensive and carefully tended properties and can be used for other dances. The masks are designed to surprise the public with their novelty (Fischer 1985:30).

For a very long time, the Guro of Côte d'Ivoire have performed secular entertainments in which masked dancers appear with their bands at commemorative feasts for the dead, in regional or national festivals, or to celebrate an event such as a good harvest or the return of some respected citizen. Tourists or other spectators unrelated to the performers have been readily accepted at such performances in Africa, and the masks are commonly also manufactured for the external market. Tourism, however, has changed over time. In the 1920s and 1930s, celebrity tourists—royalty, singers, cardinals, poets—motored across the continent visiting remote areas that have not seen a tourist in years. White tourism today is concentrated in a few locations, and the village arts' outside audience is at least half composed of urban Africans who have come home to visit or who watch traditional entertainments on television and in live performances in hotels,

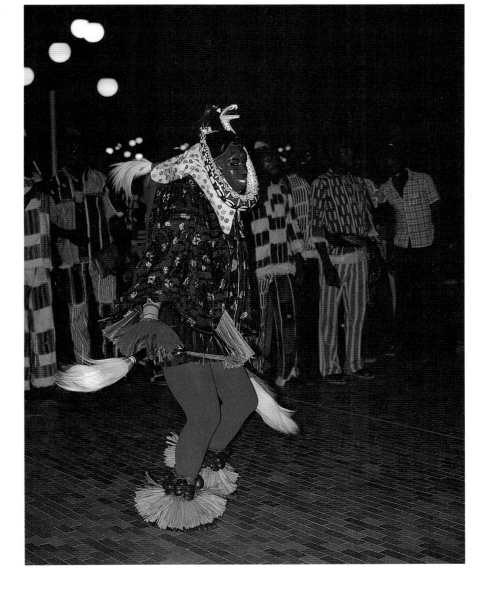

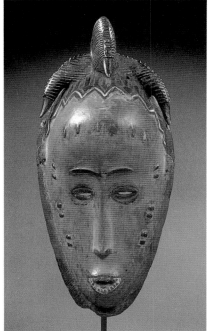

stadiums, and street parades. Africans are also substantial buyers of "tourist" art.

Gaining a new audience of foreigners or a national public has often enhanced traditional performances in the esteem of the original village audience. Modifications made for external presentations may add new luster to the home version. More often, however, the external audience, seeking something "authentic," exerts a conservative influence by discouraging all but superficial change. (Outsiders' notions of what is authentic, however, may vary widely from actual past practice.) The emphasis on theatricality that creeps into a performance created for outsiders can lead to subtle alterations in performances for the original audience. Art forms commercialized for outsiders often lose some of their deeper meanings for their original audience, particularly when other forces have simultaneously diminished their importance.

The Makonde of Mozambique[10] were subject to extensive secularization and Christianization during the colonial period; since then, nationalist African politics have made many of them refugees, often in the Tanzanian capital of Dar es Salaam, where they have found

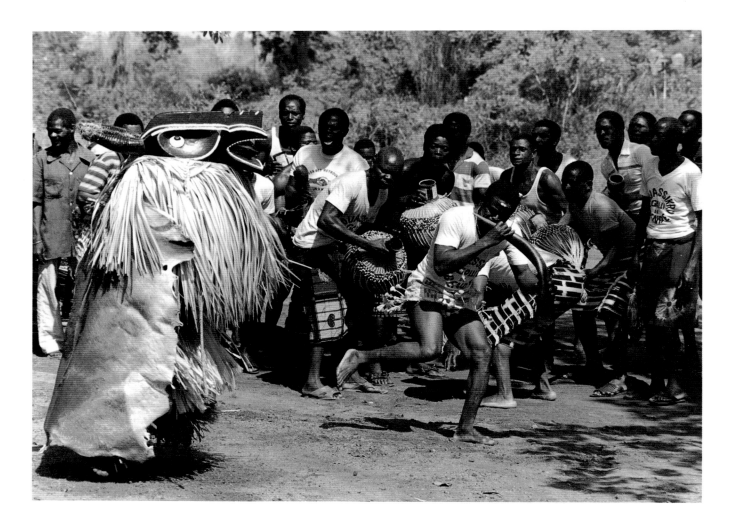

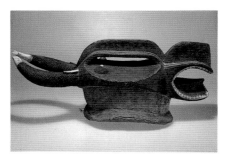

Fig. 12. This Goli Glin mask entered the collection of the Musée de l'Homme, Paris, in 1931, making it a relatively early example. The sculptural forms of such masks have remained almost exactly as they were when they were introduced, except for the use of enamel paint—though still in the old colors. The performance sequence seems subject to change, however, and Goli's deeper meaning (which for the Baule lay in its sequence) is gradually losing ground to its theatricality. Collection: Musée de l'Homme, Paris. Photo: M. Delaplanche.

work making carvings for the tourist market. There, Makonde youth, no longer able to retire to initiation camps in the bush, undergo initiation rites secluded in suburban houses, where Mapiko mask dances occur as they did before. The mask carvers have somewhat expanded the repertoire of local characters their masks depict, including not only Makonde personages but Indians, Arabs, Portuguese, and guerrilla fighters. These and other African masks, once used only for functional performances, now sometimes also entertain external audiences, a practice that expands a widespread older custom of sending mask dancers and orchestras to represent the ward or village in another village, or at the local ruler's court.

The earliest Makonde masks we know are morphologically similar to those used today. The masks still consist of a whole head and neck worn on top of the dancer's head. Superstructures have not appeared where none existed before; even new subjects have taken the traditional form. Guro masks also continue to be carved as before—as small face masks with coiffures surmounted by decorative motifs. The main difference between early- and late-twentieth-century versions of these masks and many other traditional art forms consists of an updating of some of the subjects, which now often include conspicuous modernisms. On recent Guro masks, for example, we find themes from modern life carved above the face—an elephant (symbol of Côte d'Ivoire), famous soccer players, the president, an airplane.

Fig. 11. Baule Goli Glin performance in Bende-Kouassikro village, Côte d'Ivoire, 1980. The dancers of this village have been commissioned to perform for tourists so often that they have proudly gotten themselves matching T-shirts, emblazoned "Golli de Bende-Kouassikro," which they now wear during all performances—to the dismay of tourists hoping for something more "traditional." The Goli dance, newest of the Baule dances (it was introduced only after 1910), is frequently performed on television and has become part of the repertoire of the Ivoirian National Ballet. Photo: Robert Rubin.

Fig. 13. In the 1980s, a popular Baule singer and electric guitarist who performs under the name Jimmy Hyacinthe produced a record album featuring Goli music, with Goli Glin masks pictured glamorously on the cover. Village dance troupes are called to perform Goli on national holidays and for official visitors. All this attention has tended to validate the importance of the dance in Baule villages, where Goli seems to be replacing all other mask dances.

These images refer to important people and concerns of the day—just as they did in the past.

Newly made Makonde and Guro masks are typical of contemporary traditional art in showing only minor changes in style compared to earlier examples. These and other sculptures are all somewhat more finely detailed and somewhat more naturalistic, with modeling that suggests flesh and bone; surmounting motifs are more likely to show tableaux or figures in action than in the past, and people are of course portrayed in contemporary clothing—as they always were. New and old masks are now painted or repainted with bright imported enamels and often include writing.[11] These tendencies—toward naturalism and an emphasis on color—are part of a trend that can be seen in many contemporary art forms all over the African continent (see the Introduction). The most striking realization to emerge from this examination of recently carved traditional sculptures is that formal changes have been exceedingly modest.

In a discussion of art today around the world, Paul Faber writes that certain traditional art forms

> aim to reflect current events in microcosmic concept. This was customary a century ago and the same applies today. This flexibility, dating from time immemorial, is capable of absorbing the waves of the new times without any real breaks with tradition occurring. Changes can therefore take place within the realm of materials, techniques, colors, and even forms and themes without the transition being of any real significance to the makers and users.[12]

The changes in Makonde and Guro masks, and in other entertainments that have followed the same course, have been experienced not as ruptures with the past or as abandonments of tradition, but as gradual shifts consistent with earlier practice. It seems reasonable to assume that the scarification patterns on Makonde masks and the coiffures lovingly detailed on old Guro masks were mainly those in fashion when the masks were made, and that to their original audiences they too were a comment on and a connection to the present. Continuous, gradual innovation of this sort was evidently widespread, though it is virtually impossible to detect retrospectively because we almost never have a complete chronological sequence of masks from a single place, which would permit us to distinguish chronological change from regional and personal differences.

New Art for Old Functions

New art forms invented to fit old functions can become new traditions, in a process that duplicates the genesis of earlier traditional arts. Recent inventions are integrated into the artistic complex of a society, and their late arrival may be somewhat suppressed by the community, which presents the new cult as of a piece with the old ones. Consider the case of the Baga of Guinea reported by Frederick Lamp (1989:6-7, and personal communication, December 1990). The popular Baga bird-masquerade Koni fell out of use in the 1930s, to be replaced by another young people's performance, Sibondel. But by

Fig. 14. Miniature knives used by the Shona of Zimbabwe to commemorate their ancestors. Recent examples commemorating those who died in guerrilla warfare sometimes take the form of miniature automatic weapons (Dewey 1986:65). Collections of the American Museum of Natural History (left) and of William J. and Barbara Dewey (right). Photos: William J. Dewey.

the mid 1950s, traditional dances, including Sibondel and the much older D'Mba masquerade (also known as Nimba), were considered passé by young audiences, were depleted by the art market, were under attack from the government, and were challenged by Muslim clerics. They were finally all abandoned, to be succeeded by a dance named al-Barak (after Mohammed's winged steed), which used Islamic imagery and was controlled not by old men but by young, nominally Muslim men. While the object types were new, their style was recognizably derived from earlier Baga art. All these successive masquerades conformed to the same broad patterns of practice and belief. To the Baga, their culture remained a seamless whole, traversing periods of difficulty and change in the broad sweep of history. Because of the way Baga informants talked about the al-Barak tradition, Lamp was surprised to learn that the dance was less than thirty years old.

In other cases, much older art forms than al-Barak may continue to be seen by foreign scholars as foreign implants. The people of the Niger delta have paid homage to water spirits since time immemorial. The cult of Mami Wata, a water spirit, was adopted by the Ibibio before 1922, and was still expanding in the 1970s (Salmons 1977). Though the cult is relatively new, and both the name and imagery are non-African in origin, its structure is traditional. In the powers attributed to its practitioners, the role it plays in the community, and the structures of its performances, shrines, and sacrifices, it draws upon much older Idiong divination cults. It also includes an interlude very like the traditional practice of fattening young women and presenting them to the community before marriage. It is a perfect example of twentieth-century traditional art bringing a new form to an old function.

Late-twentieth-century traditional art can serve a traditional function not only with new forms but in an entirely new medium. The Yoruba traditionally honor deceased twins with images carved of wood; in recent decades they have occasionally replaced the old carved figures with local factory-made molded plastic dolls. More radically, they may now use a photograph in place of a carved figure for a twin shrine (Houlberg 1973:26-27): when no picture exists of a dead twin, the surviving twin is photographed in appropriate pose and

Fig. 15. Hélène Leloup, a Paris and New York art dealer, during a collecting expedition in Boké, Guinea, in 1956. Nimba headdresses, made by the Baga of Guinea, are both large and scarce, and have always commanded high prices on the African art market. The truck full of traditional Baga art, including such a headdress, is indicative of the art market's hunger for traditional objects, and of the ambivalence the Baga felt about retaining their masquerades during a time of increasing Islamization. About this time, Nimba ceased to be made or performed. Photo: courtesy Leloup Gallery.

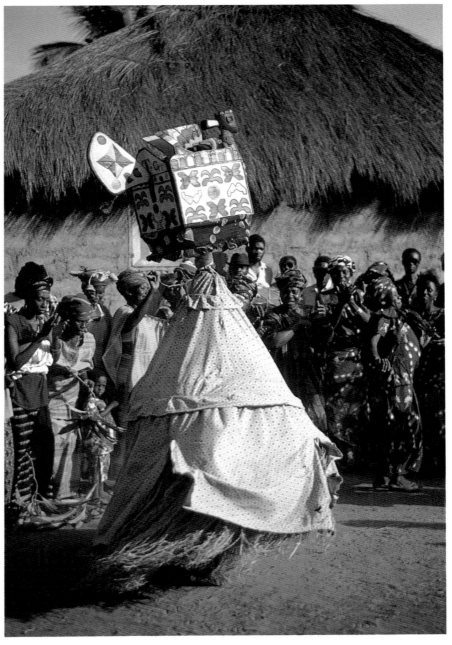

Fig. 16. Al-Barak headress in performance, Baga Sitemu, Guinea, 1990. Baga masquerades have traditionally taken the form of a high headdress over a bulky, haystack-like costume, and the mid-twentieth-century ones preserve this general configuration. The al-Barak headdress, named for the horse that carried the prophet Mohammed through the air to Medina, was invented in the 1950s partly in response to the growth of Islam in the area. Its conspicuous newness, which is part of its appeal, lies in its boxy non-organic shape, and in the fact that it is predominantly carpentered rather than carved like older headdresses. Photo: Frederick Lamp.

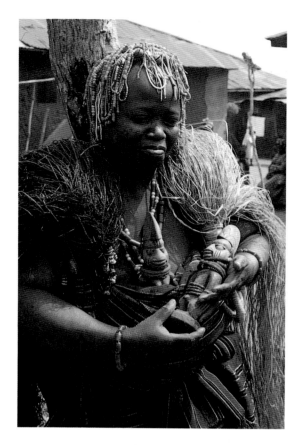

Figs. 17a-17c. The Yoruba of Nigeria consider twins minor deities and carve figures to be used in a twin cult after they die. In the nineteenth century these took the form of carved wooden figures of a kind still made today (fig. a). Muslim and Christian families have avoided the traditional figures and replaced them with a photograph or mini- mally carved figures (fig. b). The school-teacher who lost one of her twins carries the surviving twin and holds—in place of the carved figure—a factory-made plastic doll which she uses in the twin cult (fig. c). These practices represent an updating of the tradition without a rupture. Photos: Marilyn Houlberg, 1970.

clothing, and the photograph is placed in the shrine. If the deceased twin was a boy and the living twin a girl, she is photographed dressed as a boy, and vice versa. By manipulating the negatives, the twins can be made to appear as if they were sitting together. Offerings and sacrifices are made to the photographs as to the earlier carved figures, but photographs are particularly well suited to Christian and Muslim observants who want to distinguish their devotions from traditional Yoruba practice.

There are many other instances of the imaginative use of imported items as replacements for traditional artworks. By the 1950s, unable to replace the old ivory sculptures used in their Bwame initiation society, the Lega of Zaire were occasionally using Madonna figurines in place of their ivory ones, aluminum and china dishes instead of their carved masks, and light bulbs instead of the smooth ivory heads that had been used in the instruction of initiates. With clear irony, the light bulb was meant to allude to the many undesirable changes that had come with the Europeans.[13]

Style and Workmanship

Throughout the twentieth century there has been a general drift toward naturalism and meticulous detail, and a growing reliance on color. As described above, and discussed in the Introduction, complication and multiplication of forms have also been noticeable. Lettering too makes its appearance as a significant Westernism in many contexts. These trends are driven by the rise in individualism, by a new interest in material objects and the visible world, and, on a

Fig. 18. The main stadium in Kumasi, Ghana, the site of ceremonies connected with the inauguration of the new Asantehene, the Asante king, in the early 1970s. Chiefs borne in palanquins, surrounded by bearers of stools, drums, and gold-handled swords, and attended by entourages carrying the large state silk umbrellas, have entered the stadium to pay homage to the new king. The modern stadium was chosen as a setting for this traditional event in order to allow a large, mostly African audience to attend. Photo: Susan Vogel.

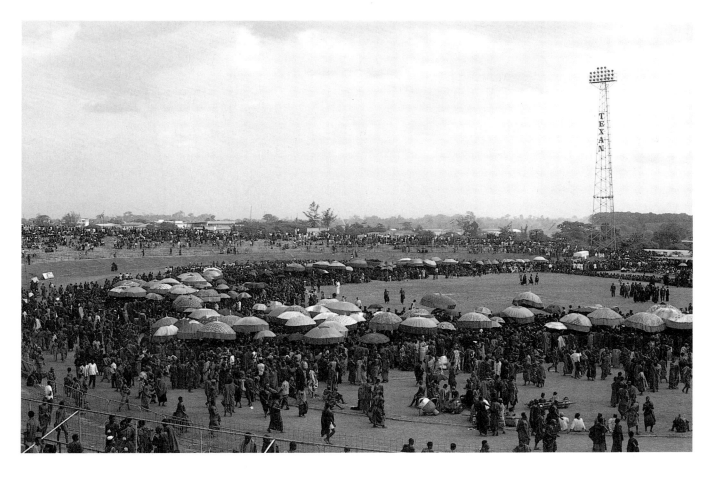

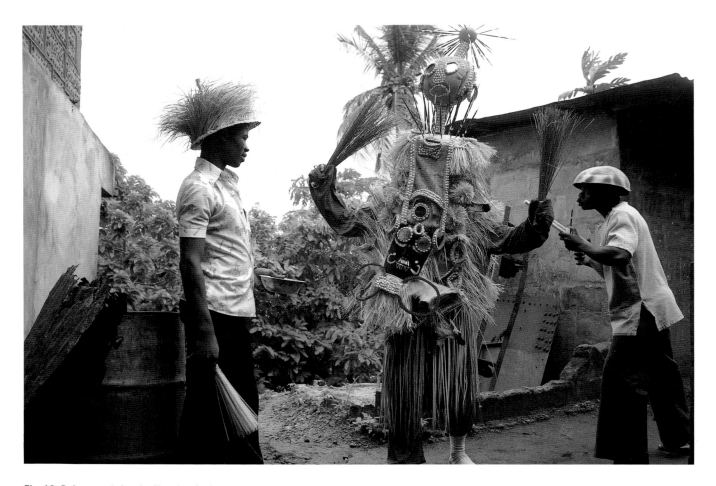

Fig. 19. Robot mask for the Hunting Society of Freetown, Sierra Leone, 1979. Inspired by a science fiction film, this extraordinary creation, invented by costume artist John Goba (on the left), has a large gourd-like head made of foam rubber and seeds, with mirror eyes and radiating antennae made of porcupine quills; in common with costumes of a much more routine style, it also has a raffia skirt and cape. Photo: Hans Schaal.

technical level, by the increase in sculpture for the external market.

Senufo artists supply one of the largest-volume productions of decorative carvings for external markets in all Africa. In the past, even master carvers spent most of their time farming, and carved only an occasional *poro* or prestige object; today there are hundreds of full-time Senufo artists. Although today's less discriminating market supports some men of limited talent who formerly could not have succeeded as carvers, Senufo artists as a group are more expert with their tools than in the past (Richter 1980:125-126); work for the tourist trade has resulted in refinements in the detail of objects made for traditional use. In the opinion of most critics and art historians, however, the artists' greater technical proficiency has not resulted in more successful works of art. The recent works are more repetitious than the older ones, and often seem overworked and exaggeratedly refined or virtuosic—perhaps because of the emphasis on technique over conviction.

The increased desire of individual patrons and artists to record their own personalities and histories is an important impulse in all strains of twentieth-century African art (discussed in the Introduction). In the past, most artworks that portrayed or stood for individuals were generic, stressing the role rather than the idiosyncratic person. A piece commissioned in 1976 by a newly installed Mossi chief is typical (fig. 20): whereas the figures that belonged to the chief's father and grandfather are relatively stylized, his is a naturalistic depiction of a soccer player in action, and in full-color uniform

Fig. 20. Figures representing three genera-
tions of Mossi chiefs. The present chief is
Naba Kom. His grandfather's figure is small,
stylized, colored black, and represents a
hermaphrodite. The standing female figure
belonged to his father. For his own inaugu-
ration, in 1976, he had the figure of a soccer
player carved. Westernisms such as the
unconventional subject and posture signal
his difference from his ancestors, alluding
to his love of soccer, his education, and his
familiarity with the national government, in
which he served as a middle-level adminis-
trator. Loungo neighborhood, Burkina Faso,
1977. Photo: Christopher Roy.

(Roy 1982:58). The piece was made to be associated with him and to
be displayed, with others he had inherited, during an annual festival
in which clan heads reaffirmed their allegiance to him. What is
significant in this example is its fundamental departure from the
intentions of earlier generations; it goes beyond a mere updating of
the imagery to make a statement through the conspicuous use of
Westernisms. Other instances, however, show tradition modernized
without altering the custom of representing individuals generically.
The latest commemorations of Shona ancestors who died in guerrilla
warfare (Dewey 1986:65, 67) are not the miniature wooden hunters'
and warriors' knives of the past but miniature wooden automatic rifles
(fig.14).

Only rarely is an entirely new style of artwork invented to fill an
older function. John Nunley has recorded a 1970s mask inspired by a
robot in a science fiction film, made for the Hunting Society masquer-
ade, which was brought to Freetown, Sierra Leone, by Egba Yoruba
in the early nineteenth century (fig.19). Despite the mask's bizarre
futuristic look, he notes, "One quickly realizes that the robot pieces
have been assembled in the traditional structure of the Yoruba
hunting garment: undergarment (*asho*), vest (*hampa*), and headpiece
(*eri*)" (Nunley 1982:46). The mask must be considered traditional art,
depicting, like masquerades of the past, a contemporary hero or
mythic figure.

The Artist as Entrepreneur and the Work as a Collaboration

In recent times, new art forms have been invented by individual artists
with an entrepreneurial spirit (see chapters II and III); in the past,
traditional artists were also often entrepreneurs.[14] It is highly romantic
to assume that they did not work for personal gain, material or
otherwise.[15] In my own experience among the Baule, I observed that
a disproportionately high number of artists and diviners were physi-
cally handicapped men, unable to support their families by farming.
Practical considerations surely affected their choice of a calling. In
the past, African smiths, carvers, and potters were all paid for their
goods, although not more than other craftspersons, and less than
successful healers; they actively advertised their skills and traveled in
search of work. Philip Peek describes a special wooden "hat" with
figures on it carved by the artist Ovia Idah "to be worn at local
festivals to advertise his abilities as a carver" (Peek 1985:58). Like
their latter-day counterparts in African cities, traditional artists were
entrepreneurs motivated to invent popular new art forms or to create
interesting variations on old ones by the desire to attract attention and
commissions. This was surely one of the mechanisms for change in the
unrecorded past.

Most nontraditional art produced in Africa today is market driven
(see chapters III and IV). Contemporary urban artists' willingness to
create what is demanded of them has wrongly been regarded as a sign
of their loss of purpose, of their corruption and prostration to the
market. But a reexamination of traditional practice makes it clear that
they are merely reenacting a long-standing traditional relationship

between client and artist. Though it has not usually been described this way, the art of traditional villages can now be seen as similarly "client driven." The conventional Western ideal posits the artist as fiercely independent, but the African presumption was always that the work would meet the requirements and express the ideas of the client, not the artist. In this regard, traditional African artists resemble traditional craftspersons in the West.

Traditional art commissioned by individuals was and is often made on the recommendation of a diviner, in response to a communication from spirits, or because a situation such as a death required it. Art made for groups was usually commissioned after consultation with all the members, and also, often, with a diviner. Cult requirements or divination might dictate such features as the type of wood, the place where the tree should be found, or the procedures to be followed during the carving (particularly sexual abstinence and food prohibitions). In every case, the clients came to the sculptor with firm ideas about the subject and the attributes to be shown in the work, often down to fairly minor details, though a frequent requirement was an open-ended request that the piece be different from other known ones. Most traditional artists fully accepted and complied with the demands of their clients.

To a far greater extent than we have acknowledged, then, the traditional work of art was the result of a collaboration between artist and client, and occasionally diviner. The artist was often a relatively unimportant person who produced important, highly regarded things for people of higher status than he. Once the work was finished, it usually came to be identified with the owner. The role of the maker was largely ignored. Roy Sieber has nicely summarized this paradoxical situation: "The artist is often depicted as 'different' . . . of a low class . . . or as very nearly the antithesis of the 'ideal' member of society . . .; yet he produces objects or performs acts which are not only welcome in the society but which often, perhaps usually, reinforce the norms of that society" (Sieber 1973:431).

Other Western art historians have tended to minimize this aspect of African art production because works created in this way do not fit Western categories of fine art, and because the collaborative process has seemed to diminish the importance of the works.

Why the Artist Was "Anonymous"
The nature of the collaboration may be one reason for the frequent "anonymity" of the traditional artist—an anonymity in which the sculptor is known but little acknowledged. Simon Ottenberg states, "Sometimes the client was considered the maker of the object, the artist only the mechanism of its production."[16] The owner of a work of art, whether an individual or a corporate group, almost invariably has more prestige, power, wealth, and visibility in the community than the artist. It is interesting to compare the African situation with the ancient Roman one:

It is a remarkable fact that creative Roman art and architecture, with vague or trivial exceptions, are anonymous. . . . The truth probably is that

Fig. 21. "Miss" mask in a Baule entertainment dance, Koumle village, Côte d'Ivoire, 1990. A recent addition to the cast of human and animal characters in the oldest Baule entertainment dance is this beautiful female named after beauty contestants, who are called "Miss" (pronounced "meese") in Côte d'Ivoire. The skit structure of the performance and the morphology of masks and costumes show no break with the past. Photo: Robert Soppelsa.

the cult of the individual had here over-reached itself: that the Roman patron was now the man who counted: that even a Column and a Pantheon were so closely integrated with the personality of a Trajan and a Hadrian that the artist and architect mattered not at all. They were employees (Wheeler 1964:9).

Craftsmen and performers [among the Gola] were persons of low status who provided services for those who could afford them. The finest work from such persons became the property of wealthy patrons who used them to enhance their own prestige. When one admired the work of a singer, a musician, or a woodcarver, one was usually informed of the name of the patron as though the identity of the actual producer was insignificant (d'Azevedo 1973:332).

In traditional communities, almost everyone knows who owns a work of art; few can recall who actually made it. Daniel Biebuyck comments of the Lega, "It is most noteworthy that the living owners of the artworks, in tracing the history of individual pieces, invariably provide the names of successive owners of the object, then invariably wind up with the first owner of the piece, ignoring or simply not knowing its maker" (Biebuyck 1976:141).

When pressed by a researcher, informants can often remember the name of the maker of a work, but this information is rarely volunteered, and is not as important to them as the personal name of the object. The prestige of a communally owned cult object would be diminished by public recognition of its mundane origins or by strong identification with its inventor. Only after Lamp had completed extensive research on the origins of the al-Barak masquerade cult described above did informants mention that it had been invented as recently as 1955, and that the man responsible was an otherwise unremarkable person right at hand. Certainly, as with medicine-making, mystification is more effective at a distance: everyone agrees that the most powerful healers live far away.

Particularly in the case of sculptures that are seen as manifestations of larger powers, communities may deliberately suppress the widely known fact that they were made by a particular person. (The common taboo against naming the wearer of a mask is a similar suppression, probably for a similar reason.) The more important the work, the more likely it is to be carved in seclusion, and the less likely it is to be credited to a particular artist. Of an exceptionally large and venerable Cameroon sculpture, Pierre Harter tells us, "This masterpiece was executed early in the second half of the nineteenth century by an anonymous sculptor, whose name was either forgotten or a carefully guarded secret" (Harter 1978:124). The phenomenon of the "anonymous" (but known) artist seems to express a cultural value in a well-organized recording system.

African folktales, although much embellished by tellers and performers, invariably begin with a formula stating that the teller is merely the transmitter, not the maker, of something that comes from long ago or far away.[17] The image of the artist as the transmitter of forms received from distant (authoritative) sources may be the most accurate rendering of the African view. Certainly all artists have a

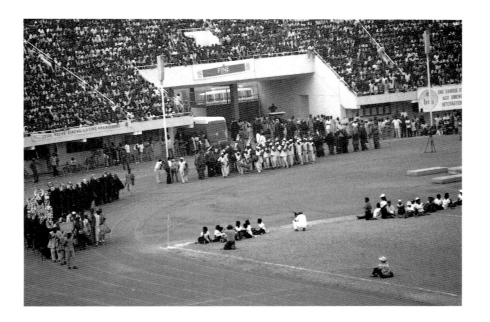

Fig. 22. Bobo masks enter the stadium in Ouagadougou, Burkina Faso, to celebrate the opening of the Pan-African Film Festival in the presence of the chief of state, 1989. These masks were one of many groups that appeared, region by region, in a parade of traditional musicians and costumed masqueraders that lasted over an hour. The audience was predominantly African. This is an example of a new function acquired by a traditional art form. Photo: Boureima Tiekoroni Diamitani.

distinct personality and transmit received forms in their own style, which can be identified and studied, but we must recognize that this aspect of the creative process is of interest mainly to the Western art historian. Perhaps a desire to validate African objects as art has pushed art historians to place too much emphasis on the artist in African societies, a distorting focus that may take us farther from understanding art as it was perceived in the original culture. The artist as unique creator is, of course, a Western culture hero, not a traditional African one.

The Invention of the Canon
An awareness of traditional art as dynamic leads to a recognition that what the West considers "traditional African art" is only the art that Africans happened to be making and using when Westerners constructed this category, sometime between about 1880 and 1920. Traditional arts from the early nineteenth century and before were probably different from what has long been accepted as the canon. The small number of works collected in Africa before the mid nineteenth century are the only reference, but a sizable proportion of them are in styles that are unidentifiable today—seemingly because they were extinct or had been radically altered by the late nineteenth century.

The canon of traditional art itself seems problematic. Closely examined, it appears as no more than a customary list, a mere convention of Western collections, lacking even a rational set of criteria for inclusion. In principle, "traditional art" (often considered synonymous with "authentic art") includes all art made by Africans for their own use. In fact, the accepted inventory of art forms does not even consistently include all the art made and used by African villagers at the end of the nineteenth century. Figural cloth banners, for example, have been made in Ghana exclusively for local use since before 1693 (Ross 1980:310), but are not normally included in the canon, probably because they are seen as acculturated (cat.19-21).

Since at least the mid nineteenth century they have been made by Fante artists for uses fully integrated into the life of the community, employing a symbolism that alludes to Fante proverbs. In contrast, Chokwe chairs are an unquestioned part of the canon, though they are a nineteenth-century invention based on a European model and frequently include European-made furniture tacks. They are probably included because they are in the expected medium—carved wood—and because most show lustrous signs of apparent age. Fante flags are suspect because they are two-dimensional pictorial works, are executed in an unusual medium, and when they look old, look tatty.

It is revealing to consider two types of art that have been unhesitatingly accepted as part of the traditional canon, even though their recent invention for the Western market is a matter of record. They reveal how limited the canonical parameters are, and how stereotyped. Working at the Kanda Kanda trading post in Shaba, Zaire, at the end of the nineteenth century, an unnamed artist who was not from the region (he may have been Chokwe) developed a naturalistic style of figure sculpture under the influence of his European clientele (Cornet 1975:55). His oddly gestural works were soon imitated by other carvers and potters, and passed into the canon under the name "Kanyoka."[18] The Kanyoka apparently make no figure sculptures anything like these; their art is described as abstract and schematic. Cornet refers to this as "a case in which, in one way or another, fakes have become authentic." So-called Kanyoka sculptures became part of the canon because they could be documented to the nineteenth century, and because they conformed to the stereotype of small, shiny, human figures.

Most Mangbetu figurative sculpture has recently been shown to have come into being after 1900 in response to the presence of foreigners. Created by artists from several ethnic groups in northern Zaire, and based both on original invention and on preexisting art forms, figurative Mangbetu art was used primarily as "a currency in their relationships with Europeans" (Schildkrout and Keim 1990:257). After producing a remarkable body of figurative artworks in a couple of decades, the Mangbetu dropped human figurative art from their repertoire (ibid. :253-254). Conventional definitions of what is traditional or "authentic" are stretched by this example, which, like tourist art, is directed mainly toward outsiders, yet functions, like much traditional art, to construct ethnic identity, and to reinforce the status and prestige of rulers.

Conclusion

A historical examination of traditional art, a recognition that it is more dynamic than we formerly thought, and a close look at the changes of recent decades lead us to recast our image of traditional art in a less romantic and idealized light, and to see it as perhaps more profoundly different from recent art of the West than we have thus far recognized. Viewing the traditional arts of Africa in historical perspective throws into relief certain qualities that are not usually emphasized. Insofar as one can generalize about so vast a field, a

consistent and important feature seems to be the desire for novelty. The audiences and commissioners of artworks seem always to have appreciated and rewarded unusual new interpretations of their inherited art forms, whether on the level of relatively minor innovations in form and iconography or, occasionally, in the wholesale importation of new art forms from neighboring peoples, often substantially adapted. It now appears that many entertainment masquerades—the characters, names, songs, and dances—were invented by young men to comment upon current events. They remained in use as long as their generation performed them and then were replaced by the next generation's inventions in a similar mode. When successor generations decline to produce a new version, the genre becomes extinct.

We have demonstrated that traditional art continues to be created thanks to its capacity to change, and to absorb new ideas and situations. The flexibility apparent in traditional art today sheds new light on the traditional artist of the past. We propose that traditional arts past and present be defined as those in which the community views the artists essentially as transmitters of received forms; and that though those artists are and were rarely anonymous in the true sense, their identity is and was usually of little interest. Their personal contribution to the creation of a work of art was seen as subordinate to the role played by the commissioner of the work or by subsequent owners. Traditional artists often collaborate with clients and others (including other artists) in the production of artworks.

Traditional African art today cannot be seen as corrupted, for it was never pure, never homogeneous, and never isolated. Rather, in Africa as elsewhere in times of change, individuals and societies have taken charge of their artistic expressions. They have selected artistic forms and ideas from the multitude available to them, and have changed their artistic repertoire. As the twentieth century reaches a close, African artists, like their forebears before them, have chosen to renew useful old forms, to take on new ones, and to cast off others in an ongoing process of organic decay and renewal.

NOTES

1. *Webster's Third New International Dictionary of the English Language, Unabridged,* 1986, defines "tradition" as "cultural attitudes, beliefs, conventions, and institutions rooted in the experience of the past and exerting an orienting and normative influence on the present."

2. Eric Hobsbawm's and Terence Ranger's *The Invention of Tradition,* 1983, has had a tremendous influence on Africanist anthropology, leading many to try to abandon entirely the use of the contested word "traditional." The absence of any suitable substitute term, the use of the word and the concept by informants, and evidence for a certain kind of cultural continuity have led many writers to use it despite themselves. Those dealing with African art have tended to overlook the important distinction the book makes between "invented traditions" and "genuine traditions," which are not Hobsbawm's and Ranger's subject (pp. 1-10).

3. Personal communication from Moussa Traoré's great-grandson, Mamadou Traoré, December 1990.

4. Writing may have been rejected precisely because it tended to fix facts, inhibiting the flexibility at the core of many African traditions, historical memories, and legal systems. It remains to be seen whether books on African art—one imagines mask dancers using dissertations as guides to rituals—will become an authority, freezing

traditions. The wheel was only useful after large-scale road-building had been undertaken by the colonial powers. It is interesting that many parts of Africa are still less accessible by road than by air.

5. It is interesting that Kolawole Ositola, a practicing Yoruba Ifa priest and diviner, not only uses the ethnographic present but updates "ancient times" to resemble the present. He writes that Orunmila, a Yoruba god, once failed to guide his children properly. As a consequence, "Instead of being a management consultant, one became a lawyer. And this disturbed the whole family" (Ositola 1988:34).

6. By this definition, of course, much European religious and other art is traditional.

7. Personal communication, August 1990.

8. I am grateful to Ivan Karp for stressing the importance of this characteristic of the arts that have endured (Karp 1988 and personal communication, October 1990).

9. G. I. Jones provides an extended analysis of this phenomenon, distinguishing between cults devoted to the supreme being, the earth, tutelary deities, and the ancestors—all of them immune from doubts and disbelief—and local tutelary, fertility, and oracular cults that could be discredited (Jones 1984:49-51).

10. This discussion concerns the southern Makonde, whose homeland was in Mozambique, south of the Ruvuma River, and whose traditional mask style consisted of helmets. (The northern Makonde, who live north of the river, in Tanzania, make more geometricized face masks and torso masks.) The southern Makonde are the originators of the well-known Makonde *shetani* style of tourist carving. J. A. R. Wembah-Rashid argues eloquently that they have survived financially by selling tourist art and spiritually by preserving their own initiation masks (Paris n.d. [1990]:42).

11. It is interesting to note that shiny enamel paint covers one of the earliest Gelede masks, recorded in the Museum für Völkerkunde, Munich, by 1888 (Kecskési 1987:120). The old masks, however, are mainly colored with locally produced, water-based paints, though Nigerian sculptors early on began to use imported laundry bluing, ink, and later the ink from ball-point pens and boiled carbon paper in place of indigo.

12. He continues, "the situation is different in the case of certain types of art which in external appearance scarcely change at all but which are embedded in a new economic pattern," i.e., when production becomes oriented toward an external market (Faber 1988:13).

13. Lega villages were not electrified at the time, and the light bulb made a typically indirect reference. Its display to initiates was accompanied by the aphorism, "He who seduces the wife of a great one eats an egg with rotten odor." According to Daniel Biebuyck, this "indicated that with the advent of the whites everything had changed, for the severe sanctions that were traditionally exercised against those who seduced a high ranking initiated woman were not recognized by the colonial courts" (Biebuyck 1976:345).

14. Those who commissioned works of art could also be entrepreneurs, and spectacular sculptures could help "advertise" their cults. Writing of Eastern Nigeria in the 1930s, G. I. Jones reports, "People did not have to seek out these cults, they were brought to their doors by 'travelling salesmen.' The establishment of private shrines for a deity was a lucrative business for the priests in the village where its principal shrine was located and who could be said to own the Juju. Many of them travelled about the country in the same manner as doctors and diviners and similar specialists in magic and the supernatural" (Jones 1984:48).

15. Dolores Richter provides a good review of the literature substantiating this point. Her examples span the continent and go back to the eighteenth century. She makes the further point that mass-production of craft items in anticipation of sales was well established in precolonial Africa (Richter 1980:1-4).

16. Personal communication, August 1990.

17. I am grateful to Philip Peek for pointing this out. The subject is treated in detail in Peek 1981:30.

18. Kanyoka figures were classified by Frans Olbrechts as a Luba substyle in the 1930s (Olbrechts 1959:78-79).

ENTER THE BUSH

A Dogon Mask Festival

Walter E. A. Van Beek

MAY 18, 1989: As the steep Bandiagara cliff casts its shadow over the village of Amani, the men of neighboring Tireli gather at the roadside to thank their hosts for the splendid mask festival. It has been a good time, this *dama* in Amani: the masks were beautiful and performed well, the visitors were received with honor, and beer was plentiful. Yédyè Pudyugo, the ritual speaker of Amani, leads the Tireli delegation to a deserted compound, where four huge jars of millet beer are waiting for them. The men gather around the brew and quietly down the eighty-odd liters of beer. Glancing at Yédyè, Mananu, leader of the men from Tireli, taps his iron ring against a bell and starts singing: "Thank you for the beer, you who stood over there, poured out, and we drank, thank you." His clan brother Amaga follows with the second verse: "Thanks for Tepènyo [an ancestor of Amani], God has done well to the first settler here; you are sons of the same father, you will understand us." "May God help you," sings Mananu, "help the ones who work the millet, may the rich God help you; as brothers, you understand our words." Answering in proper fashion, after the many repetitions of the song, Yédyè launches into a long greeting, thanking his guests in the ritual mask language (*sigi so*): "What you said does not come from a child, it is truly the word of the old ones. When you came here, not even a dog could bark at you, no stone could offend

your foot. Compared to you I am but a youngster, and we did not honor you enough; many men and women have come to look at our masks; you are the children of God, going back home no thorn will touch your feet." In return, the men from Tireli thank their host for his graceful reception of their thank you song, then finally gather their belongings and leave the dancing grounds where they have spent most of the last four days. It has been a good *dama*, and Amani can be sure of a good year with an abundant harvest. Next year in Tireli, perhaps!

Masks and Mask Festivals

The Dogon of Mali love their mask dances; nothing excites them as much. Whenever a *dama* is held, hundreds of people from the neighboring villages flock to the dancing grounds to watch the masks, comment on the dancers, perform where needed, and applaud the performance as a whole. They compare it assiduously with their own festival, their own masks, their own dances, taking a fierce chauvinistic pride in their home variant of the feast. The Dogon mask festivals have also drawn much attention from academics and tourists. From the first explorers (Desplagnes 1907) to the first major description by Griaule (1938) to the recent publications of Dieterlen (1989, 1990), this complex has been the object of intricate description and elaborate speculation.

Before following a mask festival like Amani's through its course,

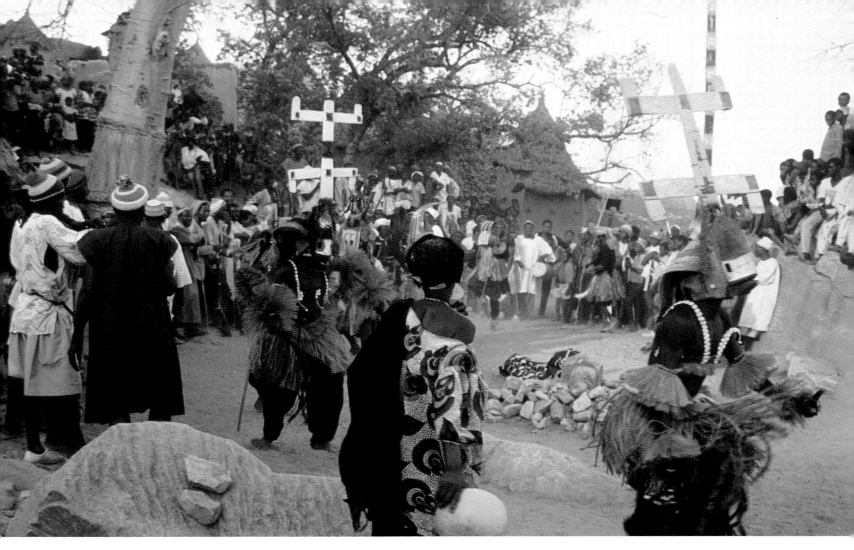

and venturing into our own interpretation of it, let us first define what the Dogon mean by *èmna*, the word we translate as "mask." That word suggests above all a covering that disguises the head. Tourists, art dealers, and museum curators routinely call Dogon head coverings "masks." For the Dogon themselves, however, the notion of *èmna* includes the whole person dancing in a costume of which the headpiece is just one part. Masks are not worn; masks dance, perform, and shout. The total outfit comprises red and black fibers for skirts and arm adornments, a pair of very wide Dogon trousers, a headpiece attached by cotton bands, and various paraphernalia belonging to that particular costume—a dancing stick, or a rattle, or a dancing ax (fig. 1). The essential element in this ensemble is the fiber, made from the hibiscus plant and dyed a fiery red. These fibers share the name *èmna*; sometimes a few are tied on a stick and are used to prohibit women

from approaching a waterhole, and these too are called *èmna*. The headpiece, though important, may change from one performance to another; in fact it is the fibers that define the outfit as a mask, and the headpiece that indicates which particular mask is in play.

The mask ritual has several parts. Though their details vary greatly from village to village, the following elements are common:

1. There is a period in which the masks are made and the village drums repaired, which lasts at least a month. During these weeks, the boys to be initiated roam the village at dusk in the *èmna bèdyè* (pupil mask).

2. A number of ritual entries are made into the village. The masks come from the bush and enter from various directions. This, in my view, is the crucial ritual element of the mask festival.

3. In a series of public dances, the masks perform at various

Fig. 1. Mask performance during a funeral. Mask rituals are a part of the complex of Dogon ceremonies connected with death. Funerals, held once each year, are elaborate four-day-long ceremonies with dancing, singing, and mock combats involving the shooting of Dogon-made flintlock guns. The high point, in the case of the death of an elder, is a performance of a dozen masks at the main dancing ground of the village, after which all the men, old as well as very young, join in a final dance. This appearance of the masks in the first funeral (the mask festival, the *dama*, being the second funeral) can be interpreted both as a first farewell to those who "commanded" the masks, and as a first contact of the dead with the bush, their future abode. All photos: Walter E.A. van Beek.

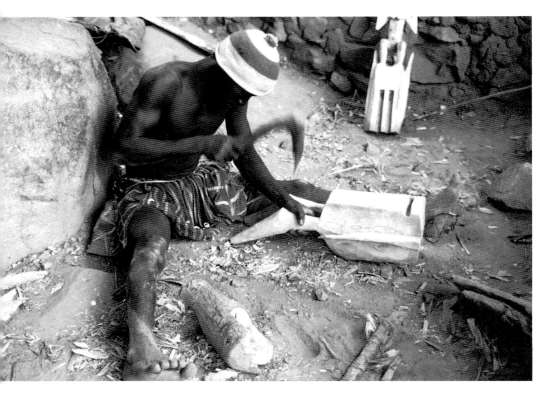

Fig. 2. The carving of a mask. The young men participating in a *dama* for the first time must carve or plait their own masks, including the headpiece. They must grow hibiscus for its essential fibers, buy the beads and the cowrie shells, and cut trees for the wooden headpieces. Some masks, such as the "healer," with its four human figurines, demand intricate carving; others, like the "tree," which is five meters long, are difficult to construct. These may be carved by a specialist, usually a blacksmith. As wood is scarce, permission to cut it must be asked both of the elders of the village and, on behalf of the whole village, of the "*Eaux et Forêts*," an institution of the Malian government. For the *dama* this permission is always granted.

places in the village.

4. Rituals of segregation follow, in which those who have died since the last *dama* are given their final farewell, and the masks themselves take their leave.

The *Dama* of Amani: Preparation for the Ritual

After the good harvest of 1988, the grandsons of the fourteen men who were central in the last *dama*, thirteen years earlier, come together and decide that a new *dama* can be held. After asking permission of the fourteen oldest men now living, they start the preparations. Thirteen years is about the standard time between *dama* for the villages at the foot of the cliff. In fact, many men in Amani have anticipated the festival, and have already cultivated a fair amount of sesame, one of its necessities. Word gets out to the people of Amani origin living in the plains and even in Côte d'Ivoire.

The young men who are to perform in this *dama* for the first time prepare huge quantities of hibiscus fibers. Then they start on their masks, carving or plaiting headpieces, drying and dyeing their fibers, collecting cowrie shells and beads for the decorations, and ar-

ranging the long Dogon trousers that belong to any mask outfit. Most of the masks are made by the dancers themselves (fig. 2), though certain renowned carvers and blacksmiths may work on request. All the dancers make more than one mask, as they all have to wear the *bèdyè* mask during the event's opening sequences; each carves or plaits several headpieces more, in order to change roles in different dances. The choice is up to the individual, guided by age and personal preference. Young boys often choose the small hare or rabbit mask (*èmna goû*), which is easy to dance, and perform in a group. Some masks are tricky to dance, like the shaman's (*èmna binu*), as the dancer must enact a possession during the dance, and runs the risk of actually being possessed. The most popular mask is the *kanaga*, the stork, the most famous of all Dogon masks, often referred to as the "*croix de Lorraine*." Other popular ones are the *èmna tiû*, the tree or "big house" mask, and the *tingetange* or stilt mask.

As fabrication continues, the period starts called *yange èmna*, or fire masks. At night, the young men who are to perform their first *dama* gather at the village perimeter and, accompanying themselves on the slit drum, practice their dancing. Fire is taboo here, and any man passing by is forbidden to carry a flame. No one may talk to the dancers, except in the case of a death. During this period, which may last a fortnight or so, the women of Amani are not allowed to leave or enter the village at night, as they would risk seeing the masks "naked," without head coverings. If women cross the village borders in the dark, the masks, adorned with just a few fibers over their trousers, accost them and make them pay, also fining their husbands. Tales abound of women from foreign villages being slaughtered by masks when they enter the village territory. To avoid these prowlers, women hurry home; after the market in neighboring Tireli, the women

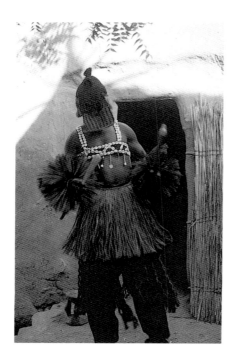

Fig. 3. *Bèdyè*, the pupil mask. All the dancers must make this mask, which is probably the oldest form, a simple plaited head covering, yet is the most crucial in the festival. It symbolizes the fact that men must be initiated into the use of masks, into the ways of the bush, to gain knowledge and power. The *bèdyè* masks are the first to appear in the festival, emerging from the bush even before the *dama* is fully underway. As "pupils," the young men learn to make the masks and, in the month preceding the main rituals, gather at evening clothed as *bèdyè* to practice the dances, to beat their slit drums, and to scare off women. The masks may also be spotted by day, roaming the village to greet the elders and to reconnoiter the ritual places.

of Amani are the first to leave, whether they have sold their merchandise or not. In earlier times, in fact, no work was done at all during this period. But times have changed, and the commerce in onions continues during the day. The nights, however, are used for dancing.

At the crack of dawn at the end of *yange èmna*, the dancers and many of the older men leave the village, heading for a pond in the dunes to the northeast.[1] There they spend most of the day, drinking beer brought to them by the *yasigine*, the "sisters of the masks," who also fetch them water. In the village the women and the remaining men gather bowls of mush and oil of sesame and fill the beer jars standing at the meeting places. Around four in the afternoon the masks emerge from the bush in a long single file. All of them are *èmna*, though the older men, who walk first in the line, wear fibers only around the waist. They also sport indigo trousers, and plaited headpieces worn loosely on their heads. The new *èmna*, the younger men, close up the rear, wearing white trousers without fibers. Each carries a short stick and a thorn branch in his hands. Twice, at places identified by the older men, the whole line kneels, while Yédyè shouts from afar his greetings in *sigi so*, the mask language:

> God has seen you, has seen a good thing. Something big is there, something small, if anything is wrong, it is with God. This is not work for children. If you see a woman, beat her. Greeting, good heads, who came running, all the women are afraid, beat them.

After the second greeting the masks shout their high-pitched cry, "hé, hé, hé," and disperse to the various places where beer and food are stored. The young ones swarm out into the village, chasing those few girls who have not yet hidden themselves away, and search out houses where there has been a death since the last *dama*, signaled by a reed mat in the entrance. There they beat their sticks

against the doorpost and throw stones into the yard, demanding their share of beer. Beer has been brewed in other compounds as well. Few people from other villages are present, as most fear to enter Amani on this day, which through its "blackness" is dangerous for them.

Though the masks have entered the village, they are still seen as "naked." The preparation period intensifies as the young men put their costumes and headpieces in order. Though beer drinking continues through the weeks that follow, it is on a smaller scale, for much work is still to be done. Besides finishing the masks, the young men make new drums, hollowing out the trunks of trees. The old men of the village prepare the skins to cover them. In the afternoons, some of the young men don their *bèdyè* masks, plaited fiber hoods, the simplest of all head coverings (fig. 3). In full adornment they roam the village, where they ask for beer in the compounds.

These activities last another four Dogon weeks (of five days) or so, or whatever time is needed for the dancers to carve and plait the rest of their masks.

Descent from the Scree

The final preparations are made over a period of four days. In a complex ritual involving one mask, the elders plant the *dani*, the dancing pole, and build an altar at the heart of Buguru, the dancing grounds. After some individual forays into the village, the masks finally gather on May 15 on the scree several hundred feet above the village. The drums are beaten to warn women and children not to approach the masks, who spend the day preparing themselves. Finally, when the sun disappears behind the cliff in the late afternoon, the masks emerge, the old men leading them down the paths to Buguru. At one point the traditional trail downward passes through a compound that somebody has built on it since the last *dama*. And since many years have elapsed since that festival, the

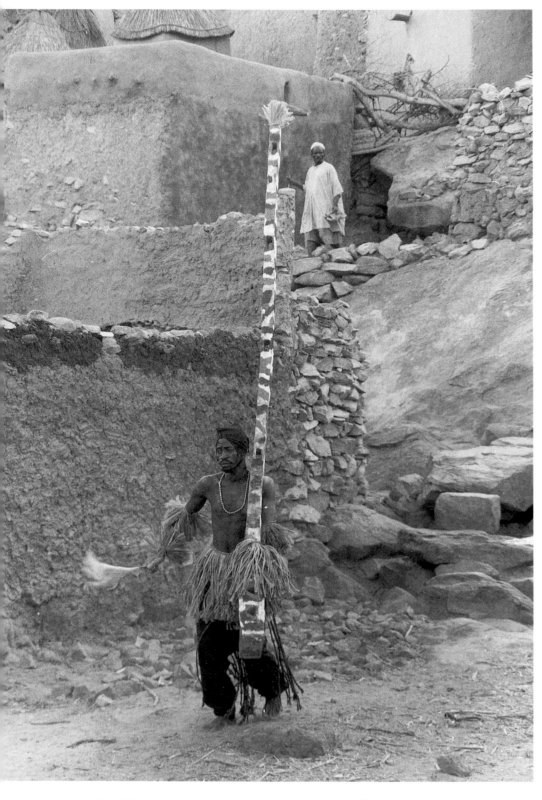

exact route to be followed has become a little hazy; the old men engage in heated discussion as to whether a particular stone should be passed to the right or to the left.

Finally the masks arrive at the dancing place for the first public performance. The drums, which have been brought straight to Buguru, start calling masks and spectators, while from the dancing grounds old men shout exhortations into the village. The old guides, dressed in sloppy *bèdyè* masks, emerge first, followed by the masks proper. Two *waru* (antelope) masks, the keepers of law and order, open the file, followed by six *tingetange*, two *sadimbe* (sisters of the masks), one *odyogoro* (goiter), one *tâ* (door), four *modibo* (Muslim officiants), twenty-two *kanaga*, and four *tiû*. The last elder to emerge carries the *agamagâ*, the grand mask (fig. 4). A real sister of the masks, a *yasigine* (as opposed to a *sadimbe* mask), walks between the last men in the line.

It is still a time of high taboo: women, children, and strangers remain at a distance. Only the men of Amani are allowed on the spot. The atmosphere is one of both serious business and easy camaraderie. The dancers are guided meticulously in the proper way around the *dani* and altar, counterclockwise, but this first day, performances are somewhat disorganized, neither the dancers nor the leading elders being fully secure about the "old ways" they are supposed to follow. Women being absent, there is no real need to hide the identity of the dancers; after their performance they shove their masks to the back of their heads to get some fresh air, and to see better. When a mask is damaged, as the *kanaga* sometimes is when touching the ground in the vigorous dancing, helpers repair it without fuss, in view of everyone. If women were present, this would be done behind the rocks or a tree.

The first to dance, to the sound of the drums and bells, are the *tinge-tange*, the stilts, as these masks are difficult and tricky to use, and dan-

Fig. 4. The arrival of the *agamagâ*, the grand mask. The original mask, found in mythical times by people in the northeastern village of Yougo, is represented in several ways. One of them is the *dani*, the dancing pole, erected at the main dancing ground (see also fig. 9); a second is the *èmna na*, a bull-roarer swung at night whose sound is the voice of the mask. In many villages, Amani amongst them, a third representation is by a long mask of the "tree" type, called the *agamagâ*. This mask, as shown in the illustration, is never worn on the head, but is carried around and shown to the dancers during the festival. For the rest of the time it is kept in one of the many crevasses of the village scree and guarded by the elders.

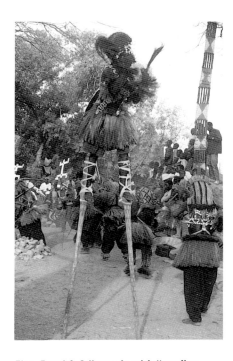

Figs. 5 and 6. Stilt mask, with "tree" or "big house" mask. Among the many types of masks, these two are the most spectacular and the most difficult to dance. Practice for the stilt mask starts at a tender age (fig. 6). The mask represents a waterbird, but its body gear adorns the wearer as a Dogon girl with a cowrie-decorated skirt, jutting breasts, a small money box, a horse's tail, and the elaborate hairdo that girls used to wear at the festivals. The masks tie on their stilts against a house near the dancing grounds, and perform before all the other masks. After their dance, they entrust their stilts to their kinsmen and join the troupe as "girls."

gerous when the dancers are tired. The *tingetange* dance slightly apart from Buguru, at a small flat place close to the scree where a building enables them to tie on their stilts. Their long legs aside, they are adorned like either Dogon or Bambara girls, their plaited headpieces covered with cowrie shells, beads, little mirrors, and strips of metal; and their bodices a rich display of beads and shells around jutting breasts made of baobab fruits. The stilts dance as a group, admired by all, as theirs is the most difficult technique. Years of solo practice in the bush precede this display of expertise; the dancers have worked up from little stumps while still children (figs. 5 and 6) to ever greater heights. The mask as a whole represents a waterbird (probably *Himanthopus himanthopus*), and the dance mimics the bird's characteristic jutting head movements. Shaking little money boxes and horsetails in their hands, the stilts trot along the square, while the elders shout encouragement in *sigi so*: "Greetings, God and masks, forgive us, it is your work, your work from the cavern. It is very good for the elders, people have come to see you dance, it is your work, up to you." As they shout they pound sticks on the ground before the approaching stilts. When through with dancing, the masks sit down in the little Christian chapel built next to the dancing place, untie their stilts, hand them over to the custody of a kinsman, and join the rest of the masks, keeping on their costumes as girls.

The elders have introduced the masks to the *dani* and to the altar by circling around them three times, then leaving the floor. First to appear at Buguru itself is the main body of masks, the *kanaga*, a long row of wooden crosses dancing more or less in unison. The other masks follow behind them. All the masks initially dance together, circling the spot three times, all joining in the same routines. Then they perform in smaller groups. The *kanaga* go first: three or four at a time, each

goes through a vigorous choreography in which he dips his head, draws back, then circles his cross to the right, touching the ground with its tip (fig. 7). Much shouting accompanies this exercise, the spectators praising the good performers, throwing boos and laughter at the poor ones. The long line of *kanaga* takes quite a time to perform, as each mask tries to remain on stage as long as possible. Some have to be shoved off by an elder to make place for the next.

Then the other masks get their share of attention. The spectacular *tiû*, four to five meters high, move in together like a walking thicket of trees. Like all wooden headpieces, this huge one, representing both a tree and a clan house, not only rests on the dancer's head but is tied to his waist with strips of cloth through a mesh of cords at the back. To maneuver, the dancer bites on a grip inside the headpiece. It takes good teeth as well as a strong neck to dance this mask, as the huge contraption has to move vigorously. Swaying the tree to and fro, each time touching the ground, and whirling it around horizontally, the dancer shows himself a real *sagatara*, a strong young man, eliciting shouts of praise from the bystanders, who keep at a safe distance (fig. 8). One of the performers fails in raising his mask from the ground and is booed away, while the spectators chatter about who he is, and why he lacks strength.

When the trees are finished, the other masks follow, in no particular order, though the older men precede the younger ones. This year Amani has quite a few *modibo* masks, representing Muslim teachers (marabouts); long colored hair on the plaited hood is the main characteristic. Next up is a *sadimbe*, a mask featuring a female statue fully adorned as a sister of the masks, and representing the mythical first woman who found the *èmna*. Behind it comes a *tâ* door mask, representing the Dogon granary doors. This is a new type of mask that most people have never seen be-

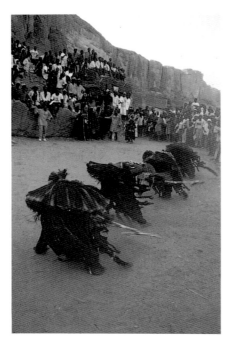

Fig. 7. A group of *kanaga* dancing. The *kanaga* mask is by far the most popular of all, and has come to represent Dogon masks all over the world. Its original meaning—a large white bird, probably a stork—has become somewhat blurred, not least by the dubious interpretations of early Dogon researchers. The *kanaga* is easy to carve (see fig. 2), not too hard to dance, and still allows for individual performance and a show of excellence in dancing. It should be danced by youngsters of about twenty years of age, who are trying to marry, and for whom an attentive mass of admiring girls is most important, even if they have to keep a respectful distance.

fore. The masks representing girls —*tingetange* who have shed their stilts—then follow with their dance, accompanied by the two *waru* masks representing the oryx gazelle (*Oryx dammah*, or *O. gazella*).[2] These latter are by far the most active masks: their task is to keep order in the proceedings, moving the spectators to the edge of the dancing ground, and chasing off women, girls, and small boys. The *waru* is the real performer among the masks, danced by the most imaginative of the dancers, interacting constantly with the crowd. Moving between masks and audience, they may greet oncoming strangers by running up to them to test out their knowledge of *sigi so* greetings. A good *waru* mask is essential for a good show, though it is sometimes assisted or even replaced by a monkey mask. But there is no monkey mask here at Amani and the burden falls on two *waru*, who dance quite well despite the scorching heat of the late May afternoon.

A few more masks are present too, not as popular as the others, but interesting all the same. One is the *odyogoro*, the goiter, wearing a carved headpiece with a huge protuberance under its chin. Goiters are common here, and the mask draws gusts of laughter from the crowd as it prances around, hacking away with an adze in midair, unable to bend down to the ground. More laughs are drawn by the *pulo* mask, representing a Fulani man with his horse. Several types of the *pulo* are possible; this one is a quite simple plaited hood of *bèdyè* type, and the focus is on the stick horse that he almost manages to fall off while dancing. At the end of the long row, an elder carries the *agamagâ*. Ritually the most important mask of all, it represents the first mask, and is never worn, just carried around. When the dance is over, it will be brought back to the village. After the first round of dancing, the masks all crouch near the *dani* and the altar to be thanked and blessed by the village speaker (fig. 9).

At dusk, the masks end their per-

formance. All have been on stage several times now, and both dancers and drummers have grown tired. One tree mask wants to continue after the leading drummer has already stopped. "You are tired, you know," shouts the drummer; the mask, who never speaks, denies it, shaking his head, but has to stop anyway. It is the end of the day. Slowly the masks mount into the village, an occasional drum beating.

Second Entry: Descent from the Plains
Before sunrise the next morning— May 16, 1989—all the neophytes gather at the foot of the cliff to hear the oldest man of the village pronounce his blessings over them. Crouching under the overhang of a huge boulder, clothed only in white Dogon shorts, they intersperse his long well-wishings and admonitions in *sigi so* with occasional mask cries, the high-pitched "hé, hé, hé" that is the only sound masks may utter. When the old man is finished they eat and dress for dancing, in long indigo trousers, necklaces and other jewelry, cotton bands for tying on the mask, and the tobacco-tinted cap each wears under the headpiece. In their hands they carry swords or horsetails. The rest of the morning is spent in what the dancers themselves consider a high point of the festival, a dancing contest without the mask disguises. Guided by the elders, they circle the largest *tei* (public square) of the village three times, then crouch in a large circle. An elder gives a long public praise, with wise, frequently modest remarks ("Pardon, pardon, you are the ones who do the work"). Often the young men rise up, shout their mask cry, wave their horsetails, then settle down again. The rest of the morning is spent in the various dancing grounds of the wards, the young men taking turns in the various mask dances, to the delight of the villagers, to decide who is the best dancer. At noon the drums are silenced, the dancers drink their inevitable beer, and the crowd disperses, having come to a general consensus as to who is now the top

dancer of the village.

This day is called *manugosugo*, "descent from the plains," and the afternoon program is definitely the highlight of the festival. The sequence of dances is similar to the last series of the day before, but with one large difference: today people from the neighboring villages will be present. Beer and water have been brought to the dunes, where, in the early afternoon, the men join their younger brothers, who have guarded their masks and belongings.

In the neighbouring villages of Tireli and Yaye, people prepare themselves for their part in the proceedings. Women finish brewing beer, men don their finest clothes, and late in the afternoon they set out toward Amani. Reaching the village, the women disperse to present the beer to their own and their husbands' friends, while the men fan into the dunes, where the dancers are busy clothing themselves. The scree is already in the shadow of the cliff when the first drums start calling the masks. First the *tingetange* start moving, walking at ease toward Buguru, with their masks at the back of their heads, their faces bared, while young brothers amble alongside them carrying

their stilts. Accompanied by drums, the main body of masks then sets out in one group. Their northeastern flank is shielded by the men from Yaye, while at their southwest side the men from Tireli form an accompanying file. The rationale of this arrangement is indeed protection: the two neighboring villages shield the masks from the envying stares of villages farther away, so that, informants state, no foreigners can assess Amani's strength.[3]

The whole troupe—two *bèdyè*, four "girls," two *modibo*, five trees, and twenty-two *kanaga*—move as a body; nobody may interrupt their procession, nor cross their lines. Only a *waru* walks outside the group, chasing away outsiders (fig. 10). Now the masks are all fully "clothed," their adornment complete and their headpieces in place. This is the last and the greatest arrival of the masks, and it is done in style. No one discusses the trail, or argues about priorities; everything has been settled by this time. Led by the elders, flanked by the neighbors, and admired by the visitors from other villages, the forty-five masks dance their way into the area round the altar and the *dani*, drums and bells accompanying them. Again the stilts are the first to per-

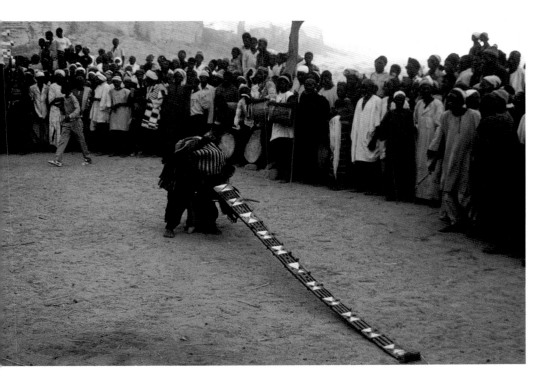

Fig. 8. A *sagatara*, a "strong young man," performing with a "tree" or "big house" mask. The headpiece, made of planks of light wood lashed together, is not particularly intricate to carve, but is hard to construct. Like all wooden masks, it is maneuvered with an interior grip for the teeth. Long, heavy, and cumbersome, it requires a strong neck and a solid jaw: the dancer must swing the headpiece to and fro in sweeping circles, offering the *sagatara* a chance to show themselves off. As all the men are readily recognized, the solo performance of a tree mask puts the dancer at the center of attention. The mask's other name, "big house," refers to the clan houses that form the center of the Dogon villages.

form, nine of them today. Like a flock of gigantic waterbirds they come stepping from the low building where they have tied on their stilts, rattling their boxes and waving their wands. Afterward, since they will perform several times today, they rest against a tree near the grounds, watching the next section dance. As before, the *kanaga* dominate, and all of them have to perform. The one *waru* is very busy, roaming the perimeter of the dance to keep women and children, noninitiates, at a distance. A throng of male spectators circles the ground, about half of them from other villages. This is when Amani is judged as a whole for its mask performance. Up to now, the strangers from other villages have not been overly impressed with the dancing and the organization, but today it is for real. The *dama* is "complete" now, fully clothed and adorned, fully danced. From faraway rooftops in the village, the women and girls follow the performance. Small boys creep through the spectators, to be chased away by the very active *waru*. The elders and the *orubaru*, the officiator from another Dogon ritual, the *sigi*, continually shout in *sigi so*, beating their sticks on the ground to stimulate and honor the dancing.

At dusk the dancing halts, the drums are silenced, and the masks and spectators repair to the village. At the deserted dancing ground the old men who are in charge of the masks engage in the *dalewa lagu*, the first of the two farewell rites of the *dama*. All of their predecessors, the men who presided over the last *dama* thirteen years ago, have owned a special personal stool, the *sigi dalewa*, associated with the *sigi* ritual. Carrying the stools of these men, each of the living elders, in strict order of age, calls upon one deceased, saying, "This is the end now, it is finished with you here, be gentle and have peace." With a powerful blow he shatters first the stool, then a chicken on the altar. Leaving the dead chickens there, the men gather the fragments

of the stools and throw them away in one of the deep crevasses of the scree, abandoned and never referred to again. Before leaving the grounds, each of the old men touches the *dani* with his right hand, calling out the name of one of the dead predecessors, and then one of them uproots the pole and puts it back in the cavern in the village, where all the *dani* are kept.

The Public Performances
The next morning is the day of *yenu kèdyè*, "meeting the foreigners," the start of the truly public dances. From the early morning of May 17 on, the masks dance at the various *tei* of the village, the dancing squares on the scree. Throughout the day they visit the compounds of the men who have died since the last *dama*, and greet the dead by dancing on their roofs; afterward the dancers are honored with huge quantities of beer. Then they dress again, unite in groups of six to a dozen, and perform again at the *tei*. In the afternoon, when all the dead have been greeted, the masks converge upon the central *tei*, where the whole village and numerous guests await their arrival. Accompanied by drums and bells, group after group performs, the same dances as always.

Toward five, many of the guests from the other villages gather at the compounds of their Amani friends, especially those whose mothers have come from one of the neighboring villages. For the guests, this finishes the proceedings of the day, but for the people most closely involved in the *dama* one important ritual awaits: the *gèû budyu*, "pour the black." At the central *tei*, relatives of all the men who have died since the last *dama* gather, each with two small jars of beer and two tiny empty cups. As one of the leading elders pours beer into each cup, he also pours a good part on the ground as a libation: "This is for you, this is for you, it is finished now." The rest of the beer is poured into a large jar, an action called "gathering the huts," and all present—only males of the village

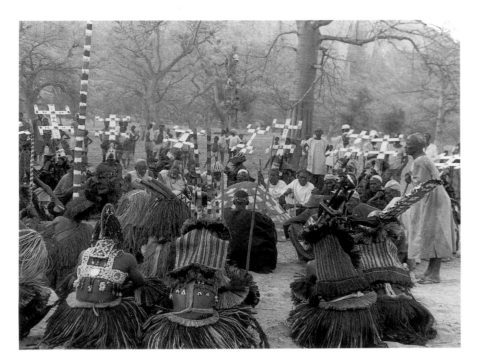

Fig. 9. The masks are thanked and blessed by the village speaker. After their performance at the first great entry, they gather at the dancing-ground altar, crouching to receive their praise. Yédyè, the ritual speaker of Amani, addresses them in a long invocation, spoken at full voice: "God, thank you, it all depends on you. This is not a thing of ourselves, but a thing of old, a thing found. You have danced well, this we could not do, it is the force of the village that could dance. May God bless you, give you many children." At intervals, the dancers stand up, wave their horsetails, and shout the mask cry: "Hé hé hé." The speech is made long by many repetitions, as ritual speech should be, and is entirely in *sigi so*, the ritual language of the Dogon.

—quietly drink it. People from neighboring villages are definitely excluded from this part of the ritual. Thus all the deceased have been told their farewell, and the second funeral as such is over.

During the next day, May 18, 1989, the masks draw the largest crowds of the whole festival, for once all the major rituals are over, women as well as men from other villages are free to enter the village of the masks. Gradually throughout the day, thousands of people gather in the immediate vicinity of the large *tei*, where from the late morning the masks have performed in small groups. All the rocks and roofs are crammed with well-dressed people, eager to watch the final dance. The women have come closer now, just a few rooftops away, while the young children sneak through the throngs of spectators to catch a close glimpse. Yet the ever attentive *waru* mask continues to chase them away. When the shadows of the cliff arrive at the dancing square, the delegation from the neighboring village of Tireli arrives with their hourglass drums and dancers and one mask, ushered in by one of the masks of Amani. The Tireli men dance into the square, some of them joining the musicians on drums and bells. When they are finished, the Amani

speaker thanks them in *sigi so* for supporting the *dama*. After the polite reply from the Tireli delegation, Yédyè invites the guests to beer. They all sit down and drink, as described in the introduction.

During the following days the *dama* tapers down. A few masks with drummers visit the outlying parts of the village, and later walk all the way to a village in the plains, settled also by descendants of Amani. Before they leave the old men gather at the *tei* and sing some of the mask songs, ending the *dama*, as the ritual is now transferred to other villages.[4]

Things from the Bush: Toward an Interpretation of the *Dama*

Dogon mask rituals can be approached in many ways, but a crucial element is the relation between men and women. Throughout the mask festival, as we have seen, expressions of male superiority abound—in speech ("Hit the women"), in the behavior of the masks, and in the symbolism of the mask outfits and paraphernalia. Of obvious significance are the sticks the masks carry when entering the village: short sticks with rounded tops, to be used for beating women. And the central taboo of the masks concerns women: women may not

Fig. 10. The line of *kanaga* arrives at the dancing ground, flanked by a *waru*, the antelope, who clears their path by chasing away uninitiated spectators—young children and women. The *kanaga* are the first to emerge from the bush, their height making them visible from a good distance away. The part of the *dama* shown here, the descent from the plains, is the second great entry of the masks. The village is visited by the bush in its full splendor and diversity, the source of power and wisdom, health and fertility. This is a spectacle for the living as well as for the dead. Not only is the village reinvigorated with power, but the deceased are integrated with the bush, their ultimate destination.

come into close contact with any part of the mask, whether headpiece, paraphernalia, or especially the red fibers. Women are not supposed to know that the masks are costumed men; though of course they are perfectly aware, not only that men are inside the masks, but also who the men are. Women are not supposed to comprehend the mask language of *sigi so*; though of course they do, and women who are "sisters of the mask" understand the language without receiving any special instruction (see fig. 1 for such a *yasigine*). The myth of the masks' origin (see also Griaule 1938) describes a balance between men and women. In that tale, the masks —which came from the *yènèû*, the bush spirits—were first found by a woman, who donned this new outfit

and terrified her husband. After some time an old woman told him where the mask could be found. Then he made himself into a mask and used it to dominate his wife, and since that time, men wear the masks, and use them to control women. This is evident outside the context of the *dama* proper, in the corrective ritual called the *puro* (van Beek and Banga 1990), where the collective errors of wayward women are "punished" by a great show of anger from the masks.

The balancing male taboo is against menstrual blood and menstruation as such, and, in a more general way, against any show of female genitalia. A relationship has often been posited between the red fibers and menstrual blood, and though that connection could not be verified in

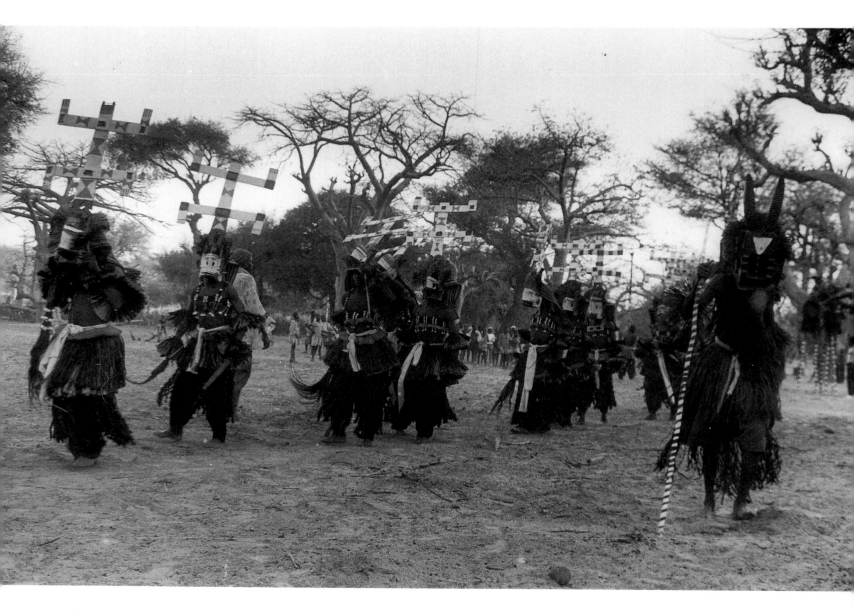

the field, it may nevertheless reflect Dogon thinking. And whether one makes this association or not, the masks themselves, with their headpieces, fibers, and paraphernalia, show a trend toward the female gender: pointed breasts, skirts, maybe the red color, and jewelry all point toward a feminization of the men. By no means does this happen only in the mask festival. In the yearly ritual held just before the rainy season, the *buro*, the young men deck themselves out in female jewelry, and plait their hair as young girls do. The same thing can be seen in the *sigi* festival (Dieterlen and Rouche 1971), where a feminization of performing males is again evident. The *sigi*, described in detail in Griaule (1938), is as male centered as any of the mask rituals, and should be considered in conjunction with them.

When we consider the intent of the rituals, the meaning of male feminization becomes clear: in their intended effects, both *sigi* and *dama* address fertility. After a *dama*, crops should be abundant, whereas the *sigi* should lead to numerous offspring, guaranteeing a splendid new generation. In both instances the women are absent, and the men do the performing. In both instances the disguised or ornamented collectivity of men suffices to guarantee fertility, be it agricultural or human. Combined with the male taboos against menstruation and menstrual blood (the cessation of female fertility), the host of medicines to cure overdue menses (van Beek 1990), and the shame men experience when confronted with blatant female sexuality, this suggests that the whole mask and *sigi* complex may be seen as a male appropriation of fertility, in which the role of women is ritually marginalized, and men, by transforming themselves, become self-sufficient in procreation. In the masks, men claim to control the sources of fertility, of power, of life.

The question then arises as to whence the men derive their powers. The answer, I would argue, is that power comes from the bush;

the masks represent the bush coming into the village. For the Dogon the category *oru*, the bush, contrasts sharply with *ana*, the village. The notion of *oru* bears very complex connotations. On the one hand the bush is dangerous: no one will ever venture to sleep in it, without the protection of huts or people. Several types of spirits roam the bush and may attack people or exchange body parts with them. One often-voiced fear is that spirits will exchange eyes with humans and render them blind. On the other hand, from the *oru* stem all wisdom, knowledge, power, and life. The bush is the *fons et origo* of everything that makes life possible. The animals of the bush, for example, have a perfect awareness of what humans are up to, of their intentions, mistakes, transgressions, and frailties, and know what the future holds for humans (van Beek and Banga 1990). And according to the founding myths of the mask and *sigi* complex, these rituals originated with the spirits of the bush and its animals: the masks began as a gift from the *yènèû* to the *kei*, the black ants, who were the first to dance in masks. From them, the masks were stolen by a bird, who dropped them near a human settlement in Yougo, where a woman found them.

The masks, then, are essentially bush things, representing the power and the wisdom of the bush. The most important rituals in the *dama*, as we have seen, are usually the coming of the masks, their arrival at the village from the bush. Starting out first from the "east," i.e., from the direction of Yougo, where the masks originated, the masks arrive "naked," clothed only in untinted fibers. Later they arrive in their complete outfit, this time from the plains, from the bush, where the spirits dwell. And at the end of the festival they leave toward the "west" for the next village, and finally for the bush again, back to the place of origin. So knowledge of the masks is transferred from village to village, in an "east-west" direction, while the masks them-

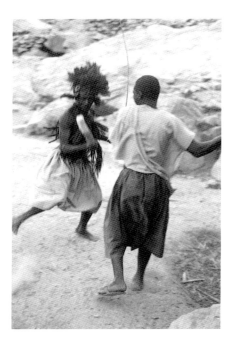

Fig. 11. Alei Pudyugo accosted by a mask, which may punish people for perceived transgressions. As a Christian, Alei Pudyugo declined to participate in the Amani *dama*. Other men of his age, however, some of them also Christians, did dress as masks, wearing at first just a few fibers and a *bèdyè* mask on the tops of their heads. When a group of them came across Alei Pudyugo one evening, they went for him. Brandishing their sticks and lashes, they silently danced before him, whipping at him, separating him from the others, cornering him. They never said a word nor uttered a sound, even when Alei addressed them in *sigi so*. Only when he took up a stick and danced with them did they relent. But silence reigned throughout: masks do not speak, even if barely disguised.

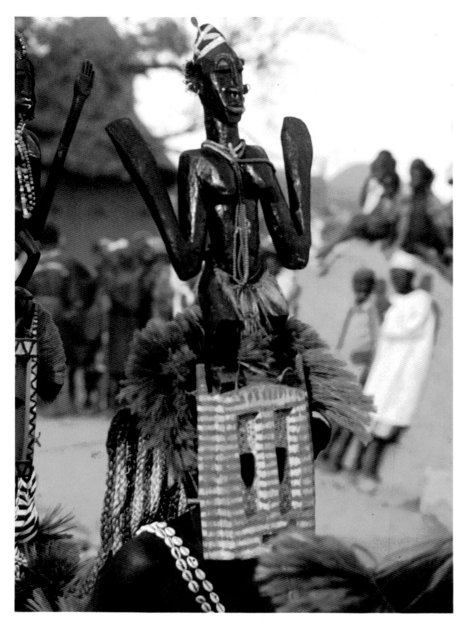

selves in their completeness come and go between village and the bush, i.e., "north-south."

One central argument for this interpretation is language. First of all, the masks do not speak: they only shout a meaningless, high-pitched cry. Even when the wearer of the fibers is unadorned, he is forbidden to speak (fig. 11). The importance of the spoken word is central in the Dogon definition of a human being (Calame-Griaule 1965); speaking is human, silence is bush. Whoever can speak Dogon is Dogon (van Beek 1983). Characteristically, the masks are never addressed or exhorted in Dogon; they are spoken to only in *sigi so*. Some specific features of the ritual language are revealing. As a derivative language, *sigi so* has a 20 percent overlap with Dogon, and a simple syntax (Leiris 1948). More important, it never appears in a two-way communication. It is used to recite long texts, and to exhort or to greet masks; never is any answer given to the quite standardized expressions. And *sigi so* is actually seldom spoken, but nearly always shouted, at the top of the voice, even when the recipient mask is quite close. In essence, *sigi so* implies a form of linguistic noncommunication. When the masks are addressed, they are spoken to as people speak to animals, without expecting any response, and shouting as if at a distance. Besides, the founding myth of *sigi so* explicitly states that the language derives from the bush, from the *dyinu*, the bush spirits, who taught the first *sigi* initiate.

So masks enact the bush endowing the village with power and fertility. Incorporating the power of the bush, the men try to guarantee life for the village, rejecting the women as such but embracing their symbolic identity, in dress and adornment as well as in masks. Thus the "great woman" mask (*èmna sadimbe*) may be viewed as a metaphor of the *dama*, a man disguised as the woman who first danced the mask (fig. 12). The situation is fraught with dialectics: as a male

Fig. 12. The *sadimbe* or "great woman" points back to the masks' origin. According to the myth, the masks were created by the bush spirits, given to the *kei*, the black ants, then stolen by the buzzard, to be found finally by a woman in Yougo, a village at the cliff. The woman dressed in the mask and scared her husband, who did not realize that the mask was his wife in disguise. After an old woman told him where to find the costume, however, he donned it himself and scared his wife. Since then, men use the masks. The *sadimbe* mask depicts this first woman, dressed and adorned as one of the *yasigine*—the sisters of the masks, a group of women, all born during the *sigi* ritual, who perform some tasks in the mask festival, such as giving the masks beer and water in their hideout in the bush.

means to appropriate fertility, the masks are a threat to actual female fertility; touching a mask may render a woman sterile. Male ritual power, thus, is as ambivalent as the bush itself, powerful but also dangerous, at the same time guaranteeing and threatening the continued existence of the village. This dialectic is highlighted by the fact that this male empowerment is part of a death ritual, a farewell from the old men, a theater for the deceased. Male ritual fertility is associated with death as well as with life.

If masks are "things coming from the bush," what then do the individual masks represent? Two central Dogon ritual masks, the *bèdyè* and the *adyagai*, the "red thing," represent the bush as such: they are simple hoods, unornamented but for two, four, six, or more eyes. Informants agree on the fact that the earliest "original" masks that came from Yougo are these plaited hoods. *Bèdyè* means pupil, while *adyagai* is the name of a red stinging insect that descends on the millet (fig. 13). Both masks are the epitome of "things from the bush," unrecognizable, knowing and seeing, dangerous and powerful. In the same league, in their own way, are the antelope, the monkey, and the one mask that depicts elements from the mask myths, the *sadimbe*, the woman who originally found the masks.

A large category of masks represents bush animals: buffalo, antelope, waterbird (stilts), hare, hyena, leopard, elephant. The *kanaga* too are probably storks, though this original symbolism has been somewhat lost. Perhaps the long tree mask is of the same category, though it is harder to interpret; the explanation of "two-story house" is often given as well. Finally, there are human beings more or less associated with the bush, like the hunter. In Dogon culture, hunting is a bridge between the bush and the village, and the hunter is someone from the bush. His mask vividly expresses this attitude: a fierce countenance, with large protruding teeth and a

bulging forehead (fig. 14), reshapes the figure into a nondomesticated human (Pern, Alexander, and van Beek 1982:120, Griaule 1938:318). Other masks of this type stress the relationships between bush and village. One of them is the *binugèdyu*, the shaman, another intermediary between the two, and between men and spirits. The mask of the *dyodyongunu*, the healer,[5] has similar features: human and more than human, carrying four figurines on his head. He too is an intermediary, since health is thought to stem from the bush. Also important in this respect are the masks of women, like the Dogon or the Bambara girls. Though of course very human, they represent primarily unmarried women, and as such depict a segment of Dogon life somewhat associated with the bush. For though the contrast between men and women and that between village and bush does not run wholly parallel, there is some association of women with the bush and of men with the village.

The *Dama* in Change

As a core ritual for the Dogon, the *dama* reflects the changes that bear upon the society. Timing is one of these. The *dama* is held much later in the season than formerly; the intensification of dry-season cultivation has seen to that. Whereas formerly the *dama* was held in the cooler, drier months of January or February, now late April is normal for the start. This is the time of the *buro*, the yearly ritual marking the onset of the rains and cultivation, and the danger of rain falling on the masks—a very strict taboo— adds to the elders' worries. Timing has changed in other ways as well. The young men of today often have to return from far away to participate in the masquerade. The Dogon have known migration of labor for at least two generations. But the scale is different now. It has become an established phase in the life of Dogon youth to get out, earn money, and come back. The youngsters being initiated tend to be older nowadays.

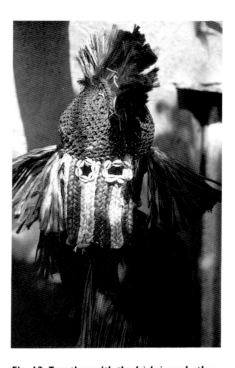

Fig. 13. Together with the *bèdyè* mask, the *adyagai* is at the same time one of the simplest and most central masks of the Dogon. In an unspecified way, it represents the essential bush, for though the name *adyagai* refers to a stinging red bush insect, it is clear that the mask's reference is much wider: the bush as such. Whenever a single mask performs in a ritual, it is an *adyagai*. At the first funeral of an old man, for instance, this mask dances on his roof, and takes a brass ring serving as a personal "altar" into the bush. When the dancing pole was planted in the Amani *dama*, an *adyagai* danced around it first, sounding a bull-roarer, and when the trail to all the ritual places had to be established for the remainder of the masks, an *adyagai* scouted it. The mask's main features are its many eyes, symbols of knowledge and power, and a central aspect of all masks.

The masks too have changed, and the festival with them. Comparing the older data (Griaule 1938) and informants' statements about the past with present-day mask performances, one sees new masks joining the troupe, and old types, like the elephant mask, dropping out as people lose interest in them. But most masks survive. Dogon masks form an open system with a historic accumulation: new masks come in, some masks are marginalized, but most of the old ones remain. Consequently, beyond the bush symbolism, new ways of interpreting the world emerge in the masks, including political ideas, and the expression of individuality.

During the last century the Dogon have been increasingly drawn into a wider world, and have invariably found themselves at the bottom of the political scale. The new power-holders have been depicted in masks, but differently from the bush: not as all-wise sources of fertility, but as all-too-human aliens of strange appearance and weird behavior. Masks of Fulani women, Mossi horsemen, or a Sawo warrior are examples of this. The threat of these characters is no longer vague and spiritual but concrete and physical. As their power brings nothing of real value, their political dominance can be offset by subjecting them to ridicule. These powerful outsiders are the laughing stock of the Dogon spectators: the Fulani woman hops around the square in her dance, trying to sweep up cattle droppings, while her husband may fall off his wooden horse.

In a similar vein, two more recent types of masks represent strangers coming in from abroad. The first one is the *modibo*, the learned Muslim. The second is the *anyara*, the white man, the European, of which we note three variations. The mask is always clothed in trousers and a shirt, and the head is covered by a huge wooden mask painted a fiery red, with long wavy hair, a wild bristling beard, and a hooked nose. In the first variant, in Griaule's days, a colonial officer was imitated,

writing small bills for the audience, and saluting when he received his "taxes." Now the tourist is imitated; the same mask operates with a wooden "camera," forcing his way through the crowds in order to get a good shot. Especially interesting is the Sanga variation (Griaule 1938: 583), where the white person sits on a chair as two Dogon sit on the floor. Waving a notebook, the "European" asks the silliest questions: the mask of the anthropologist! (figs. 15 and 16). Although the power relation is absent, the same kind of ridicule holds for the *odyogoro*, the mask with a huge wooden goiter who mimics the difficulties a goiter sufferer has in cultivating crops.

Performance, the quality of dancing, weighs especially heavily with this kind of mask. More than the others, these masks are spectator oriented and interact with the audience. The enrichment of the spectacle of the *dama* has probably heightened competition among the dancers; Dogon daily life offers few arenas for individual excellence, which in any event is mistrusted in Dogon culture. The *dama* is a venue for (limited) social prestige, and a tendency to lessen the anonymity of the masks has emerged in it: today's *kanaga* may bear the written name of its owner. In this regard, of course, schooling makes itself felt as well, as it stimulates both individual expression and writing. The fact that the dancers tend to be older today also has an effect here.

Tourism, another factor in Dogon country, has led to a proliferation of masks. The number of masks per person has increased dramatically, with each dancer making at least two or three headpieces beyond the *bèdyè* to sell to tourists. In principle, this does not present a problem, as masks have always been discarded after their use in the *dama* for which they are made. Old masks have significance not for the Dogon but for art dealers. The village has to retain enough masks to dance at funerals, however. More masks are also made as tourists demand more mask performances.

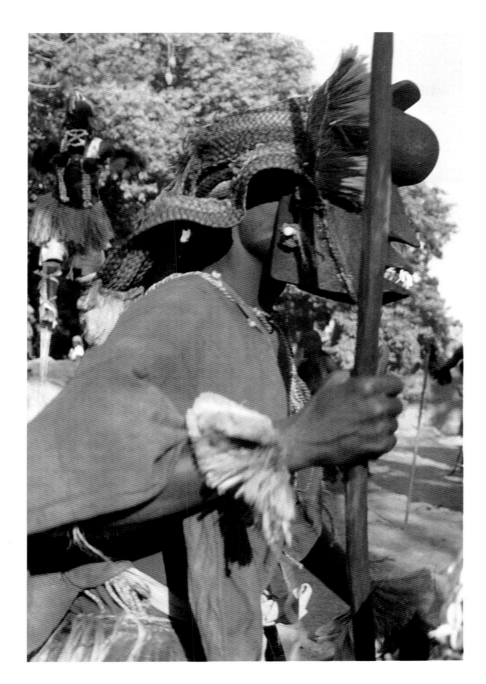

Fig. 14. A "hunter" mask, *èmna dana*, portraying the fierce bushman any successful hunter must be. For the Dogon, hunting is essentially a magical skill. Game animals, as part of the powerful bush, cannot be hunted by a "simple person" without magic, as they would know everything about their pursuer. The game must be overpowered by magical means. Thus a hunter has to be both a magician and a "bushy" person: a character between bush and village, an intermediary between power and man. The fierceness of his countenance, with its bulging forehead and protruding teeth, reflects just that. The dance of this mask often involves a challenge between the hunter mask and an old hunter from the audience. Both go through the same paces, the old man mimicking any move of the mask.

New masks also emerge, quite rapidly, with an eye for sales. In the Amani *dama* two of them surfaced, a mask of a sheep and one of a door. One had the impression that some Bambara masks may have influenced the maker of the sheep mask, who happens to have worked in Abidjan as well as in Bamako. The door mask was quite traditional in its figuration—a straightforward plank with a number of stylized figurines— but the colors were not traditional at all. In this change, the masks have come almost full circle: from the bush, they have "come home," depicting domestic things,[6] a change one might call

their "domestication."

On the other hand, the performance of mask dances for tourists, as done in Sanga and several surrounding villages, strengthens the importance of performance, the men taking pride in a really good dance (Lane 1988). These tourist performances recreate the conditions of the public dances in the third phase of the *dama*. Their frequency in and around Sanga has brought some cognitive dissociation between the *dama* as a ritual and as a performance for outsiders; the dancers speak about them as two quite distinct events. Tourism, however, has definitely boosted Dogon pride in

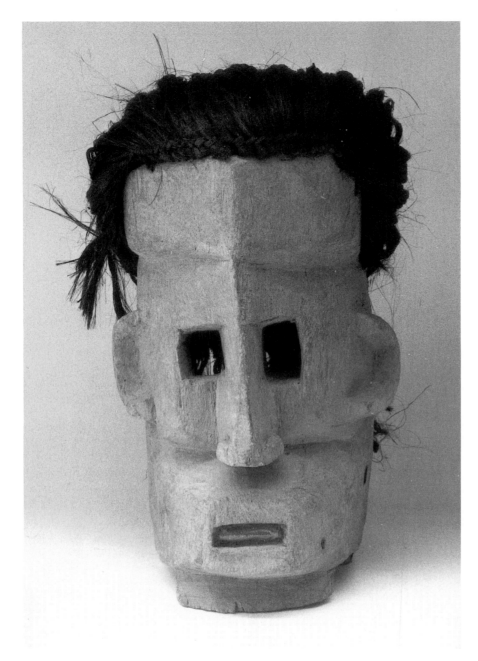

their masks, both as artifacts and as performance.

Religion, of course, is a crucial factor. The roots of the *dama* lie in traditional Dogon religion, and consequently religious change is of prime importance to it. Both Islam and the usual variants of Christianity are well established in Dogon society. In principle, in fact, the villages away from the cliff are either Christian or Muslim. The rituals described are linked to the core area of the Dogon, the escarpment, but in these villages too, both religions have made their inroads. There, too, a growing part of the population no longer performs sacrifices (the Dogon definition of the practice of their traditional religion). Still, even in the cliff villages with a majority of Muslims, such as Sanga, the masks still dance and the *dama* is still held. When the more performative aspects of the festival are highlighted, integration with the new religion becomes less problematic.

In a way, this whole pattern of change fits in well with Dogon culture in general. The Dogon show a high level of cultural pride, and in no way consider themselves a cultural minority. They have a clear idea of the value of their own traditions, and understand the need to retain the old while embracing the new. The masks may ridicule power, albeit the human variant, in their treatment of white men, but this ritual of rebellion has a mildness that seems to stem from a high self-esteem, a gentleness that fits well into Dogon culture. A chuckle is what the holders of power deserve, and never are they truly shamed. The masks' behavior allows the people portrayed to retain some of their dignity, while the legitimacy of their power is never questioned. Shame or loss of face (*dogo*) would be much more devastating, especially in Dogon eyes (van Beek 1983), but the Dogon feel secure enough in their own culture to be content with a slightly condescending amusement. Many changes have come to the

Figs. 15 and 16. The mask of a European. A fairly new mask, the *èmna anyara* was used in the days before independence to depict colonial officers writing out tax bills and taking in money. Later, when tourism developed among the Dogon, this mask, clad in European-type trousers, came brandishing a camera, annoying everyone as he tried to get a good shot of the proceedings —the tourist. A very special third version, seen here, portrays a European sitting on a chair with two Dogon sitting on the floor next to him. The "white" man (the mask is in fact painted a fiery red) makes notes, and asks the silliest questions: the anthropologist. This one portrays the author (fig. 16).

mask festival by addition, as more new masks have emerged than old ones have disappeared, and elements of performance and ridicule have been added to fertility rites. The Dogon do have a way of fitting new elements into their existing cultural patterns: new etiological tales are joined with the traditional myths, new divination techniques supplement old ones (van Beek 1991), new material objects are joined with artisanal techniques (van Beek 1983), and new relations with outsiders are incorporated into existing social networks. Then the new elements become "traditional," meaning they are quickly considered as *tèm*, "found," and the difference between the recent innovation and the old legacy gets blurred. The old masks function at the core of the ritual alongside a growing contingent of new ones, for which the religious function is less dominant. So, adding on new elements to the masquerade, the Dogon enlarge the range of the *dama* without deleting the ritual as such. Rituals of rebellion, individual performances, and sales to outsiders notwithstanding, the masks still emerge powerful from the bush, scare the women, and endorse the men with the power over life and death, at least for one unforgettable month each dozen years.

NOTES

1. The Dogon would define this as "east." Living at the foot of the cliff, they conceive its direction as east-west; according to them, the sun rises and sets parallel to the cliff. The geographic direction is actually more northeast-southwest.

2. The roan and sable antelopes designated in the literature as *Hippoliagus equinus* or *niger* (Dieterlen 1990, Griaule 1938) are identified by my informants with the Dogon name *kaî*.

3. The same reasoning may explain why in some villages the masks dance a serpentine trail, so that an enemy cannot count them.

4. The rainy season of 1989 was very good, and the crops were abundant in the fields. At the end of September, however, a cloud of locusts descended on the Dogon area, devouring the crops that had been so assiduously danced for.

5. This is the mask identified by Dieterlen as Dyongou Serou, a presumed ancestor. As indicated elsewhere (van Beek 1991), this interpretation is not correct.

6. The *èmna na*, a mask carved in the form of a cow, in fact represents a wild buffalo, *oru na*, like *Connochaetus* or *Damascalis*.

GLOSSARY

Agamagâ	Grand mask.
Ana	Village.
Anyara	White man.
Binugèdyu	Shaman.
Buro	Rain ritual.
Dalewa lagu	"Beat the stool," farewell ritual.
Dama	Mask festival, "taboo."
Dani	Dancing pole.
Dogo	Shame or loss of face.
Dyinu	Bush spirit.
Dyodyongunu	Healer.
Èmna	Mask.
Èmna adyagai	"Red thing."
Èmna bèdyè	Pupil mask.
Èmna binu	Shaman's mask.
Èmna goû	Hare or rabbit mask.
Èmna kanaga	Stork mask.
Èmna modibo	Muslim officiant mask.
Èmna na	Bull-roarer mask.
Èmna odyogoro	Goiter mask.
Èmna pulo	Fulani mask.
Èmna sadimbe	"Sister-of-the-masks" mask.
Èmna tâ	Door mask.
Èmna tingetange	Stilts; waterbird mask.
Èmna tiû	Tree or big house mask.
Èmna waru	Antelope mask.
Gèû budyu	"Pour the black," farewell rite.
Kei	Black ants.
Manugosugo	Descent from the plains, last major entrance into the village.
Oru	Bush.
Orubaru	*Sigi* officiator.
Puro	Corrective (mask) ritual.
Sagatara	Strong young man.
Sigi	Sixty-year ritual.
Sigi dalewa	*Sigi* stool.
Sigi so	Ritual language.
Tei	Public square in the village.
Tèm	Found.
Yange èmna	Fire masks, the first part of the mask festival.
Yasigine	Sister of the masks.
Yènèû	Bush spirits.
Yenu kèdyè	"Meeting the foreigners": public mask dance.

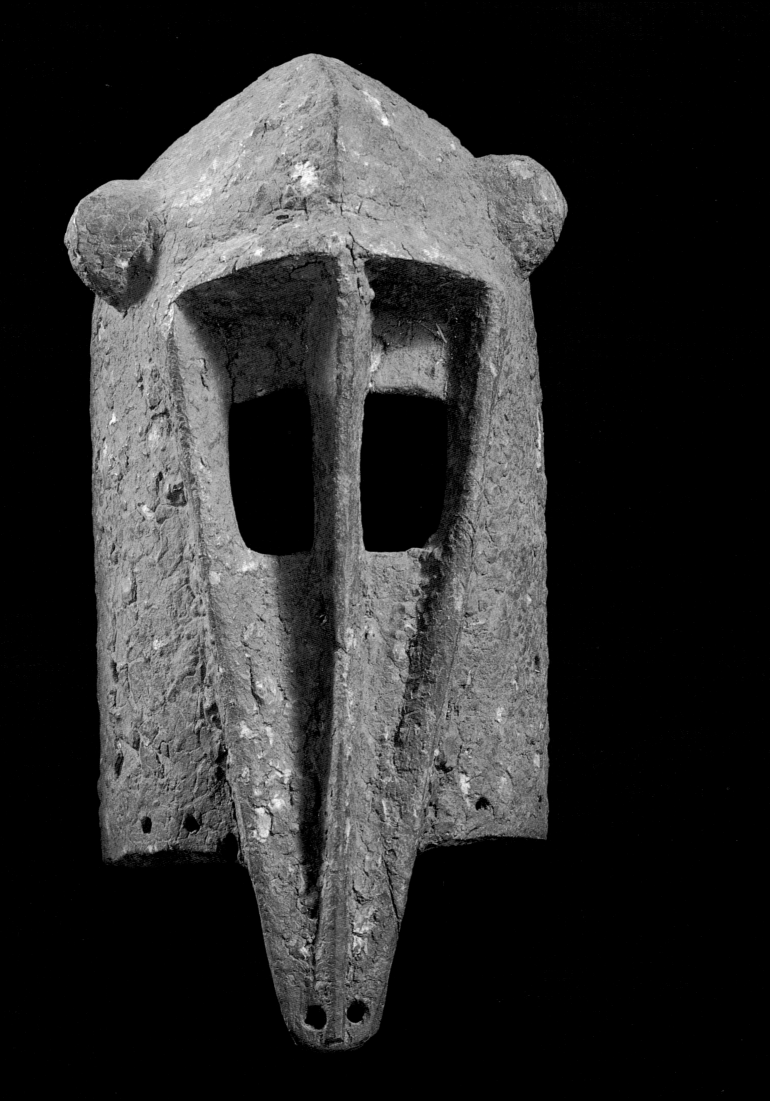

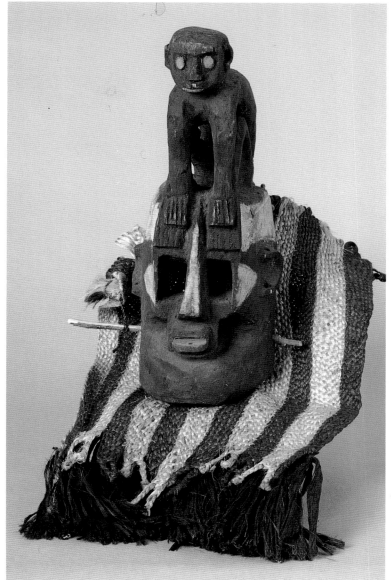

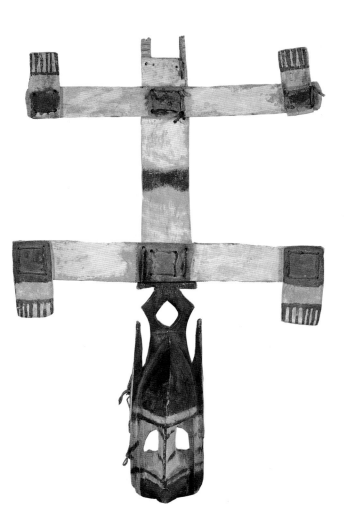

Cat. 1 MONKEY MASK, EARLY 20TH C., UNKNOWN DOGON ARTIST (MALI), WOOD, H. 33 CM. COLLECTION: MAURICE W. SHAPIRO.

Cat. 2 *KANAGA* MASK, CA. 1940S, UNKNOWN DOGON ARTIST (MALI), WOOD, H. 92.5 CM. COLLECTION: THE RENEE AND CHAIM GROSS FOUNDATION.

Cat. 3 BLACK MONKEY MASK, LATE 20TH C., UNKNOWN DOGON ARTIST (MALI), WOOD, PAINT, AND RAFFIA, H. 43 CM. COLLECTION: W. E. A. VAN BEEK.

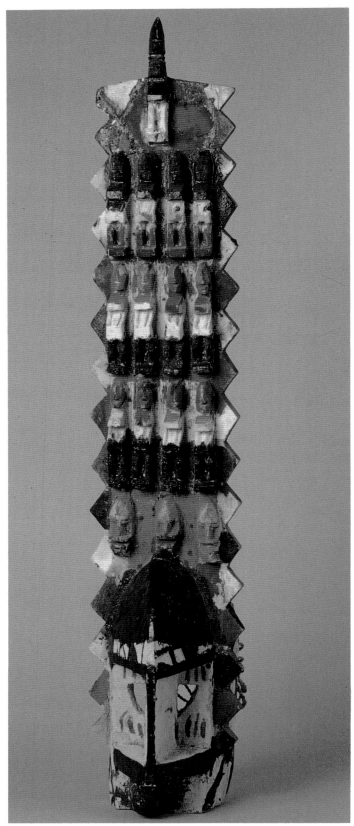

Cat. 4 MASK, MID 20TH C., UNKNOWN DOGON ARTIST (MALI),
WOOD AND PAINT, H. 414 CM. COLLECTION: THE CHASE MANHATTAN
BANK, N.A.

Cat. 5 MASK, LATE 20TH C., UNKNOWN DOGON ARTIST (MALI),
WOOD AND PAINT, H. 110 CM. COLLECTION: W. E. A. VAN BEEK.

Cat. 6 MASK, LATE 20TH C., UNKNOWN DOGON ARTIST (MALI),
WOOD AND PAINT, H. 35 CM. COLLECTION: W. E. A. VAN BEEK.

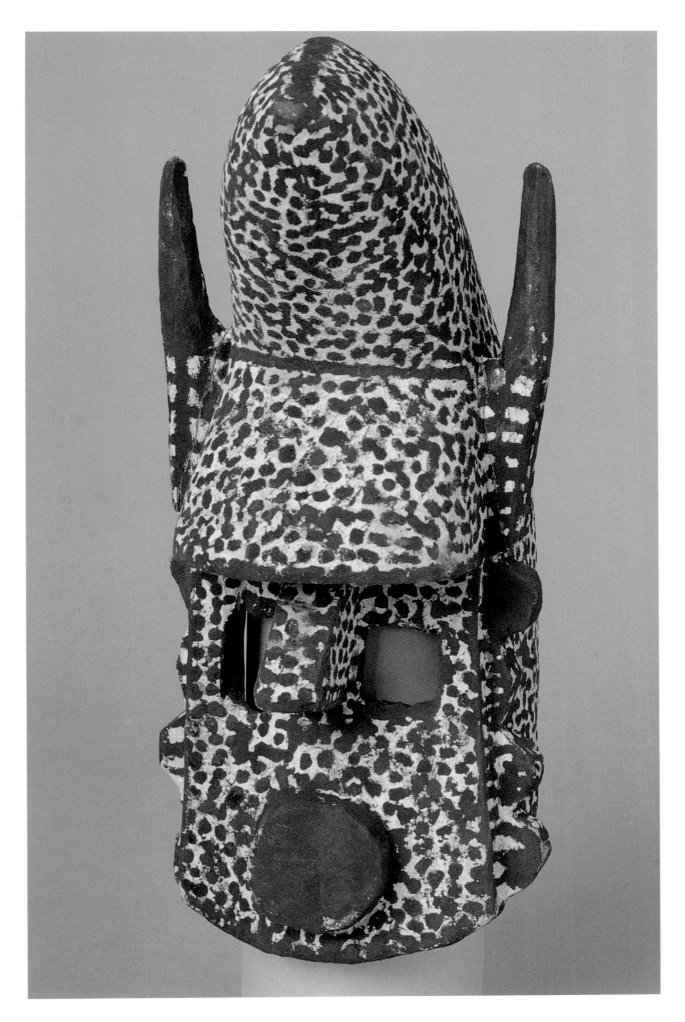

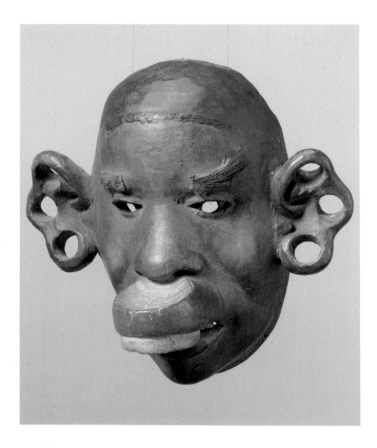

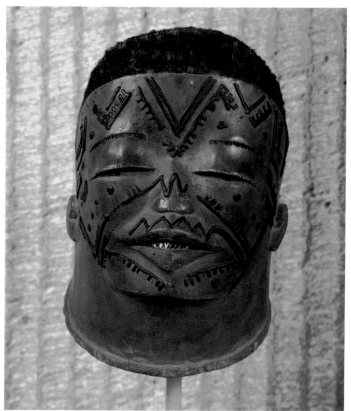

Cat. 7 **MASK,** EARLY 20TH C., UNKNOWN MAKONDE ARTIST
(TANZANIA), WOOD, FUR, HAIR, WAX, AND PIGMENT, H. 21.5 CM.
COLLECTION: THE DENVER ART MUSEUM.

Cat. 8 **MASK,** EARLY 20TH C., UNKNOWN MAKONDE ARTIST
(MOZAMBIQUE), WOOD, HAIR, WAX, AND METAL, H. 25.4 CM.
COLLECTION: DES MOINES ART CENTER. GIFT OF MR. AND MRS.
JULIAN BRODY.

Cat. 9 **MASK,** MID 20TH C., UNKNOWN MAKONDE ARTIST
(MOZAMBIQUE), WOOD, HAIR, AND PAINT, H. 30 CM. COLLECTION:
UDO HORSTMANN.

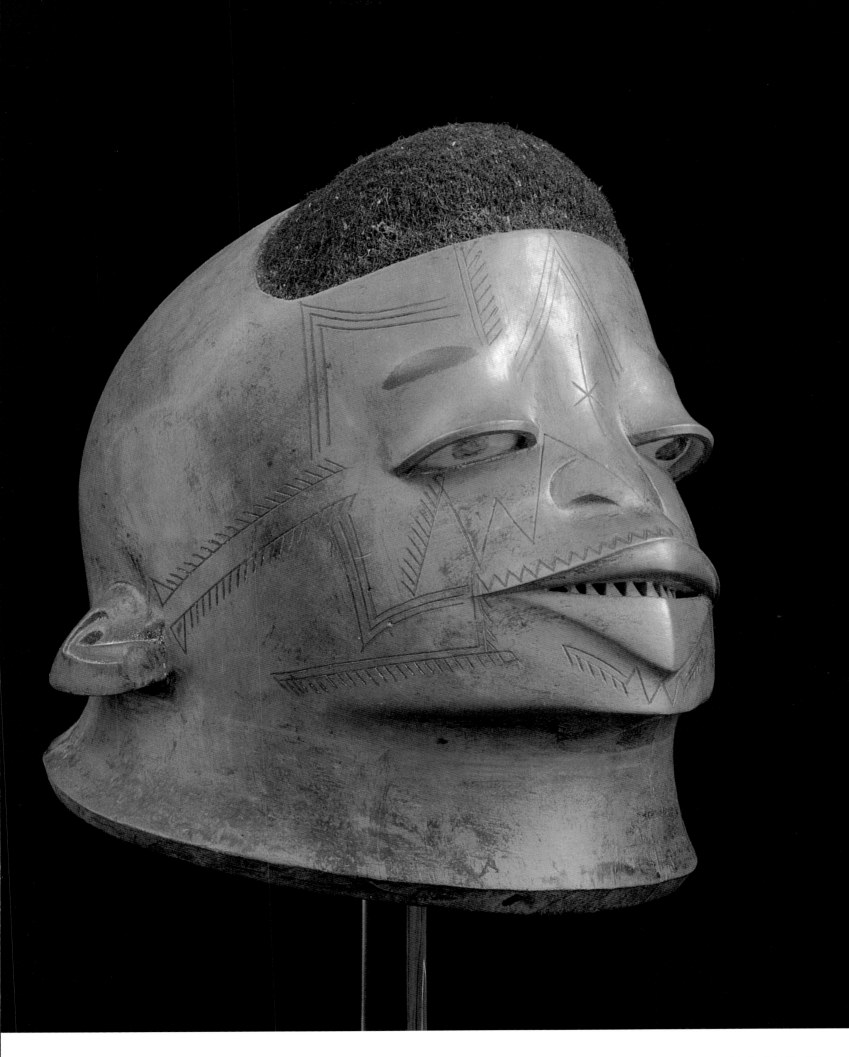

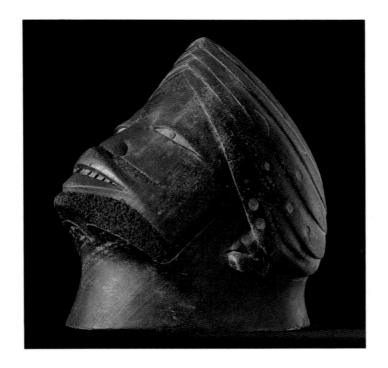

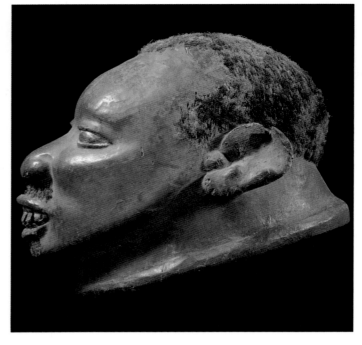

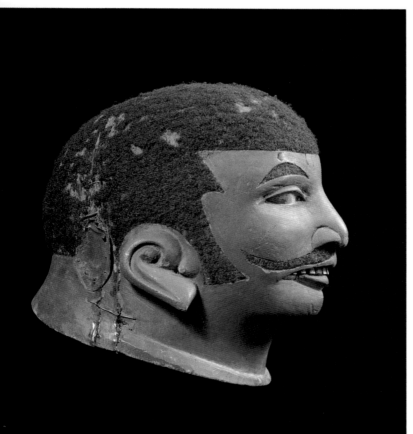

Cat. 10 MASK DEPICTING A SIKH, MID 20TH C., UNKNOWN MAKONDE ARTIST (MOZAMBIQUE), WOOD, HAIR, AND PAINT, H. 30 CM. COLLECTION: ALLAN STONE.

Cat. 11 MASK, MID 20TH C., UNKNOWN MAKONDE ARTIST (MOZAMBIQUE), WOOD, HAIR, AND PAINT, H. 30 CM. COLLECTION: ALLAN STONE.

Cat. 12 MASK DEPICTING A PORTUGUESE, LATE 20TH C., UNKNOWN MAKONDE ARTIST (MOZAMBIQUE), WOOD AND PAINT, H. 27 CM. COLLECTION: LEONARD AND JUDITH KAHAN.

Cat. 13 FEMALE DANCE HEADDRESS (NIMBA), EARLY 20TH C., UNKNOWN BAGA ARTIST (GUINEA), WOOD, H. 103 CM. COLLECTION: ERLE LORAN.

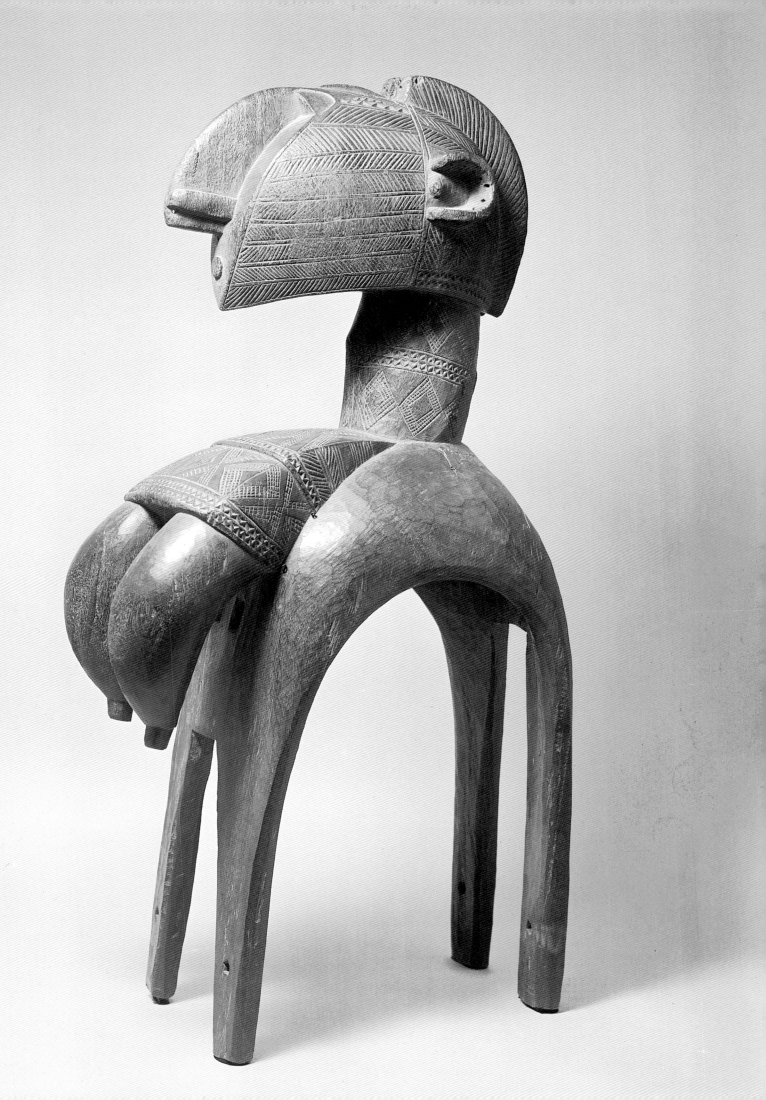

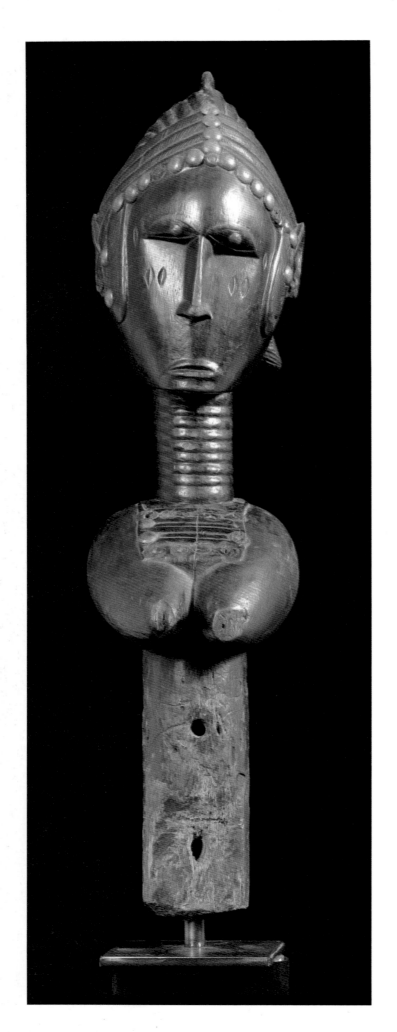

Cat. 14 FEMALE BUST HEADDRESS (THE MAIDEN SA SIRA REN), EARLY 20TH C., UNKNOWN BAGA ARTIST (GUINEA), WOOD AND METAL TACKS, H. 54.6 CM. COLLECTION: LEONARD AND JUDITH KAHAN.

Cat. 15 FEMALE BUST HEADDRESS (YOMBOFISSA), EARLY 20TH C., UNKNOWN BAGA ARTIST (GUINEA), WOOD, PAINT, AND HAIR, H. 47 CM. PRIVATE COLLECTION.

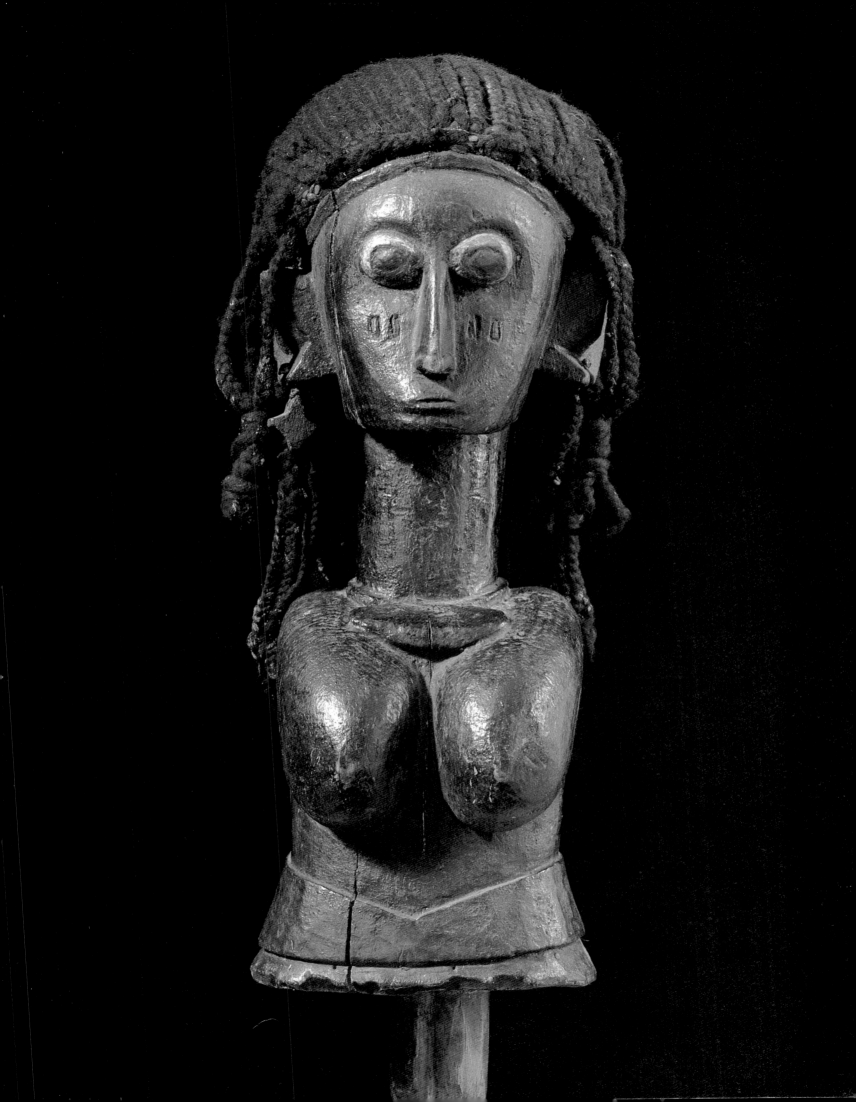

Cat. 16 WINGED FEMALE BUST HEADDRESS (TIYAMBO),
MID 20TH C., UNKNOWN BAGA ARTIST (GUINEA), WOOD AND PAINT,
H. 104 CM. PRIVATE COLLECTION.

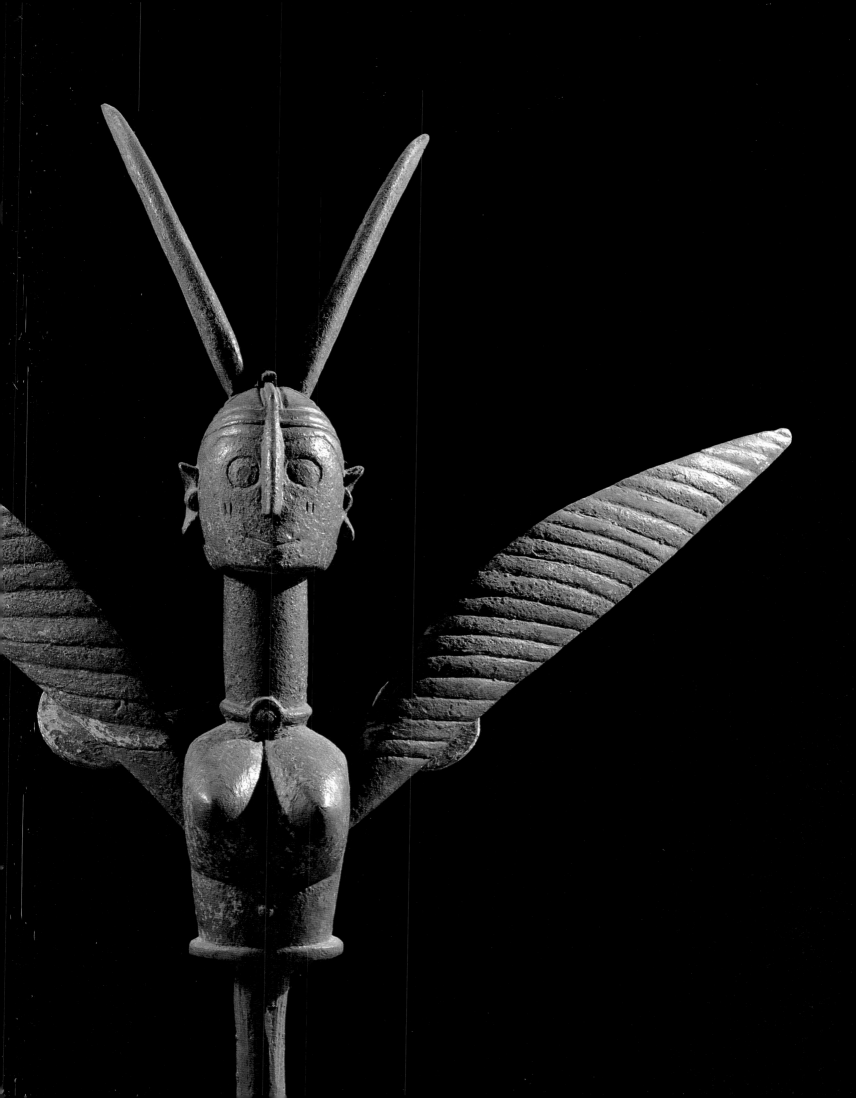

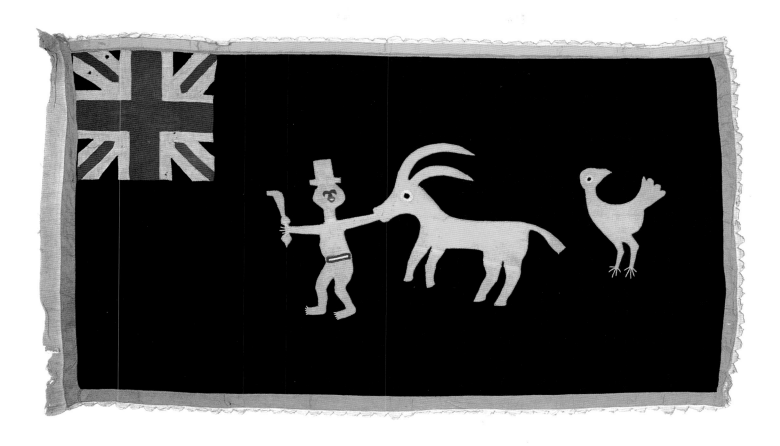

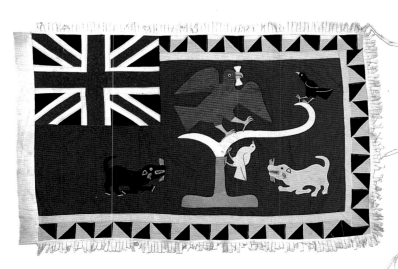

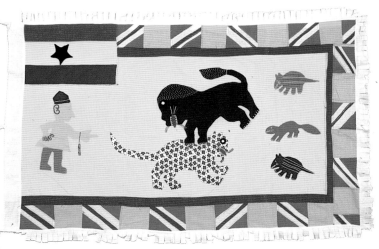

Cat. 17 AL-BARAK HEADDRESS, LATE 20TH C., BY SALU BAKI (GUINEA), WOOD AND PAINT, L. 102 CM. COLLECTION: FREDERICK LAMP.

Cat. 18 SIBONDEL HEADDRESS, MID 20TH C., UNKNOWN BAGA ARTIST (GUINEA), WOOD, PAINT, BAMBOO, AND RAFFIA, H. 71 CM. COLLECTION: FREDERICK LAMP.

Cat. 19 FLAG, 1910, BY NSEDU (FANTE, GHANA), APPLIQUÉD AND EMBROIDERED COTTON FABRIC, 94 x 107.2 CM. COLLECTION: FOWLER MUSEUM OF CULTURAL HISTORY, UCLA. GIFT OF MRS. W. THOMAS DAVIS.

Cat. 20 FLAG, 1950, BY KWEKU KAKANU (FANTE, GHANA), APPLIQUÉD AND EMBROIDERED COTTON FABRIC, 110 x 167.6 CM. COLLECTION: FOWLER MUSEUM OF CULTURAL HISTORY, UCLA. ANONYMOUS PROMISED GIFT.

Cat. 21 FLAG, 1981, BY KOJO ANOKYE (FANTE, GHANA), APPLIQUÉD AND EMBROIDERED COTTON FABRIC, 100.3 x 157.5 CM. COLLECTION: FOWLER MUSEUM OF CULTURAL HISTORY, UCLA. GIFT OF DORAN H. ROSS.

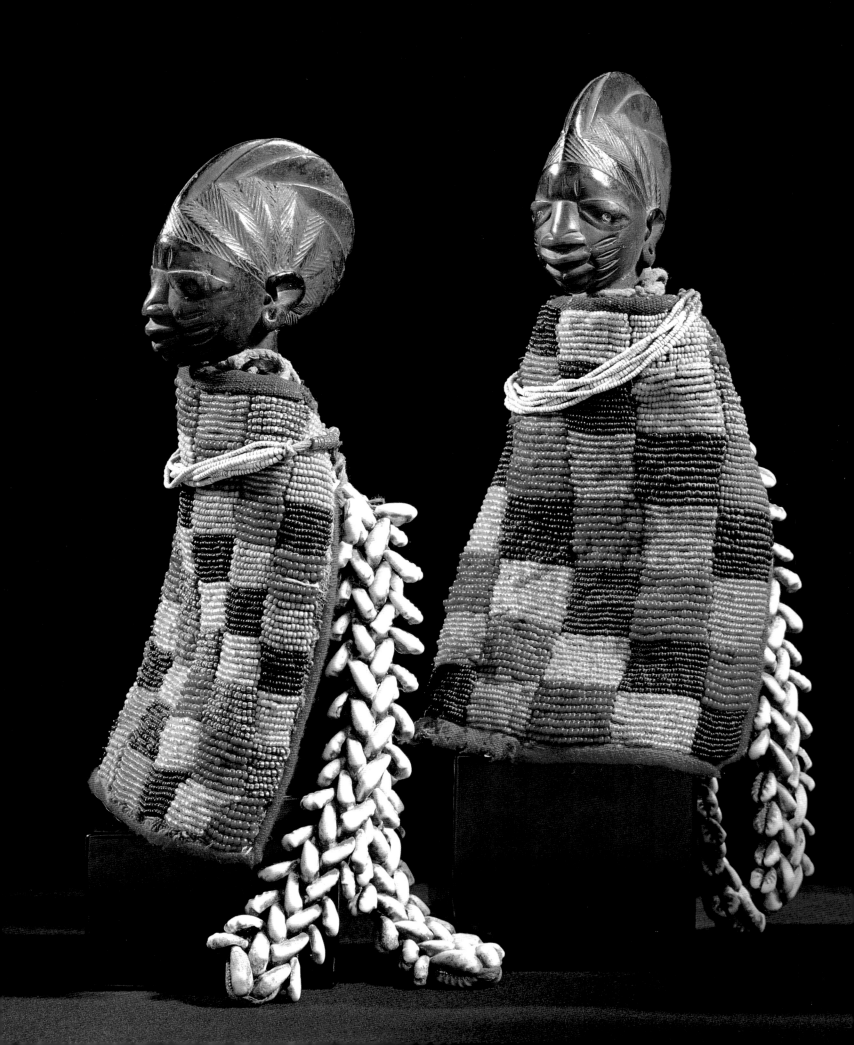

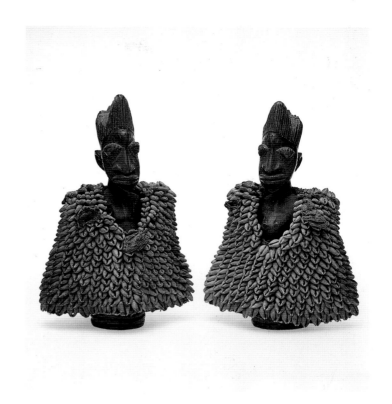

Cat. 22 *ERE IBEJI* **TWIN-CULT FIGURES,** EARLY 20TH C., UNKNOWN YORUBA ARTIST (NIGERIA), WOOD, BEADS, COWRIE SHELLS, AND CLOTH, H. 24 CM. COLLECTION: THE MNUCHIN FOUNDATION.

Cat. 23 *ERE IBEJI* **TWIN-CULT FIGURES,** EARLY 20TH C., UNKNOWN YORUBA ARTIST (NIGERIA), WOOD, COCONUT SHELL, COWRIE SHELLS, STRING, FABRIC, LEATHER, AND PIGMENT, H. 26.2 (FEMALE) AND H. 26.5 (MALE) CM. COLLECTION: FOWLER MUSEUM OF CULTURAL HISTORY, UCLA. FROM THE BARBARA JEAN JACOBY COLLECTION.

Cat. 24 **DOLLS USED AS** *ERE IBEJI*, MID 20TH C., UNKNOWN FACTORY (NIGERIA), MOLDED PLASTIC AND METAL, H. 25 CM. COLLECTION: FOWLER MUSEUM OF CULTURAL HISTORY, UCLA.

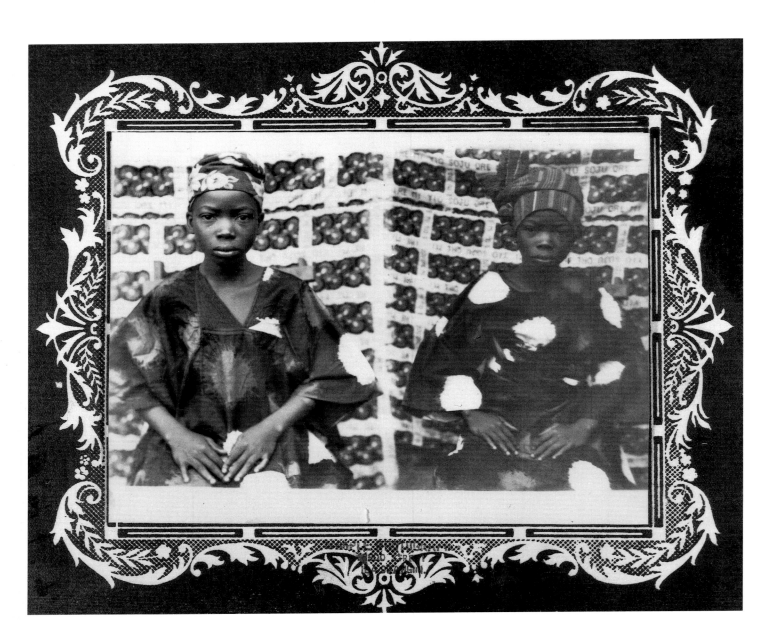

Cat. 25 *ERE IBEJI* **TWIN-CULT PHOTOGRAPH,** LATE 20TH C. UNKNOWN PHOTOGRAPHER (NIGERIA), GELATIN SILVER PRINT MATTED WITH BORDER, 00 x 50.8 CM. COLLECTION: CENTER FOR CREATIVE PHOTOGRAPHY, UNIVERSITY OF ARIZONA.

Cat. 26 *ERE IBEJI* **TWIN-CULT PHOTOGRAPH OF TRIPLETS,** MID 20TH C., UNKNOWN PHOTOGRAPHER (NIGERIA), GELATIN SILVER PRINT MATTED WITH BORDER, 00 x 50.8 CM. COLLECTION: CENTER FOR CREATIVE PHOTOGRAPHY, UNIVERSITY OF ARIZONA.

Cat. 27 *CHI WARA* **MALE HEADDRESS,** EARLY 20TH C., UNKNOWN BAMANA ARTIST (MALI), WOOD AND METAL, H. 81.3 CM. COLLECTION: THE RENEE AND CHAIM GROSS FOUNDATION.

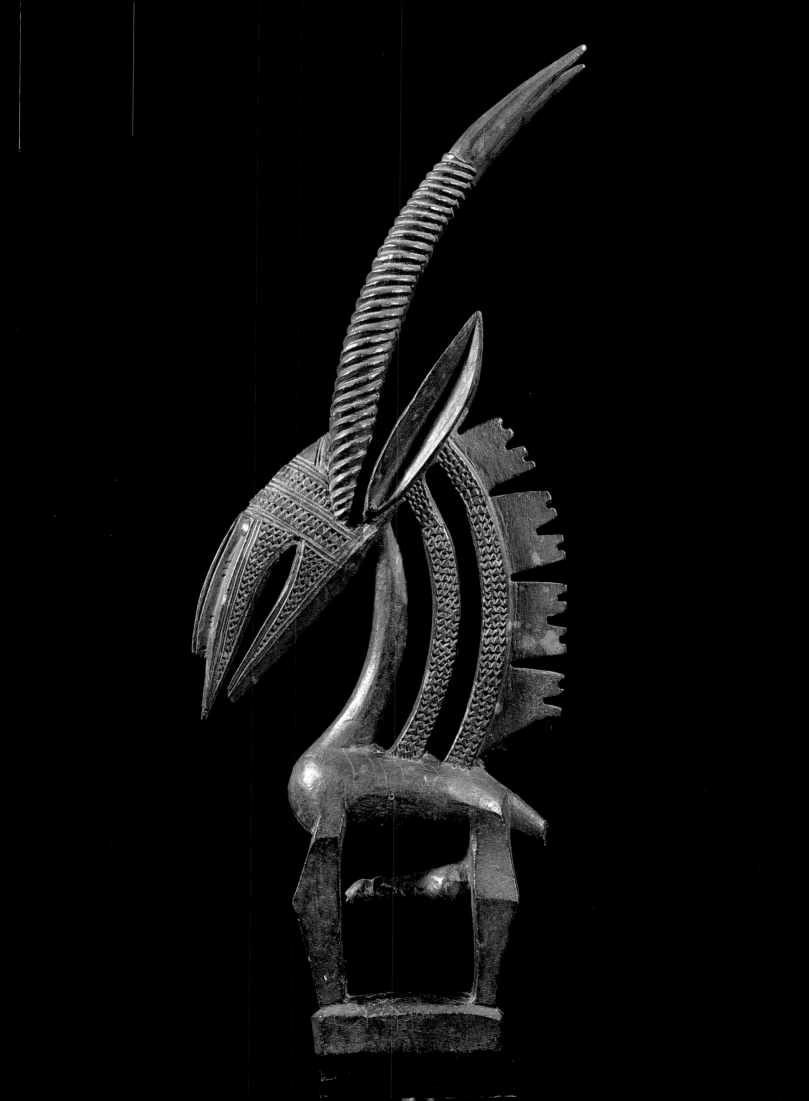

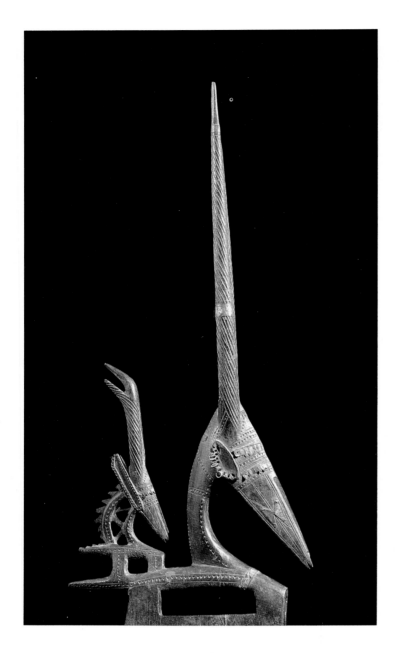

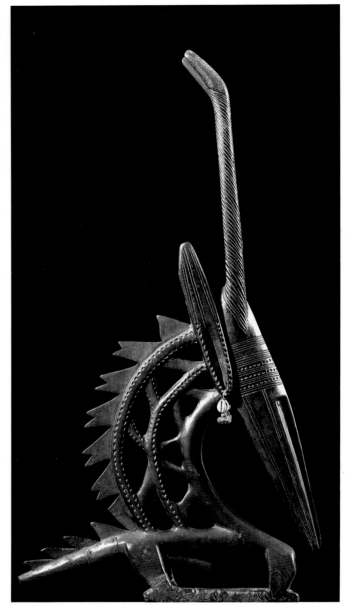

Cat. 28 FEMALE *CHI WARA* HEADDRESS, EARLY 20TH C.,
UNKNOWN BAMANA ARTIST (MALI), WOOD AND METAL, H. 71 CM.
PRIVATE COLLECTION.

Cat. 29 MALE *CHI WARA* HEADDRESS, EARLY 20TH C.,
UNKNOWN BAMANA ARTIST (MALI), WOOD, COTTON, COWRIE SHELLS,
AND METAL, H. 81.3 CM. COLLECTION: MR. & MRS. ALLEN
WARDWELL.

Cat. 30 PAIR OF *CHI WARA* HEADDRESSES, SECOND HALF 20TH
C., UNKNOWN BAMANA ARTIST (MALI), WOOD AND RAFFIA, H. 99.7
CM. COLLECTION: MR. & MRS. ROBERT BILLION-RICHARDSON.

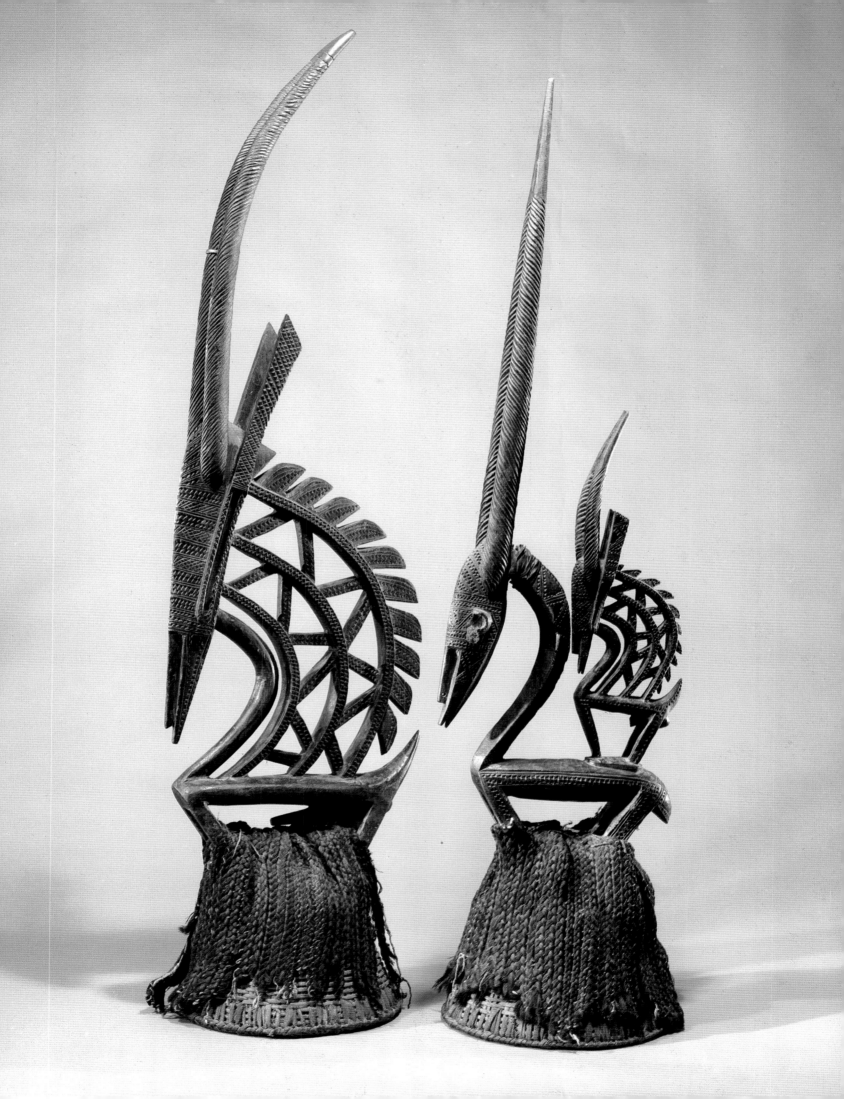

Susan Vogel

A portrait photo of the deceased elder was broadcast for a solid hour during prime time on a major Ibadan-TV network. This costly event marked the emergence of the "electronic memorial" among the Yoruba.
Marilyn Houlberg, 1990

A bold new kind of functional art has appeared in Africa, an art that upholds traditional values but uses ostentatiously untraditional forms and materials. This art is usually the invention of a highly original artist who has developed a distinctive form of his or her own. Some of these artists, clear-sighted observers of their societies, express their communities' new aspirations and self-images. They often have neither much formal education nor a history of apprenticeship as an artist; many, in fact, were trained in trades such as carpentry and building, which gave them skills they have elaborated into art.

FUTURE TRADITIONS

The artists who create New Functional art are often entrepreneurial promoters of their work, and may become prosperous and well-known. If they are successful, they can accumulate large workshops, attract apprentices and imitators, and may in time be remembered as the originators of an ongoing art form.

The genesis of these new art forms may parallel that of the older arts now considered traditional. Few records of the origins of traditional art forms survive, but it seems quite probable that some began similarly as the inventions of imaginative people responding to their life situations. Many traditional art forms, especially masks, have myths of origin recounting how they were given to people by spirits in the wilderness; the Ngombe of northeastern Zaire, for example, according to Alvin Wolfe, say that a man named Bosokuma, without family and too poor to marry, dreamed that the spirit of his father gave him a wood figure, which brought him success in "magic." Taken into the forest by spirits, he learned to carve and to make medicines for success in hunting, which later earned him considerable renown (1955:66). Wolfe speculates that Bosokuma actually learned to carve figures from neighboring peoples, but I would wonder whether the

Cement tomb sculpture of a chief in a cemetery in Lagos, Nigeria. In Africa, commemorative sculptures representing the dead are an innovation that took hold in the period since World War II. They are expensive, and are paid for by many members of the extended family. This example, by an unknown artist, is less successfully naturalistic than some more recent ones. Photo: Marilyn Houlberg, 1970s.

basic techniques of wood-carving—at least the use of machete and knives, if not of the adze—were not sufficiently well-known to allow someone with talent to achieve elementary competence by trial and error. (Figurative sculpture in the Ngombe region is fairly rudimentary). This archetypal story may differ from many others only in being recent enough to have been recounted by the protagonist (usually nameless) and to have been recorded by a researcher. The element of financial motivation may not be unique either.

The outstanding characteristic of New Functional art is that although it generally "belongs" to groups or corporate entities rather than to individuals, it is not seen as ethnically rooted. Like traditional art, it usually expresses a belief system, sometimes a sufficiently elaborate one to be considered a religion. Yet because it seems to transcend ethnicity, uses new media, and is frequently connected to the incoming faiths of Christianity or Islam, the owners of New Functional art see it as progressive or modern, while they associate ethnically based traditional art with the past. New Functional art reflects the mixed-ethnic settings in which it has generally developed, but it often recapitulates traditional use contexts such as masquerading, healing cults, shrine decoration, and funerals. Blending forms or practices from several ethnic groups with newly invented ones, it attracts people of diverse origins living mainly in towns, who often also patronize traditional arts.

This art is "functional" in the same circumscribed way that tradi-

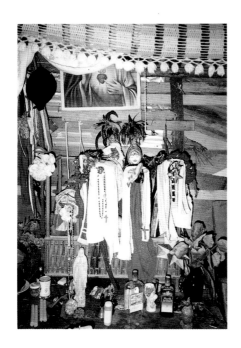

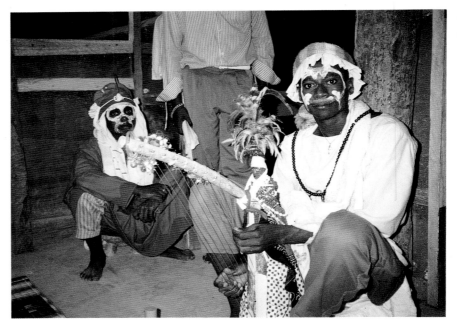

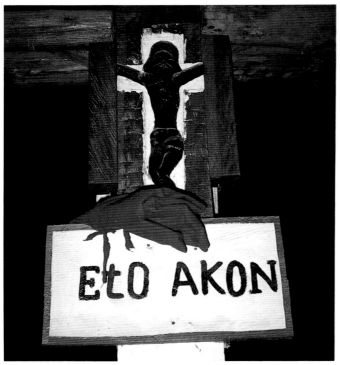

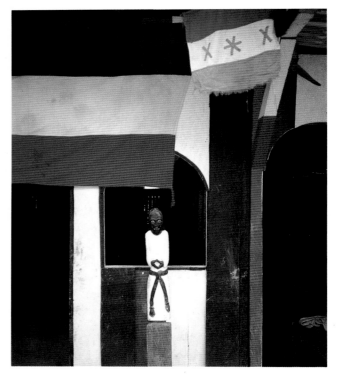

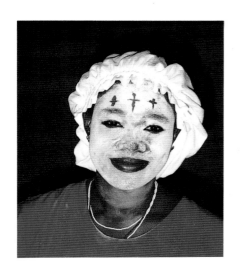

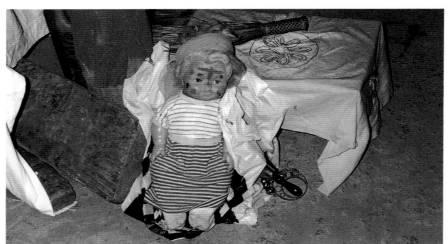

tional art is "functional": in this context the word refers to objects made for some concrete purpose—to be used as a coffin or worn as a mask, for example. It also describes objects made for an event to which they are essential, such as the unveiling of a tomb monument, a ceremony demanding, of course, the monument itself. New Functional art has not usually been considered an independent category by scholars, but is normally dealt with as "popular art," along with the art here called Urban. Though the visual forms of New Functional art are as direct and expedient as those of much Urban art, they really have more in common with traditional art. Urban art is primarily "art to look at," made as commercial or decorative work; New Functional art, like traditional art, is made to serve a purpose. Urban art is often produced in advance, for sale through middlemen to unknown, usually individual buyers; New Functional art, like traditional art, is generally made on commission, often for groups. Urban art, finally, is displayed in homes and privately owned businesses; New Functional artworks, again like much traditional art, are displayed in public or in communal places such as chapels, cemeteries, and the streets, often as the centers of rituals and community festivals.

New Functional art often allows people a public expression of both their respectful allegiance to a conservative past and their forward-looking commitment to a progressive future. The blatant newness that distinguishes this art is a big source of its appeal. In some respects, New Functional objects seem to exemplify an aesthetic of multifariousness. They are almost always complex in form, and made of many parts: wooden objects are carpentered Western style, never carved of a single piece of wood; masks and costumes include as many motley, unconcealedly heterogeneous elements as possible. Sculptures may simulate heterogeneity with naturalistic paint that disguises their uniform cement or wood surfaces as cloth, flesh, metal, masonry, or plants. This aesthetic of heterogeneity is well suited to the fragmented, multiethnic, polyglot environment of the jostling towns in which it flourishes.

New Functional art is the least well documented strain of contemporary African art. Found mainly in towns and semirural areas, it has escaped the notice of sociologists studying Urban art, and has rarely attracted the attention of art historians, who usually focus mainly on the traditional arts of the villages.[1] This is also the strain of African art with the smallest number of known artists, partly because it is still largely unstudied, partly because it depends upon the single visionary creator. In all likelihood, though, many more New Functional artists will become known in the future. They are producing some of the most exciting and unexpected art made in Africa today.

Kane Kwei, Coffin Maker

Two New Functional artists have become particularly well-known since their works were first published. Kane Kwei (b. 1927), a Ga man living near Accra in Ghana,[2] never went to school, but was apprenticed to a carpenter. Among other things, Ghanaian carpenters

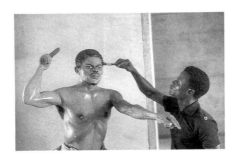

Fig. 7. S. J. Akpan (Nigerian, b. ca. 1940) at work in the mid 1970s. Dramatic figures shown in action are made mainly as eye-catching decorations for commercial establishments such as hotels, restaurants, and gas stations. Akpan's mastery of a degree of realism difficult to achieve in cement is clearly visible in the modelling of muscles and veins on the sculpture's extended arm. Photo: Keith Nicklin and Jill Salmons.

Fig. 8. Family portrait on the occasion of the unveiling of a memorial sculpture, southeastern Nigeria, mid 1970s. This expensive commemoration required contributions from many individuals, which is why it commemorates a man who died more than a decade earlier. Inside the small structure is a cement sculpture of the deceased by an unknown artist, and wall paintings showing masqueraders in action. Photo: Keith Nicklin and Jill Salmons.

made fancy coffins in the form of straight-sided rectangular boxes with glass-covered windows in the sides, sometimes lined with colored paper, and with cutout metal ornaments nailed to the sides and tops. In the mid 1970s he was also producing traditional "linguists'" staffs and palanquins for chiefs. When his dying uncle asked him for a special coffin, he thought, for the first time, of making a coffin representational, and produced one in the shape of a boat. (His uncle had been a fisherman.) It was a big hit in the community, and soon other customers began to ask him to build one for them. Eventually Kane Kwei's inventions came to the attention of an American dealer, Vivian Burns, who published and exhibited his work in San Francisco in 1974 (Burns 1974:24-25). Two decades later his artistic reputation extends overseas,[3] and he is the head of a large family workshop producing coffins for local customers and for tourists. Kane Kwei's art has a destiny, however, that few artists have had to face since the ancient Egyptians: the works that his local clients accept are buried and disappear. One can only imagine that he is glad to receive commissions from tourists and foreign museums.

The attention Kane Kwei has received from foreigners has increased his local standing. Two more large coffin workshops nearby now imitate his work. (The idea has not spread beyond the immediate area, however.) Early on, Kane Kwei developed two dozen or so popular models, which have not changed much over the years. The subjects allude to the lifetime trades of their dead occupants: most popular are a boat, two different fish, and a whale, for successful fishermen in this coastal area; a hen with chicks, for senior women with large families; an onion and a cocoa pod, two big local crops (in the 1970s Ghana was the world's largest cocoa producer); and a white 1970s-model Mercedes-Benz, designed for customers such as the owner of a large taxi fleet or other rich businessmen and -women. More infrequent designs include an airplane, for great travelers (hinged wings permit the coffin to be carried into the deceased's bedroom); a modern villa; and, for traditional chiefs, a traditional stool, as well as an eagle, an elephant, and a leopard. Kane Kwei's customers are apparently satisfied with this existing repertoire.

The repetition of a limited number of models makes for efficiency in the workshop. Unlike most traditional African art and furniture, Kane Kwei's coffins are carpentered, like European furniture, rather than carved from a single piece of wood. (Coffins themselves are rare in traditional African culture). They are naturalistically painted with enamel paint, and are at least 5½ feet long, with a removable lid and an upholstered interior including a mattress and pillow.

It is easy to misread these objects. Kane Kwei's huge naturalistically painted vegetables and surrealistic manufactured goods superficially resemble some contemporary Western art, but were invented by an artist quite oblivious to that similarity. Kane Kwei never went to primary school, and it is quite safe to say that when he made his first representational coffin he had never heard of Claes Oldenburg. His most frequent commissions are neither surreal, comical, nor kitsch:

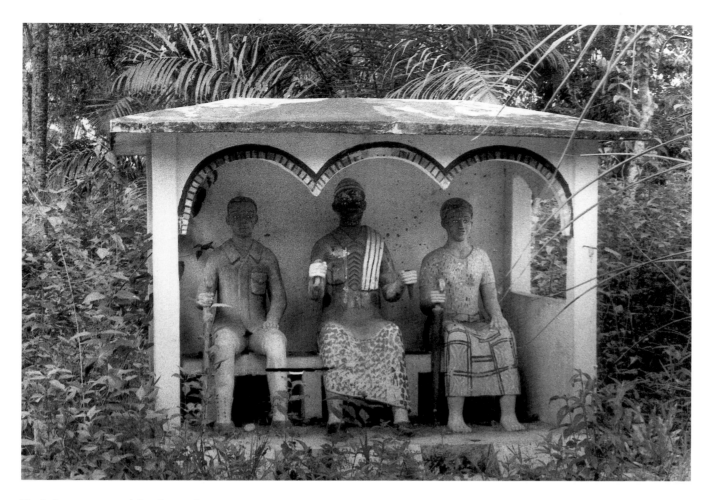

Fig. 9. Cement memorial sculptures by an unknown artist in the structure specially constructed for them, southeastern Nigeria. The generalized naturalism of these life-size figures resembles some earlier Mbari mud sculpture from the nearby Ibo area more than it does Akpan's highly colored, specific realism. Photo: Keith Nicklin and Jill Salmons, mid 1970s.

they are *coffins*, made for his clients' final rest. They are also matter-of-fact depictions of things in his and his clients' daily lives. Diametrically opposed to Surrealism, Kane Kwei's art does not distance its viewers from the real world; it expresses familiarity, connection, ownership. Significantly, it makes no distinction between natural objects (plant and bird forms) and manufactured goods of European origin (airplanes and cars, or even villas): for the coffin-maker and his patrons, all these things are part of the surroundings. The lack of subjects from traditional life is due to the fact that only the prosperous can afford elaborate funerals, and except for farming and fishing, traditional occupations no longer lead to wealth.

Visitors to the "*Magiciens de la terre*" exhibition in Paris in 1989 were especially charmed by Kane Kwei's white Mercedes-Benz, in which they seem to have seen a wry, Western-style critique of modern life. Nothing could be farther from the case. (Who would want to be buried in a critique?) This coffin is not a criticism of material success but a wholehearted celebration of it. The Mercedes must be understood as as the preeminent African symbol of wealth, status, and respect. One week after Nelson Mandela was released from prison, Mercedes-Benz of South Africa, Ltd., announced that it had agreed to its black workers' demand that it give the antiapartheid leader a $100,000 car.[4] One cannot imagine the followers of Lech Walesa or Martin Luther King insisting on this distinction to honor their heroes. The South African workers were expressing the same characteristi-

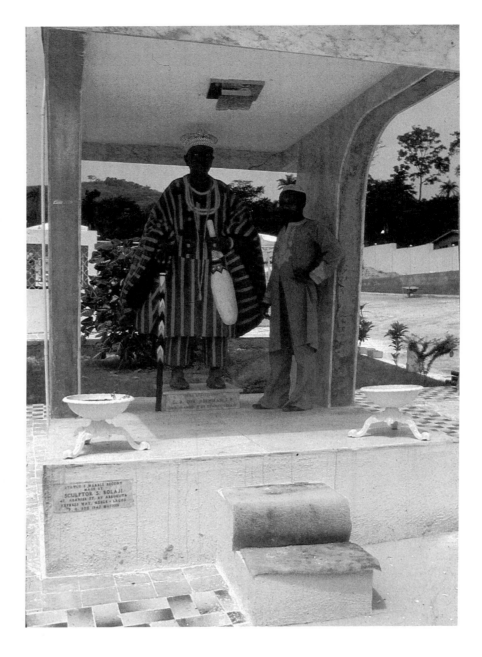

Fig. 10. Cement pavilion commemorating a wealthy chief, signed by S. Bolaji, near the deceased's elaborate home and swimming pool in the Yoruba area of Nigeria. The lifelike figure of the chief, his cane planted on the ground as if he were about to step down from his plinth, is based on a photograph. The objects he carries are prestige emblems—a beaded cane and a horsetail fly whisk. Though the voluminous robes are fully plastic, the artist's real interest lies in the interplay of line and color in the striped robe and patterned cane. A classicizing row of acanthuslike motifs adorns the roof line. Photo: Marilyn Houlberg, 1980s.

cally African, symbolic reading of the Mercedes that we find in the car coffin.

Elaborate, expensive coffins and funerals, though frowned upon by Christian churches, express a traditional ideal of celebrating the family by honoring the dead. Traditional funerals for important people were elaborate affairs that lasted for days, and were attended by hundreds. Coffins were not a significant element of these ceremonies; for the most part, traditional African societies wrapped their dead in cloth or mats to bury them. The great expense of a funeral was the purchase of food, drink, and gifts for guests, performers, and others. The average price of a Kane Kwei coffin equals the average annual per capita income in Ghana (Secrétan 1988:90), but the cost is shared by the whole family. The modern art of Kane Kwei permits his patrons to uphold traditional values publicly through a conspicuously untraditional means.

S. J. Akpan, Sculptor in Cement

Sunday Jack Akpan (b. ca. 1940)[5] lives in a semirural area of Nigeria, where he is famous for his striking life-size cement figures. "He perceived that there was money to be made from the increasingly popular art form of cement sculpture" while he was still in primary school (Nicklin and Salmons 1977:32). Having left school to apprentice himself to a builder, he learned bricklaying, and began to experiment with making sculpture, first in mud, then in cement, teaching himself through trial and error. Reinventing roadside advertising, he placed examples of his work along the main road near where he lives. Today he has acquired "many of the trappings of modern Nigerian middle-class success."(ibid.33). He is the most skilled of many artists working in a similar vein in his region, making not only funerary monuments but also "art to look at"—sculptures for display in gardens and outside commercial enterprises such as hotels and garages. Akpan cannot make a living with these works alone, however; he also produces crucifixes, armorial bearings, and cement lions and other animals for the tourist trade, although by far the majority of his clients are local.

Akpan's figures are mainly New Functional art, made to commemorate the dead, like Kane Kwei's coffins. These life-size figures are mounted on tombs and unveiled during the memorial celebrations known as "second burials." They are enormously expensive in local terms, but are paid for by many members of the deceased's extended family (Nicklin and Salmons 1977:33). Akpan did not invent the genre of naturalistic cement funerary sculpture, with detailed clothing and accoutrements. He has extended the genre's range of subjects, however, and has brought it to a degree of realism seldom found in the works of other artists.[6] Traditional Ibibio tombs were essentially unmarked, though large cloth constructions were made for the "second burials" of important people, with figurative appliqué banners and an assemblage of personal objects representing the deceased in different ways. Since there was no earlier tradition of tomb sculpture in most places (except in the lower Zaire River region), the cement figures must be considered the beginning of a new tradition.

Akpan admits of no master, asserting that his work is the result of a God-given gift. Outside his workshop is a sign emblazoned with the words "Natural Authentic Sculptor"; by this he means that his work is " 'natural'—the consequence of his own innate talents—and 'authentic'—closer to reality than the work of any other local artist" (Nicklin and Salmons 1977:34). As Souillou observes, this art denies all historical antecedents, "claiming a radical foundation that does not look to tradition for its legitimacy. . . . [Therefore, it] forces the observer to make a modern and even post-modern reading of its works" (1986:31).

Ode-lay, An Eclectic Masquerade

At their most interesting, New Functional artists mix the new and the

Fig. 11. A Yoruba woman wearing damask patterned with the image of a Mercedes-Benz, 1970s. Many African art forms celebrate wealth and material success without irony or mockery. The Mercedes-Benz is the archetypal symbol of prestige and wealth all over Africa. Like their symbols, people in high places are usually treated with respect and deference—most of it sincere, though they are not immune to ridicule. Photo: Marilyn Houlberg.

Fig. 12. Tomb surmounted by a cement airplane in the Yoruba area of Nigeria. The exploits and extraordinary deeds of the dead have always been remembered, but in the past they were more likely to be preserved in verbal than in visual modes. Airplanes are still objects of wonder among some rural peoples, and they appear on tombs in many different places. Photo: Phyllis Galembo, 1989.

Fig. 13. Ode-lay costume by the artist Ajani, Freetown, Sierra Leone, 1979. Masks of this type are expected to look rich, exotic, and complex. Enhancing these effects is the fact that nothing here is of local origin (except for the overall structure of mask and costume). As in most traditional masquerades, the makers and wearers of Ode-lay outfits are all men. Color is as important as form in the Ode-lay aesthetic. Photo: Hans Schaal.

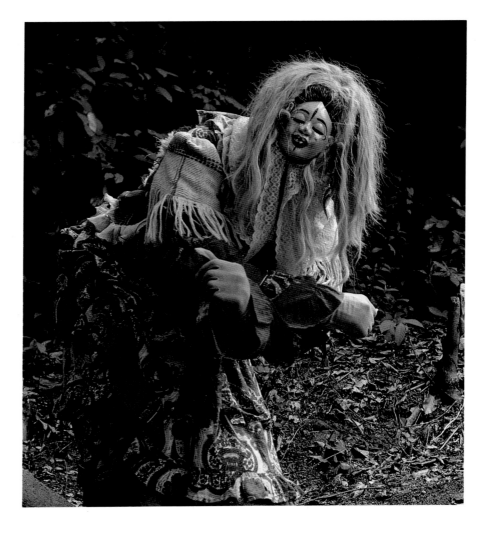

Figs. 14 and 15. Locally made grillwork in front of the Celestial Church of Christ, a syncretic church in the Yoruba area of Nigeria. Adapting the ancient Yoruba medium of wrought iron to new ends, the artist has created drawings in space. This new art form depends heavily on color to make the Biblical scenes readable; the artist has chosen muted colors, avoiding the strong colors used in traditional Yoruba art. Photo: Marilyn Houlberg, 1983.

old in knowing ways that go beyond improvisation and bricolage to become formalized systems of visually arresting expression. These works often recontextualize Western objects or cultural forms in ways that would startle their makers. Consider the costume performance of an Ode-lay society, founded in 1977, observed by John W. Nunley in downtown Freetown, Sierra Leone a few years later. The main function of Ode-lay is the creation of group solidarity in a multiethnic urban setting. It serves partly as a kind of social club where young men meet to drink and smoke, listen to the latest music, and plan stunning masquerade performances in competition with other Ode-lay groups. Among other things, Ode-lay art expresses the modernity of its members, showing that they are "with it." Though the mask disguise in this late 1970s performance, for example,

was made of traditional parts of the Yoruba Hunting *devil* [masquerade disguise], its materials were far different. The pants and shirt (*asho*) were constructed of foam rubber with dyed pink chicken feathers glued to the surface; the *hampa* (vestlike garment) was made of Christmas tree ornaments, lace, mirrors, beads, and several face masks; and the *eri*, or headpiece, was centered around a half-figure of Mammy Wata flanked on each side by human-headed snakes, built of wire substructures covered with snake skins. The costume had movable wings, called angel wings (Nunley 1982:45).

Fig. 16. Pulpit in the Catholic cathedral in Libreville, Gabon. In the 1970s the church commissioned dozens of tall carved pillars, a baptismal font, and other artworks including this pulpit from an artist who was not academically trained. He and his assistants produced a large body of work in a style that seeks to blend traditional sculpture forms, such as the Fang head shown in cat. 131, with improvised passages of naturalism. Photo: Susan Vogel, 1985.

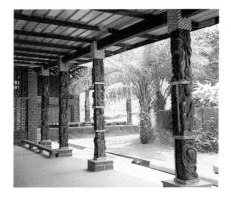

Fig. 17. Columns surrounding the cathedral in Libreville, Gabon. The artist has struggled, sometimes successfully, to wrap his narrative scenes around the alien column form. Re-used in such contexts, however, traditional African art forms usually seem to lose their emphatic vitality, becoming insipid and decorative, especially when the wood is varnished as it is here. Christian art in Africa has yet to capture the fervor of Africa's Christians. Photo: Susan Vogel, 1985.

As part of the preparation for the procession, Nunley says, the group stopped at a shrine and made sacrifices of common African offerings—a bowl of uncooked rice, a bottle of dark rum, two split kola nuts—as well as of an uncommon one: a 45-rpm record, sacrificed to assure a "record-breaking" performance. Other sacrifices were made and records smashed along the route of the procession (ibid).

The first reaction of many Westerners may be to see this use of familiar things—particularly the records and Christmas ornaments—as a strange, naive, inappropriate, even comical misunderstanding of the correct meaning and use of their cultural property. What is happening here, however, is actually a subtle reinterpretation of Western forms in terms of African values and symbol systems. Fully absorbed into the culture, the records have become fluent references to both Western and African cultural modes.

The verbal and visual punning here—records broken for a "record-breaking" performance—is a feature of traditional arts. (Masqueraders in Sierra Leone, for example, wear black costumes and are said to have emerged from the water; in the Mende language, words for "black" and for "water" are homonyms.) And the offering of expensive imported records corresponds to the ancient custom of sacrificing valuable things, appropriate to the occasion or the god. Except for the rice, all the traditional offerings Nunley mentions are usually classified as "hot"—they are sacrifices that activate the spirit. Similarly, dark colors like that of the records are often associated with danger or violence. The "hot" reggae music they contained also reinforces this logic of sacrifice. ("Cool" or calming offerings—often white chalk, or cool water—would not be appropriate at the beginning of a spectacular, dynamic, competitive entertainment performance.) Recontextualized and read for both their African meaning and their foreign content, these records have become part of the material culture of Ode-lay.

Creativity

The creativity of most New Functional art lies less in the making of the individual object than in the invention of the whole art form, and in the conception of the style. Much imagination is also devoted to recasting ready-made objects for new uses. Western uses of Western media such as cement and cloth, and of techniques such as carpentry, are predominently utilitarian and nonfigurative; African artists have reexamined these modes for their figurative potential.[7] New Functional art can resemble traditional and Urban art in that individual works may be closely similar, conforming more or less to preexisting models. Important parts of them may even be completed by apprentices or assistants. While innovation and original effects are essential to the success of Ode-lay masquerade costumes, in other cases, after the initial invention, the only challenge to creativity is to vary the rendition in interesting ways. Clients seem satisfied with a popular model when there is no variation to speak of.

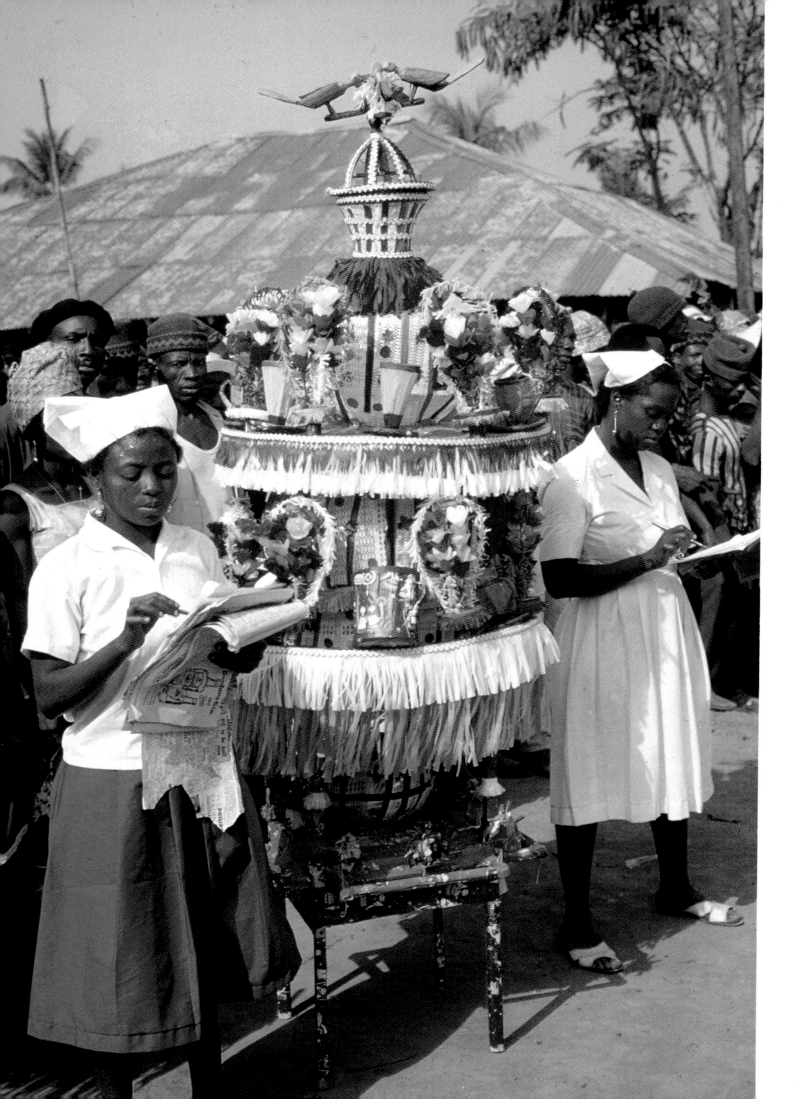

It seems significant that the artist who has invented his or her own art form seems unconcerned to vary its individual examples. Kane Kwei, for example, designs without drawings or sketches, so that the coffins inevitably vary slightly, but this is more a working preference than an aesthetic policy. One might argue that insofar as the coffins are mass-produced, they resemble tourist art or manufactured craft items, especially since they are sold in part to tourists. But it is important to remember that alone among the artists we have discussed here, but like certain contemporary Western artists, Kane Kwei has invented an original art form and a style that are entirely his own.

New Functional art serves a multiethnic audience in Africa, where ethnicity can be read on every face and in every name but where ethnicity connects to the past. In its eclectic use of heterogeneous materials, New Functional art expresses both a break with the past and a freedom from the West. Its artists shun both the traditional African media (none of these artists has invented a new wooden mask or carved figure) and unaltered imported things, proclaiming their participation in a new African culture.

NOTES

1. Keith Nicklin and Jill Salmons are an exception; they were the first to publish the work of S. J. Akpan (Nicklin and Salmons 1977), and of another unconventional artist who escapes easy classification, Akan Edet Anamukot (Nicklin 1977).

2. Most of Kane Kwei's clients are from another ethnic group, the Asante (Burns 1974:25).

3. Kane Kwei has been the subject of a full-length film, and he was one of the artists represented in the vast "*Magiciens de la terre*" exhibition mounted by the Centre Pompidou, Paris, in 1989. All but one of the pieces he showed in the "*Magiciens*" exhibition were not real coffins but half-size models. Recently the De Young Museum in San Francisco exhibited one of his coffins, and the Museum voor Volkenkunde in Rotterdam commissioned those shown here and recorded the process of their creation.

4. *The New York Times*, 20 February 1990, p. A4.

5. Akpan's work has been exhibited in Paris, in a two-man show shared by another nearby artist in cement (Souillou 1985), and he was invited to participate in the "*Magiciens*" exhibition. The figures he created in Paris for the exhibition were purchased by the Museé d'art contemporain de Lyons, and some are exhibited here.

6. J. Souillou traces the origin of Nigerian cement tomb sculpture to the work of Ghanaian artists in Lagos after World War II. But though highly stylized cement tomb sculptures were photographed in the Ibibio area by D. Rosevear around 1930, it is unlikely that any remained when Akpan began his career, in the 1970s. Cement funerary sculptures replacing earlier mud or wooden ones are found in several parts of Africa, most notably among the Kongo of Zaire. A new art form, they are now widespread among peoples who formerly did not mark tombs in this way, especially in southern Nigeria (Bini and Yoruba); they are also made by itinerant Ghanaian artists throughout the Akan areas of Côte d'Ivoire.

7. Figurative cement sculpture is also made in other parts of the third world (such as India), where the mode has probably been independently invented many times. The construction of sculpture out of many pieces of wood is an old European tradition, but it would be hard to overstate the scarcity of European artworks in sub-Saharan Africa.

Fig. 18. Tissue-paper lantern, perhaps representing the tomb of Hussein, displayed in Rokpur, Sierra Leone, in 1967. Since the 1930s, Muslims of various ethnic origins in Sierra Leone have celebrated the holy month of Ramadan by displaying or parading illuminated tissue-paper lanterns in fantastic shapes. The lanterns' makers compete for prizes based on size, striking colors, and complicated and amazing shapes, along with virtuoso craftsmanship in the cutting and pleating of the fragile paper. The parading of these objects, the interaction with the audience, and the centrality of drum music are traditional African elements, though this particular festival is a strictly Muslim affair. The lanterns are apparently of North African origin (Nunley 1985, Bettelheim 1985). Christians celebrate a similar festival in Gambia, demonstrating the mobility and mutability of art forms in Africa. Photo: David P. Gamble.

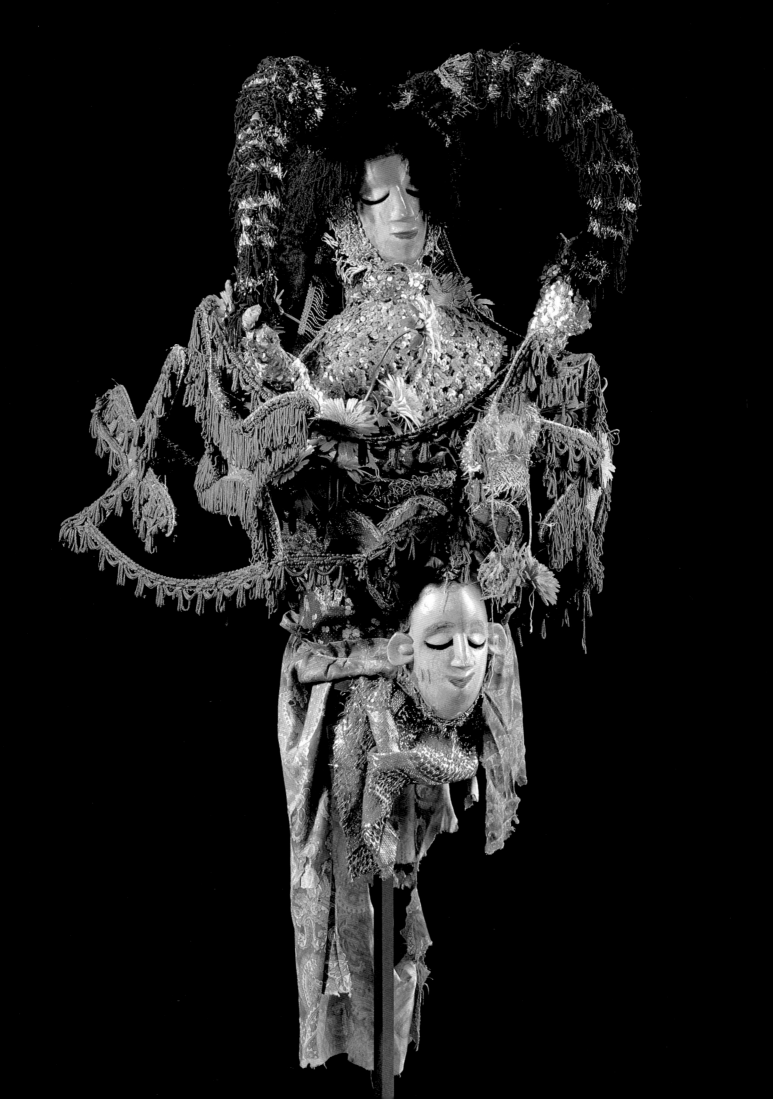

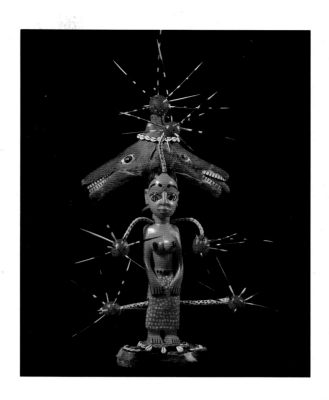

Cat. 31 ODE-LAY MASK, LATE 20TH C., UNKNOWN ARTIST (FREETOWN, SIERRA LEONE), WOOD, TINSEL, CLOTH, AND PAINT, H. 120 CM. PRIVATE COLLECTION.

Cat. 32 ODE-LAY MASK, LATE 1970S, UNKNOWN ARTIST (FREETOWN, SIERRA LEONE), WOOD, PORCUPINE QUILLS, TINSEL, CLOTH, AND PAINT, H. 116 CM. COLLECTION: MR. AND MRS. MARK ROSENBERG.

Cat. 33 ODE-LAY MASK, 1979, BY JOHN GOBA (FREETOWN, SIERRA LEONE, B. 1944), WOOD, PAINT, PORCUPINE QUILLS, MIXED MEDIA. H. 132 CM. COLLECTION: HANS AND BETTY SCHAAL.

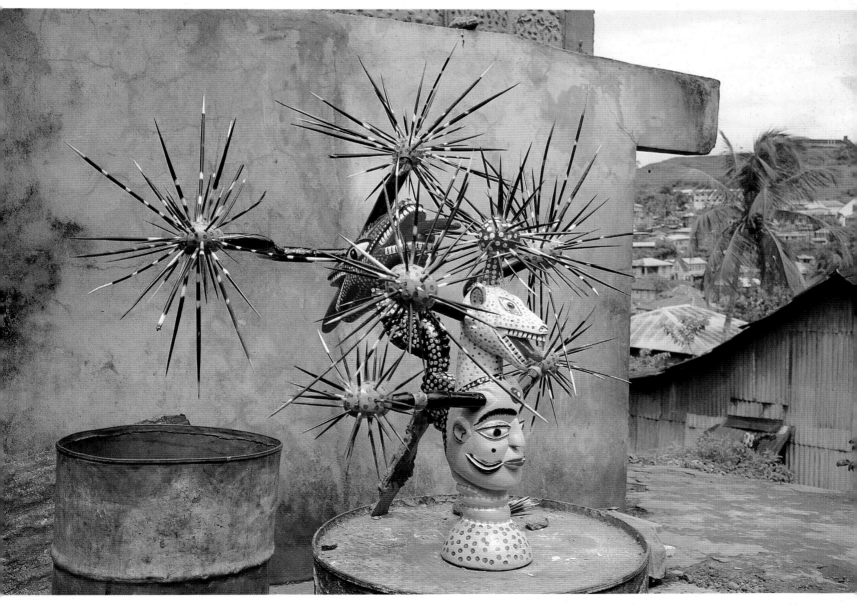

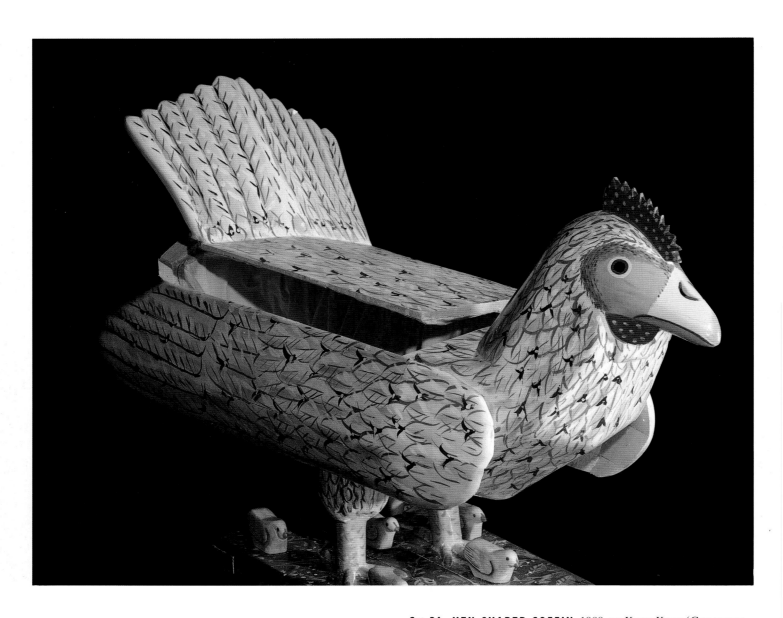

Cat. 34 HEN-SHAPED COFFIN, 1989, BY KANE KWEI (GHANAIAN, B. 1924), WOOD AND ENAMEL PAINT, L. 230 CM. COLLECTION: MUSEUM VOOR VOLKENKUNDE, ROTTERDAM.

Cat. 35 COCOA-POD-SHAPED COFFIN, EARLY 1970s, BY KANE KWEI (GHANAIAN, B. 1924), WOOD AND ENAMEL PAINT, L. 266.7 CM. COLLECTION: M. H. DE YOUNG MEMORIAL MUSEUM, THE FINE ARTS MUSEUMS OF SAN FRANCISCO, GIFT OF VIVIAN BURNS, INC.

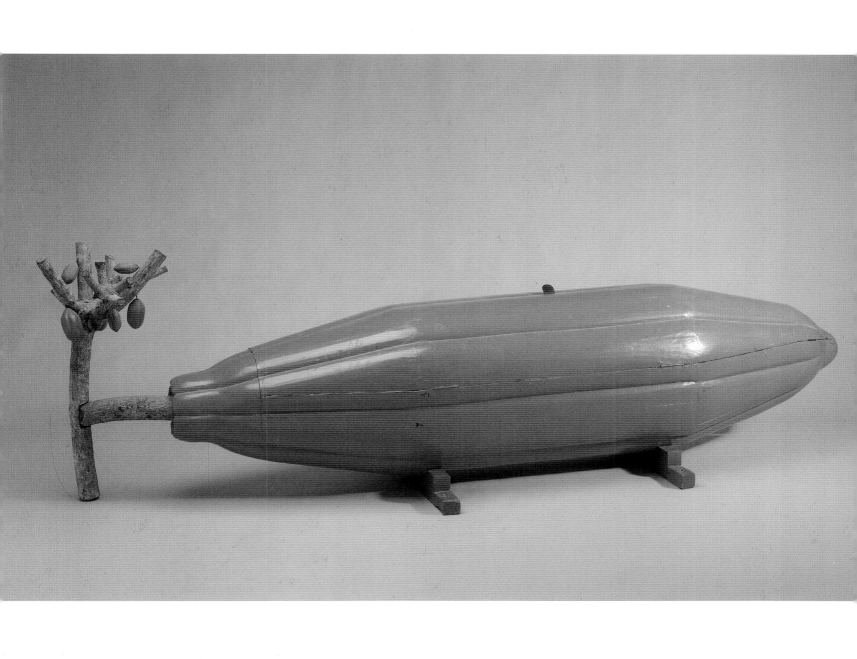

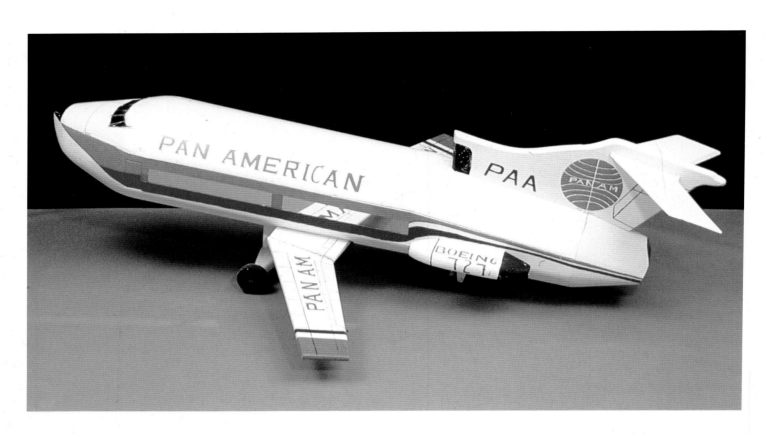

Cat. 36 **AIRPLANE-SHAPED COFFIN,** 1989, BY KANE KWEI (GHANAIAN, B. 1924), WOOD AND ENAMEL PAINT, L. 274.3 CM. COLLECTION: MUSEUM OF INTERNATIONAL FOLK ART, MUSEUM OF NEW MEXICO.

Cat. 37 **MERCEDES BENZ-SHAPED COFFIN,** 1989, BY KANE KWEI (GHANAIAN, B. 1924), WOOD AND ENAMEL PAINT, L. 265 CM. COLLECTION: MUSEUM VOOR VOLKENKUNDE, ROTTERDAM.

Cat. 38 **ONION-SHAPED COFFIN,** 1989, BY KANE KWEI (GHANAIAN, B. 1924), WOOD AND ENAMEL PAINT, L. 285 CM. COLLECTION: MUSEUM VOOR VOLKENKUNDE, ROTTERDAM.

Cat. 39 **PORTRAIT OF A MAN IN UNIFORM,** 1989, BY S. J.
AKPAN (NIGERIAN, B. CA. 1940), CEMENT AND ACRYLIC PAINT, H.
184.5 CM. COLLECTION: MUSÉE D'ART CONTEMPORAIN DE LYON.

Cat. 40 **PORTRAIT OF A MAN IN COAT AND TIE,** 1989, BY S.
J. AKPAN (NIGERIAN, B. CA. 1940), CEMENT AND ACRYLIC PAINT,
H. 192 CM. COLLECTION: MUSÉE D'ART CONTEMPORAIN DE LYON.

Cat. 41 **PORTRAIT OF A SEATED CHIEF,** 1989, BY S. J. AKPAN
(NIGERIAN, B. CA. 1940), CEMENT AND ACRYLIC PAINT, H. 173.5
CM. COLLECTION: MUSÉE D'ART CONTEMPORAIN DE LYON.

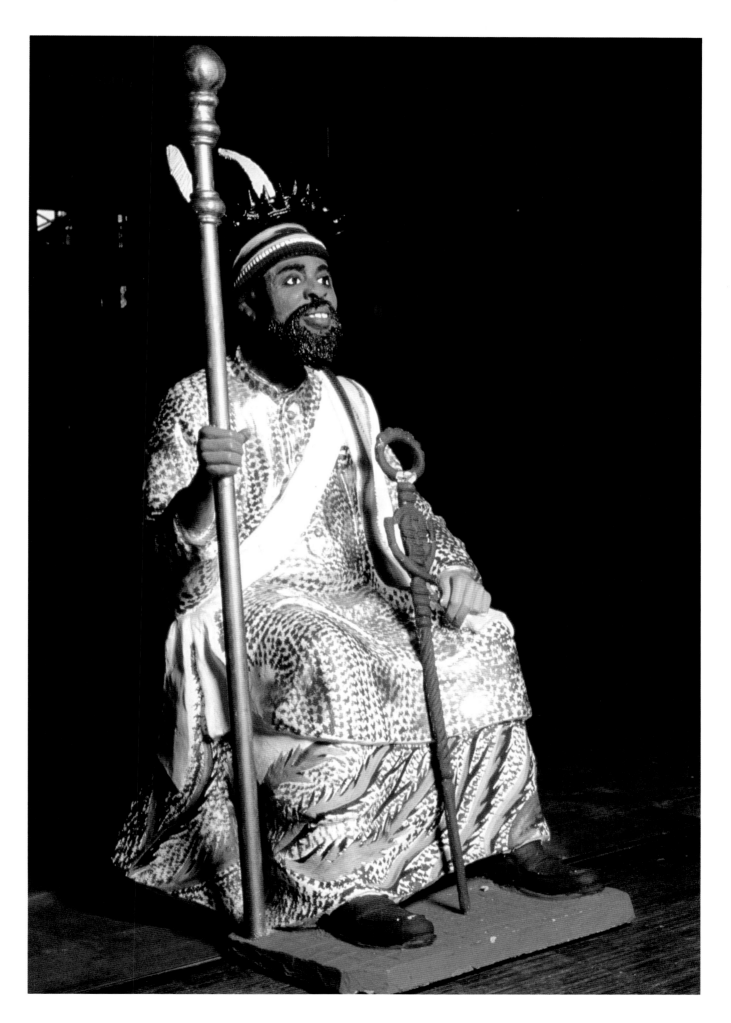

Susan Vogel

Urban art is the only strain of African art to portray the artists who make it, and the world they share with their clients. Its subject is their daily existence; its characters are their families and their neighbors (as well as imaginary and legendary figures); its stories are their farce and their drama; it is designed for their shops and homes. Urban art is a fast-moving, pragmatic art made by people who do not necessarily consider themselves artists but are out to earn a living. It consists almost entirely of painting and photography—there is no sculpture to speak of—produced in large volume to be sold in the artists' shops or peddled on the streets. In the poorer urban and town neighborhoods you might see it in modest homes, in bars, on market stalls, and on the sides of trucks. It arose first in cities, growing out of the needs of small businesses, and from the desires of urban people to own an "art to look at" that would be their own.[1]

Urban art is of two kinds: commercial art, essentially advertising or attention-getting decoration for businesses such as restaurants, dressmakers, or barbers, and transport outfits; and "art to look at,"

ART OF THE HERE AND NOW

paintings or portrait photographs for private individuals. Both genres may be made by the same artists in the same materials and styles. Though it originated in the colonial cities, Urban art has spread to smaller towns and villages, especially in West Africa, where it is practiced by itinerant painters and photographers based in the towns. Like all African art, Urban paintings are also purchased by Westerners.

This extraordinarily vigorous work has sometimes been described as "sign painter's art." Urban artists are literate without being particularly educated—they rarely have more than elementary schooling. They have usually learned their craft by apprenticeship in a sign-painting shop, where they acquired such important skills as lettering, silk-screening (for T-shirts), the making of rubber stamps, and how to paint the shop's repertoire. The more talented among them seem to have learned more about painting through trial and error than from their masters. Though many artists are essentially self-taught, they teach themselves to imitate the conventional subjects and styles of the genre. A limited number of highly conventionalized and very popular images exist in each genre, reproduced hundreds of

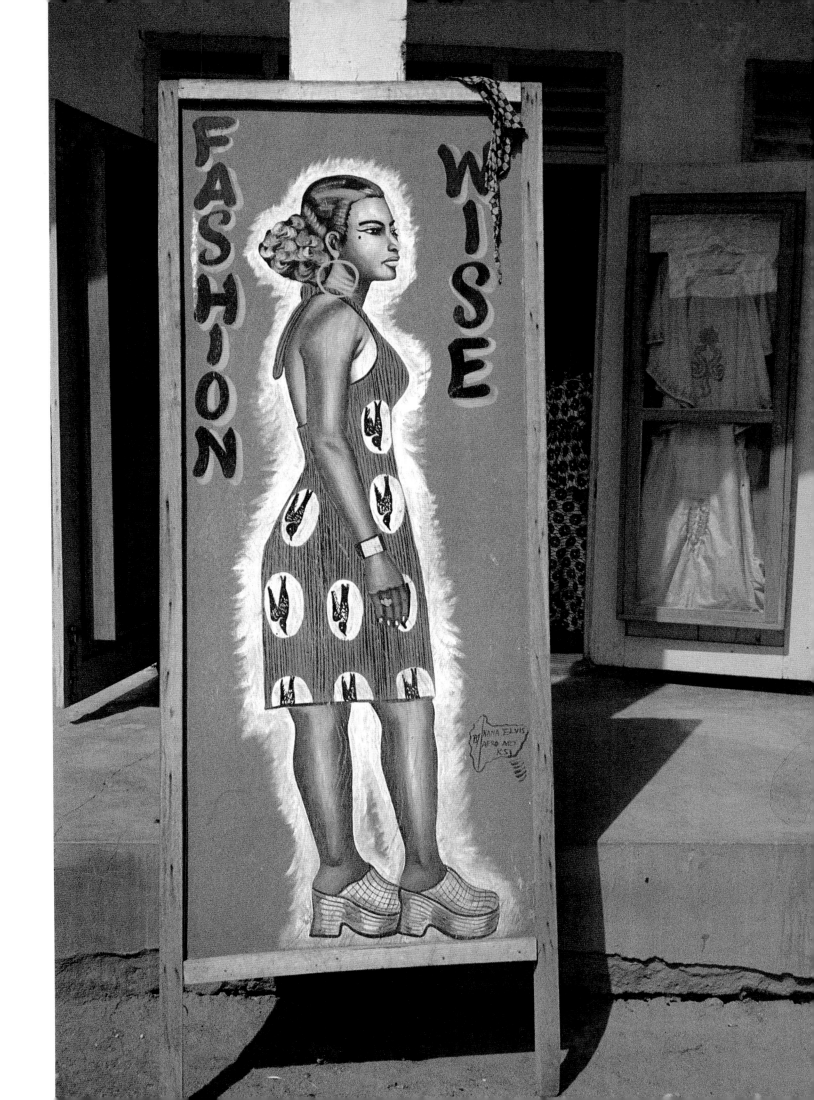

Fig. 2. Painting on glass of a portrait photographer at work, signed "Modou Fall" (Senegalese). Photography and painting on glass have each served the other in unexpected ways. In the early days, photo portraits provided the formal models for works on glass, while more recently, outmoded glass paintings were taken to the local framer to be scraped clean and used to frame photographs. Photography has been well established for a long time, even in rural Africa, which is served by itinerant photographers. In the Moke painting on this subject (cat. 72) a carefully preserved old photograph is shown. Private collection. Photo: Jerry L. Thompson.

◄ Fig. I. Dressmaker's sign by Nana Eln's Afro Art, Kumasi, Ghana, 1978. To attract attention on the street, and to advertise the merits of the business, signs often portray satisfied customers. Urban artists depict their own world, its people, and their belongings—here, a beautiful woman wearing the shoes, cloth pattern, and halter dress that were then fashionable. Photo: Christine Kirsten.

times by numerous artists. Noah's Ark and Sheikh Amadou Bamba are popular glass painting themes; Mami Wata and *Colonie belge* are two important Zairian examples. For some Urban artists, artmaking is a profession, but for many, especially young men, it is occasional work at which anyone might try their luck—taken up when they have the time or need some money, then dropped when other things come along. In Shaba in the 1970s both painters and the general public saw artmaking as a trade roughly equivalent to carpentry rather than a specialized craft (Szombati-Fabian and Fabian 1976:4, 17).

Urban artists have almost no contact with the officially recognized artists of their regions, who do not consider them artists. In Kinshasa, with its passion for naming art styles, the sign-painter artists have received the putdown name "*Watistes*," after the Mami Wata theme that they so frequently paint. The inclusion of Urban work, selected by a European, in the CICIBA Biennale in 1985 was much resented by the academically trained International artists who made up the national delegations. These artists explained to me that their education, a kind of investment they had made, entitled them to become artists and to sell art, while the "autodidacts" had spent nothing on training and were in some sense trying to cut illegitimately into their market.[2] The International artists were not immune to the charm and audacity of the Urban paintings; they simply argued in terms of status and economics rather than merit. The mixture has not been repeated in later biennials.

Photography

The earliest kind of Urban art may have been the portraits made by African photographers in the first decades of the twentieth century. This early work already shows a peculiarly African sensibility that survives in more recent Urban photography. The main focus is the human figure—other subjects, in fact, aside from an occasional landscape, are almost nonexistent. The photographs are formal. Compositions show a characteristic desire for centrality, completeness, and stability. The principal subject is almost always dead center in the picture, and full figure; whether posed singly or in groups, people face the camera, so that the image almost always shows both their hands, feet, and eyes. Any props also appear in their entirety. The backdrop is parallel to the picture plane, and close to it, creating a shallow space. Many pictures seem to have been taken out of doors —probably from necessity, since the electricity needed for indoor photographic lighting arrived late in much of Africa.[3]

The people in these photographs present themselves with the same seriousness they favor on ceremonial occasions.[4] Their formality sometimes seems to go beyond decorum to suggest that they are collaborating with the photographer in the creation of a somewhat stylized presentation of themselves (cat. 60); some poses feel difficult and uncomfortable (cat. 58). Painted backdrops contribute to the effect of unreality: for all their sharply receding perspectives, they are not realistically painted, and make only cursory claims to representa-

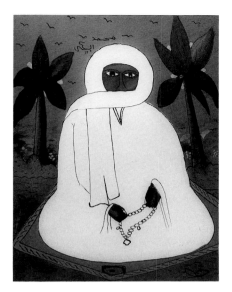

Fig. 3. Portrait of Sheikh Amadou Bamba in prayer with Koran, by an unknown Senegalese glass painter, Dakar, 1976. Collection: Jeanne Mullin. Photo: Ima Ebong.

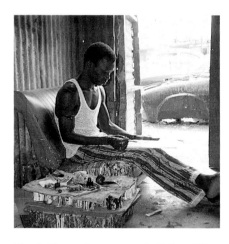

Fig. 4. Glass painter at work, Dakar, 1989. Outlines are drawn with ink—freehand or traced—then filled with large areas of flat, bright color. Photo: Susan Vogel.

Fig. 5. Decorated wall in a traditional wattle-and-daub house in Bangokro village, Côte d'Ivoire, 1978. A sort of archaeology of decoration can be seen in the old-style painting of an elephant and dots, overlaid with some rather old portrait photos, and newer pictures cut from magazines, calendars, and advertisements. This room was more of a storeroom than a sitting room—it contained a few chairs mainly used in the courtyard before the house. Photo: Susan Vogel.

tion. In cat. 61, for example, the juncture of painted airport tarmac and actual bare ground is too clear, and the subject stands too close to the painting for any convincing illusion to have been intended. (One of the earliest photographers represented here [cat. 55-57], an unknown Togolese active from before 1914, made pictures atypical of African work in their relative informality, in the lounging ease of their elegant subjects, and in their asymmetry. Like painters of the period, he was probably more influenced by European images than his successors, and more likely to have been trained by a European.) Later photographers use the camera to create stylized images that do not record a reality but rather seem to create one (cat. 62).

Glass Painting

The Urban art form of painting on glass elaborated in Senegal is intimately linked to photography. In fact, a small blurry photograph, visibly copied from generations of copies, that today hangs high on the walls of many of the shops and homes of devout Muslims in Dakar was the model for one of the icons of glass painting. Taken around the time of World War I, it is a portrait of Sheikh Amadou Bamba— Islamic holy man, political leader, and founder of Senegal's Mouride Muslim brotherhood. His body is enveloped in a white robe, his head muffled in a long scarf.[5] Dozens of permutations of this image have been diffused through Senegal in paintings on glass. The popularity of glass painting in Senegal peaked in the 1950s and has since diminished to the point where today it is mainly purchased by whites.

The medium seems to have come to Senegal from Islamic North Africa around the turn of the century, and to have spread from master to apprentice until today it has hundreds of practitioners.[6] While North African glass painting, derived from a Turkish and Byzantine icon-painting tradition, has been supplanted by mechanical reproduction, the Senegalese version was initially stimulated by photographs and other mechanically reproduced images, and has appropriated

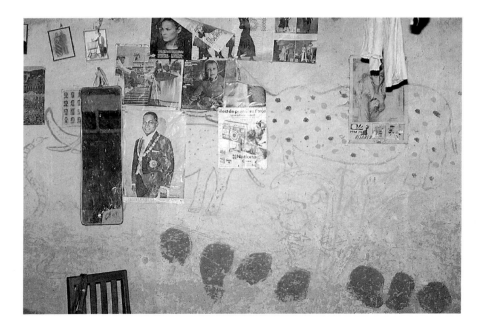

Fig. 6. Sign painters' shop in Libreville, Gabon, 1989. This unusually large, smashing facade advertises the painters' ability to create visibility for other businesses, and demonstrates part of their repertoire of images and lettering. Signs announce that they can decorate cars, create overhead street banners, and do portraits. Several artists worked here in 1989, including Koumba Gratien, who was attending the art academy, and who won a $1,000 prize at the 1989 CICIBA Biennale, making him also an International artist in our sense. Photo: Susan Vogel.

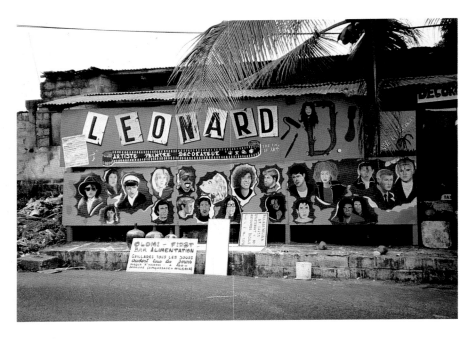

Fig. 7. Record and general store, Bolgatanga, Ghana, 1978. The bird-patterned fabric worn by the woman painted on the right, and echoed in the painted decoration on the facade, was also worn by passers-by. An important aspect of Urban painting is the way in which it mirrors its audience, their lives, and their desires. Photo: Christine Kirsten.

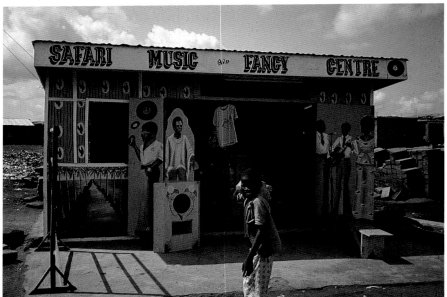

Fig. 8. Barbering salon in Ibadan, Nigeria, 1974. Clients choosing their styles from the photos were assured of the latest look because, according to the sign, it came from the capital, Lagos. Photo: Mark Schlitz, courtesy of Marilyn Houlberg.

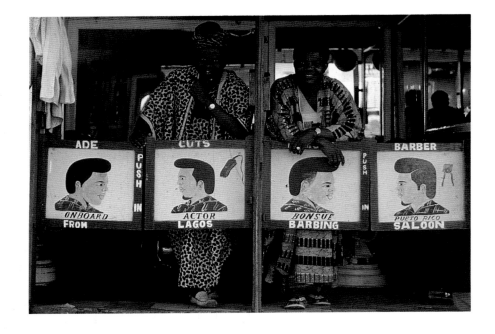

their visual conventions.

Glass painting originally became popular in Senegal as an inexpensive way to copy photographs, chromoliths, and postcards as home decor.[7] Glass painters also created decorative frames for photographs and postcards, and made portraits freehand. A large part of their production is devotional: scenes from Bamba's life, or from the Old Testament; important Islamic monuments such as the Kaaba and the mosque at Touba; Al-Barak, Mohammed's miraculous mount. They also paint portraits of political figures (mainly leaders of Senegal's resistance to colonial rule), history scenes from the colonial period, and narrative scenes of everyday life. These are usually accompanied by a moral tale, but paintings on glass are not all high seriousness. Some, clearly, are made and bought for their sheer beauty, and others offer irreverent and humorous remarks on human nature that would have pleased Chaucer: a ferocious woman chases a lion out of her house while her quivering husband hides; a thief is arrested while his jubilant victim—a woman—dances and his wife (purse full of money) sulks; a comically tearful little husband watches the departure of his large disgruntled wife, child on her back, her mortar for pounding food on her head.

The compositions of glass paintings resemble those of African photographs in their habitual frontality, symmetry, and shallow space, but their use of large areas of strong color butted one against the other is specific to the medium, and is clearly the artists' delight. Saturated blues, reds, and yellows, usually without shading and undimmed by pattern, give their work its bold graphic quality. These colors, combined with bright pinks, strange greens, metallic golds, and other surprising hues, are rendered luminous, glossy, and very smooth by the glass on which they are painted. This glass is very thin, to give the impression that the translucent color is on its surface rather than protected underneath it, as is actually the case. The subject and sparse details are first drawn in black ink, then the outlines are filled in with enamel paint.[8] Spaces and forms are deliberately flattened and simplified; floors and rugs tilt toward the viewer to provide geometric fields of color. The artists usually cover the entire surface of the glass, more or less evenly separating the picture elements. Their skies are mostly cloudless and their backgrounds plain with the subject high in the frame. In a portrait, the figure is usually shown against a flat screen of solid color, the head near the top of the frame, the rest filled by garments.

Glass paintings are sold inexpensively by peddlers in street displays, as well as directly by the artists, who also work on commission. The genre has come to seem rather old-fashioned to its original audience, which can now afford mechanically reproduced devotional images and studio portraits. Tourists are the important buyers now so a number of Dakar shops and galleries provide another outlet for glass paintings. Shading and patterned textures are beginning to appear. The medium lends itself to copying—tracings can be made directly onto the glass—and apprentices, younger brothers, and lesser

hands turn out fairly competent versions of subjects perfected by the studio masters. Yet though repetition has always been a significant feature of glass painting, no two works are alike. In 1979, the widely admired studio of Gora M'Bengue (1931-1988) turned out a series of pictures of deer, all traced from the same model and all apparently painted out of the same can—but since the backgrounds range from gray cliffs to palm trees and green fields, the pictures bear little resemblance to one another.

Middle Art and Moke

Senegalese glass painting is unique among the schools of Urban art in its unusual medium and in its explicitly foreign origin. Most Urban art forms were generated on the spot, invented by their practitioners in response to a market. The need for inexpensive commercial signs and billboards, for example, led to the emergence of entrepreneurs specializing in painting and lettering. By the 1940s, local sign painters in many places, but especially the Anglophone countries, had created a genre of elementary advertising and commercial decoration that was pictorial as well as graphic. Even today, most Urban artists make rubber stamps, silk screens for T-shirts, signs, and banners, as well as paintings of various sorts. In fact, it is skill in lettering that qualifies an Urban artist as a professional— there is a general sense that any untrained person can draw or paint, but lettering is something else.

Most of the early examples of Urban painting, commercial signage for the artist's local clients and for his own use, are panels depicting subjects designed to attract customers. Middle Art (the professional name taken by the Nigerian painter Augustin Okoye) has painted a self-portrait on his shop door, inviting potential clients to "see The Manager In Charge" (cat. 45), and another self-portrait in which the artist delivers a rubber stamp to a satisfied, high-prestige client, the prominent political leader the Sardauna of Sokoto (fig. 4, p. 270). These advertisements take a direct approach and use the artistic means at hand. In both, the faces are fully modeled (probably copied from newspaper and ID photographs), while the body is rendered as layers of flattened forms depicting clothing. The bulky heads on flat bodies, and the big figures pressing against the edges of the narrow panels, create tension and interest, but these features cannot be seen as calculated artistic devices, and appear only here and there in Middle Art's work.

Urban painting went beyond commercial signage in Zaire in the 1970s, when hundreds of artists began to produce paintings by the thousand in a fully elaborated form of expression made for and by the poorest working classes in the cities. Though many of these artists also continued to work as sign painters, the market that had developed for decorative paintings was large enough to allow many others to produce "art to look at" full-time. Ilona Szombati-Fabian and Johannes Fabian have done a penetrating analysis of these paintings, their meanings, and their social context; the authors estimate that by the early 1970s at least 500 paintings were being sold a month in

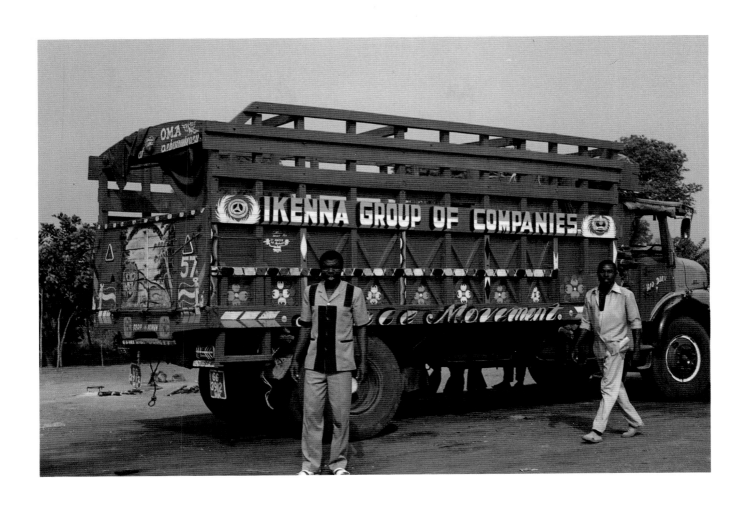

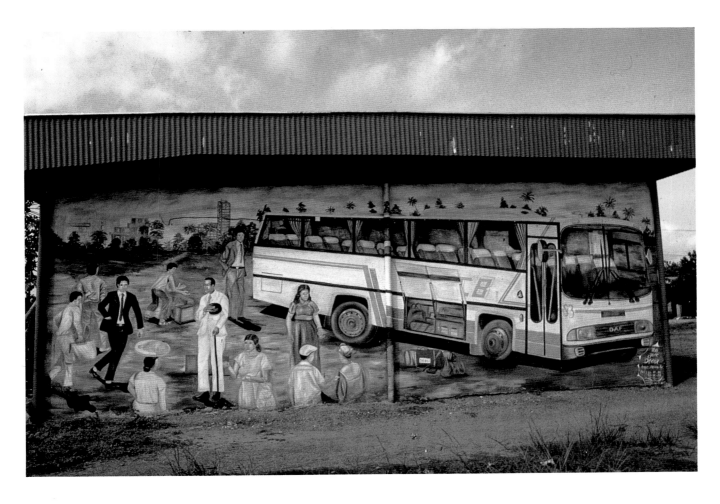

Fig. 11. The artist Moke (Zairian, b.1950) in Kinshasa, 1988. Moke was orphaned at an early age, and had very little schooling. His journalistic paintings are not particularly political, and do not carry the telltale lettering characteristic of Urban art—and he is a very popular artist with the public. Still, Moke was not mentioned in the text of the semiofficially sponsored publication *60 Ans de peinture au Zaire*, whose index lists over seventy other Zairian artists, virtually none of them Urban. Photo: Ronald Ruprecht.

Fig. 12. The artist Cheri Samba (Zairian, b. 1956) in New York, 1990. Despite the attention he has attracted recently from Western galleries, museums, and critics, Cheri Samba gives the impression of knowing exactly who he is and where he wants to go—and not go. He seems to feel clearly that his art is sustained by his rootedness in Kinshasa, even though in practical terms it is now virtually impossible for Kinois to purchase his paintings. Photo: Ima Ebong.

Shaba province alone (1976:2). Low prices pushed artists to sell a painting every day in order to live. These harsh conditions nonetheless allowed a number of talented painters to perfect styles of real distinction. One of these was Tshibumba Kanda-Matulu (born ca. 1950), who worked in Lubumbashi, Shaba province; his ambitions were considerable.[9]

Tshibumba, who called himself a "painter-historian," set out to tell the entire history of Zaire in hundreds of pictures. All have a legend written on the bottom, and all have a wealth of details that create a sort of "you are there" immediacy and argue for the truth of the story they tell. Tshibumba's history paintings, his own creation (cat. 67-70), are executed in soft colors with even, meticulous brushstrokes, and have none of the crude workmanship and awkward passages seen in the most popular conventional subjects, which he must have painted hundreds of times, such as *Colonie belge* (1970s; cat. 66), an image of political oppression from the past and a covert commentary on the Zairian present. In this allegory of state power, African officials abuse the citizenry while Europe, in the person of white officers, looks on acquiescent.[10] Tshibumba's pictorial vision is highly personal. *The Historic Death of Lumumba*, for example (1970s; cat. 67), is an eerily strange composition: three corpses, close to us and very large, lie under a darkened sky in a tiny barren landscape reminiscent of Calvary. Its very emptiness suggests both celestial benediction and sinister deeds. In Tshibumba's works, objects and most of the important figures (with the exception of Patrice Lumumba) are shown far away or are seen from behind, often in surprising perspectives, and the viewer often seems to stand not behind any audience in the picture but alongside the protagonists, and confronted by the crowd.

The most Westernized of these artists in his approach to painting —because he is the least concerned with transmitting an explicit message—is the painter known simply as Moke (born 1950). His panoramic pictures of middle-class city life portray it as populated by a big cast of characters who are exuberant and ultimately benign; he sees all the filth, corruption, and petty vice that surround him, but he paints them without bitterness. Moke's point of view is essentially optimistic. Here the "little people" always manage to enjoy themselves and to impede the great, and the poor have their revenge, fighting adversity with humor and style. The owner of a humble pushcart can flash through traffic pushing a wooden Mercedes and can paint his broken shoes to look like stupendous snarling leopards (1990; cat. 75). The conspicuous shoes in Moke's work may refer to his own history: orphaned at an early age, on his own in the huge city of Kinshasa, he was a shoeshine boy until he chanced upon the square where Urban art was displayed for sale. Realizing he could get money for paintings, he quickly began to make and sell them, and eventually pulled himself into a relatively prosperous middle-class existence solely by his own energies and skills. This artist's early signatures read "*Peintre Naif Moke.*" By the late 1980s he was "*Peintre Moke,*" and

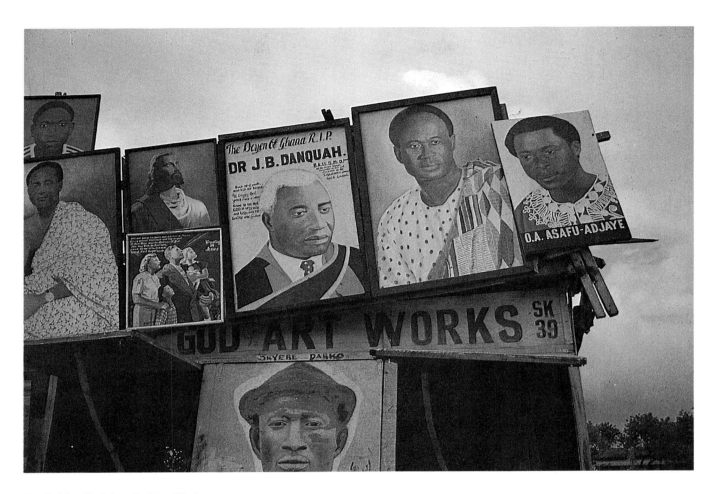

Fig. 13. The Almighty God Art Works shop in Kumasi, Ghana, 1978. Offered for sale are portraits of Jesus Christ, Kwame Nkrumah, the Brazilian soccer hero Pele, and a funeral portrait of J. B. Danquah, along with an inspirational painting of a white family "trusting in Jesus." Made of enamel paint on plywood, they could be exhibited in front of a business, or in a more private office or living room. Photo: Christine Kristen.

now he is simply Moke—no need for explanation.

Cheri Samba

Moke is a retiring man, in direct contrast to Cheri Samba (born 1956), whose caustic view of Zaire and Europe is unique in African art. Cheri Samba is also virtually alone among African painters in the extent to which he has caught the attention of the Western art world: since exhibiting in the "*Magiciens de la terre*" exhibition in Paris in 1989, he has had several gallery shows and one museum exhibition in Europe and New York, and has aroused more interest from the Western press than any other African artist.[11] Like his friend Moke, he comes from extremely humble origins. He began painting as an apprentice to other sign painters, and he also drew a newspaper comic strip for some years, an experience that remains an important influence.

Cheri Samba's ambitions are remarkable but not unattainable: sometime in 1988, when he was still a relatively obscure Kinshasa painter, he told Jean-Marc Patras, now his Paris dealer, that he wanted a place in art history. He shows every sign of being on his way to one. He may also be on his way to becoming an International artist, not because of the attention he has attracted in the West but because he may eventually address a primarily international audience in his art, changing his style and subject matter accordingly.[12] Since he began to exhibit in Europe he has barely repeated himself at all. For the moment he is still perfecting his Urban style, but should he

become preoccupied with painterly issues, or lose contact with his Kinshasa audience, he would have more in common with International African artists than with Urban ones. Zairian officials probably consider Cheri Samba's style and subject matter too uncouth for his pictures ever to represent the Zairian nation officially in international forums, but should that happen, it would also distance him from Urban artists. The man and his art as we have known them are still nothing like the "official story", and so far he remains rooted in his Urban tradition.

Cheri Samba's wild hybrid style combines an improvisational realism with comic strip drawing, passages taken from photographs, and a fine sense of composition. He is particularly gifted at representing manufactured objects such as fans, refrigerators, pots, toothbrushes, and above all furniture with a delirious relish. The colors of his paintings—acid, painfully bright, and occasionally highlighted with a little glitter—are as caustic as his view of the world. Compositions are almost cinematographic in their sharply receding diagonals, in the way they cut figures off at the edges of the frame, and in the unusually high or low perspectives they sometimes take. Cheri Samba usually gives a panoramic view of a scene, including numerous figures (a device typical of Urban painting). But he can also zoom in on a subject, especially when that subject is himself.

Cheri Samba's outlook is as hybrid as his style, combining audacious political mockery with a ribald Hogarthian humor and a moralizing streak.[13] No subject is immune from his fine-tipped brush and penetrating writing. Though he depicts movement poorly, his paintings still have a juicy energy found almost nowhere else in contemporary African art—his current work may be more original than any other in Africa right now, in any mode. Cheri Samba feels that his greatest innovation is his extensive use of text in his pictures, which he intends as a device to slow viewers down, making them look carefully. Always attuned to business and self-promotion, he has also said that the long texts assure a crowd in front of his pictures, drawing attention to them.[14] But the well-written, lively dialogues and narratives carefully lettered on his pictures in nuanced French, Lingala, and Kikongo are in fact much more than this: as Jean-Pierre Jacquemin perceptively notes, they not only explain the scene, adding penetrating and hilarious details, but constitute the pictures' action and drama (1990:25). They are also the key to understanding the artist's message, which they give us straight: Cheri Samba usually means exactly what he says—and no more.[15]

Context and Content
The affinities between Cheri Samba's art and certain traits of current Western avant-garde painting have nothing to do with the influence of Western art. Rather, both he and certain Western artists, quite independently of each other, have drawn upon popular "low-art" images, and these similar sources have resulted in parallel forms. Cheri Samba comes out of a comic strip and signwriter-cum-advertising background in which artists are not concerned with good taste or

skillful technique (except in lettering). His use of writing is less a philosophical interrogation of picture-making than an involuntary sign of his commonalty with all the African sign-painter artists. And the awkward passages in his work are not deliberate or ironic, and reflect no aesthetic goal. His most recent 1990 paintings, in fact, show marked technical improvements over earlier ones, confirming that his technique has always been essentially makeshift.

In all Urban painting we sense that the artists' control of their tools and materials is uncertain, and that elements of their work may be as much a matter of chance as of choice.[16] Jacquemin describes how in 1986 Cheri Samba, frustrated in his attempts to portray himself as he wished, resorted to surreptitiously pasting a photograph of his face on one of his paintings.[17] Guy Brett calls these artists' technical means "provisional," and suggests that the effects they produce are not necessarily the effects they seek (1986:12). He would say that had Middle Art had the skill, he would have painted photographically accurate bodies for the naturalistic heads in his portraits. Artistic means in any case are not the Urban artists' main interest; they are concerned less with issues of style or technique than with communicating their message as directly as possible. This desire for immediacy has been attributed to the fact that they are addressing heterogeneous city masses who do not necessarily share a visual code. Karin Barber writes, "Their performance style, because it is designed to overcome the anonymity of the new urban crowd, is intensely concerned with the dissolution of distance, the creation or recreation of a rapport which traditional performers could take for granted" (Barber 1987:107).

Fig. 14. Painted bar facade in a small village, Côte d'Ivoire, 1978. Itinerant painters from nearby towns and cities visit villages looking for work. Striking or novel lettering can be as important as the painted image to artists and clients. Artists carefully sign their paintings—more as a promotional device than from pride of authorship. Photo: Susan Vogel.

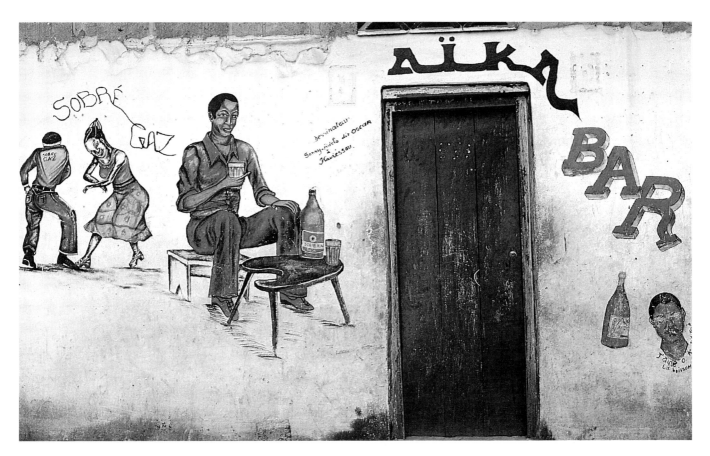

This attempt to neutralize distance, not only on the part of the performer/artist but also on that of the populace/client, may be the essence of Urban art. These public, particular, idiosyncratic paintings and photographs may be created to satisfy the desire for personal presence, for a sense of connection to one's surroundings, in the impersonal city. They may express an impulse akin to, say, wanting to shake hands with the teller before beginning one's banking business, or greeting the taxi driver before entering the cab. Some of the earliest manifestations of the Urban art tradition seem to have been extravagantly painted sentences and pictorial decorations on buses, trucks, and occasional taxis.[18] The hand-painting of vehicles—especially new ones—runs completely counter to the European sense that a car should be anonymous, its model and color machined and standardized. Western cars are not supposed to mark an individual presence in traffic. But the personalized African vehicle —one thinks of the buses in Dakar, their windows painted with multicolored flowers, or thoughtfully covered with artfully folded napkins to shade the passengers, during the 1970s—is instantly recognizable. Since the earliest days of Urban art, merchants have wanted more than lettering—they have wanted distinctive images. The highly particular Urban paintings in public places are an inebriating antidote to the modern African city, a way of establishing human contact in its anonymous crowds of strangers, and in its architectural uniformity and impersonality.

Popular Art or Urban

Throughout this discussion I have avoided the troublesome name by which Urban art is usually known: "popular." Barber's brilliant examination "Popular Arts in Africa" deals with the word's defects as part of a tripartite system separating "traditional," "popular," and "elite," and concludes that the term is only useful to the extent that it describes an indefinite area between the other two (1987:19) —an area unconstituted and emergent. Barber proposes a definition "by default," noting that the concept of popular arts in Africa has yet to be theoretically constructed (ibid.:5). She observes that by "popular" "the great majority of scholars have meant some version of the idea of 'emanating from' or 'belonging to' the people," and that a smaller group have used the word in reference to art that moves people toward political action (ibid.:7).

In place of a term that would identify the social place of the artists and audiences, or the method of marketing, I have preferred one that indicates only the locus of this art form. Urban art is flexible—it can be exhibited internationally (as this exhibition and many others attest), it can be created in villages, and it can be sold to or even specifically created for tourists and expatriates. (This is true of all the strains of African art I have named, and artists can pass from one to another of any of them.) The most marked feature of the African art called "popular" is the way it has grown up in twentieth-century cities, and the ways in which it reflects their character and the welter of attitudes of their inhabitants.

Fig. 15. A painter from the Almighty God Art Works working on a composite portrait of Ghanaian leaders, Kumasi, Ghana, 1978. At right is a painting of the Hindu monkey god. The artist is copying a photograph—one of many mechanically produced images, including Indian, Egyptian, and Christian chromoliths, that serve as models for Urban painters. Photo: Christine Kristen.

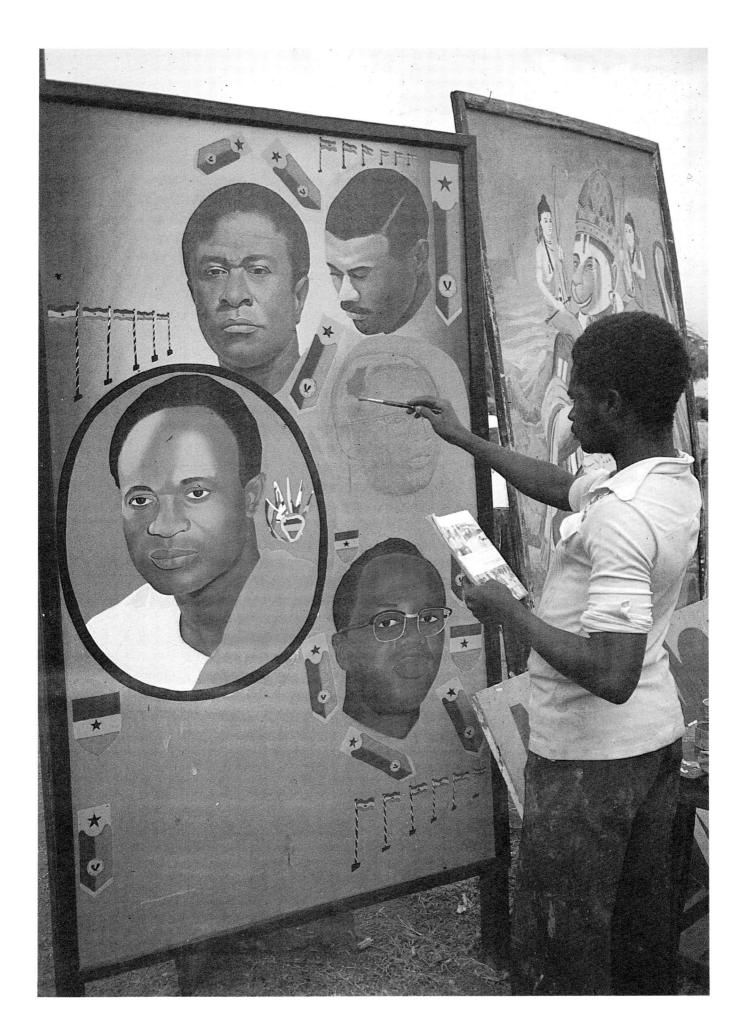

Fig. 16. "Painting: Sales and Delivery—Sand, Gravel, Cement," a sign leaning against the facade of the Leonard painting shop in Libreville, Gabon, 1989. The biggest steady income of many Urban artists comes from signs, banners, rubber stamps, and silk-screened T-shirts. Photo: Susan Vogel.

In the context of contemporary African art, the name "popular" causes immediate confusion. In a very real sense, traditional art, with very few exceptions, is (and was) also popular art, being made by and for the people. The name "popular" in art history also carries implications of "folk" and "naive" art, words that carry a suggestion of inferiority in respect of some other, more sophisticated social entity, and this does not fully describe Urban artists either: though they deal with issues of status in their art, and are aware of the relatively low social position they and their art occupy, their art is not a folk version of "high" art nor are they primarily preoccupied with social class. Folk art is also an inappropriate denomination. Folk art usually arises as a provincial or poorer version of "high" art, from which it may take many of its models. But there is no indication that Urban artists use any but the visual sources in their immediate surroundings to constitute their art. They show no inclination, for example, to imitate International art or traditional art. Like traditional artists, they address their own audiences full-heartedly, without looking over their shoulders, so to speak, at the "elite" arts. The implication that these artists are naive is false: though their artistic means are simple and direct, their view of the world is as nuanced and responsive as any other African art form, and their work is as expressive and eloquent.

In fact, Szombati-Fabian and Fabian argue that this art (which they call "popular") is not transitional (between tradition and modernity) but is the result of a synthetic consciousness: that artists and consumers "neither define the forms and contents of this art against a tradition nor towards modernization" (1976:18). Like the artists who originate New Functional art forms, these artists and their publics recognize no source for their art outside of themselves, and they see themselves as part of no linear historical progression. They function like the *radio trottoir*, the sidewalk broadcasting system that circulates rumors, unofficial news, and true, scandalous, and deflating stories of local and national events faster than real radio, and without benefit of any equipment at all. Urban artists and their publics see themselves suspended in their own time, owing nothing to the past, building nothing for the future, but continually inventing themselves and their culture by drawing on the here and now.

NOTES

1. There were, of course, large traditional cities long before the colonial period. Their art was what we would call traditional. And traditional art is also made and used in most African cities today.

2. Passions ran high. One night, some particularly charming paintings by an "autodidact" artist from Niger who had attracted public attention disappeared from the hotel lobby where they were displayed. Still, the first prize went to another "autodidact" artist, from the Central African Republic.

3. Stephen Sprague, describing the studios of ten photographers he studied in the Yoruba town of Ila-Orangun in 1975, reports that many had no running water or electricity, and that they exposed negatives for printing by means of an old view camera mounted in a window with sunlight directed to it by a mirror. A kerosene lantern with red cloth wrapped around the globe served as a darkroom light (1978:58).

4. The need to hold still during long exposures may have been a factor in the formality of these poses, though in the 1960s, '70s, and '80s I found that Baule villagers who wished me to take their picture stood similarly stiffly, though modern camera equipment had removed the need to do so. Sprague makes similar observations about the Yoruba.

5. See Shaw 1986. Bamba (1850-1927) was not only a major religious leader, but prefigured the independence movement by preaching that the people of Senegal could rule themselves without the French. Between 1895 and 1902 he was exiled to Gabon by the French, but returned a hero. The Senegalese salesmen seen selling useful things on the streets of New York in recent years are almost all members of the Mouride brotherhood.

6. In the literature, glass painting is sometimes given the corrupted French name *souwer*, or *suwer*, from the French *sous verre* or *peintures sous verre*—"paintings under glass"— phonetically transcribed with a Wolof accent. *Suwer* seems to have come to mean all kinds of decorative pictures, whatever their medium (Renaudeau and Strobel 1984:43).

7. See Renaudeau and Strobel 1984.

8. The pictures are backed with cardboard from used boxes and are edged with paper tape to hold the backing to the glass. They are sold ready to hang by a string looped through holes in the cardboard.

9. Tshibumba disappeared in disquieting circumstances in the late 1970s.

10. Szombati-Fabian and Fabian have made an extensive analysis of this image (1976:7-16). See also Bogumil Jewsiewicki's essay "Painting in Zaire" below.

11. Of all the criticism written about Cheri Samba lately, nothing touches the superb analysis by his longtime friend Jean-Pierre Jacquemin in "*Saint Cheri Samba, vie et oeuvres (im)pies*," 1990.

12. Cheri Samba says that most of his sales since 1987 have been to foreigners (interview, April 1990), and his recent exclusive contract with the Jean-Marc Patras Gallery in Paris effectively cuts him off from Kinshasa clients. (See cat. 81, which deals with his doubts about taking this big step.) He still lives in Kinshasa, however, and still exhibits his paintings in front of his shop. The paintings shown in his most recent Paris exhibition, in late 1990, treat local subjects, such as the coming of a democratic government to Zaire; yet they are completely accessible to Westerners. I doubt that he would be willing entirely to give up his Zairian following for a European one.

13. This audacity is no mere posture—Cheri Samba works in a place where political frankness is harshly punished. He narrowly escaped having his paintings removed from a Kinshasa exhibition because they were considered obscene, a threat with graver consequences.

14. Interview, New York, April 1990.

15. *Paris est propre* (1989; cat. 78) depicts African street-cleaners in Paris near the Trocadero (on the right of the picture), which houses the vast African ethnographic collections of the Musée de l'Homme, France's great art booty of the colonial period. No subtle point is being made, however—when he made the work, Cheri Samba was unaware of the building's contents (interview, April 1990).

16. This is not true of Senegalese glass painting, or of photography, however, probably because both require a more formalized training in the techniques that produce the works themselves.

17. The painting is *L'Arbre sterile au fruits amers n'est jamais l'objet des jets de pierres* (Jacquemin 1990:14).

18. The first seem to have appeared in Ghana right after World War II, and may be related to the highly elaborate Ghanaian tradition of proverbs. By 1952, Bogumil Holas had published an article on inscriptions on vehicles in Abidjan (Holas 1952). For an interesting analysis of the connections between painted vehicles and other Urban art forms, see Oledzki 1981.

PAINTING IN ZAIRE

From the Invention of the West to the Representation of Social Self

Bogumil Jewsiewicki

Urban painting in Zaire was "invented" (Hobsbawm and Ranger 1983) by and for the literate (but not intellectual) petite bourgeoisie of the cities. In the 1960s it had a strong regional basis, but today it is found more and more frequently in the homes of university graduates whose collective memory is less and less attached to regional roots. By the end of the 1980s painters had also been obliged to adapt to a generational change. Recollections of colonialization and of the explosion of political violence in the 1960s were embedded in the memories of the adult public of the 1970s, but the concerns of the younger generation of urbanites, those born during and after the 1960s, are dominated mainly by such worries as social injustice, the violence of daily life, political arbitrariness, and new gender and generation conflicts. These Zairians feel a tension between the ideal of political solidarity and sudden, unpredictable individual success. The image of Mami Wata (fig. 1) expresses their individual hopes; paintings of *Colonie belge* (fig. 2) translate their political experience (see the groundbreaking anthropological analyses by J. Fabian and I. Szombati).

Today, syncretic Christianity has displaced old social tensions and has redirected the energy that went into them toward more cooperative ends. The Christian ethic has also transformed the practice of sorcery, creating personal conflicts that have become a major theme of painting: the canvas has become more than a sign, it serves as a sort of ex-voto, a protection against evil—which may encompass the social other, including the other gender. The main themes of earlier Zairian urban painting were Mami Wata, *Colonie belge*, and civil war. This imagery survives in the paintings currently produced for local, private consumption, though the meanings have changed. And today's artists also divide their work between Christian themes, including the struggle against pagan evil, and village folklore in the form of landscapes, hunting scenes, and village ceremonies. The theme of erotic magic is largely reserved for foreigners and local intellectuals.

The urban painter, like the rural sculptor, resembles the jazz musician: he develops a theme without pretending to exhaust it. Neither the painting nor the performance is an attempt to surprise its public; instead, it re-creates what everyone already knows, and invites the participation of all present. The artist's imagination is limited to improvisations on well-understood themes, sometimes suggested by the client. Given that poor sales can stop production completely—since the painter may then lack the means to buy materials—these artists usually make numerous versions of themes that sell well. Such works are not copies, for successive paintings on the same subject are executed from memory, or from one original (a printed image, for example; see fig. 3), but usually not from earlier paintings by the artist. A sale gen-

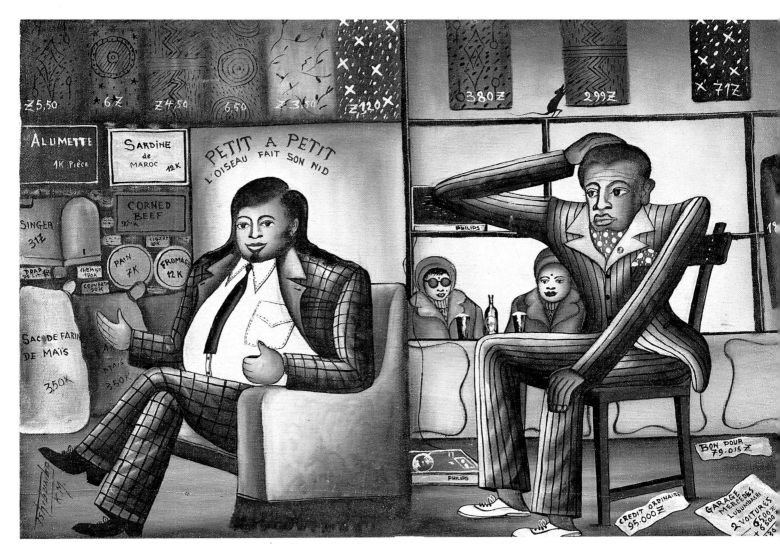

Petit à petit (Little by little), ca. 1970s, by Tshibumba (Lubumbashi), paint on flour sack. Collection: Bogumil Jewsiewicki.

erally leads to a new version of the theme by the same or another painter. Describing the period during which he worked mainly for the local market, Cheri Samba has said that he was not satisfied until he had produced at least two or three versions of a theme; he felt that he did better work from one depiction to the next, and that in a society without art critics, the sale of many versions of the same subject was a proof of success.[1] What we might call copies, then, are better seen as successive sketches.

A preoccupation with accuracy, and the attempt to legitimize his own discourse, push the painter to follow a model. A print, photo, or other mechanically produced image offers a way to organize the picture space, and the painter may copy important details. As the model is "digested," it undergoes variations from one execution to the next. An artist may work an image first in black and white and then in color. The pictorial model, which invariably comes from the West, seems to be accepted as a sort of legitimate language for the painter, as French words are in political speech. Those same models, in the form of pictures cut from magazines and catalogues, have decorated Zairian homes since at least 1920.

We must not forget that a painting is treated as merchandise in the exchange-structured relationship between painter and client. The same situation held in the old European-directed workshop studios. Around 1950, Maurice Alhadeff ran a painters' workshop in Léopoldville (now Kinshasa). He respected his artists' imaginations and bought everything they made, but he managed the paintings like the inventory of a curio store. The difference between his acquisition costs and his selling

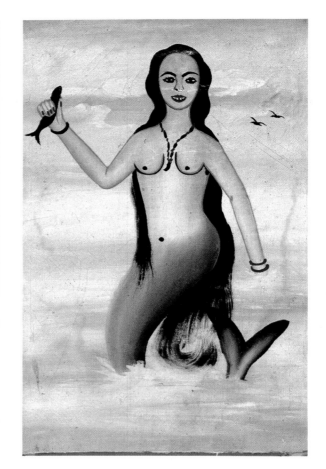

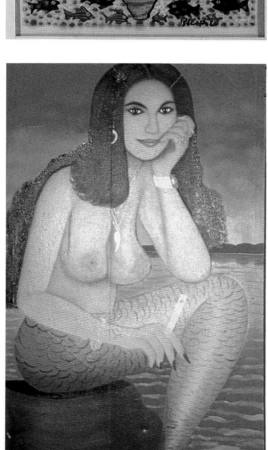

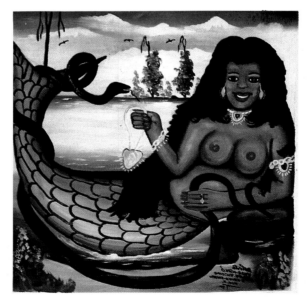

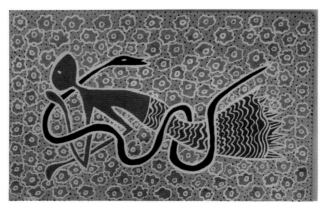

Figs. 1a-1g. The image of Mami Wata ("Mother Water") is found throughout West and Central Africa. In some areas, especially Nigeria, Mami Wata is also a religious cult. The image originated in the Western icon of the siren, and, at least in Zaire, in the European medieval tale of the mermaid Meleusine (H. J. Drewal 1988). There is also some West African influence in the images from Zaire, where West African traders were very numerous in the 1960s, but where Mami Wata has never been a cult. The Mami Wata story mainly addresses male power, including material wealth. An encounter with Mami Wata can give a man sudden access to wealth and power, but there is a price to pay: secrecy, fidelity to Mami Wata, and the sacrifice to her of one's family members.

The Mami Wata tale was circulating in Zairian cities at least as early as the 1950s, but became widespread only by the end of 1960, when the image began appearing in urban painting. The first images of the 1950s and 1960s (figs. a and f) were Western in form, and were produced largely for a Western audience. Mami Wata begins to show the influence of urban popular culture in the 1970s and 1980s (fig. b; see also cat. 64).

Since the late 1970s the Mami Wata image has increasingly described relationships between men and women, and has become increasingly erotic (figs. c, d, and e). Mami Wata becomes a prostitute (*femme libre*, or "free woman") and ultimately an overtly erotic female image in urban advertisements. In fig. g, an unfinished painting photographed in the Kinshasa workshop of the painter Wayis, the woman takes the place of the man in the Mami Wata story, and the snake replaces Mami Wata herself. The woman is rich: the snake, her lover, vomits money after each copulation. Their relationship must be kept secret. When the woman's human lover (hidden under the bed) discovers it, the charm is broken and she dies.

Zairian paintings of Mami Wata by:
a) Pilipili (Lubumbashi), n.d. Private collection. Photo: Eric Kawan. b) Artist unknown, probably late 1970s. Acquired from a Mbandaka trader who had it on display in his living room (see fig. 7d). Collection: Bogumil Jewsiewicki. c) Artist unknown, n.d. Unknown collection. Photo: courtesy J.-P. Jacquemin. d) Vuza Ntoko (Kinshasa), 1990. Collection: Bogumil Jewsiewicki. e) Moke (Kinshasa), 1975. Unknown collection. Photo: courtesy J.-P. Jacquemin. f) Mode Muntu (Lubumbashi), n.d. Collection: V. Bol. g) Wayis (Kinshasa), *Rich Woman and a Snake*, 1990. Photo: Bogumil Jewsiewicki.

The kinds of male-female relationship reflected in recent Zairian Mami Wata paintings are also demonstrated in local texts. Top right: an excerpt from the life story of an urbanized Kinshasa woman. Center right: a recent popular song by Luambo Makiadi, who is seen as a critic of Kinshasa society, and the OK Jazz, in the form of a dialogue between Adam and God. Bottom right: a recent newspaper article from Kinshasa.

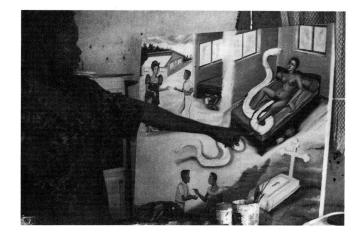

My younger sister was an "office" [mistress] of a high party official. He bought her two parcels of land, one in Bandal, the other in Lemba, and a car, electrical appliances, and so on. . . . Eventually there was an unfortunate encounter between the official and a young delinquent with no future who also frequented my sister. You must understand that men with money may have three or four "offices" at their disposal, on top of their proper domestic duties. They are often irregular visitors to their young women, who are in the full season of love. The women resign themselves to irregular visits because they have to feed and clothe themselves, like every Zairian woman who has any self-respect—that is, who wants to impress her friends. But sexually they suffer. Hence the possibility of love affairs with young unemployed men, marginalized but well taken care of by these women, the "offices" of the big bosses. This is how my younger sister lost everything she could have gotten from the high party official

(Ndombe wa Ntumba 1984:239-240).

How did woman become a she-devil made to ruin men?
Who taught us this deviltry?
You say that Eve was the first to eat the fruit.
Who gave the fruit to Eve?
Have you heard that a female angel quarreled with God to ruin you?
Men, you cause your own troubles among yourselves.

CHORUS:

You see your friend's wife,	But when it comes to your own wife
You try to court her.	You look for judges,
You see your neighbor's daughter,	You look for family strife.
You wink at her.	Quoted in Olema 1984:125.

How can a man who enjoys relatively great material and financial advantages lock himself up in his paradise without being tempted by the "serpent" or the noonday demon? How can a young girl or a mother, without education or defenses, and governed by need, resist the temptation to earn a few zaires in an interlude of pleasure that is not forbidden and is discreet? How can a "little chick" escape the claws of a young girl from a well-off family, or of a famous woman, or of a sexually unsatisfied "diva," if all that is asked of him is to give a little pleasure, to "render a service?" How can a well-educated but poor young girl or mother keep up with the competition of women's fashion, or with the daily spectacle of walking wardrobes and women encrusted with jewelry, without spending some supplementary hours outside the conjugal roof? How can they hold up their heads before coworkers who are "installed," and who only come to work in taxis?

Who shall throw the first stone, and at whom?

We must simply be aware of the dangers that confront us, and with which we confront others, including our own families. In this context, we are more in need of ethical than of technical assistance.

Ndombe Mundele, "*L'humanité malade du sida,*" *Salongo*
29 March-4 April 1990, p. 7.

prices enabled him to amass a stock of a few hundred canvases to protect the studio from the ups and downs of the market. By the same logic, Moke and Cheri Samba, successful Kinshasa painters today, work for the local market only upon orders the customer makes from a photo album of their earlier works. During the 1970s, Pilipili, a Lubumbashi painter from Le Hangar workshop of Pierre Romain-Desfossés, rarely painted a noncommissioned painting, working mainly from photos of his own works.[2]

It would be erroneous to conclude that the painters' imagination is limited. Rather, it is channeled by the market toward either repetition or diversification of themes. The nature of each artist's clientele, and particularly the proportion of local to Western buyers, determines the degree of thematic diversity. Painters less established than Pilipili or Moke usually work with a wide variety of themes, knowing that their small number of customers can acquire very few paintings, and that the same theme is unlikely to be purchased twice. A painter with many clients, however, may find any number of customers for paintings on a single theme. Again, depending on their access to the foreign market, the painters find themselves faced with two opposing tendencies. On the one hand, the local market of Zairians and passing tourists may encourage the repetition of successful themes. On the other, although limited in number, foreign art-lovers who sometimes present themselves as patrons may favor experiments and thematic diversity. The painters' access to these markets varies considerably depending on their geographic location and personal contacts. Often the "discovery" of an artist by Europeans is a matter of chance. According to many painters, it is impossible to live on local sales, even for the artists who paint advertising signs, unless one has access to one of the two markets of foreigners—the tourists and the patrons.

Contemporary Urban Painters and Their Work

It is difficult to compile an inventory of any one painter's works when it is so important to the artists to sell their canvases. Only those most famous outside Zaire, such as Cheri Samba or Moke, have photographs of their relatively recent work. Cheri Samba has kept a photo of every painting he has done since his Parisian successes. In addition, a theme executed only once may disappear among more popular themes that appear in several collections, and that seem to echo the distinctive themes of urban art.

These painters are highly dependent on the social imagination of the milieu in which they work, and are very sensitive to the reactions of their public. Their creations are as much chronicles of social and political life as they are materializations of imagination and social memory. Many of them tend to favor certain themes: Moke, from Kinshasa, for example, could be classified as a journalist with an eye for spectacular events, often picked from the news (a public ceremony, the passage of a presidential cortege, a reception given by a noted host, even a traffic accident; cat. 72-75). Cheri Samba, also from Kinshasa, is primarily a moralist and teacher who will try to instruct not only members of his own society but anyone he considers in need of a lesson, as illustrated by his recent painting *Paris est propre* (Paris is clean, 1989; cat. 78). Tshibumba Kanda, from Lubumbashi, who vanished in the early 1980s, was essentially a historian, and was sensitive to contemporary political events (fig. 4). Even if the limited corpus available to the writer makes the designation of a specialization for other painters more difficult, such specialization is present, as Zairian art critic Badi-Banga Ne-Mwine has emphasized (Badi-Banga 1977:27). While open to all requests that might involve a sale, each painter at the same time reacts personally to a particular social milieu.

That sensitivity to milieu dictates

themes and subjects, as in Cheri Samba's painting *Les Capotes utilisées* (Used condoms, 1990). The artist was in the process of finishing this work when a short paragraph about condoms being used by children as balloons (see fig. 5) appeared in a Kinshasa newspaper. At the time of my visit in March 1990, a month before the end of the Second Republic, Cheri Samba was working simultaneously on this painting and two others for his New York exhibition. Each addressed an important local problem of the moment. *La Rue des lacs* (The street of lakes) calls on citizens to get involved in repairing the potholed roads that are paralyzing the city. The painting takes up the government's call for decentralization and for public involvement in social affairs, but criticizes the lack of state maintenance. Some see the work as a stark unveiling of corruption and misappropriation of funds. Another painting deals with the proliferation of syncretic Christian churches, seen as a major political problem. *Les Capotes utilisées* is as much about AIDS as about public morality, with a wink at eroticism, the hidden side of Cheri Samba's work. All three subjects were at the center of any conversation in Kinshasa at the time (see fig. 5).

Cheri Samba seems to enjoy slipping more or less explicit allusions to eroticism into his paintings, despite the double censor that he faces in the public and the state. Erotic images are explicitly prohibited in Zaire; an exhibition of Cheri Samba's work in Lubumbashi in 1984 was nearly banned at the last minute by the governor. Born and educated in a region once marked by Protestantism and later by the presence of Jesuits, Cheri Samba himself represses his obvious taste for painting nudes. He always needs a reason (such as criticism of adultery, or other kinds of moral correction) to justify the painting of nudity to himself.

In the case of Cheri Samba, as in that of many other painters, one can speak of forbidden games made possible by the European clientele. Erotic paintings are produced only for Europeans; the painters actually hide them from local women and children. The sexual freedom of urban Zaire is only an appearance veiling the exploitation of women, especially young girls, by the powerful. In this prudish society, sex is a kind of merchandise to be exchanged for money and power. So say many popular songs, at any rate, as well as a number of Cheri Samba's paintings.

From "Traditional" Art to the Invention of Painting

"Popular"[3] art in Zaire today is a purely urban and increasingly "petit bourgeois" phenomenon. In order to understand its place in Zaire's postcolonial society, one must put aside the Western bourgeois notion of art, without, however, abandoning it completely. We must transfer the focus of our analysis from the unique work of art to the relationship between the artist and society, particularly noting the sociopolitical dynamics of power. We need not abandon aesthetics—quite the contrary. But it is essential to realize that aesthetics and taste are not only social but political phenomena, with a history of their own (Jewsiewicki 1989a). In its history of mutation and invention, Zairian painting passes from politico-religious commentary to profane decoration, without dropping the linkage between aesthetics and politics. It also moves from the work of urbanites in search of social identity to a function as commodity, as petit bourgeois urban art.

The roles of the artist as an individual creator, of the work of art as a unique object, and of the spectator/consumer who "discovers" the objet d'art's aesthetic value are important to the understanding of art in Western bourgeois society. But these distinctions were irrelevant to the societies of premercantile Central Africa.[4] The artists of such societies may have given birth to forms, but those forms did not become the bearers of the artists' social identity. And the artist held no copyright over any form unless politically authorized to do so. A Kuba king, for example, could proclaim himself the author of any new form created by the artists of his court (Bope, n.d.:12-13; see also Vansina 1978). The distinction between the material act of creation and the social title of creation is analogous to a social group's treatment of parenthood: the father is considered a parent only if—through an agreement such as marriage, adoption, or purchase—he has the right to engender the relationship that brings his offspring into a given group.

Icon and performance, inseparable from one another in premercantile Africa, together constitute a symbolic and codified communication. Colonialism imposed important changes on this kind of communication through its diffusion of mechanically reproduced images. The narrative understanding of these images was dictated by bureaucratic institutions such as church and school, and authority came to be contained in text, whether pictorial or written. Insofar as it was supported by an institution, text represented institutional authority; it stood outside the passage of actual time and shunned the circumstantial improvisations possible in performance, imposing instead a narrative, purpose-oriented logic. (A village parade of the colonial hierarchy could constitute a performative reading of the political order [see fig. 6d, Lubaki's Visit to the governor]. It was principally a way of appropriating the text and cannibalizing authority.)

In colonial and postcolonial Africa, written text and mechanically reproduced images (coins, tax chips, religious and chiefs' medallions, printed images of the saints, book illustrations) have been imposed as the norm by bureaucratic authorities. Presented as more truthful than what is actually real, they modify visual communication and impose upon it the linear construction of Western (Indo-European) language. Increasingly, especially

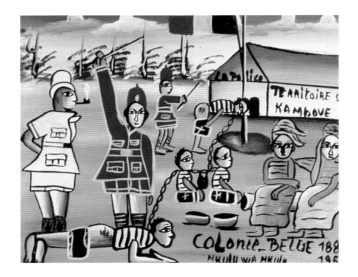

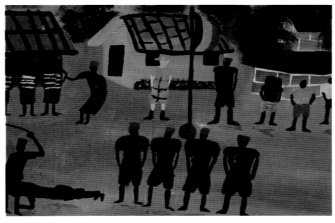

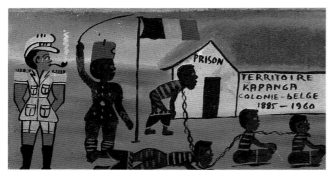

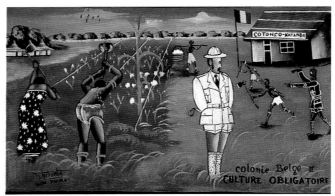

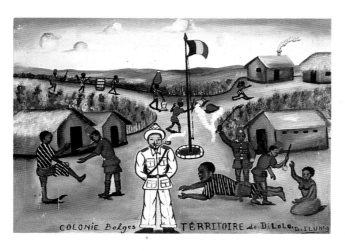

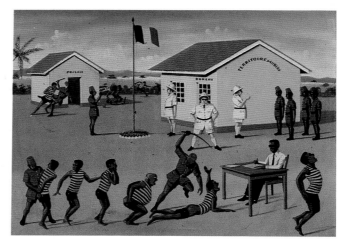

Figs. 2a-2f. *Colonie belge* (Belgian colony) paintings not only describe part of the actual history of life in the Belgian Congo but also allude to the domination of individuals by the state today. The theme probably appeared in the urban art of Shaba province, Zaire, as early as the 1960s (see Szombati-Fabian and Fabian 1976), then spread throughout the country during the 1970s. Its popularity is a result of President Mobutu Sese Seko's introduction in 1972 of such practices as weekly compulsory collective labor for public purposes, usually done on Saturdays (*salongo*), and the "*salut au drapeau*" (salute to the flag), recalling former colonial abuses. The *salut au drapeau* takes place every morning in front of every government building, including schools and hospitals. As in colonial times, it is intended to confirm the submission of the people to the state.

Colonie belge paintings vary from place to place to reflect local events and memories. In the eastern part of Zaire, the paintings frequently depict the execution of white missionaries by rebels in the 1960s. In the southern part of the country, the theme is most often presented as a rendering of specific historic events, while in Kinshasa it is usually stripped of historical context and presented simply as a crude flogging of citizens by soldiers (see fig. 10c).

Paintings of the *Colonie belge* theme by: a) Nkulu wa Nkulu (Lubumbashi), 1973. Collection: Bogumil Jewsiewicki. b) Artist unknown, n.d. Unknown collection. Photo: courtesy J.-P. Jacquemin. c) Artist unknown (signed F. T., probably Lubumbashi), probably late 1970s. Collection: Bogumil Jewsiewicki. d) Tshibumba (Lubumbashi), early 1970s. Collection: V. Bol. e) B. Ilunga (Kolwezi), early 1970s. Unknown collection. Photo: courtesy J.-P. Jacquemin. f) Artist unknown (Bunia, northeastern Zaire), 1990. Collection: Bogumil Jewsiewicki.

Top right: a Zairian remembers the days of the colony, and bottom right: an excerpt from a Kinshasa newspaper's letters page during the Mobutu years.

Lokolama was a prison village. First the soldiers would come before the sun was up to wake us with blows of the whip. And this whip was worthy of the name. You'd get about ten lashes and you wouldn't feel the cold. We'd run away like tarsiers [lemurlike animals] surprised in their nest by a snake. After a roll call, we'd run to the well to draw water: tanks and tanks to be filled every day. And then we'd go to the fields, which were endless. When we came back, we'd have to weed the yard. Work is good when the body is nourished, but we barely saw a plantain and were so skinny that you could count our ribs under our skin. This went on and on.
(Nyang Nyang 1984:203).

It happened during the salute to the flag

Citizen Editor in Chief:
 I am a worthy son of this country and I have the right to have my dignity respected. Just because I was walking on the avenue de l'Université in the Ngaba area, more than a hundred meters from a police station where a salute to the flag was beginning, is no reason for a policeman to have grabbed me by the belt and to have dragged me away to be humiliated in jail.
 If I am writing to you to publish my indignation, it is because some policemen are showing an excess of zeal. When you hear no whistle, and no one in the know signals you that a salute to the flag is beginning, wouldn't a simple statement, or a polite warning, be a better course for the police than to humiliate you?
 Mbayamwanza Kankologo
 Av. Kisangani
 Kinshasa/Ngaba

The editor's reply:
Article 138 of the Penal Code punishes any outrage to a national emblem by penal servitude of from eight days to three months. In effect, out of respect for the national dignity-which includes your own—the law forbids any gesture of contempt against the flag and other emblems of the state.
 Salongo **29 March-4 April 1990, p. 8.**

in the cities, images are circulated in mechanically produced copies rather than through performance. Possessing such an image attests to one's social position, or to one's allegiance—as in the case of those urban homes decorated with illustrations cut from magazines and catalogues discarded by whites. The urbanite's choice of decoration was limited, leaving almost no room for aesthetic preference. These illustrations exposed urbanized Africans, at a very early date, to the authoritarianism of industrial mass culture. The decoration of the home proclaimed one's identity, one's inclusion in the "modern" world, as did the names Beleji (Belgian) and Mundele (white), the wearing of Western clothing, and the use of the name Belge for a town's African quarters.

Throughout the twentieth century, the village performance has been progressively transformed into objet d'art and merchandise. The renaissance of tradition, especially in terms of the political manipulation of its external signs, became central to the ideology of authenticity in Zaire's Second Republic (1965-1990). Since the mid 1970s, "traditional art" has offered a unique opportunity for the villages—emptied by the urban emigrations, and abandoned to economic and political isolation—to affirm themselves as guardians of "roots." President Mobutu Sese Seko's "authenticity" policy, built around an idealized anthropological conception of African culture and a simplistic redefinition of ethnicity, was intertwined with the international trade in African art. Zaire's collective ethnic memories, embodied in objects and oral texts ostensibly from the past, gained new force, while postcolonial ethnography reproduced a tale of the continuity of tradition, treating the colonial period as a parenthesis (Jewsiewicki et al. 1990). The effort to shape Zairians as producers of cultural artifacts "from the past" was a safe way of defining a politics of the future. Anthropological surveys fo-

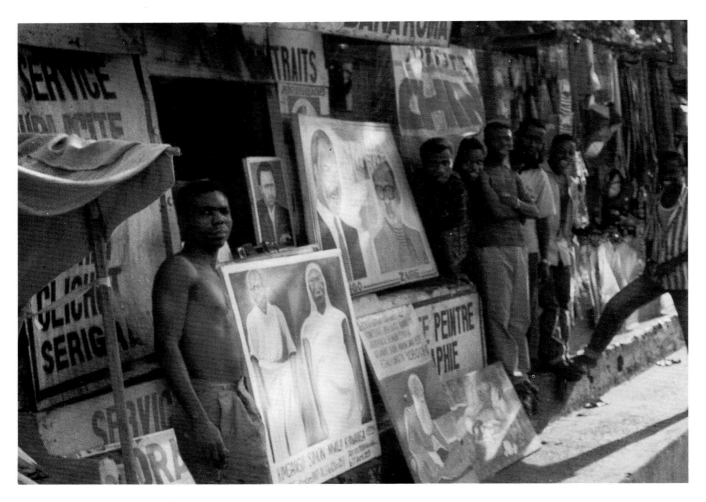

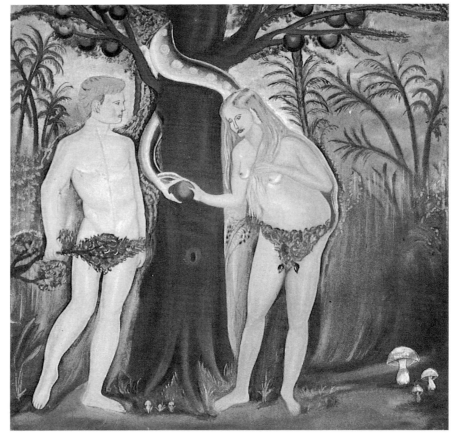

Figs. 3a-3c. The painter and the model. Chin is a very active Kinshasa painter who produces both paintings on canvas and mural advertisements. I bought a painting of Adam and Eve from him that was exhibited in front of his workshop (fig. c). Two days later, I found him working on another painting based on the same lithograph (fig. b). When it was finished, the new version was undoubtedly also shown outside the workshop. a) Chin in front of his workshop, Kinshasa, 20 March 1990. b) *Adam and Eve*, unfinished new version, 1990, by Chin, also showing lithograph that served as the model for both versions. Photos: Bogumil Jewsiewicki. c) *Adam and Eve*, 1990, by Chin, oil on canvas. Collection: Bogumil Jewsiewicki.

cusing on tradition, and the sale of "ancient" art objects, stimulated this attempt to affirm a collective political self under an ethnographic umbrella. Just as the authenticity ideology stressed the continuity of the old traditions, disguising the colonial origin of the contemporary state, art experts agreed that truly African art stood apart from time and real contemporary life.

An important prejudice lies in the denial that Africa's creativity could absorb and digest the colonial shock. The division of culture into two poles—modernity and tradition, separated by the colonial conquest—sidesteps the problems of appropriation—of Africa's cultural and intellectual cannibalization of the West. Today, in fact, the only modern art considered legitimate in Zaire operates within the framework of Western culture. This includes works that celebrate the Africanization of Africa (Mudimbe 1988).

We have obscured the invention of a West in the African imagination. This invention has been at work in Central Africa for a century. Cultural intermediaries there have cannibalized the West without losing their identity;[5] artistic and religious creators, in fact, began to explore an idea of the West at the moment of the first contacts, integrating the West into their construction of a world vision. Christianity played a part in this process: the West's book—the Bible—and its symbols helped people to imagine a less unpredictable world, and to act in that world. At least since the seventeenth century in the Kongo culture region, Saint Anthony seems to have played a pivotal role in the appropriation of Christianity, his cult statuettes serving as charms for personal protection. In 1704, a Kongo woman named Kimpa Muita, baptized Beatrice, undertook a program of social reform that accorded to the Christian logic of redemption, which it combined with the healing idiom of Kongo society. A woman incarnating a male saint, she gave Saint Anthony the political legitimacy of a matrilineal an-

cestor. She also gave her followers, the Antonians, a dream of restoring a matrilinear social structure (Gonçalves 1980). For decades this intellectual and artistic movement was considered a cultural bastard, and was thought to spring from Kongo inability to understand Western culture. The Antonians were thought childish and primitive, for the West resists appropriation by other cultures; it has never agreed that cultural exchange goes in both directions.

The Origins and Social Context of Zairian Urban Painting
The first Zairian paintings on paper and canvas—by Lubaki and Tshyela Ntendu (Cornet et al. 1989), from the 1920s and 1930s—should similarly be analyzed as an intellectual and artistic reading of the colonial West. These painters tried to understand what colonial modernity meant, seeking to put the colonialists, their objects, and their people into a meaningful framework (fig. 6). They did their best to play the game of making the West understandable and acceptable to their fellow urbanites, using the plastered walls of houses as well as paper to figure in paint their understanding of the Western perception of themselves and their universe. But knowledge is power, and once Westerners had satisfied their curiosity about these artists they allowed them to sink into oblivion, despite exhibitions in Brussels, Paris, Geneva, and Rome. The Western market was only interested in "traditional" and "primitive" art (which had just emerged as an investment), "unspoiled" by the effort to be socially relevant.

In order to understand these artists' lives, so typical of the Belgian colonial world before 1950, we need to compare painting with writing, especially printed writing, and to consider the role of Christianity. A Lubaki drawing depicting objects and themes of colonial "modernity" would speak to someone who knew the code and could reconstruct the performance, giving it social and

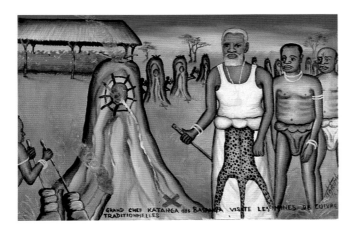

GRAND CHEF KATANGA des BASANGA VISITE LES MINES DE CUIVRE TRADITIONNELLES

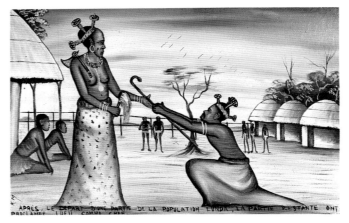

APRES LE DEPART D'UNE PARTIE DE LA POPULATION LUNDA, LA PARTIE RESTANTE ONT PROCLAMÉ LUEJI COMME CHEF

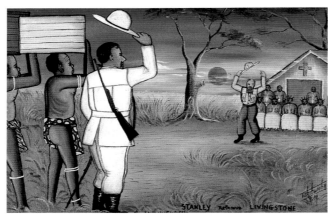

STANLEY Retrouve LIVINGSTONE

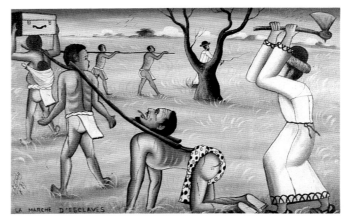

LA MARCHE D'ESCLAVES

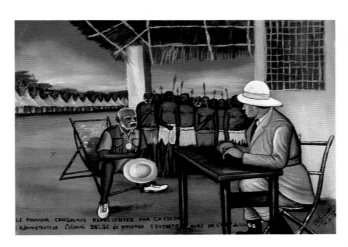

LE POUVOIR CONGOLAIS REPRESENTER PAR LA COLON L'Administrateur Colonial BELGE de passage S'ENTRETIEN AVEC UN CHEF

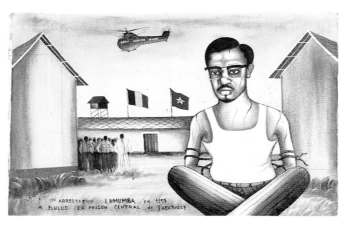

1er ARRESTATION LUMUMBA en 1959 A BULUO LA PRISON CENTRAL DE JABOTVILLE

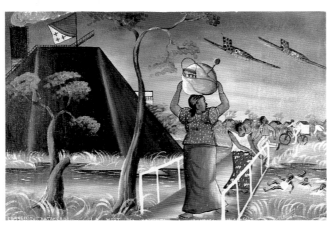

LES ELECTIONS KATANGAISE

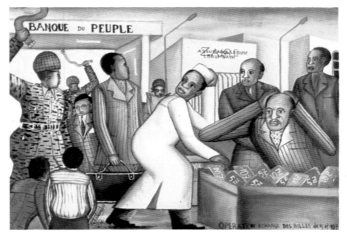

BANQUE DU PEUPLE

OPERATION ECHANGE DES BILLES de 15/11/197

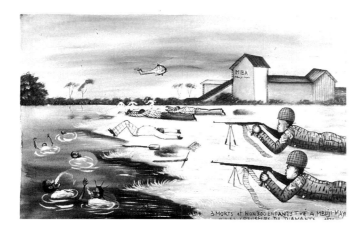

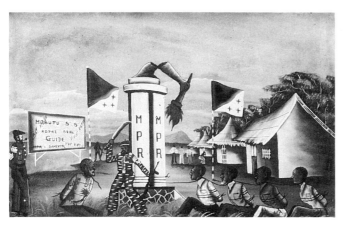

Figs. 4a-4j. The Lubumbashi painter Tshibumba Kanda, an artist of the 1970s, always thought of himself as a historian of Zaire. Even when painting contemporary events, he treated them as a historian would. An important portion of Tshibumba's work shows scenes in southeastern Zaire from precolonial times to the present. In the late 1970s he also painted events from the history of the Kongo kingdom. His painting of the colonial and postcolonial past is largely done from a "national" point of view, with Patrice Lumumba his favorite hero. The secession of Katanga, the subject of numerous paintings, is presented more as a time of suffering than as an event that failed to bring autonomy.

Tshibumba's captions (always in French, though here translated into English) are as significant as the details of his paintings, both testifying that something really happened in the time and place shown.

a) The great chief Katanga of the Basongo visiting the traditional copper mines. b) After the departure of one part of the Lunda population, those remaining proclaimed Lueji as chief. c) Stanley finds Livingstone at Mulungwishi. d) The march of the slaves. **e) The Congolese power represented by the colony. A Belgian colonial adminstrator talking with a village chief. f) First arrest. Lumumba in 1959 in Bulolo, the central prison in Jadotville. g) Katangan secession. The death of the innocents in Lubumbashi, 1960-1963. h) Operation for the exchange of five- and ten-zaire notes. [To reduce the amount of paper money in circulation, Mobutu decreed that old five- and ten-zaire notes were no longer valid and should be exchanged for new ones, in designated banks, within a very short time span, and for a limited amount per person.] i) Three deaths and 300 children not killed in Mbuji-Mayi. "The diggers of diamonds" 1978. [Presenting both the official and the opposition's versions of an event in which the Zairian army opened fire on individuals lawfully digging for diamonds in Kasai; Tshibumba paints the three deaths officially acknowledged on land, but also many more dying in the water.] j) Tribalism in the Shaba aggression, or the massacre of the militants. March 9, 1977. All paintings collection of Bogumil Jewsiewicki.**

political meaning. As in the religious discourses of the period (Tupelepele, Kimbanguism), the work does not so much fetishize modernity as take control of it, acquire knowledge of it. It's true that a Lubaki drawing of a black man on a bicycle belongs in some ways to the same category as a photograph of a well-dressed family with a bicycle, or with a sewing machine: it is a confirmation of success. But since these artists used a Western medium of communication, their work also fulfilled a need for knowledge, enabling people to make sense of the colonial world, a world that at first seemed mad. In a frenzy of image-making, Lubaki and Tshyela Ntendu created an inventory of colonial society while attempting to master it. Trying to understand the world around them, they also used the visual language of performance —pot-lids carved with scenes from old proverbs, and other such. Their construction of this iconic account incorporated narrative principles into the logic of a performance. Their experiments with two-dimensional language are very similar to the construction of a printed story in a mission journal.

Among urban painters as among syncretic religious leaders, it is important to establish a professional and spiritual genealogy—to be educated by such-and-such a person, who had served an apprenticeship with such-and-such a person, and so on. (This is also a common practice among Islamic scholars and leaders in Africa.) Kinship, the political idiom of society, serves to define the relationship between master and pupil in such a way as to reassure the prospective buyer, especially the foreign buyer, of the worth of the proposed merchandise. Like a Kuba mask or a Luba sculpture, a Pilipili or a Tango (see Cornet et al. 1989:134) painting has guaranteed market value. The mechanism is largely profit- and sale-oriented, but also arises out of the mutual ignorance of artist and client as to the respective cultures and aesthetic values of the other. This

situation is well described by André Scohy (1950:140), writing of the period around 1940: "Thus it is remarkable to see the speed with which the fashion for whipped cream skies or canned spinach trees can spread. . . . And, as soon as a landscape seems to have any real success, you see it reproduced in two, three, sometimes ten examples until the clients' appetite is satiated."

Throughout the 1950s, the colonial administration actively promoted various forms of interior decoration. In homes like Lubaki's in the 1920s, the walls might be painted with images of objects and persons, but the only decorations brought in from the outside would have been the illustrations cut from magazines and catalogues thrown away by whites. Wedding photos, or snapshots of the man of the house with his bicycle, did not enter the home until the 1940s and 1950s, when the social structure and the organization of domestic space, with the encouragement of the colonial authorities, began to follow a bourgeois Western model. Paintings found their way into local people's homes during the 1970s, alongside other forms of interior furnishings such as magazine illustrations, mechanically reproduced images of saints, enameled saucepans, wild-animal skins, and sculptures and copper repoussé works from the tourist market (fig. 7). This was a moment when urban Zairian society was again beginning to enjoy a relatively autonomous social and cultural life, as it had experienced on two previous occasions—first in the 1920s and then again at the end of the 1940s. Georges Thiry, the Belgian administrator who "discovered" Zairian urban painting for the West, has described the atmosphere of the 1920s:

Sunday, returning from my walk over to the ivory carver's hut [Lubaki's], I see Elisabethville [Lubumbashi] glowing. The bars, the cinemas overflow with blacks. To the bicycle races flock a crowd of clerks, garage mechanics, factory workers, telephone operators from the railroad, and workers from the copper mines. In the native quarter victrolas play under canopies, the blacks are putting the last stitches on inexpensive shirts cut out of sacks that once contained Le Soleil brand flour, or they munch roasted ears of corn. Over beyond winds a locomotive dispensing bouquets of sparks. Negresses called Bonbo Kongolo, Mitonga, Marguerite Avion, Gabrielle Kousou, Isabelle Mwamba, in their Sunday dresses, their long legs in white stockings and high heels, pedal past on bicycle promenades along the road (Thiry 1982:18).

The trio of bar or dance hall, music, and painting is the dominant feature of every affirmation by this urban society of its cultural autonomy. These three elements, in fact, may be associated in many ways with the application of expressions such as "detribalized" as opposed to "native."[6] As early as the 1920s, symbols of Western everyday culture such as clothes and glasses were being recycled and digested by Zairians:

I pass near a series of huts, then kinds of villas decorated with old automobile tires and surrounded by fences made of flattened gas cans. . . . A chicken cut out of a piece of zinc serves as the weathervane of a shanty; a gas drum filled with earth becomes a flower pot (Thiry 1982:13).

And I notice that the modern blacks have observed and reproduced on their walls, often with great ingenuity, the trains and their mysterious whistles, the river steamers and their national flags, the planes, some with one board, others with two, as the Congolese say; the bicycle that leaves on the earth an endless cord, the telephone with its Hello Hello, the revolver that resembles a spring, the missionary who smokes enormous pipes, the parasol of Madame. . . . I discover too, reproduced on the walls, elephants and wrist watches, leopards and garters, pairs of scissors, faucets, watering hoses, in short the thousand and one inventions that embellish a great city bazaar in Europe (Thiry 1982:11, 13).

Figs. 5a-5c. Excerpts from Kinshasa newspapers give the best proof of Cheri Samba's sensitivity to local issues. These reports were all published at about the same time that the artist was working on the paintings illustrated here. Announcing the New York exhibition in which the paintings were shown, the weekly paper *Salongo* compared Cheri Samba to the well-known Kinshasa singer Luambo Makiadi, whose songs frequently criticize Zairian society (fig. 1), and called him "an authentic artist, in touch with the depths of his people's souls, and with their most unpronounceable dreams" (*Salongo* 29 March-4 April 1990, p. 12).

Paintings by Cheri Samba (Kinshasa, b. 1956): a) *Les Capotes utilisées* **(Used condoms). b)** *La Rue des lacs* **(The street of lakes). c)** *Pasteurs d'aujourd'hui* **(Today's pastors). All paintings 1990, acrylic on canvas. Photos: courtesy Jean-Marc Patras Galerie, Paris.**

CONDOMS
Only the evil-minded can be scandalized by my repeated attacks against the administration of city hygiene. There really is ample cause. What I see is more than upsetting. I would say it is even criminal. . . . Around certain hotels in the capital, you can find kilos of used condoms. Children pick them up and try to blow them up like inflatable balloons.
Salongo **29 March-4 April 1990, p. 2.**

It cannot be repeated enough that Kinshasa "the beautiful" [*la belle*] is becoming more and more "the garbage pail" [*la poubelle*]. The spectacle of stopped sewer drains, of gutters and drains full of sand and refuse, is our daily lot.

La Semaine 30 March-April 2 1990, p. 8.

The residents of Kinshasa...participate as accomplices in the degradation of the city. It cannot be otherwise when one sees high grass growing near houses, and when one looks at the corners of vacant lots and streets being transformed into dumps and urinals, if not restrooms.

Elima 22 March-2 April.1990, p. 2.

Must we wait for the command of *salongo* [compulsory community work] to clean up the refuse that blocks our gutters every day?

Le Phare 22-28 March 1990, p. 5.

To fight against what defiles the capital is to battle against potholes, to annihilate the tendency to transform every street into as much of a garbage dump as the streets and avenues of the markets, where traffic has become impossible.

Le Phare 22-28 March 1990, p. 5.

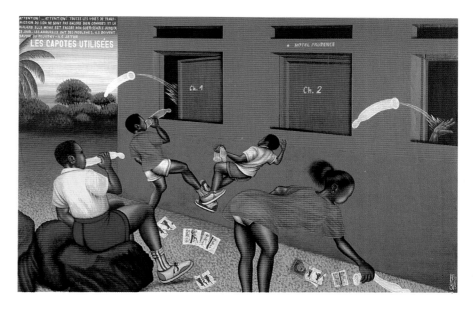

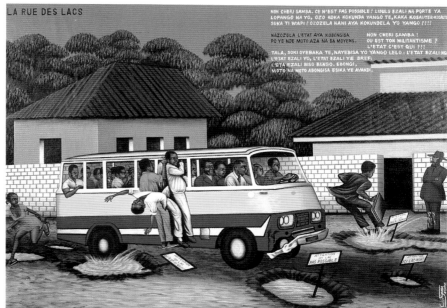

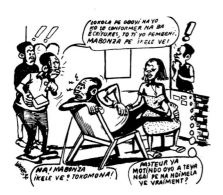

A cartoon from a page of Salongo (29 March-4 April 1990, p. 19) devoted to a well-publicized conflict in the Pentecostal church involving the moral conduct of one of its local leaders. The cartoon's text, in Lingala, reads:
Man on left: Because of your behavior, which has not conformed to the Scripture, you are fired! In fact, you won't get any contribution from the Church.
Preacher: Not even the contribution from the Church? Well, we'll see!
Observer on right: Would I believe the word of this type of preacher?

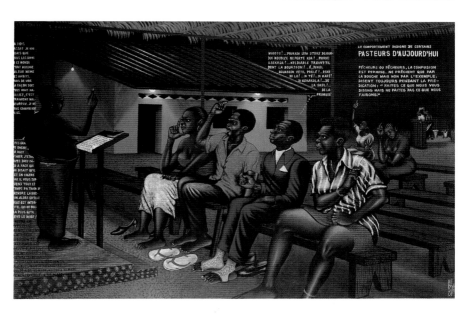

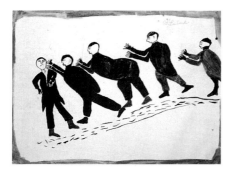

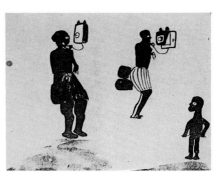

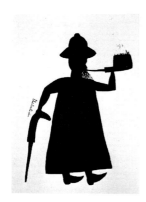

Figs. 6a-6m. Albert Lubaki's and Tshyela Ntendu's inventory of the colonial (modern) world (made between 1926-1936): a) Lubaki and his wife Antoinette with friends in Panda Likasi (Shaba) mining town, late 1920s. Photo: Thiry 1982:12. b) Wall painting from Uele region, probably first quarter 20th century. Georges Thiry describes the same kind of painting in Shaba and in Kasai in his story of his "discovery" of Lubaki and Tshyela Ntendu. Photo: Périer 1948:56. c) Colonial army, by Tshyela Ntendu (Kasai). Photo: *Horizonte* 1979:153. d) Visit to the governor, by Lubaki (Shaba). Photo: Cornet et al. 1989:47. e) Village, by Lubaki. Notice the man on a bicycle in the center, above him a huge table (a symbol of bureaucratic power), and the Belgian flag in front of the local colonial administration post: there is a scene similar to this, minus the bicyclist, in one of the *Colonie belge* paintings—see fig. 2f. Photo: Cornet et al. 1989:35. f) Congolese [Zairian] telephone operators, by Lubaki. Photo: Périer 1948:72. g) The missionary, by Tshyela Ntendu. Photo: Thiry 1982:35. h) Madame (white woman) with umbrella, by Tshyela Ntendu. Photo: Thiry 1982:36. i) Colonial agent with a typewriter and a bottle, by Tshyela Ntendu. Photo: *Horizonte* 1979:147. j) Train, by Lubaki. Photo: Cornet et al. 1989:15. k) Car, by Tshyela Ntendu. Photo: ibid.:25. l) Steamer, by Tshyela Ntendu. Photo: ibid.:27. m) Bicycle, by Tshyela Ntendu. Photo: Thiry 1982: cover.

Black urban mutual-assistance organizations and clubs had much in common with the social life of white colonial society, which was also populated by solitary people searching for community outside the institutions in which they were employed. The African mistress, called a "housewife" by the whites but a "*femme libre*" (prostitute) for the blacks, was an important member of a society characterized by professional, residential, and social discontinuity. The moralizing canons of Christian bourgeois culture speak of this society in terms of anarchy and debauchery, but it actually had a coherent cultural logic. Entrenched in this logic is the image of Mami Wata. African urban culture was crushed during the 1930s, when people were forcibly returned to the "traditional" life of African villages or to urban workers' compounds. Very often, however, these people had already been shaped by whites—missionaries, administrative officials, and so on.

The paintings on canvas of the 1940s and 1950s seem totally unrelated to the plastered and painted house walls of the 1920s and bear little relation to the magazine illustrations used for urban interior decoration. They seem created to satisfy the white man's vision of Africa, to help him invent his "true" Africa:

In many cities of our colony [the painters] go from terraces to cafés selling their illustrations. Among those in Léopoldville [today Kinshasa], consider Albert Mongita, whose canvases sell for around a thousand francs and sometimes more. For his animated scenes, his views of markets and festive crowds, they call a painter named Dombe "a black Brueghel." Nkusu da Costa, an Angolan living in Léo, specializes in landscapes and portraits, as do the Bata and Kiabelua brothers (Scohy 1950:140).

In the 1950s, the higher strata of urban society, the *évolués*, were promised assimilation into the colonial world on the condition that they conformed to the Belgian petit bourgeois life-style in their homes, dress, eating habits, etc. Music and later painting, initially addressed to the ordinary city-dweller, cannibalized this petit bourgeois model of behavior and integrated it into local urban culture. For at least a quarter of a century there were two cultural models in the cities: one trying to integrate elements of local African culture into a Western model—of which Mobutu's authenticity doctrine is a culmination—and another digesting the West into a living Zairian urban culture. In the 1970s, an urban painter would "photograph" with a paintbrush the face of his client, using a passport photo as a model—not only because urban poverty made a painted portrait cheaper than an enlargement, but also because painting gave the artist more freedom to portray a social ideal of beauty and respectability (fig. 10e).

Contemporary Urban Painting in Its Social and Cultural Setting

A Zairian painting refers to a story and emits a narrative, even when the story is not explicitly represented in the picture space. A number of paintings adopt a comic strip style (Cheri Samba first drew comic strips), each image constituting a chapter in the tale. An even greater number of works contain numerous episodes of a story—not clearly distinguished from each other pictorially, but intersecting with one another instead to produce the effect of a simultaneous narrative. As no sequence is imposed among the images, the viewers must create one, adjusting it to suit the meanings they give to each element. It is possible to twist these meanings, to contrast them with their variants, and thus to observe them in a temporal dimension of one's own. Time becomes a category created by the observer. These works reintroduce the factor of contingency, chance, surprise, into space and time.

Urban painting combines two types of communication: image and text.

Through captions written on the canvas, a story presents itself as belonging to modernity (figs. 4 and 5). In the urban universe, these captions sometimes constitute a legitimate way of talking politics. It also happens, however, that image and writing express two divergent truths: the legend reproduces the official state version, but the image signifies what is known through other channels, including rumor. In addition, the written text and explicit references to writing allude to social control. The administrator or the judge is always accompanied by a table, enabling him to put people into writing, making them slaves of the state. For the painter, writing constitutes a business card, an affirmation of the painting's allegiance to the authoritarian space of modernity.

The petit bourgeois living room in Zaire transforms what was, in the village, a public space into a private space. Here interaction with the host can occur without anyone else's knowledge, and without the participation of the neighbors. Such privacy would have been peculiar in the village, and could once have led to accusations of sorcery. In the city living room, however, it becomes normal. Social interaction slips away from group control. The painting transfers the public performance to a private place; it can be owned by a single person, and gives its owner a sense that his social position has been confirmed. But not everyone has a living room, and most city-dwellers share the social space of an overcrowded urban lot or street that cannot be controlled by individuals or families. This interdependence of living space and painting has a political meaning: if the painters' public is limited to those who possess a living room, pictorial production is likely to be oriented toward the tastes and interests of this relatively well-to-do group of people. People who aspire to this group, namely students and unemployed graduates, organize their bedrooms as space ready to receive paintings. But the decoration con-

sists of illustrations cut out of magazines, as the paintings cannot yet be afforded.

The painters themselves often attempt to become part of the urban petite bourgeoisie. With few exceptions, they are literate, and the majority have attended secondary school. Those who emerged during the colonial period, such as Mwenze Kibwanga and Pilipili, have become art teachers. Moke, Cheri Samba, and Sim Simaro, successful painters of the next generation, have invested in urban lots or taxis. One must therefore be careful when referring to these artists as "popular" painters. Their hopes and tastes are "bourgeois." Although the word does not mean the same thing as in the West, there is a bourgeois culture and a bourgeois taste in Zaire. Christianity is the most striking common denominator of this culture, and Zairian Christianity stresses a feeling of guilt. This is a syncretic faith, as Protestant as it is Catholic, practically as African as it is Western, as pagan as it is monotheistic. Its world vision is organized according to the dualistic paradigm of sickness and healing. Proclaiming the priority of an anthropologically defined community, it centers upon men, and respects authority and hierarchy, though it also criticizes the political regime from the ethical and legal positions of Christianity.

In order to survive, the members of this culture practice what they call "article 15," which recommends that they "look after themselves," and affirms that anything is acceptable as long as it is efficient. Writing and education are central values, even if everyone acknowledges that they are no longer instrumental in social promotion. The desire for modern, preferably ostentatious consumption is embodied in the *sapeurs*, the "dressed to kill" (Gandoulou 1989), such as the musician Papa Wemba, who provide a model of the well-dressed man that young people are willing to sacrifice everything to attain. Bar and restaurant owners like to use an image of a musician *sapé* as a business advertisement (fig. 8).

The Imagery of Urban Painting

Urban painting in Zaire is both homogeneous and diversified. The homogeneity comes from the unity of the country's urban culture, and from its shared memories and sense of history. Violence is a central feature of this work, the "natural" right of all power. Even gratuitous violence is the sign of a power relationship. And a great number of the paintings, including the numerous nostalgic representations of the village (which is often shown on fire), address violence (Jules-Rosette 1984): a parachute attack, the civil war, the Belgian colony, women fighting. Even a theme as pictorially peaceful as Mami Wata makes reference to violence: the destruction of her chosen one appears as the normal end to a relationship with the siren. The arm raised to strike, and often bearing a weapon, is a universal sign of power, and appears regularly in these paintings. (The gesture is shared with the power figures of the Kongo region [cat. 127–129], where, from the nineteenth century on, force played a dominant role in a structure of increasingly individualized social relationships. Perhaps what we see here is a continuity of symbols from nineteenth-century sculpture to twentieth-century painting.) Two further themes underscore the solitude of ordinary people: fortune (chance) and hierarchy, which is connected with violence.

In the Belgian-colony subject, as in paintings of the civil war, women usually express the suffering of victims of violence. Thus a major trait of Zaire's urban social structure appears in these paintings: the ideological and normative domination of women by the patriarchy. Mami Wata and Catholic nuns are the only females to hold any power, and to play active roles, in Zairian urban painting. Mami Wata, usually white, is the key believed to enable the urbanite to penetrate the arbitrary universes of the state and of wealth. The images of nuns refer to the power of the Catholic church, and these are the only

Figs. 7a-7e. Social status, the Western-style living room, and painting as decoration are strongly interrelated in Zaire. In its effort to promote African *évolués* (mainly urban, French-speaking functionaries of the state and of the Catholic church) as a modern and modernizing group, the colonial administration encouraged them to adopt Western values, including housing. a) Living room of an *evolué*, Léopoldville (now Kinshasa), late 1950s. The room is almost an exact copy of a Belgian-colonial petty functionary's living room, which in turn reproduces the urbanized village culture of Belgium. b) An exhibition of urban housing for *évolués*, Léopoldville, 1958. Photos: Congo Press, from Phototèque, Musée Royal de l'Afrique centrale, Tervuren. c) The workshops of a painter and a cabinet-maker lie side by side, and paintings and furniture are exhibited for sale together, Kinshasa, 1990. d) Living room in the house of a retired trader, Mbandaka, 1990. e) Living room in the house of a skilled worker, Lubumbashi, 1990. Photos: Bogumil Jewsiewicki.

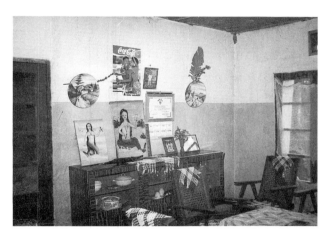

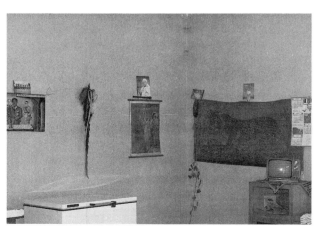

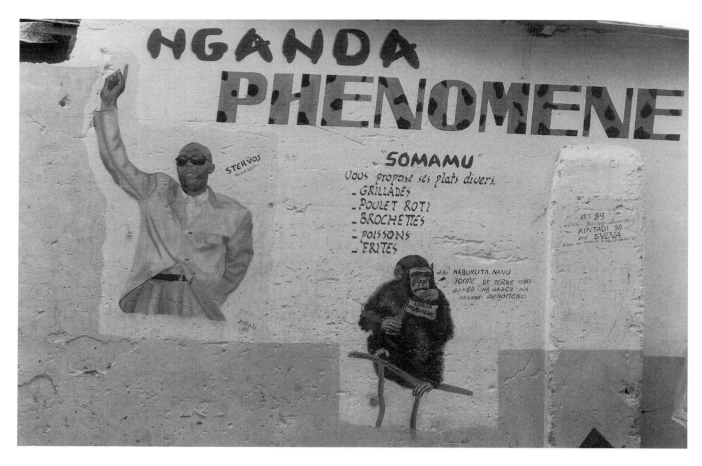

Fig. 8. Mural painting as advertisement. This restaurant (*nganda*) advertisement was painted by an artist whose professional name is "Art 89." A *sapé* man at the left bears witness to the high standards of the customers. Kinshasa, March 1989. Photo: Bogumil Jewsiewicki.

women to display the raised-arm gesture. But since they belong to the church, they are more Mami Watas than females, for they are celibate, and do not participate in society's regeneration.

Three themes circulate in hundreds of images, and represent the power relationship created by submission, jealousy, the denial of legitimacy, and the hope that one day chance, which is neither innocent nor free, will make one its accomplice. They are, chronologically, the popular icon of Mami Wata, *inakale* (the cul-de-sac, the inability to escape from adversity; fig. 9), and *simba bulaya* (the lions of Europe, representing the white cannibal; cat. 66). The Mami Wata images express the desire to be taken up by those with power, even to the point of betraying one's own people. According to local belief, a man chosen by Mami Wata not only owes her obedience and secrecy concerning their relationship, but must also periodically sacrifice those close to him. Thus a relationship with her, a source of power and wealth, expresses the

arbitrary nature of power, which chooses whom it wants and destroys when it so desires. Familiarity with power does not come free of charge, for power feeds off those its servants sacrifice to it. Power is nature's sorcerer. The same idea appears in the images of *simba bulaya*, also called *mitumbula*, which present the white, or the white man-eater (though nowadays "white" is a generic term for powerful), as the personification of power, living off the victims brought to him by his assistants.

The crisis of the Second Republic, which struck hard in the mid 1970s, led to the increasing popularity of the *inakale* theme, which expresses the despair of a man, or more rarely a woman, caught in a situation with no way out (Biaya 1989). The pictorial organization of these images is adopted from a genre of engravings in old travel books. (It is also found in Senegalese glass painting.) A lion or leopard attacks the individual on land, while a crocodile (sorcery, the pagan devil) attacks from the water and a serpent (the Chris-

tian devil) prevents refuge in a tree. Certain of these paintings bear as their legend a biblical verse asserting that God is the only salvation. Another, more political interpretation, however, is sometimes made of the theme: *inakale* represents society as a slave of the predatory state, betrayer of its own people. The lion is the state as a Western-born but now-indigenous beast. And water is the Mami Wata element from which President Mobutu, according to popular belief, drew his power. Also, though the Janus-like devil is certainly represented in Christian discourse as the serpent and in local, pagan idiom as the crocodile, paganism too has political meanings, signifying not only spiritual damnation and exclusion from modernity but, more prosaically, exile to the village, a site of political nonexistence to which the state relegates its enemies. Another pagan serpent appears in the Mami Wata images, where it opposes the chalicelike Christian cup that she usually carries in her hand. This is an allusion to ordination, which, during the colonial period, transformed an ordinary black man into a quasi white—on condition that he sacrifice his own people, for by refusing to have children, he also refused to reproduce his society. The serpent presents itself on the side of nature, of the pagan village world, the space of nonexistence that threatens the unfaithful state servant.

The relationship with power is also a major theme of Belgian-colony scenes. These paintings usually cast themselves as drawn from memories of colonial days, but they actually address current political issues; some painters even replace the soldiers' uniforms and the colonial flag with the contemporary Zairian equivalents. The immense white man, cultivating an air of indifference, seems completely uninterested in daily events. He recalls President Mobutu, who likes to portray himself both as the source of all power and as arbitrator. The soldiers exercise real power over men effectively reduced to slavery; in certain paintings the latter are chained. The women, who are excluded from the political arena, express society's suffering. The whole is presented in the realistic setting of a colonial administrative post. In the colonial era, the day began with the raising of the flag, and with the distribution of punishments and tasks to prisoners. Ever since the politics of "radicalization" of the early 1970s, saluting the flag has become an imperative daily ritual in all Zairian institutions, while *salongo* (compulsory community work) has emulated the forced labor of the colonial era. It seems that the Belgian-colony theme became popular at the very moment that Zairians were vividly reminded that the nature of the state had not changed with the end of colonialism.

Contemporary urban painting in Zaire is a diverse phenomenon, and the presentation of these pictorial themes varies from one region to another and from one painter to another. The work is guided by the desire to establish painted history in the realities directly known to the public. It also translates the specificity of workshop modes and traditions that vary considerably. Comic-strip-inspired painting seems especially characteristic of Kinshasa, while historical painting has been important in Lubumbashi and in other cities in the mining zone. The parachute attack (cat. 71) is a favorite theme in the eastern part of the country, especially in Kisangani, a city that actually experienced it firsthand. And many painters have developed not only a personal style, but also a specific discourse in response both to their perception of their social role and to the conditions of the market. In this respect, a recent, rather unexpected explosion of painting in the gold-mining area of Bunia, where there are no Western patrons and tourists, should be noted. The liberalization of gold mining and the development of commercial activities in this borderland area have had the effect of attracting painters, for a newly born petite

Fig. 9. *Inakale*, artist unknown, sold on a street in Kinshasa, 1989. Collection: Bogumil Jewsiewicki.

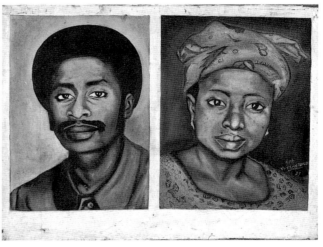

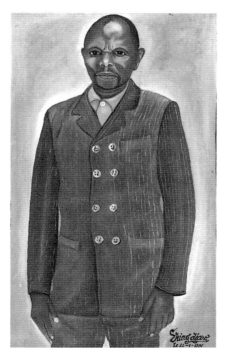

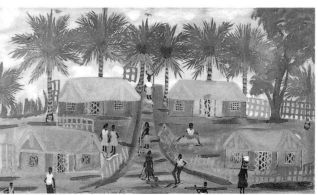

Figs. 10a-10g. a) Leopard and parrot, artist unknown, exhibited in a restaurant in Basankusu in 1970. b) AIDS victim, by Vuza Ntoko (Kinshasa), 1990. c) *Colonie belge*, by Nolvudi (Kinshasa), 1988. d) Self-portrait and portrait of the artist's mother, by Vuza Ntoko, late 1970s. Used as an advertisement of the artist's skills. e) Portrait of a man, artist unknown, unclaimed portrait painted on commission, Kinshasa, 1990. f) Women struggling, artist unknown, sold in a street market in Kinshasa, 1989. g) A street in Mbandaka, artist unknown, before 1969. All paintings collection of Bogumil Jewsiewicki.

bourgeoisie of army officers involved in gold trafficking, unemployed university graduates digging for gold, and others has created a market.

In his dialogue with society, the painter is not a simple sounding box. He listens and looks not only to give visual pleasure but to tell the truth (with the necessary caution) on social and political levels. While presenting his society's imagination and memory, he tests his own ability to create, and he initiates a two-dimensional performance in which people will want to participate when hosting others in their living rooms. In Zaire's Second Republic, though every city dweller had to be involved in politics (since no social or economic activity was possible without some kind of political patronage), talking politics was dangerous. From the moment of the Second Republic's birth, the religious discourse of this Christian society expressed a political as well as a moral critique. The same was true of Zairian painting—an "ideological crime," to borrow Dominique LaCapra's (1982) description of Flaubert's *Madame Bovary*, created in a situation in many respects comparable. (Painting was not the only idiom disguising a political discourse beneath a moral one: some Zairian singers were imprisoned because of the political aspects of songs they wrote attacking those in power.)

Working under the restrictions of the Second Republic, Cheri Samba and other Kinshasa painters, including his friend Vuza Ntoko, created an idiom in which moralizing, eroticism, and politics were so mixed that one spoke for another. In this game of fine substitutions, everyone seemed aware of what was meant, though it could not be verbalized without great risk. The April 1990 collapse of the Second Republic has allowed a more openly political critique. Paradoxically, however, the new openness may send painting into a more truly private, more ornamental role than before. Under the Second Republic, Zairian urban painting was a response to a specific political oppression. How will

it be transformed if it becomes the voice of a society that is the paradigm of the postcolonial state?

NOTES

The initial translation of this essay from the French was done by Elizabeth Reeve. The present text was established with the invaluable aid of Enid Schildkrout and Susan Vogel. Stephen Benjamin and David Frankel spent much time editing the final version and helping with the captions. Johannes Fabian, Ivan Karp and Susan Vogel offered extremely helpful comments. J.-P. Jacquemin kindly made his slide collection available. Muniana Lubangi translated the French and Lingala texts that appear in the captions. I would like to thank all of them, stressing, of course, that the final responsibility for shortcomings and errors is mine.

1. Interview with Cheri Samba at his Kinshasa workshop, March, 1990.

2. For a discussion of the Alhadeff and Romain-Desfossés workshops, see Cornet et al. 1989.

3. We would certainly be better off without this worn-out concept, which has no meaning except in opposition to the idea of "high" culture (Fabian 1978, Grignon and Passeron 1989, Barber 1987). Unfortunately, the persistence of positivist and scientific epistemology at the very base of social science makes us unable to get rid of it completely. As often as possible, I will try to be more precise.

4. I mean societies in which market exchange did not play a central social and political role. Some societies were mercantile as early as 1850, and even before— Tyo, Kongo, Chokwe. Others became so only by 1920.

5. Western bourgeois culture has obliged the world to become its object. We have taken others, without their knowledge or consent, for a compost to enrich our culture's essence (in our mind the universal one) through cross-breeding. Entrenched in the narrative construction of time, and protected by the Cartesian principle that excludes everything that cannot be mastered within its framework, the other did not interest us intellectually unless irreversible time sheltered us from its initiatives. That imaginary, evolutionary time, by the way, is itself a narrative construct.

6. These terms were associated in the 1920s with mission journals such as *Nkuruse*, in the 1950s with the French-language black journal *La Voix du Congolais*, and in the 1970s and 1980s with such popular novels as Zamenga's *Batukesanga*, published by the Catholic publisher Éditions Saint Paul.

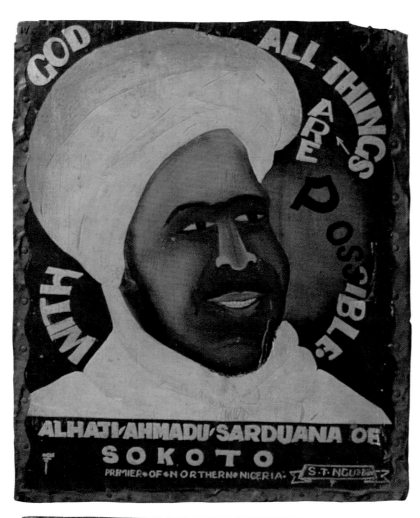

GOD ALL THINGS ARE POSSIBLE WITH HIM

ALHAJI AHMADU SARDUANA OF
S O K O T O
PREMIER OF NORTHERN NIGERIA. S.T. NGUBE

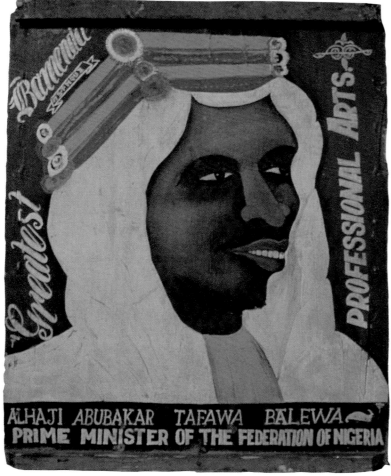

Bamenda GREATEST PROFESSIONAL ARTS.

ALHAJI ABUBAKAR TAFAWA BALEWA
PRIME MINISTER OF THE FEDERATION OF NIGERIA

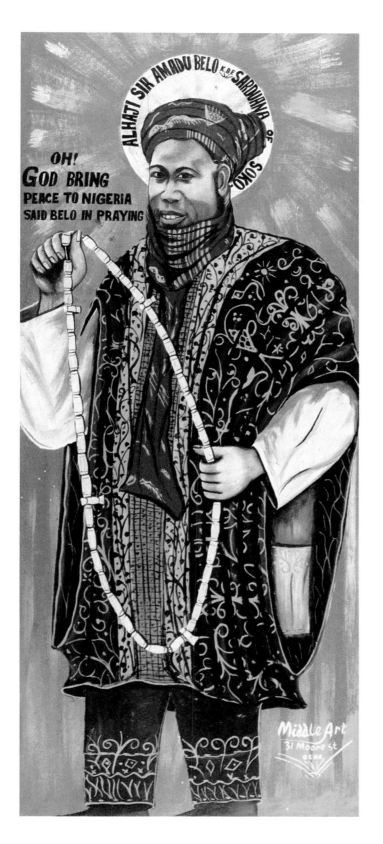

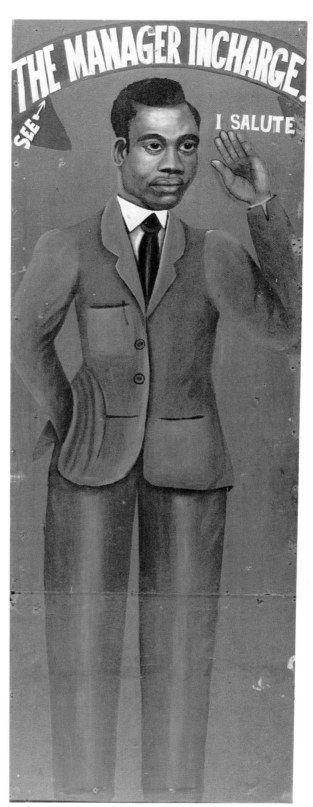

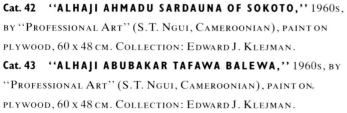

Cat. 42 **"ALHAJI AHMADU SARDAUNA OF SOKOTO,"** 1960s, BY "PROFESSIONAL ART" (S.T. NGUI, CAMEROONIAN), PAINT ON PLYWOOD, 60 x 48 CM. COLLECTION: EDWARD J. KLEJMAN.

Cat. 43 **"ALHAJI ABUBAKAR TAFAWA BALEWA,"** 1960s, BY "PROFESSIONAL ART" (S.T. NGUI, CAMEROONIAN), PAINT ON PLYWOOD, 60 x 48 CM. COLLECTION: EDWARD J. KLEJMAN.

Cat. 44 **"OH! GOD BRING PEACE TO NIGERIA SAID BELLO IN PRAYING,"** 1970s, BY MIDDLE ART (NIGERIAN, B. 1936), ENAMEL ON PLYWOOD, 110 x 46.5 CM. COLLECTION: IWALEWA-HAUS, BAYREUTH.

Cat. 45 **"THE MANAGER IN CHARGE" (SELF-PORTRAIT, THE ARTIST'S SHOP DOOR),** 1970s, BY MIDDLE ART (NIGERIAN, B. 1936), ENAMEL ON WOOD, 186.5 x 61 CM. COLLECTION: IWALEWA-HAUS, BAYREUTH.

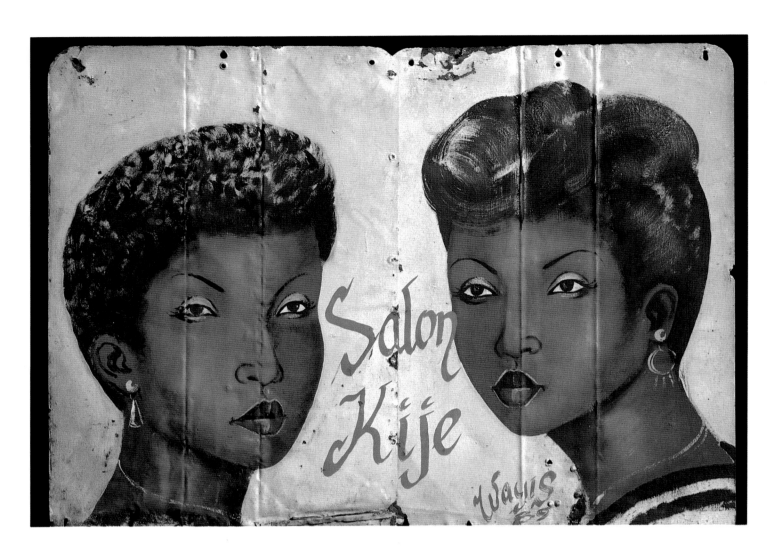

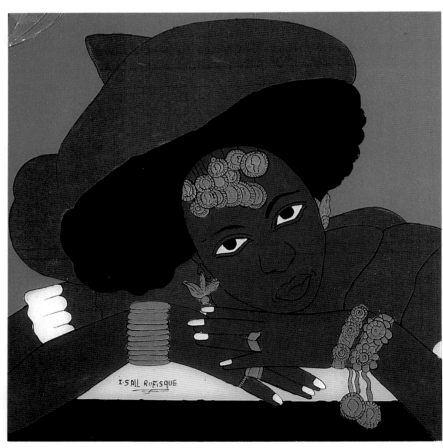

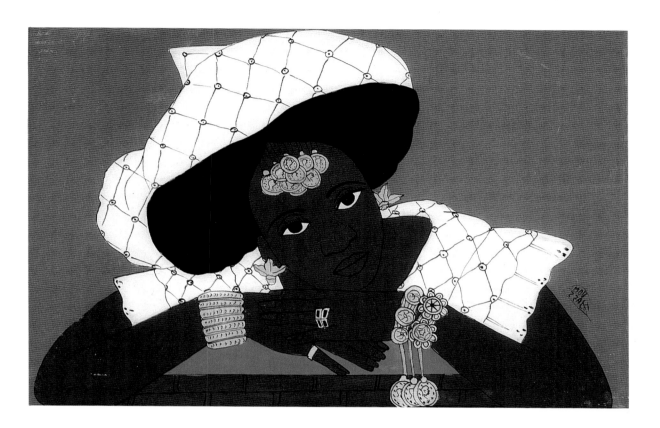

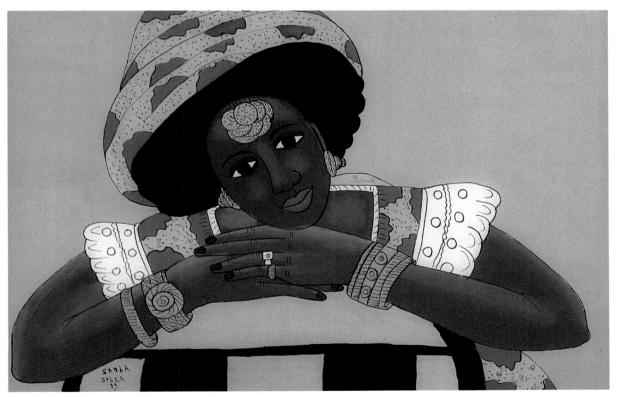

Cat. 46 "SALON KIJE," SHOP SIGN, 1980s, UNKNOWN ARTIST (ZAIRIAN), ENAMEL ON METAL, 57.5 x 80.5 CM. COLLECTION: BOGUMIL JEWSIEWICKI.

Cat. 47 PORTRAIT OF A WOMAN, 1989, BY S. RUFISQUE (SENEGALESE, B. CA. 1960S) IN THE STUDIO OF MODOU FALL, ENAMEL PAINT ON GLASS, 31.8 x 32.5 CM. ANONYMOUS COLLECTION.

Cat. 48 PORTRAIT OF A WOMAN, 1989, BY SAMBA SYLLA (SENEGALESE, B. CA. 1960S) IN THE STUDIO OF MODOU FALL, ENAMEL PAINT ON GLASS, 33 x 48 CM. ANONYMOUS COLLECTION.

Cat. 49 PORTRAIT OF A WOMAN, 1989, BY SAMBA SYLLA (SENEGALESE, B. CA. 1960S) IN THE STUDIO OF MODOU FALL, ENAMEL PAINT ON GLASS, 32.5 x 48 CM. ANONYMOUS COLLECTION.

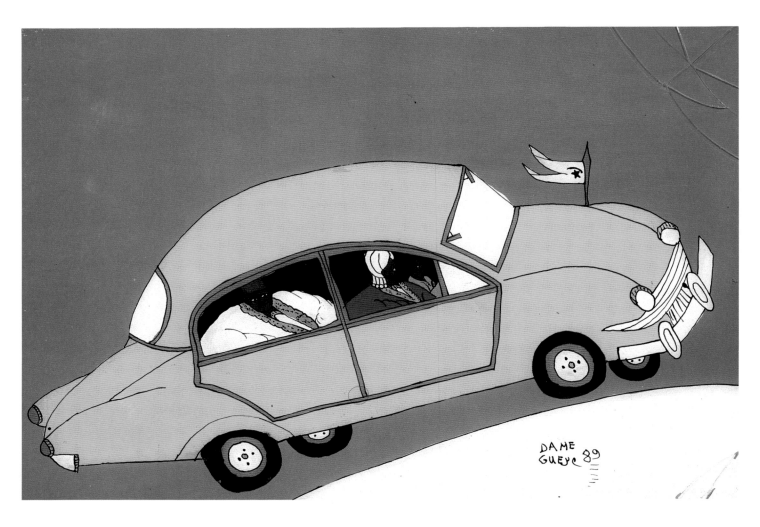

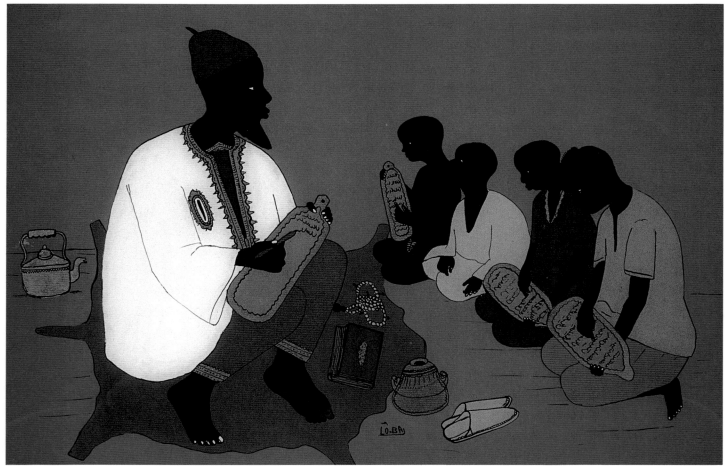

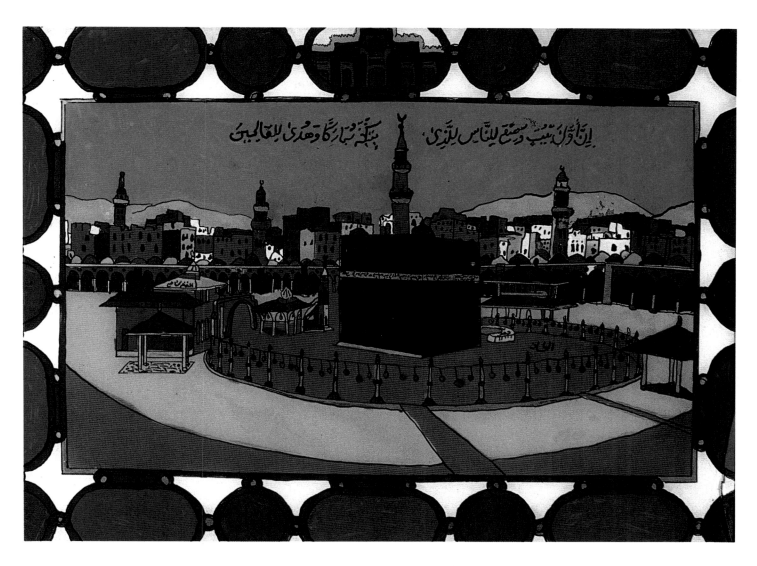

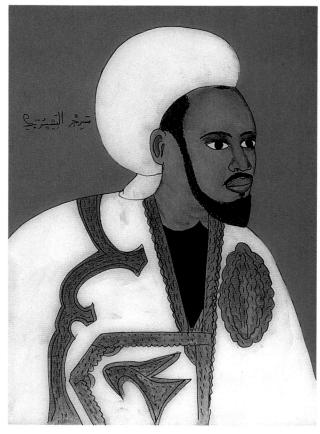

Cat. 50 MARABOUTS (HOLY MEN) ON A VOYAGE, 1989, BY
DAME GUEYE (SENEGALESE, B. CA. 1960s) IN THE STUDIO OF
MODOU FALL, ENAMEL PAINT ON GLASS, 33 x 48 CM. ANONYMOUS
COLLECTION.

Cat. 51 KORANIC SCHOOL, 1988, BY LO BA (SENEGALESE B. CA.
1950s), INK AND ENAMEL PAINT ON GLASS, 32 x 48 CM. COLLECTION:
MICHEL RENAUDEAU.

Cat. 52 THE KAABA, 1950, UNKNOWN ARTIST (SENEGAL), INK
AND ENAMEL PAINT ON GLASS, 51 x 39 CM. COLLECTION: MICHEL
RENAUDEAU.

Cat. 53 PORTRAIT OF A MARABOUT, 1960, UNKNOWN ARTIST
(SENEGAL), INK AND ENAMEL PAINT ON GLASS, 41 x 54 CM.
COLLECTION: MICHEL RENAUDEAU.

Cat. 54 PORTRAIT OF A YOUNG GIRL, EARLY 20TH C.,
UNKNOWN PHOTOGRAPHER (DAKAR, SENEGAL), SILVER PRINT, 1974,
FROM ORIGINAL GLASS NEGATIVE, 18 X 13 CM. PRIVATE COLLECTION.

Cat. 55 THE PHOTOGRAPHER AND HIS BROTHER, BEFORE
1914, UNKNOWN PHOTOGRAPHER (LOMÉ, TOGO), SILVER PRINT,
1974, FROM ORIGINAL GLASS NEGATIVE, 19 X 14 CM. PRIVATE
COLLECTION.

Cat. 56 PORTRAIT OF A MAN, CA. 1914, UNKNOWN
PHOTOGRAPHER (LOMÉ, TOGO), SILVER PRINT, 1974, FROM ORIGINAL
GLASS NEGATIVE, 19 X 14 CM. PRIVATE COLLECTION.

Cat. 57 PORTRAIT OF A WOMAN, 1930S, UNKNOWN
PHOTOGRAPHER (LOMÉ, TOGO), SILVER PRINT, 1974, FROM ORIGINAL
GLASS NEGATIVE, 18 X 13 CM. PRIVATE COLLECTION.

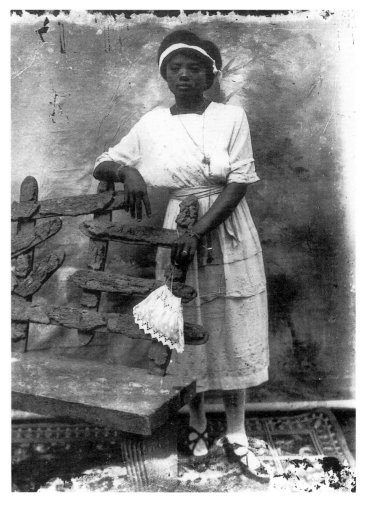

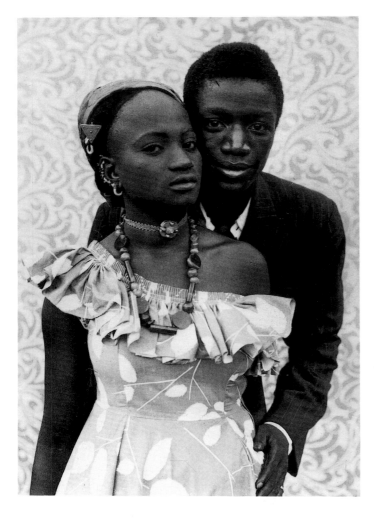

Cat. 58 **PORTRAIT OF A COUPLE,** 1950s, UNKNOWN PHOTOGRAPHER (BAMAKO, MALI), SILVER PRINT, 1974, FROM ORIGINAL NEGATIVE, 17 x 13 CM. PRIVATE COLLECTION.

Cat. 59 **PORTRAIT OF A MAN,** 1955, UNKNOWN PHOTOGRAPHER (BAMAKO, MALI), SILVER PRINT, 1974, FROM ORIGINAL NEGATIVE, 19 x 13 CM. PRIVATE COLLECTION.

Cat. 60 **PORTRAIT OF TWO MEN,** 1955, UNKNOWN PHOTOGRAPHER (BAMAKO, MALI), SILVER PRINT, 1974, FROM ORIGINAL NEGATIVE, 18 x 13 CM. PRIVATE COLLECTION.

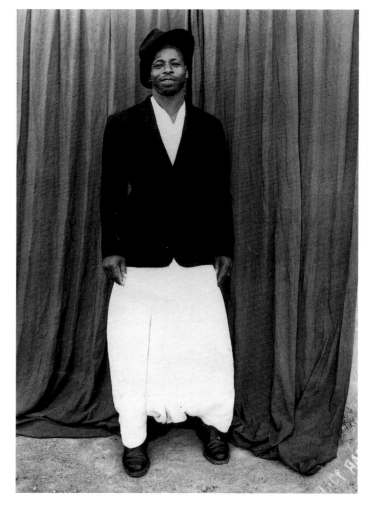

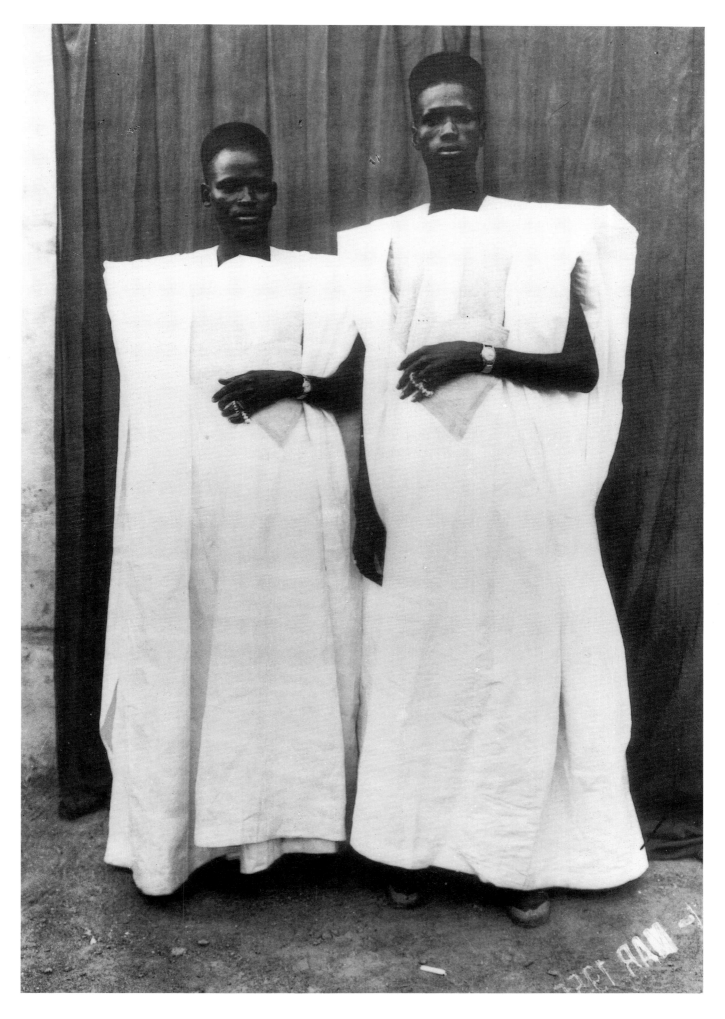

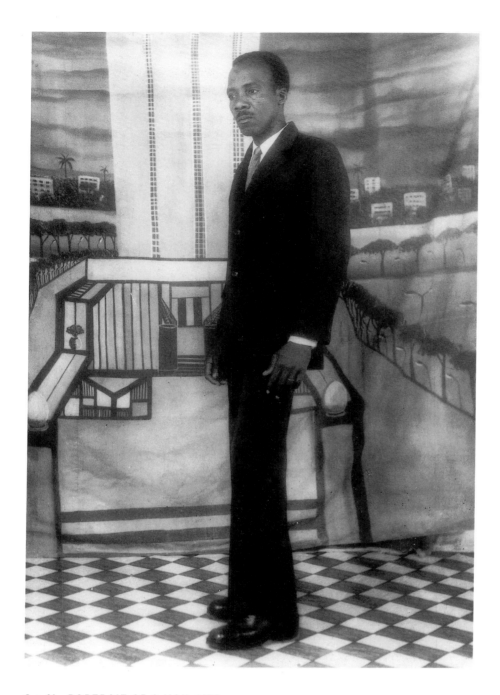

Cat. 61 PORTRAIT OF A MAN, 1970s, UNKNOWN PHOTOGRAPHER
(YAMOUSSOUKRO, CÔTE D'IVOIRE), SILVER PRINT, 19 X 13 CM.
PRIVATE COLLECTION.

Cat. 62 DOUBLE PORTRAIT OF A WOMAN, 1970s, UNKNOWN
PHOTOGRAPHER (YAMOUSSOUKRO, CÔTE D'IVOIRE), SILVER PRINT,
24 X 17 CM. PRIVATE COLLECTION.

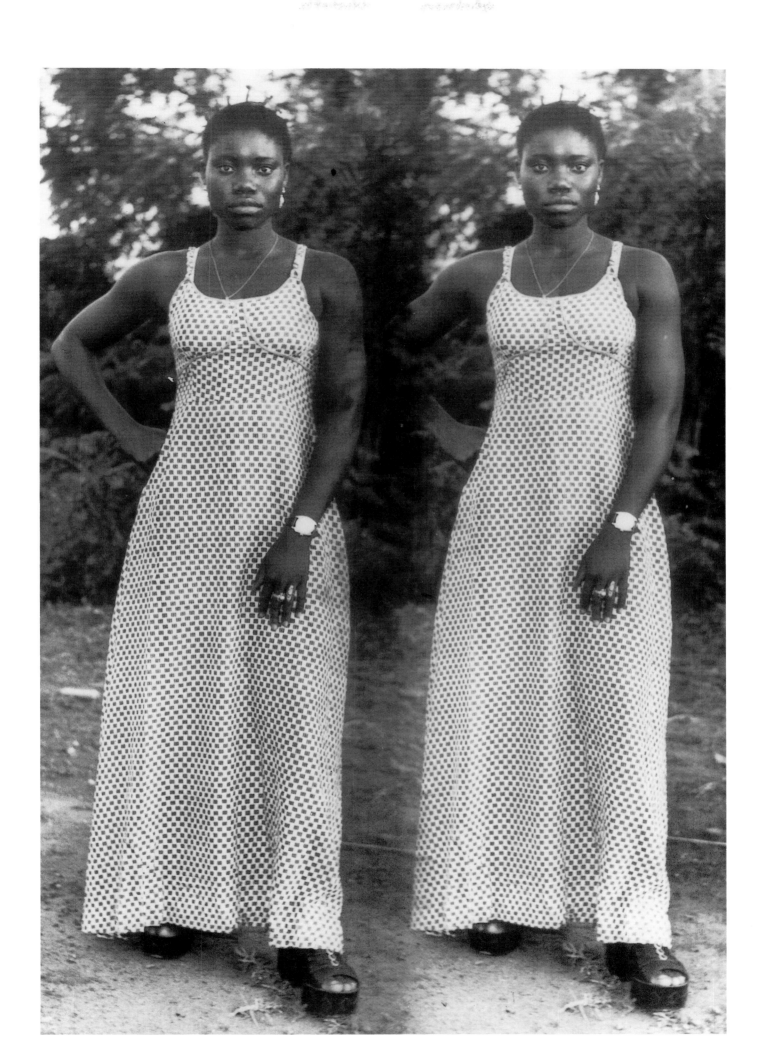

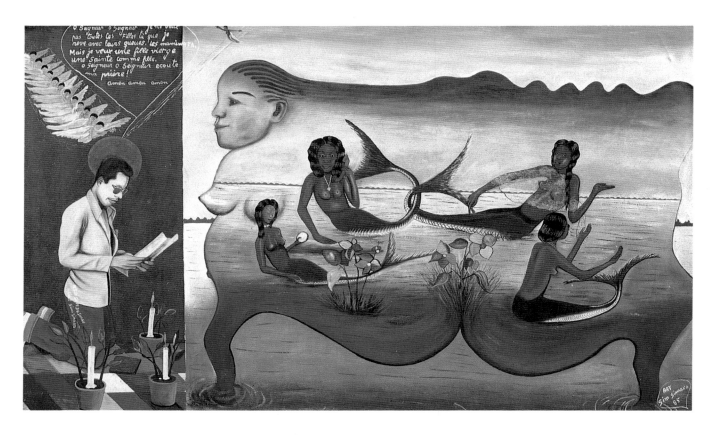

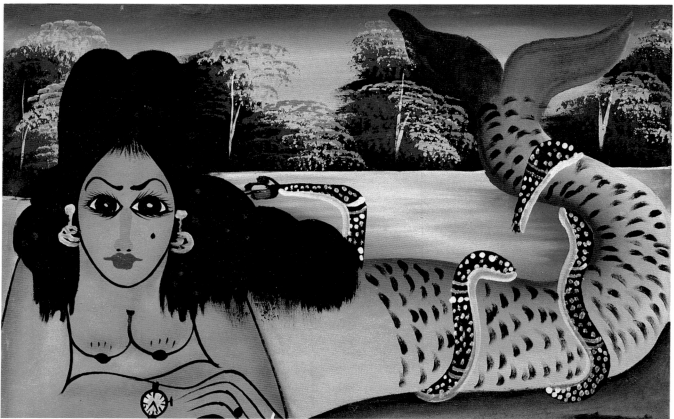

Cat. 63 *"O SEIGNEUR, O SEIGNEUR"* (Oh Lord, Oh Lord), 1984, by Sim Simaro (Zairian, b. ca. 1960s), paint on plywood, 59 x 95 cm. Collection: ciciba, Libreville.

Cat. 64 MAMI WATA, 1970s, signed Katenda (?) (Zairian), paint on flour sack, 35 x 47 cm. Collection: Bogumil Jewsiewicki.

Cat. 65 *"SIMBA BULAYA"* (The lions of Europe), 1970s, by Tshibumba Kanda-Matulu (Zairian, b. ca. 1950), paint on flour sack, 36 x 45 cm. Collection: Bogumil Jewsiewicki.

Cat. 66 *"COLONIE BELGE 1885-1959,"* 1970s, by Tshibumba Kanda-Matulu (Zairian, b. ca. 1950), paint on flour sack, 36 x 45 cm. Collection: Bogumil Jewsiewicki.

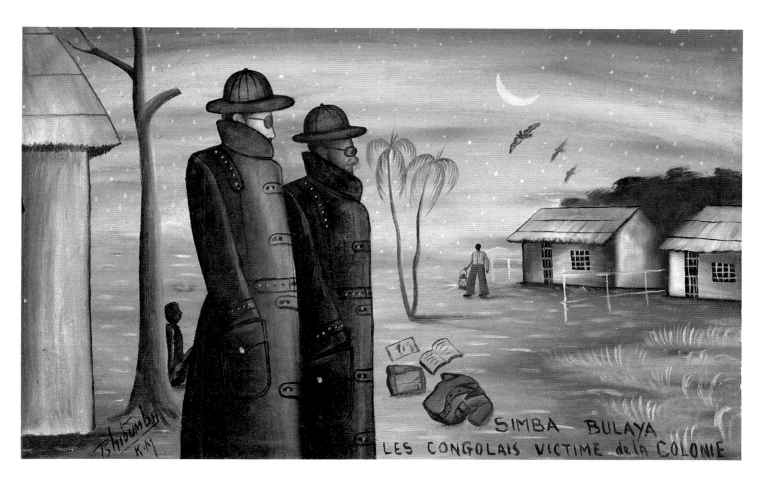

SIMBA BULAYA
LES CONGOLAIS VICTIME de la COLONIE

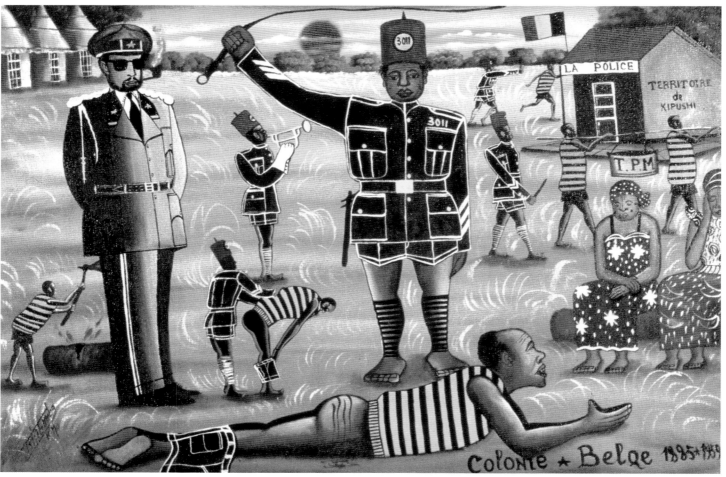

Colonie ★ Belge 1885-1959

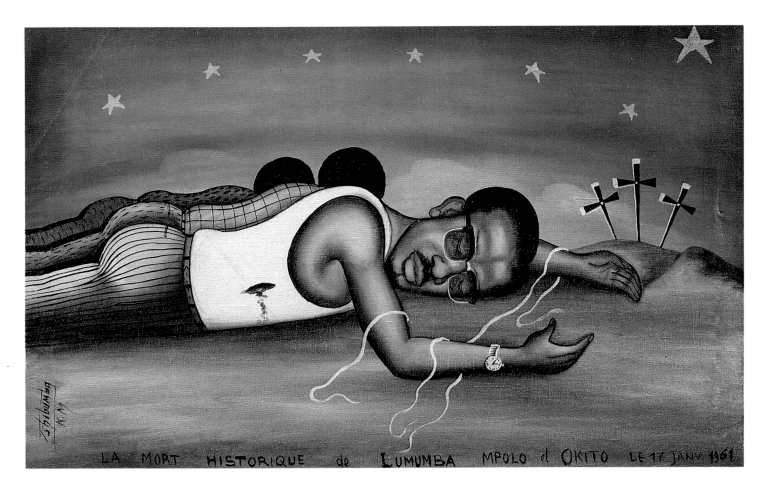

LA MORT HISTORIQUE de LUMUMBA MPOLO et OKITO LE 17 JANV 1961

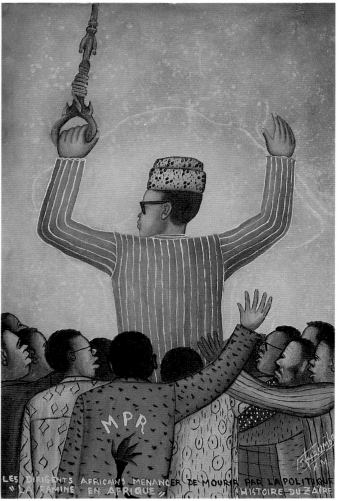

LES DIRIGENTS AFRICAINS MENANCER DE MOURIR PAR LA POLITIQUE
"LA FAMINE EN AFRIQUE" L'HISTOIRE DU ZAÏRE

Cat. 67 "*LA MORT HISTORIQUE DE LUMUMBA*" (THE HISTORIC DEATH OF LUMUMBA), 1970S, BY TSHIBUMBA KANDA-MATULU (ZAIRIAN, B. CA. 1950), PAINT ON FLOUR SACK, 36 X 45 CM. COLLECTION: BOGUMIL JEWSIEWICKI.

Cat. 68 "*LES DIRIGENTS AFRICAINS*" (THE AFRICAN LEADERS), 1970S, BY TSHIBUMBA KANDA-MATULU (ZAIRIAN, B. CA. 1950), PAINT ON FLOUR SACK, 36 X 45 CM. COLLECTION: BOGUMIL JEWSIEWICKI.

Cat. 69 "*LA BAISÉE DU ST. PERE: LE PAPE JEAN PAUL II À KINSHASA*" (THE KISS OF THE HOLY FATHER: POPE JOHN PAUL II IN KINSHASA), 1970S, BY TSHIBUMBA KANDA-MATULU (ZAIRIAN, B. CA. 1950), PAINT ON FLOUR SACK, 36 X 45 CM. COLLECTION: BOGUMIL JEWSIEWICKI.

Cat. 70 "*ON LES CHERCHE ON LES TUE PUIS ON LES RECLAME ENCORE*" (THEY HUNT FOR THEM, THEY KILL THEM, THEN THEY WANT THEM BACK), 1970S, BY TSHIBUMBA KANDA-MATULU (ZAIRIAN, B. CA. 1950), PAINT ON FLOUR SACK, 36 X 45 CM. COLLECTION: BOGUMIL JEWSIEWICKI.

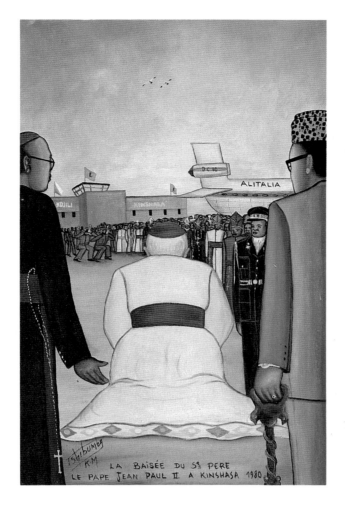

LA BAISÉE DU S^{te} PERE
LE PAPE JEAN PAUL II A KINSHASA 1980

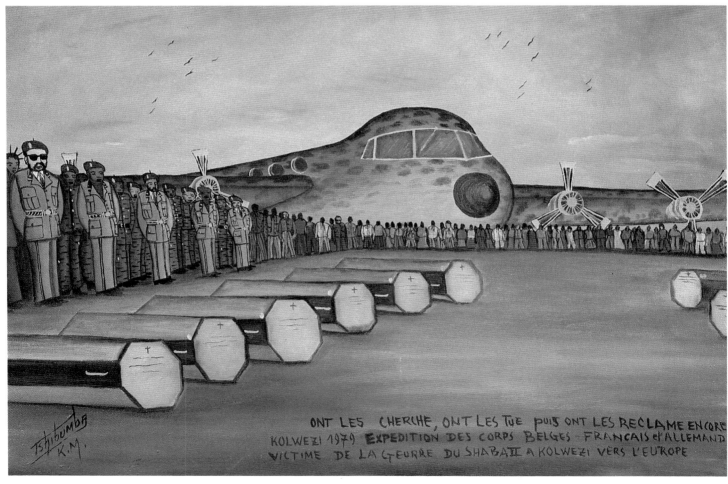

ONT LES CHERCHE, ONT LES TUE PUIS ONT LES RECLAME ENCORE
KOLWEZI 1979 EXPEDITION DES CORPS BELGES - FRANCAIS et ALLEMAND
VICTIME DE LA GUERRE DU SHABA II A KOLWEZI VERS L'EUROPE

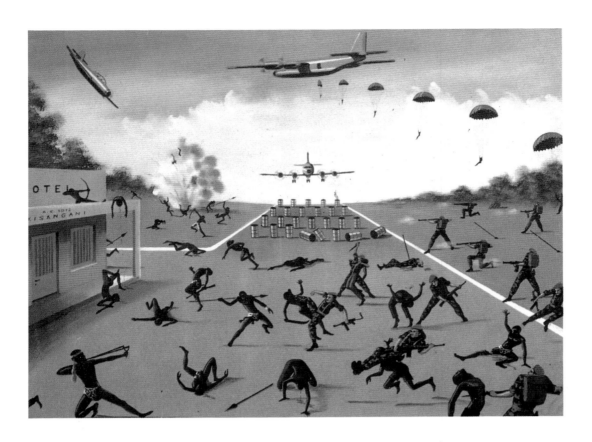

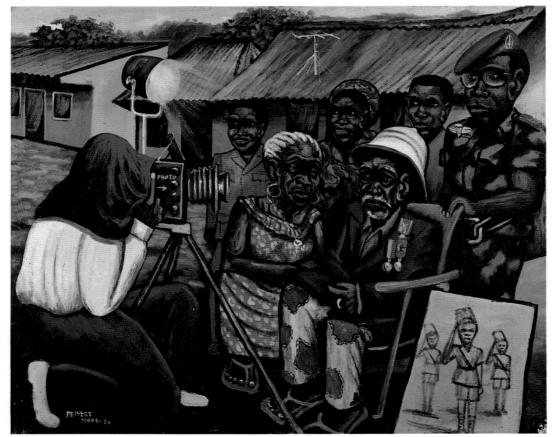

Cat. 71 PARATROOPERS LANDING IN KISANGANI, 1990, UNKNOWN ARTIST (BUNIA, ZAIRE), PAINT ON FLOUR SACK, 36 X 45 CM. COLLECTION: BOGUMIL JEWSIEWICKI.

Cat. 72 PHOTOGRAPHING A VETERAN, 1984, BY MOKE (ZAIRIAN, B. 1950), PAINT ON FLOUR SACK, 91 X 113 CM. COLLECTION: CICIBA, LIBREVILLE.

Cat. 73 MOTORCADE WITH MITTERAND AND MOBUTU, 1990, BY MOKE (ZAIRIAN, B. 1950), PAINT ON FLOUR SACK, 112 X 180 CM. COLLECTION: JEAN PIGOZZI.

Cat. 74 MOBUTU IN BANDUNDU, 1977, BY MOKE (ZAIRIAN, B. 1950), PAINT ON FLOUR SACK, 96 X 154 CM. PRIVATE COLLECTION.

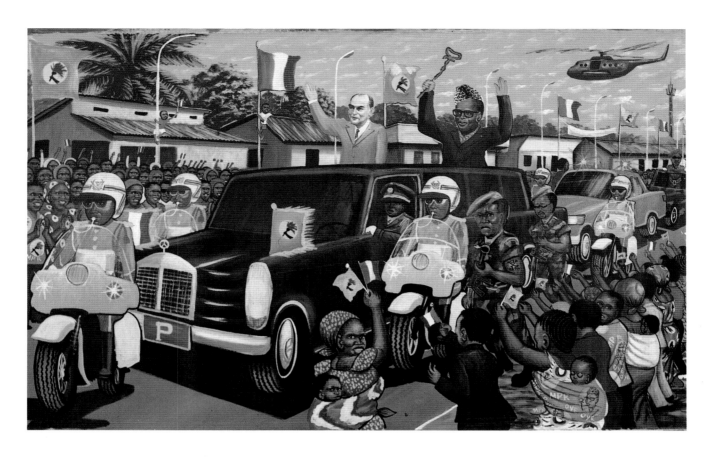

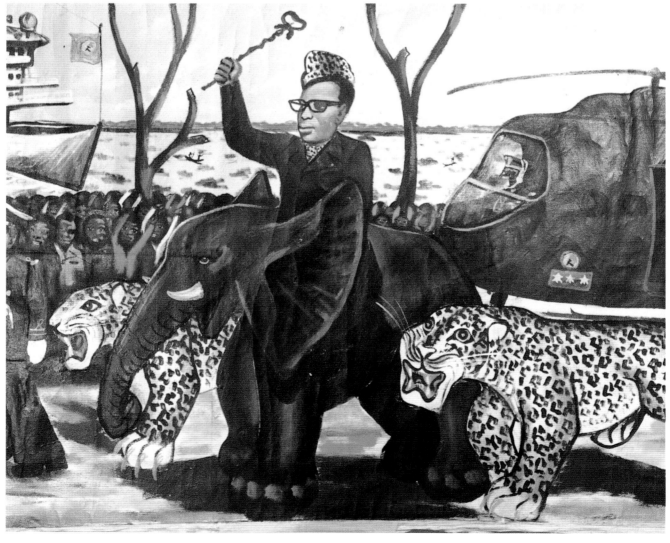

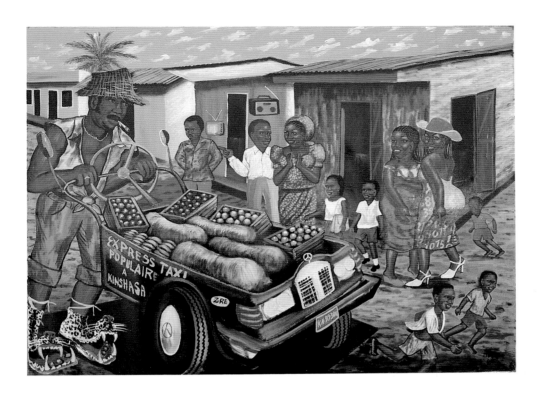

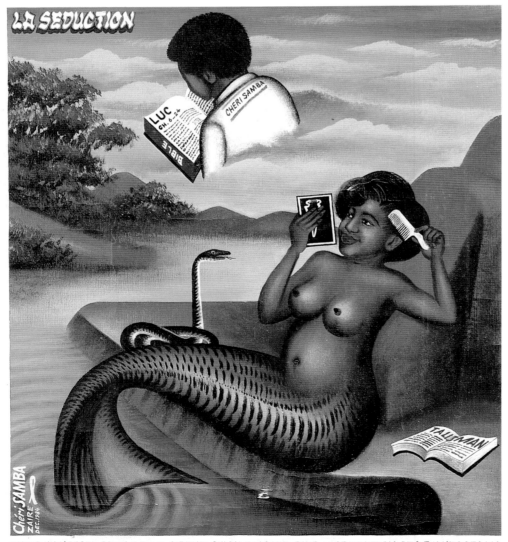

MYTHE UNIVERSEL DE LA BELLE SIRENE QU'ON INVOQUE POUR L'OBTENTION DES RICHESSES MA-
TERIELLES. ICI, LE PEINTRE POPULAIRE "CHERI SAMBA" SUGGERE DE RESISTER A CE
GENRE DE PRATIQUES MAGIQUES POUR SE CONFIER A DIEU. *BANINGA TOTIKA NZELA YA KISI

LUTTE CONTRE LES MOUSTIQUES

CHERIE, TU TUES CEUX DE DROITE PENDANT QUE MOI, JE ME BATS AVEC LES GAUCHISTES

JE LE FAIS MON AMOUR. J'EN AI DEJA TUE DEUX MAIS IL ME SEMBLE QU'ILS RESSUSCITENT

EN AFRIQUE, LA MALARIA TUE PLUS QUE LE SIDA. SURTOUT CHEZ LES PETITS ENFANTS. LE VIRUS DE LA MALARIA S'APPELE "MOUSTIQUES". CE VIRUS SEMBLE ETRE TRES PUISSANT QUE LES BLANCS ET LES NOIRS QUI VIVENT EN AFRIQUE

Cat. 75 STREET SCENE, 1990, BY MOKE (ZAIRIAN, B. 1950),
PAINT ON FLOUR SACK, 102 x 118 CM. COLLECTION: JEAN PIGOZZI.

Cat. 76 "LA SEDUCTION," 1984, BY CHERI SAMBA (ZAIRIAN, B.
1956), PAINT ON FLOUR SACK, 60 x 80 CM. COLLECTION: CICIBA,
LIBREVILLE.

Cat. 77 "LUTTE CONTRE LES MOUSTIQUES" (THE BATTLE
WITH THE MOSQUITOES), 1989, BY CHERI SAMBA (ZAIRIAN, B.
1956), PAINT ON CANVAS, 65 x 81 CM. COLLECTION: RAYMOND J.
LEARSY.

PARIS EST PROPRE

GRACE A NOUS LES IMMIGRES QUI N'AIMONS PAS VOIR LES URINES ET LES CROTTES DES CHIENS
SANS NOUS, CETTE VILLE SERAIT PEUT-ETRE LA SCORIE DE CROTTES

Cat. 78 ''*PARIS EST PROPRE*'' (Paris is clean), 1989, by Cheri Samba (Zairian, b. 1956), paint on canvas, 80 x 80 cm. Courtesy of Jean-Marc Patras Galerie, Paris.

Cat. 79 ''*LA FEMME ET SES PREMIERS DESIRS*'' (Woman and her first desires), 1988, by Cheri Samba (Zairian, b. 1956), mixed media, 133 x 201 cm. Collection: Canal +.

Cat. 80 ''*THE DRAUGHTSMAN CHERI SAMBA,* '' 1981, by Cheri Samba (Zairian, b. 1956), paint on canvas, 135 x 101 cm. Collection: Jean Pigozzi.

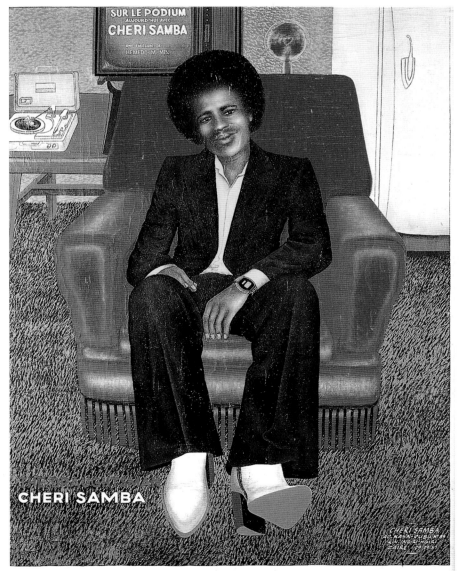

CARICATURAL DRAWING IS NOTHING, CAUSE ANYBODY CAN DOIT BUT IT IS RICH CAUSE IT TELLS YOU A MESSAGE ESPECIALLY THERE ARE TEXTS
I PERSONALLY USE TWO TECHNICS; "CARICATURE (HUMOUR) AND PORTRAIT." THIS GIVERS A LESSON TO THE ONES WHO ONLY MAKE HUMOUR.
YET, I'M A SELF-TAUGHT PERSON.
LE DESSIN CARICATURAL N'EST RIEN, CAR N'IMPORTE QUI PEUT LE FAIRE, MAIS IL RENFERME UNE RICHESSE CAR IL TRANSMET UN MESSAGE SURTOUT S'IL
Y A DES BULLES.
MOI, J'UTILISE DEUX TECHNIQUES; "CARICATURE (HUMOUR) ET PORTRAIT." CELA, POUR FAIRE UNE LEÇON A CEUX QUI NE FONT QUE DES HUMOURS.
POURTANT, JE SUIS ARTISTE AUTODIDACTE. NAYEMAKA NA NDENGE YA KOSEKISA PE NA NDENGE YA KOBIMISA ELONGI YA MOTO LOKOLA NAMONELI YANGO
NDE PO NA KOPESA NDAKISA NA BAYE BASALAKA KAKA B'AVENTURES. NZOKA, NGAI NAYEKOLA EPAI YA MOTO MOKO TE. NABOTAMA MOYEMI.

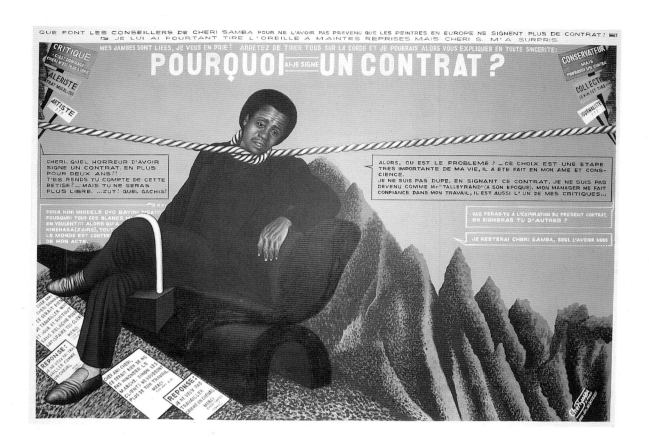

Cat. 81 *"POURQUOI AI-JE SIGNÉ LE CONTRAT?"* (WHY HAVE I SIGNED A CONTRACT?), 1990, BY CHERI SAMBA (ZAIRIAN, B. 1956), ACRYLIC ON CANVAS, 135 x 200 CM. PRIVATE COLLECTION.

Cat. 82 *"LUTTE CONTRE LES MOUSTIQUES"* (BATTLE AGAINST THE MOSQUITOES), 1990, BY CHERI SAMBA (ZAIRIAN, B. 1956),

MIXED MEDIA, 150 x 200 CM. COURTESY OF ANNINA NOSEI GALLERY, NEW YORK.

Cat. 83 *"SOUVENIR D'UN AFRICAIN"* (AN AFRICAN'S RECOLLECTION), 1989, BY CHERI SAMBA (ZAIRIAN, B. 1956), OIL ON CANVAS, 81 x 60 CM. COURTESY OF JEAN-MARC PATRAS GALERIE, PARIS.

POURQUOI CES GENS EN OCCIDENT N'ONT-ILS PAS HONTE ? PARTOUT OU JE PASSE, C'EST TOUJOURS PAREIL ET ÇA FINIT TOUJOURS COMME ÇA. ILS NE FONT JAMAIS GRAND CHOSE. QUEL MAUVAIS APHRODISIAQUE BOIVENT-ILS QUI LES AIDE A NE PAS BANDER???

Susan Vogel

Trigo Piula's painting *Ta Tele* (1988; cat. 115) speaks of the new magic of consumerism, of the hypnotizing array of temptations that have invaded the minds of the Congolese. In the painting, the people of Brazzaville are transfixed. Images of romantic love, soccer, beer, and cars lodge in their brains, implanted there magically by television screens the way witches implant things deep in the bodies of their unsuspecting victims. The traditional Kongo "fetish" confronting the people in this image is of a violent, retributive type, capable of inflicting injury and disease (cat. 127-129). The feathers on its head show that it works through the forces of the sky, like the mysterious beams of television. Trigo introduces a Westernism—this "fetish" is wired for sound, flanked by two enormous speakers. It might in fact speak, and we the viewers are right behind the onlookers in the picture. We are part of the audience. The painting is a warning, a moral lesson, a public statement. And

THE OFFICIAL STORY

the painter is a preacher exhorting the people to examine their values.

Many of the African artists we may call "international" and the societies in which they live share an assumption: art should help to define and shape the people's character. International African art, like traditional African art, must do more than be seen: it is to a considerable degree functional. Around the time of Ghana's independence (in 1957), Kofi Antubam (1922-1964), one of the country's leading artists, wrote, "My country must first establish that kind of art which will go into a museum to serve as an inspiration. The artist must help society to be less confused and more peaceful" (Mount 1973:224). And Léopold Sédar Senghor, Senegal's first president, wrote, "*Art nègre* saves us from despair, uplifts us in our task of economic and social development. . . . whether they dance the development plan or sing the diversification of crops, African artists, Senegalese artists of today, help us live for today better and more fully" (Senghor 1977:62). In modern Africa, art is expected to play a political, social, and moral role.

The surge of nationalism that crested around 1960, when many black African nations became independent, included an overt expectation that art would express and mold—perhaps even aid in the

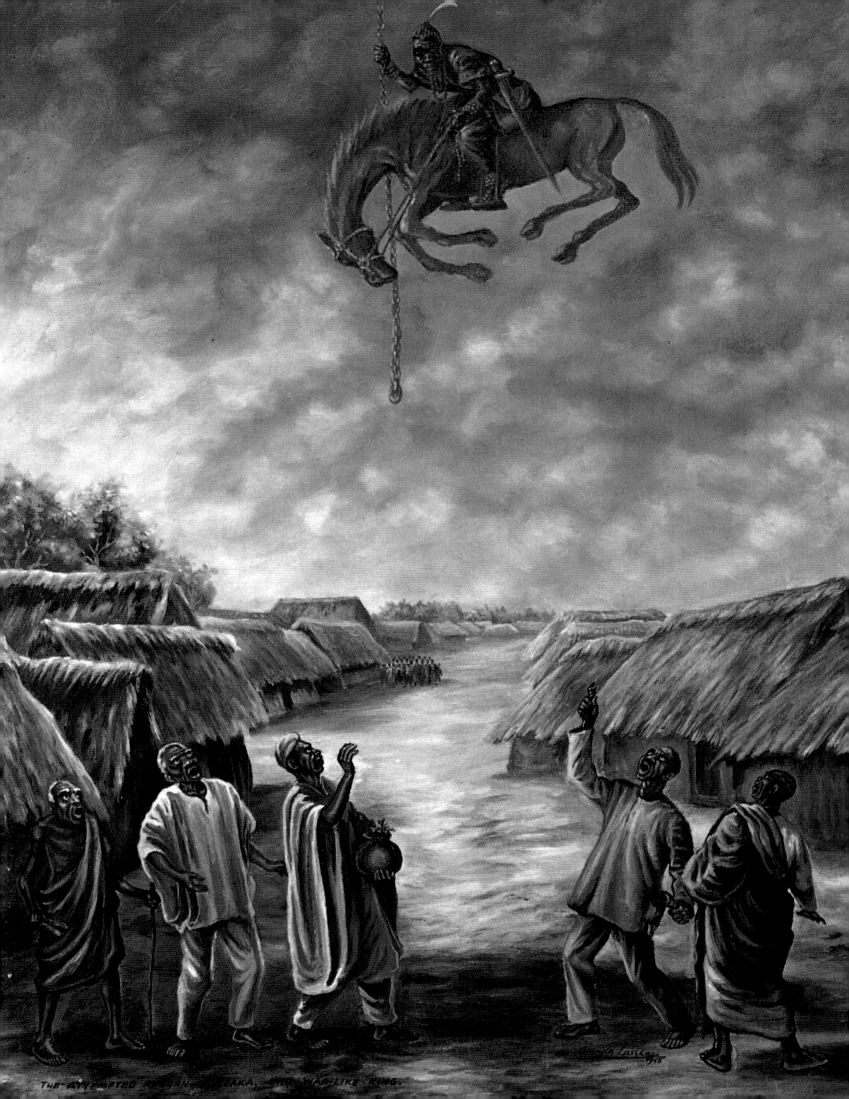

THE ATTEMPTED RETURN OF SHAKA, ONCE WAR-LIKE KING.

creation of—the new African. "Political freedom in Africa particularly must clothe itself with the colours of culture," writes Ben Enwonwu (1977:66), the Nigerian sculptor (born 1921). Art was to help shape a unifying national character out of divisive ethnic identities. It would assert Africa's independence and affirm the beauty and validity of traditional African culture, contradicting colonialist propaganda. Some called for a more or less extreme rejection of alien subjects, styles, and materials, and for a search for a new artistic language that would express the new Africa. "The artist will seek in art," according to Tshibangu Tshishiku, rector of the University of Kinshasa in Zaire, "the rising of a new order, the genesis of a new world" (Badi-Banga 1977:11).

The drama of International African art has been played out against the background of that mandate, expressed or presumed. It unfolded first under the scrutiny of colonial officialdom and later under the watchful eyes of African governments. This is the story of a search for expression undertaken by artists charged to make an art not so much for personal satisfaction as for national edification and glory.

Ideologies

The mandate to find modern African forms of expression was met by two responses. From the beginning of the century, some artists asserted their right, as artists, to use any media within their command; others wanted to search for an inner Africanness that they considered innate, either requiring only freedom to find its full expression, or buried under a crust of colonialism and Western civilization that had to be cast off. Both branches of this latter response, articulated as the widely known philosophy of "negritude," have exerted an enormous influence on contemporary African artists, whether they agree with them or not. These general responses, which span the continent, have long coexisted, with artists at times moving back and forth between them. They do not represent a chronological progression.[1]

To uphold the nation rather than the region has been central in the work of International artists from the earliest days of independence, when the artists tacitly agreed to suppress ethnic references in favor of multiethnic ones that could build a national allegiance. "Tribalism" was not only backward in the eyes of many, it was dangerously divisive. The first mission of the new national art at the time of independence was to raise the people above their old ethnic antagonisms. Thus businessmen who wore suits were seen as expressing their modern national identity rather than their older ethnic or religious ones.

One of the first African artists to insist that Africans could work in Western media and styles was Aina Onabolu (Nigerian, 1882-1963), who was a full-time easel painter by 1906. The attitudes he faced are typified by the opinion of F. H. Howard, a colonial education officer: "In the field of art, an African is not capable of reaching even a moderate degree of proficiency" (Fosu 1986:7). Even more recent African paintings that resemble Western ones, as Onabolu's do, have

◄ Fig. 1. *The Attempted Return of Ajaka Owo War-like King*, 1958, oil on canvas, by Akinola Lasekan (Nigerian, 1916-1972). Lasekan is a second-generation Nigerian painter, following the generation of Aina Onabolu (1882-1963), who was a full-time easel painter by 1906, the year Picasso "discovered" African sculpture. From then through the 1930s, European artists and African artists simultaneously experimented with each others' art styles. Many African artists perfected a naturalistic mode, which they applied to African subjects. Lasekan taught himself to paint and went on to create his own art school, becoming one of the first art teachers in Nigeria. He painted political, Christian, genre, and mythological subjects. Photo: courtesy Bildnachweis, Übersee-Museum, Bremen.

often been coldly received by Westerners. As Serge Creuz wrote in 1964, "[These Zairian artists] won't understand that the more they resemble our painters, without having, obviously, the high level of composition of our great painters, the less their work interests us, and the less it is worth as autonomous art. We want to be transported by black painters, we want a freshness of sensibility, their own way of revealing the world" (Cornet et al. 1989:202). Western critics, with their longing for difference, for the exotic, have often been most pleased by naive African art, or by the African art that is most markedly different from Western art.[2]

Onabolu became driven to prove that Africans could make Western-style pictures. In the 1920s he studied art in London and Paris, and after returning to Nigeria he was influential in getting art instruction into school curricula. He painted numerous portraits in a meticulously realistic style, recording important Nigerians for history—and assuming that his art should have a social function (Fosu 1986:7). His insistence that he and other African artists could work in the media and vocabulary of Western art was reinforced by the antitraditional position that began to be assumed by formally educated artists in the 1920s. These artists reflected the optimism of a period of sustained social and cultural change that appeared to be irreversible, and that was generally accepted as "progress." They saw traditional art as moribund, perhaps even "primitive," and certainly void of possibilities for development. The old Africa had to be swept away to make way for the new. In any case, the art of old Africa was remote from Africans educated in European universities.[3]

For some artists trained in the West, the antitraditional ideology posed a dilemma, for they had been exposed in Europe to work that was regarded as advanced, yet that showed the obvious influence of traditional African sculpture. Kofi Antubam argued,

> It will therefore be illogical for the Ghanaian in the twentieth century to be expected to go and produce the grave and ethnological museum art pieces of his ancestors. The argument that he should continue to do so because of the unfortunate influence of African traditional art on the meaningless abstractionists' modern art of Europe is not sufficient to dupe him into being complacent. He is determined to paint, sculpt, and write using such methods as are used in the older nations of the world, and basing his work on subjects selected from the meaningful and realistic aspect of his way of life (Antubam n.d.:6).

The antitraditional impulse was an early assertion of the artists' right to use any sources they chose. By and large, they picked oil on canvas as their medium, and they applied representational, relatively conservative Western styles to African subjects.

The opposed ideology favored an innate, purely African inspiration. In the colonial period, this view was mainly advocated by European art-school teachers. Brother Marc Stanislas (Victor Wallenda), founder in the 1940s of the Kinshasa school now called the Académie des Beaux Arts, was typical:

> [Brother Marc] required [his students] to maintain a certain continuity with

Fig. 2. *Mina ya Nnom*, 1970s, bronze, by Leandro Mbomio Nsue (Equatorial Guinean, b. 1938). Mbomio feels that "we have a human debt to make the ways and customs of our ancestors fruitful, prolonging them in time in keeping with new necessities" (Arean 1975:45). The son and grandson of Fang sculptors, in the 1960s he studied art in Spain, where he lived as an artist in exile for many years. He has since returned home to become Equatorial Guinea's minister of culture. Few International African artists make sculpture, and fewer work in wood. Unlike Mbomio, many seem to find Africa's rich sculptural heritage more daunting than nourishing. Photo: courtesy the artist.

Fig. 3. *New Church of Berlin*, 1960s, beads on hardboard, by Jimoh Buraimoh (Nigerian, b. 1943). An artist of the Oshogbo school, Buraimoh alludes in his work to an ancient Yoruba art form in which colored beads sewn to cloth create two- and three-dimensional images. The themes of Buraimoh's "bead paintings" are usually Yoruba mythology, but here his subject is biographical. Non-African subjects are rare in international art. Photo: courtesy Bildnachweis, Übersee-Museum, Bremen.

Fig. 4. *The City*, 1983-1987, oil on glass, by Serigne Ndiaye (Senegalese, b. 1953). Serigne is the most advanced of a number of young, academically trained Senegalese artists who have experimented with the technique of painting on glass. It is unusual for International artists to show such an interest in popular African art forms; they are usually more drawn to the dignity and seriousness of traditional sculpture and textiles. Collection: Museum für Völkerkunde, Frankfurt. Photo: Maria Obermeier.

Fig. 5. *Islamic Holy Man*, 1987, enamel paint on glass, by Gora M'bengue (Senegalese, 1931-1988). The Urban mode of painting on glass has been patronized by relatively less-well-off Senegalese since early in the century. This Urban painting shows the stable, balanced composition and projects the serene, confident world view typical of the early-twentieth-century aesthetic. The contemporary aesthetic seems more fractured, even when the artist returns to earlier art forms for inspiration and techniques. Photo: courtesy Bildnachweis, Übersee-Museum, Bremen.

traditional art, that being the obligatory point of departure. Nonetheless, they shouldn't exactly copy masks or "fetishes," but should try to improve on them by an observation of nature. On the other hand, Brother Marc mistrusted the seductiveness of international arts. For a long time he resisted showing his young pupils works of European art and even forbade them to look at books that traced its history (Cornet, in Cornet et al. 1989:136).

As the independence movement gathered momentum in the 1950s and '60s, Senghor of Senegal articulated the philosophy of negritude as a clarion call to artists.[4] The similar "authenticity" doctrine was promulgated by President Mobutu Sese Seko of Zaire, beginning in the early 1970s. The group of Zairian painters who call themselves the "Avant-gardistes" have issued a manifesto that typifies the feelings of many:

> We modern Zairian artists cannot neglect the inestimable values of our ancestral patrimony, which should serve us not only as a solid foundation, but also as a fertile source of inspiration. . . . Modern Zairian art should appear in the eyes of the world as an art endowed with young blood, animated with a magical breath. We desire that our art will entirely recover its autonomy and its intrinsic personality thanks to a casting off—brutal if necessary—of all stereotyped formulae of foreign origin. [Our art will] . . . animate hearts and spirits with the ideals of Zairian humanism (Badi-Banga 1977:118).

Embracing this ideology, innumerable artists all over Africa have sought to limit their themes and materials to those they consider as African. Especially in West Africa, they have returned to traditional materials or techniques, which they have elaborated in contemporary styles. In the 1960s Jimoh Buraimoh (born 1943), of the Oshogbo school of artists in Nigeria, began making "bead paintings," gluing beads onto a support in works whose surfaces recall the figurative beadwork crowns and bags of nineteenth- and twentieth-century traditional Yoruba art. Serigne N'Diaye (born 1953), a Senegalese artist trained at the École Nationale des Beaux Arts in Dakar, uses an Urban medium of painting on glass (fig. 5), but in a semiabstract style. In *The City* (1983-1987; fig. 4), Serigne applies the traditional brilliant colors according to a twentieth-century aesthetic that evokes the jumbled confusion and instability of city life.

The Groupe Bogolan Kasobane, a collective of six artists in Bamako, Mali, was formed in 1978 specifically to revitalize the *bogolanfini* textile-dyeing technique. Going "beyond the individualism and subjectivity of the Western 'I,'" according to Keita and Albaret (1990:50), they work together on traditional cotton cloth made of narrow handspun and handwoven bands. They use an ancient method to "innovate, using these techniques to create works that will be completely original and even modern" (Groupe Bogolan Kasobane n.d. [ca. 1988]). Groupe Bogolan paintings draw on motifs from traditional African sculpture, ancient Egyptian art, and futuristic, space-age comic books (figs. 7 and 8).[5]

Most African artists have sought subjects as well as materials in

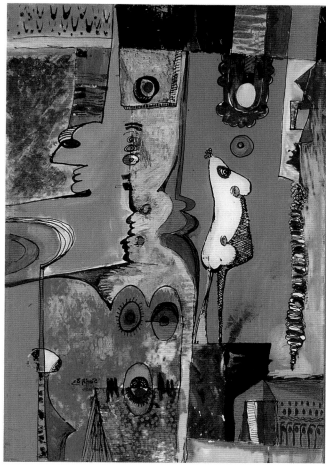

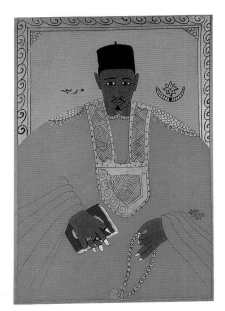

early-twentieth-century traditional life. The Ivoirian Youssouf Bath (born 1949), trained in Abidjan and Paris, works on bark cloth as well as paper, and eschews oil paint as a "revolt against cultural imperialism."[6] Many of his works are painted with coffee and chalk; their main subjects are "masks, fetishes, traditional and contemporary sacred festivals and rituals, hunters and their prey, and the spiritual state obtained in trance and meditation" (Stanislaus 1990:61). In almost any exhibition list of contemporary African works, one finds a preponderance of titles such as *Meditation at the Sanctuary, Ornaments for the Gods*, and *Of Dance and Initiation*.[7]

Ouattara, another Ivoirian (born 1957), brings a wry sophistication to the search for African subjects in traditional culture. He attaches to his canvases actual masks (of the kind made for the tourist market) and bogus "fetishes," and draws on nineteenth-century traditional art from Côte d'Ivoire as well as (sub rosa) from the remote Pacific islands. Ouattara, who lives in lower Manhattan, may be a victim of the tyranny of the traditional, or he may be ironically undermining a stereotype by aping the "wild African artist" his SoHo audience imagines him to be—deliberately feeding them a hash of "primitive" art, mixing up the actual names and styles of the traditional nineteenth-century works he portrays. He leaves the question open. Using his own private symbols (for Ouattara, paired triangles represent the hourglass, death, and the passage of time) and skillfully blending African, Egyptian, and post-Modern words and imagery, he makes a

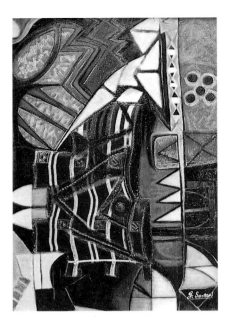

Fig. 6. Untitled, ca. 1980, oil and mixed media on board, by Gerard Santoni (Ivoirian, b. 1943). At this period in his career, Santoni was using only white, red, blue or black, the colors of much traditional art. In the central area of this picture, he has attached a piece of traditional striped Baule fabric—which remains a source of inspiration in his work today. At the time, he was loosely affiliated with the Vahou Vahou movement. Santoni, who was trained in France, and has lived and studied in New York, teaches at the Institut National des Arts in Abidjan. Courtesy of the artist; photo Susan Vogel.

moving *Samo the Initiated* (1988; cat. 98), a veiled memorial to his friend Jean-Michel Basquiat, now initiated into the final rite of passage.[8]

In reality, the simple paradigm of two distinct alternatives— assimilation or archaism—no longer exists, though many International African artists still define their choices in those terms. Late-twentieth-century traditional art has adopted cosmopolitan materials and imagery, and Western-style art academies in Africa are now staffed by African teachers, many of whom were themselves taught by Africans. The search for modern African forms of expression has been going on for at least half a century; a new, distinctly African Urban art is riding the roads and hanging on every market stall. The repertoire of forms available to young artists in Africa differs from what it was at the beginning of the independence period, and is larger than ever before. (Significantly, works of contemporary Western art are still virtually impossible to see anywhere on the African continent outside South Africa, and are known, if at all, only from photographs.) The artists in this exhibition, among many others, recognize that their culture is made up of movies and masquerades and all the things they have seen in Africa, Europe, or Asia; all they have read; all they have owned, from amulets to audio systems; and all they have ever experienced, including art training and traditional initiation. They are not preoccupied with the remote origins of the things that surround them and make up their world. They feel at home in the new Africa and free to create a cosmopolitan art.

International African Art

Once African artists began to make representational paintings on paper or canvas, their art began to be called "contemporary," the name by which it has come to be known in the writing of most African and Western critics.[9] There is nothing wrong with this term, but its meaning, "of the present era," applies equally to all kinds of art made in Africa today—including contemporary traditional art, contemporary Urban art, and New Functional art. To appropriate the word "contemporary" only for art by highly educated Africans is to relegate all other current forms to a timeless limbo or to an archaic past. (It is also to replicate the Western view of African art as outside history, a view that has obtained almost up to the present.[10])

African artists who would fall under this rubric have offered alternative names to "contemporary" when I have discussed this difficulty with them: "international," "modern," and "individual" are the most common suggestions.[11] "Modern" is confusing since it can be taken to refer to a specific Western art movement—one with which most African artists are not concerned; it is also awkward to use now that the West considers itself in the post-Modern age. "Individual" implies that other kinds of African artists lack individuality —which is clearly not the case.

"International" is probably the best appellation to replace "contemporary." The term describes; it does not denote special status.[12] The distinction of the International strain in African art lies both in

the nature of the work and in the artists' formative circumstances and working situations. International African artists address an international audience, represent their countries in international gatherings such as the Pan-African Games or in biennial exhibitions in places as various as São Paulo, Libreville, and Paris,[13] and may exhibit internationally, mainly under government auspices. Most have been educated in Western-style art academies in Africa, but some have studied in Europe or America, or were trained under a European mentor. They tend to be well traveled (though mainly outside the African continent and by invitation), and many have lived overseas for periods from a few months to years, often as part of training programs sponsored by the host countries. For the most part, their patrons are also international —expatriates, international corporations, and their own governments.

International artists deal with their African or national identity in at least some of their works. The word "international" in no way denies their identity as Africans. It merely acknowledges the wide horizons of their world, and their access to hybrid cultures. The question "How African are these artists and their works?" is a false one. It rests upon a narrow, stereotyped idea of what it is to be African, and has been used to challenge Africans who do not conform

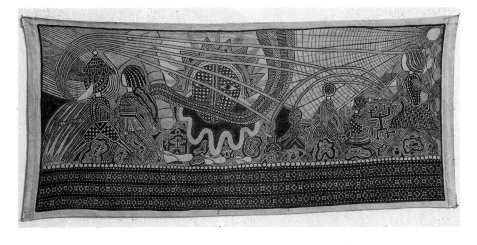

Fig. 7. *Ba Ka Kulushi juru* **(Polygamy), 1989, by the Groupe Bogolan Kasobane (Malian). This collective of six artists uses the traditional** *bogolanfini* **resist-dyeing technique on handspun, hand woven, unstretched narrow-band cotton cloth. Deeply concerned with social issues and the erosion of values, the artists write, "What will the world become in centuries to come? Faced with unforeseen consequences of a nuclear threat and chemical weapons, the question is unanswerable. How far can human grasping and man's secret ambitions go?" Photo: courtesy the artists.**

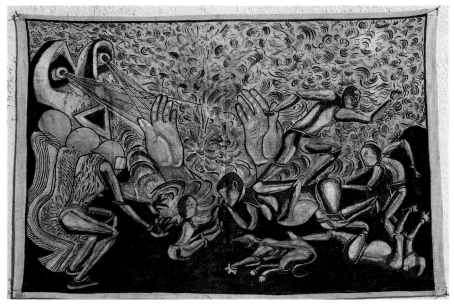

Fig. 8. *Le secourisme (Cameroun)* **(Rescue, Cameroon), 1989,** *bogolanfini* **resist-dyeing technique, by the Groupe Bogolan Kasobane. This picture seems to refer to the disaster of Lake Nyos, Cameroon, in 1987, when natural poisonous gases spread from the lake over villages and countryside, killing hundreds of people and animals. Other African artists have referred in their works to the disaster of Chernobyl. Photo: courtesy the artists.**

Fig. 9. Shelves in the house of the Mozambican artist Malangatana Valente (b. 1936), 1979. Tourist art, manufactured items, souvenirs from a trip to Asia, natural objects, and traditional crafts have all caught the artist's cosmopolitan eye. His paintings show a thoroughly digested eclecticism. Photo: Susan Vogel.

to that stereotype—to question their cultural "purity." When asked by Africans, the question probably expresses skepticism about the effectiveness of these artists in helping to define the modern culture and character of Africans. Posed by Westerners, it may originate in a naive belief that Africans instinctively tap into some deep well of ancestral knowledge and creativity that can be "spoiled" by too much contact with outside "influences";[14] that only a particular set of traits can mark an artist as authentically African; and that a person's "Africanness" may be only loosely attached, and may be shed or lost by adopting the wrong qualities or leaving the continent for too long.

The "Africanness" of African artists working in International styles is nonetheless constantly questioned in a way that the cultural authenticity of other artists never is.[15] No one challenges Gauguin's Frenchness (his own protests to the contrary). No one doubts the Europeanness of painters born of English parents in Kenya, even when they are influenced by African art. International African artists themselves have no doubts about their African identities—even those who live more or less permanently outside the continent.

What is striking about these expatriate African artists' work is how little it resembles most of the current art displayed in the museums and galleries of the cities in which they live. Fodé Camara (born 1958), a Senegalese artist currently living and studying in Paris (fig. 11; cat. 102-104), works with his own silhouette, the imprints of his hands, and images of Gorée, the former slave-depot island off Dakar. He has said his work is influenced by Jasper Johns, but he had seen only two actual Johns paintings at the time.[16] Asked whether his painting is African in its essence, and whether he sees himself as an African painter, he replies, "Yes, I am very African because Africa is above all amalgamation and recycling" (Gouard 1989:30). Iba N'Diaye (born 1928), another Senegalese in Paris, uses a flawless classical drawing technique to deal with subjects referring to multiple sources: Velázquez's painting of Juan de Pareja, for example, becomes a universal symbol of the black man facing a mindless and bestial hostility (1986; cat. 113). Citizen of two worlds, N'Diaye does not

hesitate to treat an ostensibly Islamic subject, though he himself is not Muslim: he turns the annual sacrifice of the ram that marks the end of Ramadan into a moving statement about mortality and the arbitrariness of oppression (1970; cat. 110). Malangatana (born 1936), a Mozambican who is a frequent visitor to Western museums, paints in an expressionistic style all his own (figs. 9, 10; cat. 108-109). Having seen Hieronymus Bosch beasts akin to those he has painted for years, he adds their froglike bodies to the other monsters in his paintings about the predatory nature of the state.

An Alternative Art History

The history of International African art has been told in terms of masters and schools[17]—a model based on conventional histories of European art. This model's relevance to the African case remains to be proved. Perhaps the story of European art since the Renaissance may be seen broadly as each generation's attempt to advance beyond the styles and theories of the preceding one, the underlying assumption being that art can be explained in terms of the influence of or the dialogue with the artists' teachers and their styles. Nothing suggests, however, that this drive for progress has been the dominant experience of contemporary African artists.[18]

A more useful art history might be organized according to the two continent-wide ideologies discussed above. The first of these asserts the right of Africans to make whatever art they choose—including works resembling European art—and rejects the notion that their art must be recognizable as "African." The second, articulated by Senghor as negritude, holds that African artists should reject outside influences and materials and draw on their inner Africanness.[19] These two arguments, eventually put forward by both Europeans and Africans, affected artists in different places at different rates, so that we do not find simultaneous continent-wide art movements, but rather two opposed ideological poles toward which artists have gravitated.

European art teachers and workshop directors have uniformly acted in accordance with the latter of the two ideologies, though not usually as part of any intellectual movement.[20] Their concern has been rather to foster uncorrupted what they have seen as the innately African artistic talents of their students. None of the leading expatriate art teachers, however, has been a significant artist in his or her own right. Only Georgina Beier of the Oshogbo school had a personal style strong enough to attract imitators.[21] The first European art teachers in Africa, who began work in the 1930s or so, were generally at pains not to impose or even to suggest their own personal styles. The African art teachers of that generation are less well-known than the Europeans, but were all artists themselves (Onabolu of Nigeria, as well as Akinola Lasikan in the same country, Antubam in Ghana, and the Cameroonian Gaspard Mouko, who established a studio in Brazzaville, Congo, in the 1940s [Tati Loutard 1989:3]). All seem to have taught by example, and to have been more interested in exploring the possibilities of foreign art techniques and styles than in trying to find specifically African ones.

Fig. 10. Malangatana in his home in Maputo, 1979. One of the rare artists who have been able to keep good samples of their paintings, Malangatana plans to create a museum in Maputo based on his collection of his own and other artists' works. Photo: Susan Vogel.

Fig. 11. The Senegalese artist Fodé Camara (b. 1958) in Paris, 1990. Currently living and studying in Paris, Camara normally works on fairly large canvases flat on the floor. Before the period of this photograph, the French government had temporarily put a large studio at his disposal, as the only African artist chosen to participate in an ambitious project commemorating the French Revolution. He is now painting in his dormitory room. Photo: Susan Vogel.

The Origins

The roots of International African art lie in a number of separate but quite similar events, occurring at different times and places and otherwise unrelated: a European in Africa would notice the artistic skill of Africans (mainly uneducated or low-status people in colonial society) and would provide them with materials and criticism. In a pattern that repeated itself from the 1920s to the 1960s, the mentors, often amateur artists themselves, would then create a workshop or school for the artists they had "discovered," sometimes devoting their lives and much of their means to promoting the reputations of their students.[22] (Several of the workshops developed into national art schools in which the artists of the original group became teachers.) The original mentors would express misgivings about exposing their artists to European art, and all would repeatedly insist that the work produced had been influenced neither by them nor by any European art. For the European teachers, the issue of purity of inspiration was paramount from the beginning—but was always compromised.

The earliest well-publicized case—it was certainly not the first[23]—is that of the Zairian painter Albert Lubaki (born about 1895), a supplier of various items for the tourist trade, including his own carved ivories. In 1926, Lubaki's wall paintings attracted the attention of the young colonial administrator Georges Thiry,[24] an amateur poet enthralled by Africa. Thiry gave Lubaki paints and paper and paid him for his work, sometimes requesting particular subjects. He also showed Lubaki's paintings, and those of Tshyela Ntendu, another painter he had "discovered," to Gaston-Denys Périer, a colleague in Brussels, who admired them greatly, comparing them to "an ultra-modern tapestry" (Cornet et al. 1989:20), and began actively to promote "modern" Congolese art in Europe. Between 1929 and 1931, watercolors by these two artists were shown in Paris, Geneva, Brussels (alongside paintings by René Magritte and Paul Delvaux), and Rome (in an exhibition sponsored by Mussolini). The reaction of press and public was uneven. In Paris, there were serious doubts that these could really be the work of a "naive African" (perhaps they were made by the gallery owner himself?); in Rome, the exhibition organizer rejected all subjects he considered non-African. As Périer wrote to Thiry, "He only kept some drawings of animals and of people in wrappers. Impossible to get him to include dressed negroes or those using European means (bicycles etc.)" (Cornet et al. 1989:32).

Lubaki's and Tshyela Ntendu's paintings (cat. 93-96; see also fig. 6, Jewsiewicki, "Painting in Zaire," above) are clearly an extension of a local wall-painting tradition, with no significant changes in subject, style, or technique. (Tshyela Ntendu even painted a series of large, subtly colored abstractions resembling the geometric wall paintings.) The only important differences between the wall paintings and these artists' works on paper appear to be the new medium, which permitted a wider range of colors, and the fact that the paintings on paper seem to have been made exclusively for whites. The artists do not seem to have found a local market for them, or to have expanded their foreign one. As far as we know, they stopped making them (perhaps

Fig. 12. Romain-Desfossés, founder of the Atelier d'Art "Le Hangar" in Lubumbashi, Zaire, watching one of his pupils, Mwenze, paint, early 1950s. The painter sits on one traditional stool atop another, his posture underscoring the alien nature of easel painting. Romain-Desfossés, who died in 1954, was above all concerned that his pupils should avoid influences from European chromoliths. Photo: courtesy *Life* magazine, 4 May 1953.

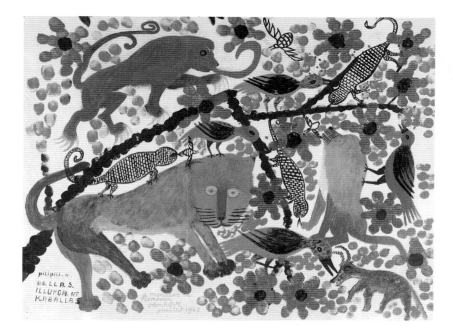
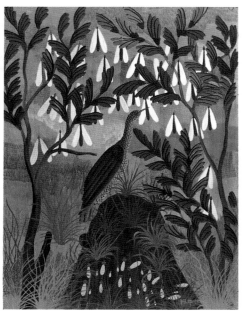

Fig. 13. *À Monsieur le Professeur Van Hove*, 1948, gouache on paper, by Pilipili, Bela, Illunga, and Kabala. Among the best painters in the Pierre Romain-Desfossés workshop in Lubumbashi, Zaire, these artists all developed individual styles, and did not normally work collaboratively. Romain-Desfossés trained them to paint from observation and from inner inspiration; he did not expose them to European art, but gave them a lot of guidance. Before coming to Zaire, from France, Romain-Desfossés was an amateur painter who had exhibited underwater scenes painted on zinc and copper sheets—elements that reappear in Zairian art. Photo: courtesy Bildnachweis, Übersee-Museum, Bremen.

Fig. 14. *Termites and Birds*, 1970s, acrylic on hardboard, by Pilipili Molongoy (Zairian, b. 1914). Like many African artists, Pilipili quickly developed a personal style that changed little over a long career. The hallmark of his work is the fine parallel brushstrokes that create a flat screen of colors behind his subjects. His delicate line and refined drawing set him apart from the other Lubumbashi artists, but he favors the shallow space, plant and animal motifs, and beautiful colors that are typical of all. These works are undemanding and decorative, and have very little content. Photo: courtesy Bildnachweis, Übersee-Museum, Bremen.

for want of materials) when their mentor left Zaire.

Lubaki and Tshyela Ntendu are not properly speaking International African artists, with whom they have in common only their European mentor and their exhibitions (which they may never have known about), but they are precursors. It is important to note that they were literate in French, and that they were familiar with European imagery through printed magazine and other pictures, which had already become wall decorations in the homes of some urban Africans like themselves. Despite their exposure to such imagery, they continued to follow the conventions of traditional African wall paintings, using areas of flat color to indicate their subjects floating on the surface of the paper, or sometimes on a baseline. Like the wall painters, they were not interested in perspective or in evoking deep space, and they used no modeling or cast shadows. They were not concerned with painterly issues or with questions of identity. It is also interesting to see that the authenticity of these precursors was already challenged in the most basic way (was this image really made by an African?), and that the work was held to the requirement of "purity" (no bicycles or clothes!).

Style and Subject

The ideologies that have guided International artists have not been theories about art per se. They have rather been about political and social identity. Thus artists on both sides of the ideological fence have practiced similar styles, despite their intellectual differences. (The works selected for this exhibition are not a representative sampling of typical styles and subjects, so this discussion only partly applies to them.)

In general, these artists are not interested in an illusionistic art, even when they are working in a relatively naturalistic style; the influence of photography seems to have been negligible. Instead, an emphasis on the surface of the picture and a strong use of line can be

seen in works by artists as different as Mode Muntu (cat. 90-92), Ouattara (cat. 97-99), Malangatana (cat. 108-109), and the Kenyan Kivuthi Mbuno (cat. 87-89). Painters working in many styles reveal a sharp awareness that the artist is painting on a flat surface. The illusion of three-dimensional space seems antithetical to their work, which typically portrays a vague or shallow space with subjects— often large—close to or lying on the picture plane, forming a friezelike composition that fills the entire frame. This sometimes airless effect does not invite the viewer into the picture. The flat, linear treatment of the surface can easily slide into decoration, as in the diverse paintings by the Nigerian artist Twins Seven-Seven, the Senegalese Papa Ibra Tall, and the Zairian Pilipili Molongoy.

International artists use traditional sculpture for its striking silhouette and seldom try to evoke its extraordinary volumes. (Their use of African sculpture in painting is illuminatingly different from Picasso's first experiments, for example, which explored not only the strong graphic element in African sculpture, but also the way forms project into space.) It is significant that several contemporary African art movements are founded instead on a connection to traditional African two-dimensional arts. The Ulists in Nigeria are inspired by traditional Igbo wall and body painting; the Groupe Bogolan in Mali by *bogolanfini* cloth; Bruce Onobrakpeya (Nigerian) and Gerard Santoni (Ivoirian) both use local textile patterns and colors in many of their works.

The works of the Nigerian sculptor Sokari Douglas Camp (cat. 100-101) are an example of the emphasis on the graphic over the plastic, and on the representational over the abstract, that characterizes International African art. These welded-metal sculptures are linear, and are representational without being illusionistic. Camp uses flat sheets and ribbons of metal to create figures and objects that become drawings in space. She does not create bulk or volumes that thrust into space, but encloses space in a frequently transparent, hollow shell. Camp does not merely evoke movement but motorizes her life-size sculptures so that they actually move. In this respect, she works like a traditional sculptor who attaches actual cloth to his figure rather than carving a simulacrum of clothing.[25] No illusion is involved because she gives us the real thing.

In its relationship to its subject, almost all International African art, like traditional African art, might be characterized as public rather than private or intimate—in keeping with its function as a collective expression. Artists rarely deal with personal imagery or autobiographical subjects; few of those living or studying abroad have depicted what they saw there (in contrast to the Western tradition of artist travelers). Painters shy away from portraits of friends or family (or of public figures for that matter), and rarely depict interior spaces. Remarkably little International African art reflects the visual world inhabited by the artists. Though most of these artists live in cities, contemporary urban culture, and such prosaic accoutrements of contemporary life as cars and buses, are very minor themes in their work. A desire to produce high art, serious art, art that is worthy of its

Fig. 15. *Hunter with Family Trouble*, 1960s, gouache, by Twins Seven-Seven (Nigerian, b. 1944). When Twins Seven-Seven began working in the workshop established by the German critic Ulli Beier at Oshogbo, Nigeria, in 1964, he had had little formal schooling. He quickly created a highly original style and continues to be a prolific painter while also maintaining successful careers as a musician, a dancer, a businessman, and recently a politician. Though his later works are repetitious, he is probably the most interesting of the Oshogbo painters. He is well-known abroad and was included in the 1989 *"Magiciens de la terre"* exhibition in Paris. Photo: courtesy Bildnachweis, Übersee-Museum, Bremen.

Fig. 16. The Nigerian artist Sokari Douglas Camp (b. 1958). Welding sheets of steel and strands of wire, Camp creates hollow, life-size figures and objects, mainly inspired by her memories of Kalabari culture. She lives more or less permanently in London but maintains her ties to Nigeria with frequent, prolonged visits. Photo: courtesy the artist.

mandate, moves artists to avoid these banal subjects, and to scorn anything that seems trivial, jokey, or irreverent.

The most personal works that come to mind are all related to the commemoration of the dead. Ouattara has created many paintings dealing with death, including the one dedicated to Basquiat (1988; cat. 98). Camp's *Church Ede (Decorated Bed for Christian Wake)* is a memorial to her father: in Kalabari tradition, the dead are laid out on an elaborately draped and decorated bed where they are visited and addressed by the bereaved, and the work is a metal sculptured bed bearing only the imprint of the departed man's body (1984; cat. 101). Camara was very affected when his father died only a year after returning from a long internment as a political prisoner in Guinea. The X rays he associates with his father's final illness find their way into his paintings as ghostly ribs (1988; cat. 103).

Often, paintings depict village life, or carry titles that suggest spiritualism, mystery, and contact with an ancestral culture. Though virtually all artists have what they would call their home village, their personal involvements with these generalized and idealized villages often feel remote and theoretical, or else weakly sentimental. Traditional sculptures echoed in paintings look like museum pieces or book illustrations; the paintings rarely show an intimate understanding of the objects. In literally hundreds of paintings of villages I have recently examined, I have noticed not a single T-shirt, wrist watch, or plastic sandal. International artists do not depict village life as it appears today, and they refrain from suggesting that it may be changing with the times or in any way threatened. Instead, they record for the future a vanishing way of life. International artists may deal with traditional culture as part of their attempt to locate contemporary Africa between an ancestral past and a modern present. This not only satisfies foreign clients, and the city dwellers who are their African patrons (all of whom have roots in the villages), but may be felt as a way of preserving a heritage (Agthe 1990b:35).

International artists not only avoid dealing with their immediate surroundings, they virtually never paint strongly felt or topical subjects. Their work is rarely critical or satirical, and only obliquely political. Critical content is almost always expressed in easily changed titles rather than in form. The works seldom allude to important social problems such as corruption, AIDS, economic development, or relations between the sexes and between the generations—all subjects that have been fruitfully (and humorously) explored by African writers, musicians, filmmakers, and Urban painters. The pressures of the two-pronged market—with unsophisticated foreigners on one side and official or elite African clients on the other—may partially explain why the vision of Africa that International art presents tends to be positive and constructive.

Interestingly, however, the basic preoccupation with ideas, ethical issues, and timeless realities that we see in International African art—as opposed to personal or transient experiences and the visible world—is also a feature of traditional African art. We can hardly assert that this constitutes a continuity between the two art forms, but

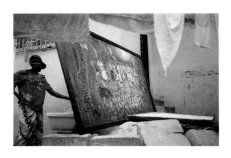

Fig. 17. A painting in the central courtyard of the house in Libreville, Gabon, where the artist Koumba Gratien lives, sometimes paints, and stores paintings. A number of other family members share this small yard, which is where all the household's washing and cooking take place. Gratien is a young artist who is just beginning to establish himself. Expensive and hard-to-get materials, cramped working conditions, and the fact that most paintings are destined for homes or offices (rather than for museums) account for the relatively small canvases produced by many African artists. Photo: Susan Vogel, 1989.

the presence of these broad traits in art made by hundreds of artists all across the continent must raise that possibility.

The Artist's World

By local standards, the economic and social situation of the International artist in Africa has tended to be almost the inverse of the position of the average American or European artist. Compared to African hospitals, libraries, and schools, art academies are not badly equipped and maintained, though by American standards their buildings and equipment may seem rudimentary. International African artists often enjoy prestige and high visibility in their own countries (sometimes holding official government positions), and they may receive relatively generous government support.[26] (One of the few commercially successful women artists in Nigeria, however, has cited lack of government support as the reason more women have not succeeded.[27]) Many artists can earn a living through their art, though many also teach at art institutes, or make such things as textiles, furniture, television-studio sets, or tourist objects for additional income. Particularly in Francophone countries, they may show in exhibitions that include generous cash prizes for the best works.[28] In some places, in fact, the profession of artist has come to be regarded as an easy way to earn money: art-school teachers complain that students apply there because the entrance exams are less competitive than those for the universities, and because they hope for good incomes.[29]

International African artists almost always live in large cities. They sell their art through direct commissions, mainly from governments and corporations, and through exhibitions, often in hotels, banks, and government and other public buildings. Additional shows are organized by arts organizations, and by local branches of foreign cultural institutes.[30] (The Italians, Germans, and French are especially active.) There are few commercial art galleries in Africa, and no system of independent alternative spaces to form a critical presence. Many countries have no art galleries at all; only a few large cities, notably Nairobi, Harare, and Lagos, have had more than one gallery/shop for any sustained period. Studies of contemporary African art often assert that International art is characterized by the lack of contact between its artists and clients as a result of the gallery system. Except for Nairobi, however, the idea that galleries and middlemen play a role of any importance is not supported by the facts.

A case in point is Abidjan, the capital of Côte d'Ivoire—a city of about two million people, and one of the most prosperous and modern in Africa. According to Gerard Santoni, an artist and professor at the Institut National des Arts, there are in Abidjan about fifty trained, practicing professional artists but no more than ten collectors. The only gallery recently closed. The best-selling artist today is Kadjo James Houra (fig. 19), the head of the national art school, who has received large commissions to decorate government schools and who also sells to private individuals. There are several official artists' associations, and art events are well covered by an

admiring press. There is no Ivoirian art critic.

The situation in East Africa is markedly different. The earliest university-based school of fine arts in Africa was Uganda's, established in the 1940s. Government commissions were available in Uganda to dozens of artists until about the mid 1970s, making them some of the most widely visible and favored of artists in Africa (Miller 1975). Support for artists ceased during the chaotic rule of Idi Amin, and has hardly existed since. In Kenya, according to Johanna Agthe's excellent new study (Agthe 1990a), the government sees art mainly as a tourist attraction, and has provided only limited support. Decades of heavy souvenir-buying safari traffic have produced a number of mainly foreign-owned commercial galleries, which thrive and dominate a well-established and densely populated art scene.[31] First established around 1960, the galleries in Nairobi were among the first in sub-Saharan Africa, but they have exhibited at least as much work by white residents of Kenya as by Africans (Miller 1975:39-44).

In recent years the East African galleries have encouraged African artists from the most diverse backgrounds. The very original Ugandan painter Jak Katarikawe (born 1940) is a self-taught artist who never went to primary school. The Ugandan sculptor Francis Nnaggenda (born 1936), who teaches at Nairobi University, was trained in Switzerland and Germany. Kivuthi Mbuno of Kenya (born 1947) attended only primary school, and speaks limited English. His is a typically Kenyan story: as a safari cook, he soon discovered that there was money to be made selling pictures to tourists. He was drawing full-time by his early thirties and has made a living from his art ever since (cat. 87-89).[32] Artists in Kenya have not formed associations but work alone in a sharply competitive atmosphere (Agthe 1990a:101).[33] Even more than other International African artists, they suffer from a lack of local patronage, but like the others, they benefit from the attentions of foreign buyers. They also sell at relatively high prices, and receive travel grants and opportunities to exhibit and sell overseas.

The lack of patronage by African collectors is the single greatest problem for International African artists today. The largest buyers of academically trained artists' work are their own national governments and Europeans or Americans. The critic Dele Jegede writes, "The

Fig. 18. *Maman Ngulu*, 1984, oil on canvas, by Mavinga (Zairian, b. 1937). Mavinga is one of Zaire's most prominent artists, and heads a section of the Académie des Beaux Arts in Kinshasa. He was a member of the "Avant-gardistes," a movement formed by ten artists in 1975, which dissolved in conflict when some members tried to turn the group into what Bamba and Musangi suggest was a kind of secret society or lodge (1987:24). This painting won fourth prize (10,000 French francs) at the 1987 CICIBA Biennale in Kinshasa. Collection CICIBA, Libreville. Photo: Robert Rubin.

Fig. 19. *La Pensée*, 1987, oil on traditional handspun, handwoven narrow-band cotton cloth, by Kadjo James Houra (Ivoirian, b. 1952). Currently Côte d'Ivoire's best-selling artist, James is a painter whose art suits the taste of the elite. He uses a common device: a network of swirling lines, unconnected to the underlying image, which knits together the different elements in the picture and locks them into a single flat plane, contradicting any suggestion of depth. Popular among artists of many schools, this device may also relate to a traditional interest in pattern on pattern, seen in otherwise unrelated practices from the stamping of batik patterns over machine-printed cloth to the polyrhythms of African music, where two or more unrelated rhythms intermittently coincide to produce a syncopated beat. Photo: courtesy the artist.

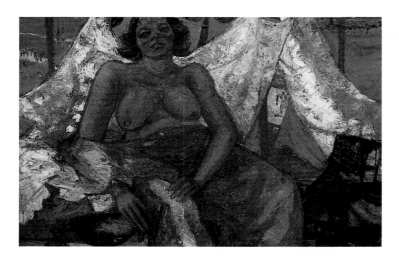

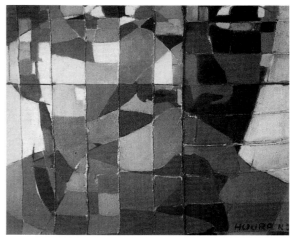

major consumer of contemporary arts in Nigeria today is the Nigerian government" (Stanislaus 1990:6). He also argues that "today, there is no gallery—private or government sponsored—which holds the promise of giving artists assured patronage through constant and well organized exhibitions" (Jegede 1983:231). And he draws a warning from this situation: "A condition in which the encouragement and promotion of art are in the hands of a government and foreign diplomats, a situation in which indigenous galleries are as rare as collectors, and an environment where a premium is placed on foreign patronage cannot for long produce an art unwarped by vested interests. Although patronage is essential in stimulating artistic efforts, its nature is what determines the character of a people's art" (Jegede 1981:11). The situation is beginning to change: in Nigeria, for example, it is becoming fashionable and prestigious for wealthy Nigerians to own and display modern Nigerian art in their homes.[34]

Another grave problem (though one less worrying to the artists and officials) is the lack of serious criticism. Artists in Africa are handicapped by a lack of perspective on their work: they see almost no art by artists outside their own milieu. The official structure is monolithic, inescapable, and indiscriminately supportive, and the press is blindly flattering. The only other opinions available to working artists come from their friends and teachers, and from artists' associations, whose criticism is limited by proximity and by politics. The issue is discussed by Badi-Banga Ne Mwine, a Zairian critic employed by the National Museums to oversee their contemporary art collection, in his *Contribution à l'étude historique de l'art plastique zaïrois moderne* (1977), a study published under the patronage of the head of state, President Mobutu. The president's picture appears on the book's first page, over a text that describes him as "crucible of the truly Zairian artistic personality, patron of the arts, generator of the promotion and dissemination of Zairian artistic culture." (No independent agency exists that could have published such a history without official patronage.) In a surprisingly frank assessment of the Avant-gardiste group, Badi-Banga writes, "Nonetheless, the assertions of the group have not yet been realized. This will depend upon a total liberation of the artists from, on the one hand, consumer art, which forever demands tired formulas and techniques, and on the other, a penchant for stylistic conformity. To accomplish this, it would seem indispensable for the artists to regularly encounter philosophers and art critics" (Badi-Banga 1977:119).[35] Nowhere in Africa does such an opportunity exist. Isolation, stagnation, and complacency are the most serious problems facing International African artists.

Some African artists live overseas for extended periods, probably mainly for stimulation, but also for personal reasons or in search of better working conditions (artists' materials are not always available in Africa, especially during times of economic crisis, and space can be hard to come by[36]). As Iba N'Diaye remarked while living in Dakar, "I need to go back [to Paris] often. . . . If I remained here I would run the risk of going to sleep. But for inspiration, I need Africa" (Mount 1973:167). African artists on their own ground have been spared the

gaze of Western critics. It was a rare event when the International Art Critics Association Congress met in Kinshasa in 1973:

> The IACA brought to a standstill the history of our modern art. Confronted with international criticism, Zairian artists became aware of the place that their creations occupied in the contemporary artistic universe. Their intellectual conformity was profoundly shaken. But not all felt the need for a new effort, particularly since a certain criticism of flattery covered them with its favors (Badi-Banga 1977:114).

For the most part, African artists in Africa form part of a thick network of activity and association that is purely local and is not an appendage of Europe. Almost everywhere, artists have formed professional associations that promote their interests, organize exhibitions for them, and represent them to the government and the public.[37] Especially in the Francophone countries, where they may resemble unions and are typically linked to the government, these associations are active and internally political, with numerous officers and official meetings, functions, and so forth. In most Anglophone countries, artists' associations are more likely to be independent, privately organized, and numerous: in the early 1960s in Ghana, there was a government ministry concerned with the arts, and one independent organization that was composed of no fewer than six smaller groups.[38]

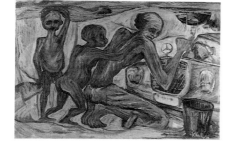

Fig. 20. *Les Netoyeurs* (The washers), 1979, oil on board, by Ndoki Kitekutu (Zairian, b. 1949). Ndoki was a member of the "Nouvelle Génération" group, which formed in 1978, succeeding the Avant-gardistes. His early work was predominantly aesthetic, according to Bamba and Musangi (1987:85), but has become more concerned with Christian values. In this relatively early painting, the impoverished car-washer is cleaning the bloody-looking headlights of a Mercedes, symbol of political power and corruption. Photo: courtesy Bildnachweis, Übersee-Museum, Bremen.

Groups of artists also form movements and issue manifestos. For example: in the early 1950s, Congolese artists espoused the "Style Mickeys";[39] the artists in Abidjan's VahouVahou movement have taken the name derisively given them—it means something like "mishmash"; Nigeria's Ulism movement draws its inspiration from the early-twentieth-century Igbo body painting and wall painting called *uli*. A recent survey of International Zairian painting lists the country's Avant-gardiste group among no fewer than four movements formed by professional painters in Kinshasa between 1974 and 1978 (Cornet et al. 1989:140-142). As Joseph-Aurélien Cornet points out, however, the movements are more likely to be concerned with technique and ideals than with intellectual or theoretical issues like those discussed in Western art movements. Nonetheless, polemic, debate, controversy, and politicking within and between these movements can at times be intense.

Mali presents a revealing example of the International African artist's activities. The fifth-poorest country in the world, it has not yet formed a university; in this context, the personal histories of two independent artists—not members of the Groupe Bogolan Kasobane —show a surprising level of activity. Ismael Diabate (born about 1945) studied at the Institut National des Arts in Bamako, the capital, and currently makes a living by teaching drawing in a lycée. Since 1970 he has had sixteen exhibitions in Mali (which has no art gallery), in places such as the Catholic mission in Segou and on the occasion of the fifth anniversary of the founding of the Association Nationale des Artistes du Mali. Abroad he has exhibited in Tunis, Moscow, Beijing, Göteborg, Angers, Havana, Paris, Stockholm, Uppsala, and in Alge-

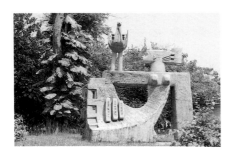

Fig. 21. Untitled sculpture, 1970s, cement, by Paul Ahyi (Togolese, b. 1930). Cement is a favored medium for large sculpture, mainly for practical reasons. Ahyi has executed many public sculptures for government buildings in the capital of Togo, Lomé. Photo: Susan Vogel.

ria. His younger colleague Abdoulaye Konate (born 1953) has a similar history, though he studied in Havana after finishing at the Institut National des Arts; he is currently employed by the National Museum as a painter.

Which Center? Whose Periphery?

Despite their mobility, and although foreigners are often their main clients, International artists share few concerns with the avant-garde artists of the main Western art centers. Perhaps because their art aspires to be socially useful, none seems to have been touched by any of the Western avant garde movements. Committed to exploring collective issues, such as what it means to be an African in the late twentieth century, they find little of use in individualistic Western art, or in approaches that question the nature and boundaries of art. Their emphasis on content rather than form—often a quite specific political or social message—also separates them from much current Western work. It may be revealing that in all of sub-Saharan Africa outside South Africa, there is not a single subscriber to *Artforum* —not one bookstore or library, not one art-school teacher.[40] Cost may be a factor, but I suspect that many African artists and teachers find the art and ideas published in Western journals irrelevant to their work, and useless in dealing with the problems that concern them. Personal experience suggests that many African artists find Western popular culture of greater interest and utility than the latest Western art. (Just as an artist from Paris might be more interested by street life in Ouagadougou than by an exhibition of contemporary Ouaga artists.) Perhaps their world and their concerns are too different for them to find sustenance in Pop art, Minimalism, Conceptual art, or post-Modernism.

Insofar as one can generalize about so large a group, International artists in Africa do not feel themselves to be marginalized or on the periphery. They are part of a dense and active network of relationships, rewards, and movements, and they answer to the concerns of their own circles. The orientation of African artists toward an art that will be useful to their countries, and toward an ideological and political focus that will deal with what it is to be an African artist, is central to an understanding of their relationship to the West. While it may not always have been so, the former colonies have to some extent turned their backs on the old "centers of culture." It is only Paris, New York, or Venice that might consider these artists to be on the fringe. From their point of view, their place may be not on the periphery of the West, but at the center of their own universe.

NOTES

1. I am grateful to the art historian Zelig I. Karp for helping me clarify this.

2. Indian artists in London have sometimes been similarly discouraged from trespassing on the turf of Modernism by gallery owners who have urged them to paint Indian subjects (Araeen 1989:28).

3. Oku Ampofo, a Ghanaian sculptor (born 1908), wrote in 1949, "There has been a definite decline, and in some areas complete disappearance [of African art], so that new generations of Africans who want to see the art treasures of their forefathers

have to hunt for them in the museums of Europe and America. . . . I found in these ancient masterpieces the emotional appeal and satisfaction which Western education had failed to cultivate in me. It was as though an African had to go all the way to Europe to discover himself! This is virtually true of most of us. Very little, if any of what is real in our own culture is taught in our schools and colleges" (Ampofo 1949:18). Ampofo most admired the work of Kwame Bediako, a sculptor who had never been to school and whose work, he felt, had not been influenced by European art. Ampofo, a wood carver, believed that an African renaissance was possible in the near future but that it would "depend largely on what educated Africans think of their past culture and civilization" (ibid.). He is an early proponent of the theory articulated as "negritude."

4. For a fuller discussion of negritude, see Ima Ebong's essay below, "Negritude: Between Mask and Flag."

5. I am grateful to Claude Ardouin for putting me in contact with Abdoulaye Konate, Ismael Diabate, and the six artists of the Groupe Bogolan, who generously provided me with information and photos of their work.

6. Oral presentation at the Studio Museum in Harlem in conjunction with "Contemporary African Artists: Changing Tradition," 21 January, 1990.

7. These titles are listed in the catalogue published by the artists' association known as AKA for its third annual exhibition, in 1988, held in Enugu, Lagos, and Nsukka (Nigeria).

8. Interview, New York, February 1990.

9. For African critics' use of "contemporary" see Lawal 1977, Badi-Banga 1977, and Odita 1983; for Westerners', see Agthe 1990a, Beier 1968, Wahlman 1974, and Stanislaus 1989. Fosu's comprehensive 1986 book uses both "contemporary" and "modern."

10. See Thomas McEvilley's essay below, "The Selfhood of the Other."

11. Though I cannot hold them responsible for the conclusions presented here, I am especially grateful for lively partisan discussions with the artists Joseph Aubin, Fodé Camara, Acha Debela, Tapfuma Gutsa, Salah Hassan, Souley Keita, Iba N'Diaye, Malangatana Valente, Leandro Mbomio Nsue, Bruce Onobrakpeya, Ouattara, and Gerard Santoni, as well as with Johanna Agthe, Mel Edwards, Ousman Sow Huchard, Helke Kammerer-Grothaus, Jean Kennedy, Amadou Gueye Ngom, and Ulli and Georgina Beier, all committed observers and critics of the contemporary African art scene.

12. "International" African artists are not claiming to be "world-class" artists in the sense of "measuring up to world standards," or "being of international renown." They are International within the perspective of African arts.

13. Many Western artists are not international artists in this sense. They are part of regional schools, and define their identity in relation to the larger nation; they exhibit mainly for local audiences.

14. Frank McEwen writes of "Shona" stone sculpture, "Mysteriously this art appears to belong, stylistically and conceptually, to some ancient tradition emanating from a local source" (McEwen 1970:16). There is no significant local stone sculpture tradition and barely any tradition of figurative sculpture.

15. "How African, in fact, is contemporary African art?" the Nigerian critic Dele Jegede asks twice, expressing concern about the influence exerted by predominantly expatriate patrons (Stanislaus 1990:29, 39).

16. Interview, Paris, March 1990.

17. The most recent comprehensive study of international African art is Kojo Fosu's substantial *20th Century Art of Africa*, 1986, published by Gaskiya Corp. Ltd., Zaria, Nigeria. Fosu organizes his material chronologically and by individual artists, partly grouped by schools. The most widely available reference has been Marshall Mount's *African Art: The Years Since 1920* (1973, reprinted 1989 with a new introduction by the author). Its organization by school and its uncritical, celebratory tone are typical of publications on this subject. Mount deals with all the art made since 1920, but he

gives short shrift to all but International African art. He considers the category he calls "New Art" in terms of schools (French-speaking and English-speaking, located in eastern and western Africa, and "Artists Independent of Schools"). A look at his illustrations demonstrates the irrelevance of such schools, at least for choice of subject and the creation of style: two broad strains of art are immediately apparent, and both are practiced by artists who have nothing else in common. The first is an academic representation that ranges from realism to a kind of impressionism, and is exemplified by the work of artists such as the Kenyan painter Elimo Njau ("mission inspired"), the Ghanaian painter and sculptor Kofi Antubam ("English-speaking school"), and the Nigerian sculptor Felix Idubor ("independent"). The second is expressionistic or highly stylized and geometricized, and is seen in the work of artists such as the Senegalese painter Papa Ibra Tall ("French-speaking school"), the Tanzanian sculptor George Kazooka ("English-speaking school"), and the Mozambican painter Malangatana ("independent").

18. There are interesting parallels here with contemporary Indian art. Gieve Patel notes a "clear difference between this account [of Indian art] and art of the West. That is the absence here of successive schools, movements, and manifestos, each attempting to progress beyond the last one in its understanding and portrayal of pictorial space. In fact, the excessive proliferation of such movements in the West in the past thirty years we view with a degree of skepticism. We attribute this quick turnover of art movements and other avant-garde exertions largely to the demands of an aggressive market. . . . The emphasis in India has been on renewal, not on a search for the new, the underlying, unstated belief being that progress is not necessarily a reaching out toward things 'never known before.'" Patel goes on to say that the greatest dangers for Indian painting are complacency and self-satisfaction (1989:200).

19. This idea, of course, echoes similar movements in other non-Western countries: the "indigenism" movement among Indian painters in the 1960s, and the Mexican Renaissance, among others.

20. Art teaching is often based on the observation of nature, which, as Cornet has pointed out, represents a scornful rejection of traditional African art (which is essentially conceptual) and leaves students alienated from it (Cornet et al. 1989:201-202). Abstraction is scarcely taught, and is generally not favored even by African artists trained in Europe or America, nor is the most avant-garde Western art. The preference rather is for art of the past or quite conservative art.

21. During the first phases of African art schools, in the 1930s, 1940s, and 1950s, many school heads were not artists but art teachers (Victor Wallenda) or amateur painters (Pierre Lods, Pierre Romain-Desfossés), or had been critics and gallery directors (Frank McEwen, Ulli Beier).

22. Pierre Lods, an amateur painter living in Brazzaville, Congo, "discovered" the talents of his cook, Ossali, and went on to found the school known as Poto-Poto, which still exists; Romain-Desfossés "discovered" the talents of Bela, his car washer, and founded the Atelier d'Art "Le Hangar" in Lubumbashi, Zaire; Frank McEwen, the museum director in Harare, Zimbabwe, "discovered" the sculptor and painter Thomas Mukarobgwa, "an untrained museum guard," and founded an informal workshop school at the museum, which still produces the well-known "Shona" stone sculpture; Pancho Guedes, an architect living in Maputo, Mozambique, did not form a workshop or school, but "discovered" Malangatana Valente, who was working as a caddy at the golf club, and provided him with materials and criticism; Georgina and Ulli Beier ran open workshops specifically designed to attract relatively uneducated and untraveled individuals in Oshogbo, Nigeria, and "discovered" Twins Seven-Seven and Jimoh Buraimoh, among many others. Oshogbo has remained a center of artistic activity for about thirty years, even though the Beiers departed in the mid 1970s.

23. Agthe mentions two sets of drawings made by Tanzanian artists before 1914 (Agthe 1990a:75).

24. See Bogumil Jewsiewicki's essay above, "Painting in Zaire."

25. For an extended discussion of this quality in nineteenth- and twentieth-century traditional African sculpture, see Vogel 1990:76-77.

26. The state is the largest employer in many African countries, so the government-

paid artist is not an anomaly.

27. Nike Olaniyi Davis, a batik artist, suggests that there are few women artists because the government has not helped pay for child care ("Nigerian Art: Kindred Spirits," 1990, a film by Carol Blue for the Smithsonian Institution).

28. At the third biennial sponsored by CICIBA (International Center for Bantu Civilization), held in 1989 in Libreville, Gabon, the thirteen cash prizes totaled about $15,000. Forty-seven artists participated.

29. The same holds true for filmmakers such as the highly successful Idrissa Ouedraogo, of Burkina Faso: "It wasn't a noble motivation to create an authentic African cinema that spurred Ouedraogo to become a filmmaker. He claims that he simply did not want to become a teacher and that Ouagadougou's film institute was close to his house" (Werman 1989:20). Ouedraogo later studied film in France and earned a degree there.

30. It is interesting to analyze the exhibition histories of nine of the best-known and most respected African artists, presented in the "Contemporary African Artists" exhibition at the Studio Museum in Harlem, New York, in 1990. Of the 285 exhibitions listed with venues, only 155 were in Africa, and of those, only 17 were in private galleries outside South Africa. Most of these exhibitions were in Kenya and Zimbabwe (Stanislaus 1990:53-120).

31. Political turmoil in their own countries and the active art market in Nairobi have brought numerous Tanzanian and Ugandan artists to Nairobi over the years.

32. I am grateful to Ruth Schaffner and the Gallery Watatu, Nairobi, for this information.

33. Art societies were founded sporadically in Kenya, mainly by European amateur painters, from the 1920s on. Many gave art classes (Miller 1975:71-72).

34. Jegede (1981:6) and Babatunde Lawal both complain that International artists price their works too high for the broad Nigerian public. Lawal notes that artists are used to charging high prices to foreign buyers (1977:145).

Interestingly, the professional classes of Zaire have seen their purchasing power so diminished in recent times that university professors have begun to hang Urban paintings in their homes both as a statement of political alliance with the poor and as an expression of their own lack of the means to maintain a Western standard of living (personal communication from Bogumil Jewsiewicki, May 1990). High government officials have also begun to patronize International painting, for example as an ideal wedding present. Imported housewares such as silver and crystal—favored gifts in the past—have become exorbitantly expensive even for the wealthiest Zairians, according to Citoyen Ngongo Kamanda, Commissaire d'État à la Culture et au Tourisme du Zaire (interview, July 1989).

35. Jegede sounds the same note: "Contemporary Nigerian artists must abandon the complacency which now characterizes their outlook. A new philosophy is overdue; a more vigorous campaign, involving government, patrons, critics, and artists must be mounted" (1983:305).

36. Lack of large studio spaces in Africa may be one reason that works by African artists living there are smaller than those by African artists living in the West.

37. The Ghanaian sculptor Oku Ampofo, who went to medical school in Britain, returned home after World War II, and "tried to band together all practicing artists, *literate and illiterate,* into a national society" (emphasis added), a rarely attempted project (Ampofo 1949:18).

38. Antubam describes the Arts Council of Ghana as made up of the Ghana Society of Artists, the Akwapim Six, the Ghana Music Society, the Cape Coast Palette Club, the National Cultural Centre, and the Ghana Writers' Society (n.d. [ca. 1961]:6).

39. The "Style Mickeys" referred to Disney's cartoons. The paintings, which were part of the Poto-Poto school in Brazzaville, are described as generally small pictures that "exalt traditional life through scenes of hunting, fishing, markets, warfare and dance." The Style Mickeys is also related to prehistoric African rock painting (Tati Loutard 1989:5).

40. Information courtesy *Artforum*, Spring 1990.

NEGRITUDE: BETWEEN MASK AND FLAG

Senegalese Cultural Ideology and the "École de Dakar"

Ima Ebong

Taking, means . . . being taken: thus it is not enough to try to free oneself by repeating proclamations and denials.

Frantz Fanon, "On National Culture," *The Wretched of the Earth*, 1961

In the center of Dakar, five minutes' walk east from the presidential palace and five minutes' walk west from a notorious street of prostitutes and pickpockets called Boulevard Pompidou, is a rundown little compound owned by a Senegalese artist and writer called Issa Samb. It is filled with an incongruous array of artworks, objects once used as props for a performance art group and now lying scattered in various stages of decay. In some ways, these objects are a collection of clues to the formation of contemporary art in Senegal.

One of them is a simple construction hanging from a tree: a mask bound by rope, like an unsevered umbilical cord, to a flagpole that bears a weathered Senegalese flag (fig. 1). The mask appears as an ironic simulation of antiquity; the wood-and-fiber detritus that hangs precariously from it heightens its ethnographic effect, its ancestral pose.

What can be understood by this pairing: the Senegalese flag, a symbol of the modern nation; and the mask, more than any other artifact a signifier of traditional African culture? Perhaps this is a commentary on the ambiguous, often tense relationship between the ho-

mogenizing impulses of the nation and the traditional cultures that African governments try to use to shape their own image. The dangling rope that connects the two objects suggests that the alliance between them is tenuous.

This assemblage is a particularly appropriate paradigm in the case of Senegal, where the postcolonial state has tried to develop a culture that incorporates the modern and the traditional, the political and the poetic, the hiding and the hidden, the flag and the mask. Since Senegal's independence, state ideology has attempted to define contemporary African culture by the concept of "negritude." And negritude became the national discourse that decided which groups and individuals in the arts were considered mainstream and which were marginal.

I want to explore the cultural ideology of negritude as a force shaping contemporary art in Senegal. My emphasis will be on the "*École de Dakar*,"[1] a generation of Senegalese artists whose proximity to former President Léopold Sédar Senghor, and to his cultural theories, earned them the name "negritude painters" (Samb 1989). I am interested not so much in a history of the school as in a description of a particular, unstable space within the Senegalese cultural mainstream, and of the lateral shifts and adjustments within it.

It is impossible to discuss contemporary art in Senegal without invoking the name of Senghor, a major architect of the philosophy of ne-

gritude (Irele 1981, Hauser 1982) and, in his various roles as art patron, poet, cultural promoter, politician, and president of Senegal from 1960 to 1980, a man of unparalleled impact on the country. His position as president especially allowed Senghor legitimately to transgress the boundaries between culture and politics, strategically aligning the former to serve the interests of the latter. His ability to negotiate the space between art and culture, and to occupy various positions in both, has had important implications for contemporary Senegalese art, which, from its inception, was incorporated into a national agenda. Even before Senegal's independence, in 1960, Senghor emphasized the functional aspect of the arts, promoting a kind of "development aesthetic" that could support the economic and social agenda of the arriving nation. In the foreword to *Cultural Policy in Senegal* (1973), Alioune Sene, then Senegal's minister of culture, explicitly sets out the state's position: "Under the vigilant care and inspiring influence of Senegal's leader, our research workers are busy evolving a style which will express the Negro-African conception of modern social life: Public buildings, private houses and housing developments will, in their turn, soon bear witness to African man through the grace of a supremely eloquent art. This confirms that, in Negritude, art in the general sense of the word is functional and part and parcel of the living day-by-day reality of things. . . .

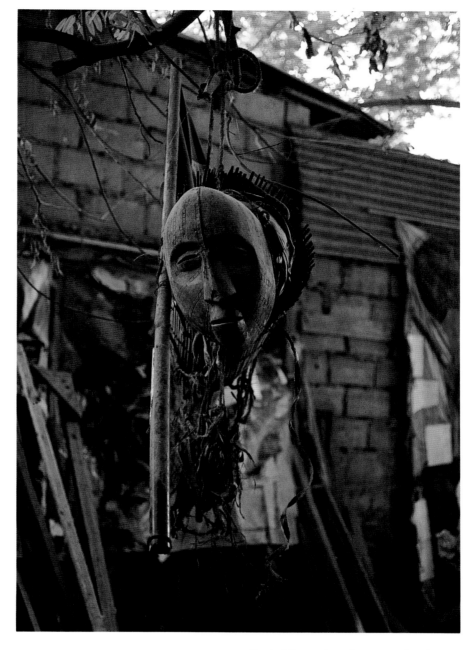

Fig. 1. A flag-and-mask construction that hangs at the entrance to the compound in Dakar where the Laboratoire AGIT-art group is based. The piece was once used as a stage prop in one of their performances. Photo: Ima Ebong, 1989.

Faithful therein to the teaching of the founders and theorists of Negritude, Senegal believes that culture is not an adjunct of politics but its pre-condition and justification" (M'Bengue 1973:10).

The idea of "the rehabilitation of Africa," the underlying agenda of Senghorian negritude (Irele 1981), began to develop a practical edge in Senghor's writing after 1950. His desire to translate his theoretical concepts into pragmatic terms derived in part from his growing participation in the political machinations of pre-Independence Senegal, and from his subsequent rise to the presidency. It was when he

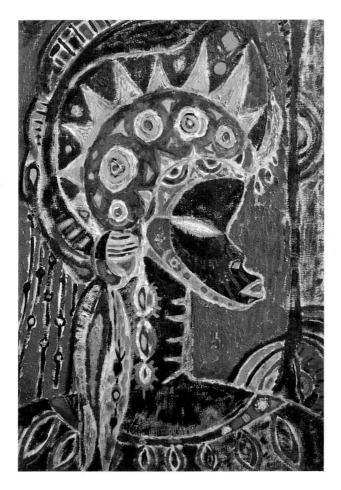

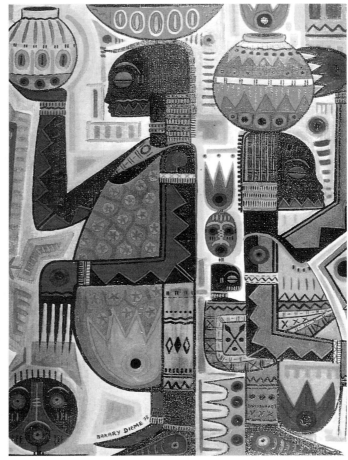

Fig. 2. Untitled, 1965, oil on canvas, 76 x 63cm., by Ibou Diouf (Senegalese, b. 1953). The incorporation of elements of traditional sculpture testifies to the "African" identity of this otherwise anonymous abstract portrait. In the work of many École de Dakar artists, traditional masks and other ethnographic material secures an affiliation with a past heritage. Ancestral subjects, annexed to the modernizing language of European abstraction, serve as the foundation of a new cultural identity. For the artists, the challenge seems to have lain in devising formal strategies that would retain the authority of a traditional identity while at the same time modifying it to accommodate more individualized artistic agendas. Diouf's extravagant combination of color and abstract pattern introduces other formal possibilities to the static mask portrait. Photo: courtesy Bildnachweis, Übersee-Museum, Bremen.

Fig. 3. Water Carrier, 1970s, tapestry, 292 x 200 cm., by Bacary Dieme (Senegalese, b. 1947). The allover patterning—which recalls African textiles—and the strong graphic design give this painting a decorative quality. Elongated arms and legs distort the figures; Dieme virtually reinterprets the human form, making it yield to his symbolic language and the mannerism of his formal design. Photo: courtesy of the Ministry of Culture, Dakar.

attained this dual role as cultural broker and president that negritude began to achieve the status of a national aesthetic, transgressing its boundaries as Senghor's own personal philosophy to inhabit a more public space as the "cultural constitution" of the nation.

Assimilating: The Art and Craft of Negritude

Senghor used various forums—exhibition openings, art publications, speeches on special occasions—to shape and promote his vision of negritude as cultural policy (see Senghor 1977). When he directly addressed artistic issues, his views often had a prescriptive edge; the tone of his writing was didactic. He liked to provide examples linking key concepts of negritude to modern art. Two contrasting views of art emerge in Senghor's writings. First, he believed that artists should shape an identity faithful to their cultural environment—faithful to African ancestral tradi-

tions and to traditional art. On the other hand, he also felt that artists should be open to influences of different kinds, and he used the term "assimilation" to express the pragmatic way in which Western cultural values could be accommodated.

In Senghor's address "*Picasso en Nigritié*," which he gave to mark the opening of a Pablo Picasso exhibition at the Musée Dynamique, Dakar, in April 1972, we get a sense of the kind of aesthetic he envisioned for Senegalese art and the *École de Dakar*. He began by staging a rhetorical question, asking "*pourquoi Picasso en Nigritié?*," then proceeded to answer by a skillful and systematic rereading of Picasso's formal achievements through key concepts of negritude. Senghor prefaced his remarks with the comment, "No artist could be more exemplary. He is a model for the School of Dakar, and his closeness to us here is a rich inspiration" (Senghor 1977:324). Then he con-

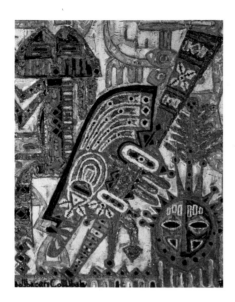

Fig. 4. Rencontre des Masques (Meeting of masks), 1976, oil on canvas, 116 x 89 cm., by Boubacar Coulibaly (Senegalese, b. 1944). Coulibaly's painting of the traditional sculpture of a variety of peoples expresses an idealized common heritage. École de Dakar artists in general quote freely from a mix of ethnic groups, but the gesture is more symbolic than truly investigative of specific regional artifacts. Ethnographic material also serves as a structural support for contemporary designs. Here, traditional shapes fuse with invented forms, creating a variety of improvised abstract patterns and designs. The expressionistic surface of the canvas—a thickly worked impasto coupled with a rich mix of color—completes Coulibaly's reinterpretation of traditional sculpture. Photo: courtesy of the Ministry of Culture, Dakar.

tinued with an analysis of Picasso, taking off from the ethnically based concept of identity on which rested negritude itself. Situating the artist within the ethnic mix of Mediterranean culture, Senghor discussed Picasso not within the framework of the formal aesthetic of European Modernism but in terms of the artist's Andalusian heritage. Somewhat didactically, he noted, "Here, then, is the first lesson of Picasso: the necessary faithfulness of the artist —and, finally, of the writer—to his surrounding milieu, to his country, his region. In a word, his rootedness in the earth" (1977:325). The statement reflects the importance Senghor attached to cultural specificity, and the role he believed it played in developing a national consciousness. On this he was most emphatic.

Senghor also discussed Picasso's formal achievements within a broad, ethnically determined complex: the artist's use of "archetypal images" drawn from his Mediterranean heritage, with its myths, fables, gods, and heroes. To Senghor, Picasso's use of symbols, and the form and content of his work in general, owed much to his assimilation of a variety of specific cultural forms. A controversial description of traits said to be inherently African— rhythm and emotion, for example, supposedly the bases of an African system of knowledge—provided the foundation for Senghor's elaboration of the influence of African art and sculpture on Picasso. Of Picasso's rhythm he noted, "[It] is the opposite of monotony. It is not the simple repetition of an element: of a sound, of a word, of a plastic phrase, I want to say of a form. . . . That is to say that it is also a rhythm of contrasts and of oppositions, of dissonances and of 'counter-rhymes,' in short a rhythm that is dynamic, 'living,' even in sculpture, which is the immobile face of figuration" (Senghor 1977:330). Senghor's preoccupation with ethnicity and cultural identity is particularly apparent in his conclusion: "In a word, the Andalusian artist teaches us Arab-Berbers and black Africans that

there is certainly no art without the active assimilation of input from abroad, but above all that there is no original spirit without rootedness in the originary earth, without fidelity to one's ethnicity—I don't say to one's 'race,' but to one's national culture" (Senghor 1977:330).

Senghor's efforts to promote negritude as a viable aesthetic of cultural nationalism are of crucial importance to the modern-day arts in Senegal. Negritude served as a frame of reference for the *École de Dakar*, helping to resolve questions of identity by providing ready-made, authenticated symbolic forms, and an interpretative vocabulary for them, that articulated an African world view. Senghor's tactical ability to merge the formal language of European Modernist abstraction with the values of negritude, as well as his revisionist reading of traditional African art through the achievements of Modernist painters like Picasso, opened the way for a strategy of reappropriation that at least on a formal level resolved the dialectic between modernity and tradition in African art. He made it clear that the absorption of Western values need not come only at the expense of traditional African ones. In addition, Senghor's concept of assimilation, through various panethnic affiliations (among Berber-Arab, black African, Mediterranean, and Indo-European ethnic groups), allowed for a global concept of negritude as an African world view.

In many ways, however, negritude was limited as an aesthetic, not only by its valorization of ancestral African art forms but by its abstract characterization of values it imagined as inherently African—values such as intuition, emotion, rhythm, and vital force. These values were to be realized through a specific formalist agenda calculated to accommodate the metaphysical dimension claimed for them. Negritude also seemed to function as a litmus test, measuring any art's ability to fulfill Senghor's requirements for a national culture. In this way

Senghor effectively narrowed the *École de Dakar*'s aesthetic options to a tightly prescribed formal and ideological zone.

Almost all of the *École de Dakar* artists attended Senegal's main art school, the École Nationale des Beaux Arts in Dakar. They were linked by their cosmopolitanism, their participation in local and international art institutions, rather than by any consciously unified stylistic program or theoretical position. Yet most of these artists explored an abstract, nonmimetic kind of figuration, a "semiabstraction." Masks, imaginary spirits, wildlife, traditional artifacts, generic urban scenes, landscapes, rural life and ritual, traditional mythology and folktales—these are the themes and motifs that have dominated the paintings of the *École de Dakar* since the 1960s. Together they form an idealized inventory of the nation's heritage, partially reworked in the modernizing language of paint on canvas. It's true that this ambiguous aesthetic convention has often allowed for highly individual formal solutions. All fall, however, within the restrictive framework of Senghor's demands for an "African" art.

Ibou Diouf, Bacary Dieme, Samba Balde, and Boubacar Coulibaly may exemplify for us the varied treatment of such ethnographic material as masks and traditional sculpture in the *École de Dakar*. All of these painters attended the École Nationale des Beaux Arts in the 1960s— during the peak of nationalist sentiment, in other words, just after Senegal's independence. The subjects of both Diouf's *Untitled* (1965), a portrait of a lady, and Dieme's *Water Carrier* (1970s) are tightly integrated into a network of forms that intersect with those of traditional sculpture (figs. 2 and 3). In Diouf's portrait, the naturalistic elements of the figure are reduced to a minimum, remodeled to fit the curvilinear forms of a mask. Likewise in *Water Carrier*, the spare outlines of figures and gourds are overlaid with geometric and sym-

bolic forms and patterns that reinforce a traditional African identity. Similar forms and patterns appear in Coulibaly's *Rencontre des Masques* (Meeting of masks), of 1976 (fig. 4), once again evoking an African identity.

Despite the inventiveness of works like these, the reworking of ethnographic material in the two-dimensional language of abstraction was in the end a constraint: it limited the imagination of the artist to formal variations arranged around a specific subject or theme. Attempts to broaden the thematic vocabulary can be seen in Amadou Seck's *Homme oiseau* (Bird-man, 1978) and in Chérif Thiam's *De la réalité au mystère* (From reality to mystery, 1977). Here the artists use traditional myths and legends as a basis for their own repertoire of fantastic creatures (figs. 5 and 7). The binary structure of Thiam's *De la réalité au mystère* reflects a tension between representational and abstract imagery: the bottom half of this sufficiently realistic drawing of a reptilelike creature gives way to two triangular forms that appear to be its wings, and that are filled in with a strange arrangement of circular and geometric shapes. Perhaps in a reflection of the artist's assertion of creative control, the distinctions between reality and fantasy are subverted by odd patterns and curvilinear forms that unexpectedly cohere into recognizable features.

The parallels between Senghor's concept of negritude and the themes and formal structures of most of the *École de Dakar* artists suggest the ideological dominance of negritude as a national aesthetic. The individuality of these artists' work was contained within a system of signification that ultimately referred back to Senghor's idealization of African culture. A famous exhortation of the former president's reflects his ambitions for art within his optimistic panorama of a national culture of Senegal: "*Art nègre* saves us from despair, uplifts us in our task of economic and social development, in our stubborn will to live. These

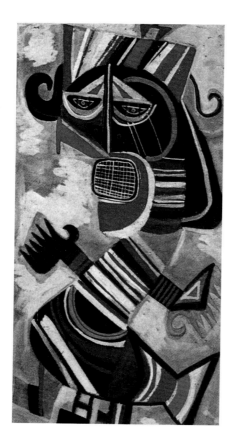

Fig. 5. **Homme oiseau (Bird-man), 1978, oil and collage, 121 x 61 cm., by Amadou Seck (Senegalese, b. 1950). Subjects drawn from traditional myths and legends serve as inspiration in Amadou Seck's paintings. Photo: courtesy of the Ministry of Culture, Dakar.**

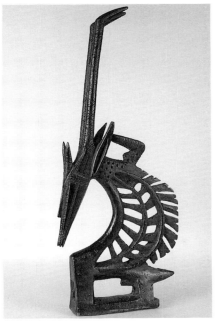

Fig. 6a. Masque, 1974, tapestry, 238 x 212 cm., by Samba Balde (Senegalese, b. 1950). These eight red curvilinear strips placed against a green background are inspired by a traditional chi wara antelope headdress (see fig. 6b). Samba Balde's updated shorthand version of the chi wara pushes the codes of recognizability governing the École de Dakar's use of traditional African themes as far as possible. Here the ambiguity between modern abstraction and traditional African sculptural form reveals an awkward moment in which rediscovery of a past occurs through the Modernist present. For the artist, however, the authority of the traditional prevails, the painting's title, Masque, ensuring its ancestral affiliation. Photo: courtesy of the Ministry of Culture, Dakar.

Fig. 6b. Bamana Chi wara headdress, early 20th c., from Mali, wood. Collection: Virginia Museum of Art, Richmond.

are our poets, our storytellers and novelists, our singers and dancers, our painters and sculptors, our musicians. Whether they paint violent mystical abstractions or the noble elegance of the courts of love, whether they sculpt the national lion or strange monsters, whether they dance the development plan or sing the diversification of crops, African artists, Senegalese artists of today, help us live for today better and more fully" (Senghor 1977:62).

Economic support from the state, a major patron of the arts, was of enormous consequence to the *École de Dakar*. The government bought artworks not only for its own collection but also to decorate its offices and embassies. This economic dependence on the state set further limits on these artists' exploitation of the creative options open to them. Indeed, artworks under state ownership often functioned as instruments of diplomacy: art and artists were seen as ambassadors for the ideals of a modern progressive African state.

"A New Art For A New Nation": Building a Cultural Infrastructure

Senghor's prescriptions for the role of art in the framework of national development were implemented in an intensive buildup of cultural capital during the 1960s and 1970s. One cannot overemphasize the role of government-funded cultural institutions in fostering the national consciousness during this period. Important examples were the Sorano National Theatre, which housed Senegal's dance and music schools; the Institut Fondamental Artistique National, a research faculty devoted to the collection of ethnographic and other such material; the Musée Dynamique, created to house contemporary art; the National Gallery, a temporary exhibition space for artists; and the École Nationale des Beaux Arts, devoted to the teaching of painting, sculpture, film, and art education.

The decision to establish a national school of art was made in 1960, the

same year that Senegal seceded from its federation with Mali and formally established itself as an independent state. Located in Dakar, the École Nationale des Beaux Arts, as it is called today, has turned out a cadre of academically trained professional artists and art educators. It is the primary degree-granting arts institution in the country.

Since it opened, the school has undergone a number of adjustments, reflected in its many changes of name and in the development of its curriculum and departments. From early on, it has taught music, dance, and drama along with the fine arts. As was common in Africa, the original educational program at the school replicated that of French art schools, and its diplomas were recognized as equivalent to the French *Certificat d'aptitude à la formation artistique supérieure* (Kalidou Sy 1989:48). The curriculum included drawing from plaster models, still life and anatomy drawing, perspective, abstraction, painting, and sculpture. In addition, a liberal-arts program provided general courses in the humanities, including African and Western art history. It would be a mistake, however, to assume that the Senegalese *école* was simply a reproduction of the colonial original. Senghor's interest in the school, and his belief in the role of art in the development of a national consciousness, made the institution an important agency for the realization of his cultural plan, especially in the 1960s. The objective, much as in his negritude theory, was to take existing colonial structures and to graft onto them values more in line with the aspirations of a newly created African nation.

Among the earliest and perhaps most important appointments to the school were two of Senegal's best-known artists, Papa Ibra Tall and Iba N'Diaye, both of whom Senghor invited to head departments in the fine arts. The unusual need for two quite separate fine-arts departments underscores the anxiety among intellectuals over the structuring of a postcolonial aesthetic.

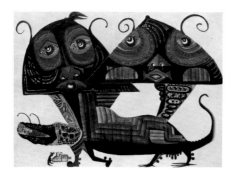

Fig. 7. De la réalité au mystère (From reality to mystery), 1977, ink, 67 x 52 cm., by Chérif Thiam (Senegalese, b. 1951). More than ethnographic sculpture, the mythical creatures and fantastic monsters of traditional legends offer École de Dakar artists an opportunity to experiment with formal styles and approaches. In Thiam's ink drawing, which recalls Surrealist imagery, the order of realistic representation is continually subverted by the play of highly stylized abstract patterns and forms. Photo: courtesy of the Ministry of Culture, Dakar.

Fig. 8. La semeuse d'étoiles (The sower of stars), 1970s, tapestry, 239 x 200 cm., by Papa Ibra Tall (Senegalese, b. 1935). The sweeping curvilinear forms and rich colors of Tall's tapestry parallel key aesthetic concepts of the negritude aesthetic such as "vital force" and "rhythm," concepts that seem to express a grand cosmic fantasy. Photo: courtesy of the Ministry of Culture, Dakar.

In many ways, each department reflected the philosophies and aesthetic concerns of its directors. N'Diaye had attended the École des Beaux Arts in Paris, and had studied under the sculptors Zadkine and, at the Grande Chaumière, Yves Brayer. He was known for his flawless draftsmanship and for his analytic construction of semiabstract forms. As a teacher, he wanted his students to be technically accomplished and to have a familiarity with and a command of both classical and modern elements of Western art. As an artist, he was resolutely independent and something of an individualist, with a healthy skepticism about the advocacy of a uniquely African aesthetic.

Tall, whose department was known as the "*Recherches Plastiques Négres*," had also been educated in Paris, at the École Spéciale d'Architecture, and later studied comparative education in Sèvres. In many respects, Tall shared Senghor's concern with establishing a theoretical foundation for the practice of contemporary art. Unlike N'Diaye's, his department was noted for its work in exploring materials and techniques consistent with an "African" frame of reference. An interest in the intuitive, the subconscious, and the spontaneous was reflected in the abstract art created by many of his department's pupils.

Senghor himself took great interest in the *Recherches Plastique Négres*, personally recruiting Pierre Lods, the Belgian art teacher and founder of the Poto-Poto art school in the Congo, to assist Tall in the department. "I heard about Pierre Lods's work and decided to include him in Senegal's cultural politics in the field of Fine Arts"—this seemingly straightforward comment of Senghor's belies the irony of employing the Belgian Lods to help African artists invent an authentically African style of contemporary painting. Lods's somewhat exotic belief in Africans' innate creative talents, mixed with his quasi-surrealist faith in creativity propelled by intuition, seemed to provide a

counterbalance to Tall's more theoretical, less liberal views.

The Limits of Flag and Mask

The artists of the *École de Dakar* were in an unusual position of privilege, receiving official patronage and institutional support from the state. Catalogues and exhibition statements described their work as giving meaning to the state, and as late as 1989, in his introduction to the Frankfurt Museum für Völkerkunde publication *Anthology of Contemporary Fine Arts in Senegal*, Senghor described artists as "ambassadors of their country," or, alternatively, as public proof of the government's progressive tendencies, reminding us that "as a patron of the artists since independence, the role of the state, which has bestowed more than 25 percent of its budget for education and culture, should not be forgotten." In many ways these artists were a new "performative subject"—a new kind of Senegalese individual in a new social role.

The fictional ethnographic repertoire of the *École de Dakar*, coupled with the state's appropriation of the works these artists made, aligned the school with an official, largely ahistorical national space in which artists were generally unable to reflect on or adjust to social and political change. The departure of Senghor as president in 1980 revealed the privileged position he had accorded to artists as quite fragile: the images and identities that artists had produced in support of the national cultural policy were now understood as surplus signs, no longer affordable under the new spirit of economic and political pragmatism, and impossible to reconcile ideologically with the reality of life after Senghor. Indeed, it seemed by the 1980s that the historical importance of the work of the *École de Dakar* had been exhausted.

Issa Samb, noting the tenuous position of artists in present-day Senegal, frames an implicit critique of the conservatism of the *École de Dakar*. To Samb, these artists' com-

Fig. 9. For many African nations the 1960s were a pivotal decade—the period in which independence from colonial rule was achieved. African leaders sought to supplant the corrosive effect of the colonial legacy through various nationalist ideologies. The First World Festival of Negro Arts, held in Dakar in 1966, served as an affirmation of African civilization and an assertion of its global impact. The festival, the creation of Senegal's first president, Léopold Sédar Senghor, brought visitors to the city from all over the world. It was a public testament to negritude as a viable cultural ideology capable of mobilizing and uniting the six-year-old nation. This publicity photograph taken during the festival reflects the dual concerns with modernity and tradition that formed such an important part of cultural national discourse in the 1960s. In the background, next to a modern building of a utilitarian architectural order is placed an obelisk—the symbol of colonial conquest and authority, now repositioned for local consumption. Directly before it is a row of Senegalese flags. United, these signs of state authority and modernity form an image of the progressive nation state. In the foreground a traditionally attired populace completes this panoramic "march-of-progress." Photo: the archives of Virginia Inness-Brown, courtesy of Fortuna—Leslie Hoffman, 1966.

mitment to purely formal concerns contributed to their co-option as accessories in the narrative of negritude:

> The *École de Dakar*, in the fringe that calls itself apolitical, has shown no participatory or courageous action in social matters. On the contrary; the school deceitfully tries to work both sides. This is dangerous because it convokes Negritude but allows itself to be used by the reigning political current.
> These painters are actually absent from the places where things are decided upon. They are no longer involved in an intellectual struggle alongside the novelists, the poets, and the scientists. Formerly the state's pampered children, most of them are simply floating in the wake of a political idea. They are torn between the image the public has of them and the call of the spirit of painting. . . . This ambiguous situation is the symptom, as painful as it

is obvious, of the contempt for every effort of investigation, and for any type of art independent of the state (Samb 1989:114).

A pair of incidents in the 1980s reveal the declining status of artists and of the state-sponsored cultural institutions after Senghor's departure. In 1983, artists were dramatically expelled from the "*village des Arts*," a cluster of old colonial buildings granted to them as studios and living quarters by the Senghor government. The artists tried to negotiate with the new government to stay in the village, but their efforts were in vain and they were evicted. In an open confrontation, police dealt with the artists sternly: their paintings, sculptures, and other personal possessions were carelessly thrown into a heap. The site was then turned over to the ascendant ministries for technical administration, water supply, and tourism (E.H.M.B. Sy 1989:108).

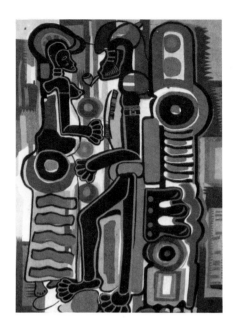

Fig. 10. Couple, 1967, tapestry, 292 x 200 cm., by Bacary Dieme. A distinctly "African" theme is woven into the fabric of this tapestry design. Figures inspired by Senufo sculpture merge with the artist's more abstract design. The attempt to find a balance between a pure abstraction and more recognizably "African" signs are reflected in the "semi-abstract" style for which the École de Dakar was noted. Photo: courtesy of the Ministry of Culture, Dakar.

A second incident involved the Musée Dynamique, a pristine colonnaded building, overlooking the sea, that many considered a symbol of the Senghor government's commitment to cultural renewal and one of the architectural highlights of the first World Festival of Pan-African Arts, in 1966. Twenty-two years later, in 1988, the museum had its last exhibition (Huchard 1989:56). It was closed after prolonged negotiations between museum officials, Senghor's successor President Abdou Diouf, and the Department of Justice, which needed a new building and wanted the museum as its site. The museum's archives—two decades worth of material—were moved to warehouses on the outskirts of Dakar.

Laboratoire AGIT-Art

Of the recent attempts to expand the boundaries of artistic discourse in Senegal, the work of the Laboratoire AGIT-art is among the most innovative. This group of Dakar-based artists includes painters, writers, filmmakers, and musicians, many of whose careers span the two decades between the idealistic cultural nationalism of the 1960s and the more pragmatic spirit of the 1980s. Laboratoire AGIT-art has attempted nothing less than a reshaping of both the language of Senegalese art and the terms on which artistic production occurs in that country today. Like the École de Dakar, the group engages aspects of Western Modernism, but it concerns itself with the conceptual ideologies of the avant-garde rather than with Modernist formalism. Its tactics of provocation and agitation, in keeping with its name, suggest a connection with the Western antiart performance aesthetic. These artists work outside the government-sponsored system of galleries and museums, distancing their collaborative creations from the painting on canvas, an art form subject to a deeply rooted system of commodity control. The interiorized, individualistic works of the École de Dakar, with their overdependence

on formal solutions, were ultimately subordinated to the cultural apparatus created to contain them. By focusing on the impermanent, contingent character of performance art, the AGIT-art group hopes to evade the existing cultural system and to become more autonomous in the process. Here, art objects function as stage props, and are clearly secondary to the conceptual aspect of the performance. In this context, the art object functions as a didactic tool, discarded after the performance as a mere footnote to the event.

The found and ready-made objects scattered around the Laboratoire AGIT-art compound—for it is this compound with which I began my discussion—indicate the oppositional framework within which the group works. The compound's kaleidoscope of variegated stuff provides a strong contrast with the carefully finished products of the École de Dakar. The cultivation of an antiaesthetic extends to the surroundings: this is not a display space like a gallery, but rather a "laboratory," a place concerned with process rather than product, an open forum for the development of concepts and ideas. The space itself reflects the group's flexibility and its ethic of contingency, for it doubles as a multifamily home. It is an outdoor living room, a laundry, and a playground in which children scramble among the debris of artwork/stage props indiscriminately piled up alongside firewood and scrap paper (figs. 11a-11e).

Tacked to the cement walls of the compound are weathered cloth backdrops covered with handwritten notes, photographs, and painted images. Inscribed on these cloths are references to Gandhi, France and its role in Senegal's colonial past, Soweto, Lenin, and Nelson Mandela. Strewn over tables and chairs are weathered Senegalese flags (figs. 12a-12c). Here stands a flag trapped in the roots of a cactus tree; there, bound with heavy rope, a flag bandages an effigy; and at the entrance to the compound is the

Figs. 11a-11e. In the Dakar compound of the Laboratoire AGIT-art, icons and images of political celebrities—Che Guevara, Nelson Mandela, Lenin, the Solidarity unionists—are mixed with local symbols: fragments of terra-cotta sculpture, Senegalese flags, hand-written notes, wood sculpture, and other odd assemblages. These familiar signs appropriated from a diversity of sources are inserted into the local political and cultural framework of contemporary Dakar. They reflect the AGIT-art group's attempt to expand artistic activity beyond the formal conventions of the École de Dakar. Photo: Ima Ebong, 1989.

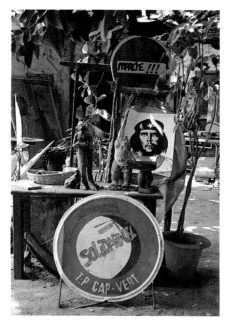

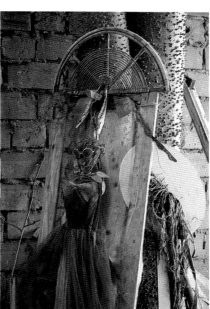

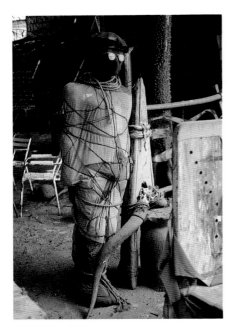

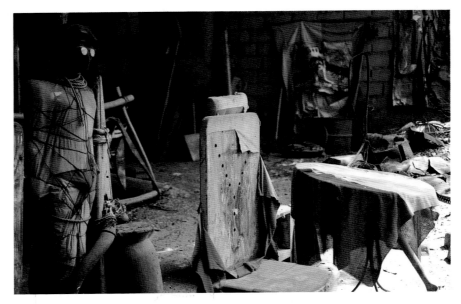

Figs. 12a-12c. Scattered around the AGIT-art compound are discarded props once used for various performances. The Senegalese flag appears as a symbol of state authority and its control over mainstream culture, one of the themes explored by the AGIT-art group. Photo: Ima Ebong, 1989.

flag attached to the mask. The predominance of the flag in the compound suggests Laboratoire AGIT-art's concern with state power and authority. In what appears to be a mock courtroom, the state appears on trial, symbolized by the bound and gagged, sunglass-wearing, anonymous figure wrapped in the flag. Taken as a whole, the compound may be seen as an attempt to expose the faultlines of Senegal's recent cultural history, to reveal the fractures between individuality and national identity. In this setting the very fabric of the state is a dominant motif.

Trespassing: Past, Present, and Future

Perhaps the most important factor distinguishing the artists of the AGIT-art group and younger artists

such as Fodé Camara (see cat. 102-104) from those of the *École de Dakar* is their refusal to accept unquestioningly any identity based on an unmediated African past. They use masks, traditional sculpture, and a catalogue of ethnographic forms not simply as ready-made "African" symbols, authenticated artifacts of a usable past to be worked into emblematic formal schemes, but rather as fragments of identities left to them from the contingencies of history. They realize that pieces drawn from the African past must be critically reconstituted to suit the internal dynamics of Senegalese culture today.

And what of the future? What possibilities are open to contemporary African artists trying to secure their own strategies and identities in the face of renewed attention

from the Western culture industry? Groups such as the *École de Dakar*, and the more recent Laboratoire AGIT-art, continue to seek alliances with the Western Modernist past in working out their cultural agendas —this at the very moment when the progressive strains of post-Modernist discourse in the West are dismantling the unilateral status of Modernism in favor of various pluralist proposals under the umbrella of global culture. As Nelly Richard notes, this attachment to Modernism in African art "reformulates the old dependencies (centre/periphery, progress/backwardness) in a way that creates a new hierarchy" (1987:10). But Richard also offers an alternative to this pessimistic outlook: the critiquing of Modernism "offers us the chance to reconsider all that was 'left unsaid'" (ibid.:12). Although Richard speaks to the situation in Latin America, her insights are pertinent to postcolonial Africa, particularly as she notes the possible benefits of a response to the opening up of Modernism's various awkward moments:

> This review of modernity allows us, once again, to pose the question of our own identity, that of individuals born of and into the dialectic mixture of different languages surrounding us, which have partially fused to produce a cultural identity experienced as a series of collisions. This identity can be understood as an unstable product of modernity's tropes which involves a continuous regrouping, distorting and transforming of imported models, according to the specific pressures pertaining to the critical re-insertion of these models into a local network. This active participation which the individual at the periphery performs, emphasizes a creativity based almost exclusively on the re-use of previously existing materials which are available either as part of the Western tradition or, more recently, prefabricated by the international culture industry. Innovative responses to these materials are based on strategies of re-determining the use of fragments or remains in ways which

differ from their original frame of reference (ibid.).

In the case of Senegal, the most effective art today is open to multiple, hybrid contexts. It oscillates between the gray areas of cultural identity with a taunting sense of free play, reflexively deploying various meanings, sometimes exaggerated or conflicting, across many different lines of interest. In this sense the Laboratoire AGIT-art's mask-and-flag construction marks both a beginning and an ending, for it parodies the cliché idea of the authority of the state, and of the state's sponsorship of ancestral cultural identity—a sponsorship literally bound by mutual interests. Somewhat humorously, the piece stages a mock execution. Both flag and decaying mask hang from the branch of a tree, left to twist interminably in the unpredictable breeze that blows off the Atlantic toward this coastal city.

NOTES

1. The term "*École de Dakar*" refers to the first generation of Senegalese painters, who made their public debut at the exhibition "*Tendances et confrontations*," organized by Iba N'Diaye for the first World Festival of Pan-African Arts, held in Dakar in 1966. Among the best-known artists participating in the exhibition were Amadou Ba, Alpha Diallo, Ibou Diouf, Bocar Diong, Ousmane Faye, Amadou Seck, and Papa Ibra Tall. A wider definition of the "*École de Dakar*" would take into account certain artists of the same generation who were not included in the exhibition, such as Boubacar Coulibaly, as well as younger artists, born in the late 1940s and starting to exhibit in the 1970s, who were trained at the École Nationale des Beaux Arts, in many cases by members of the first generation. These younger painters, including Souleymane Keita, Chérif Thiam, Amadou Sow, and Philip Sene, have developed highly individual styles, yet in many respects have not departed much from the "semiabstract" generic style of painting associated with the *École de Dakar*'s first generation. They tend to appear less constrained by their ancestral legacy and by the concern with establishing a national culture, but their work in many respects has become more insular, in the sense that an imaginative repertoire of themes and subjects becomes locked into an endless play of abstract forms and patterns.

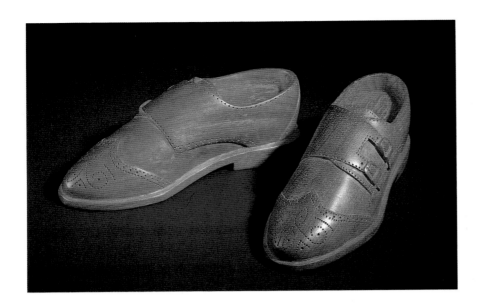

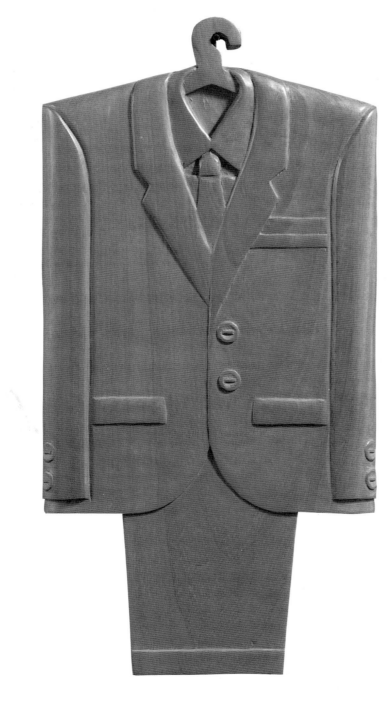

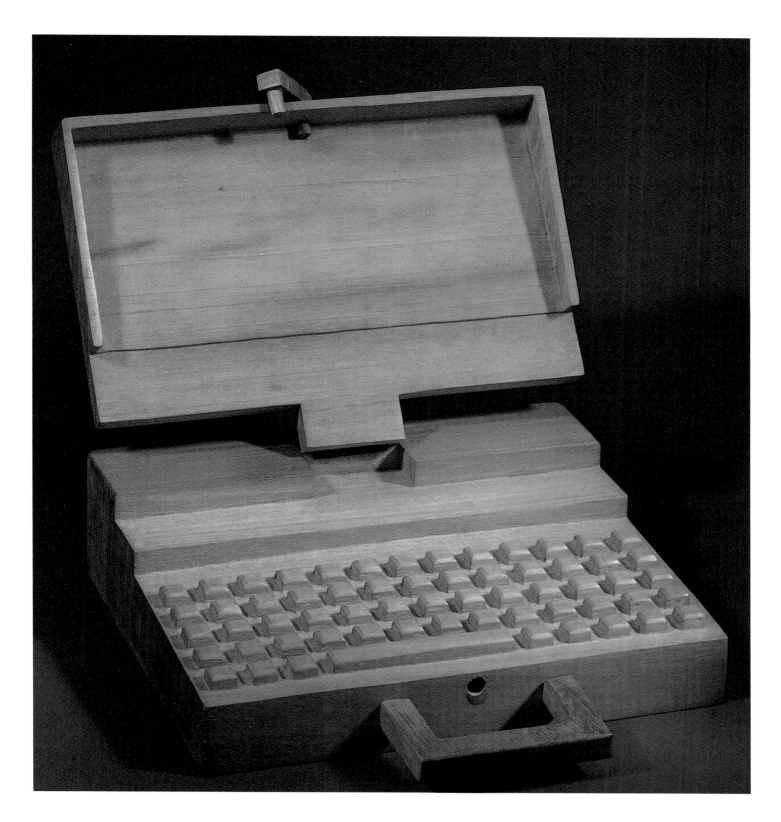

Cat. 84 PAIR OF SHOES, 1990, BY KOFFI KOUAKOU (IVOIRIAN, B. CA. 1962), WOOD, L. 27 CM. PRIVATE COLLECTION.

Cat. 85 GENTLEMAN'S SUIT, 1990, BY KOFFI KOUAKOU (IVOIRIAN, B. CA. 1962), WOOD, H. 69 CM. PRIVATE COLLECTION.

Cat. 86 PORTABLE COMPUTER, 1990, BY KOFFI KOUAKOU (IVOIRIAN, B. CA. 1962), WOOD, 35 x 30 CM. ANONYMOUS COLLECTION.

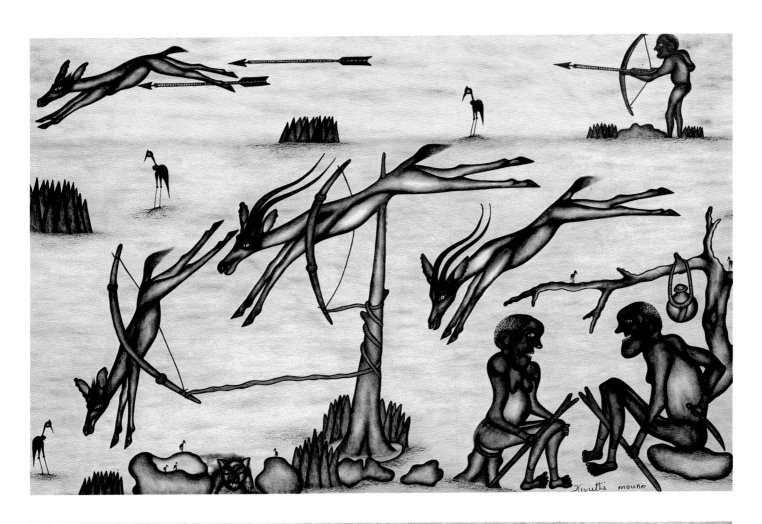

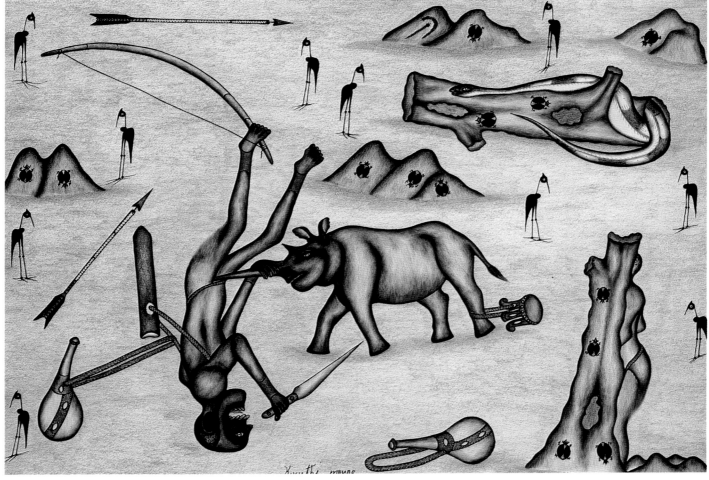

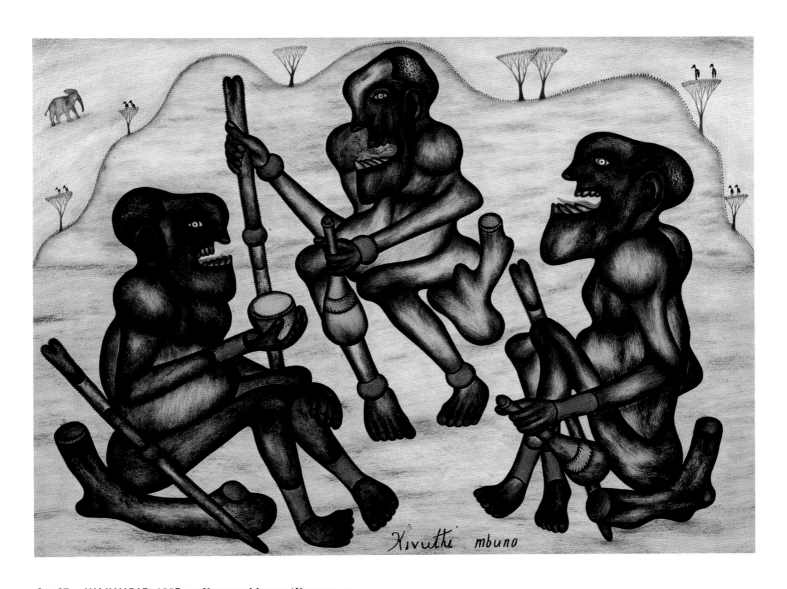

Cat. 87 **WAKIMBIE**, 1987, by KIVUTHI MBUNO (KENYAN, B. 1947), INK AND CRAYON ON PAPER, 51.4 x 76.2 CM. COURTESY OF GALLERY WATATU, NAIROBI.

Cat. 88 **MUINDAJI**, 1987, by KIVUTHI MBUNO (KENYAN, B. 1947), INK AND COLORED PENCIL ON PAPER, 57.2 x 81.9 CM. COURTESY OF GALLERY WATATU, NAIROBI.

Cat. 89 **OLDMEN DISCUSSING**, 1987, by KIVUTHI MBUNO (KENYAN, B. 1947), INK AND CRAYON ON PAPER, 38.7 x 51.4 CM. COURTESY OF GALLERY WATATU, NAIROBI.

Cat. 90 SLAVES YOKED TOGETHER, 1973, BY MODE MUNTU
(ZAIRIAN, 1950s-1986), GOUACHE ON PAPER, 31 x 48 CM.
COLLECTION: BOGUMIL JEWSIEWICKI.

Cat. 91 FIGURES CARRYING WATER, 1973, BY MODE MUNTU
(ZAIRIAN, 1950s-1986), GOUACHE ON PAPER, 49 x 61 CM.
COLLECTION: BOGUMIL JEWSIEWICKI.

Cat. 92 FIGURES DRUMMING, 1973, BY MODE MUNTU (ZAIRIAN,
1950s-1986), GOUACHE ON PAPER, 48 x 61 CM. COLLECTION:
BOGUMIL JEWSIEWICKI.

Cat. 93 THE TREE OF LIFE AND DEATH, 1926, BY ALBERT LUBAKI (ZAIRIAN, B. CA. 1895), WATERCOLOR ON PAPER, 120 x 150 CM. COLLECTION: ERIC KAWAN.

Cat. 94 BIRDS AND SYMBOLS, 1932, BY TSHYELA NTENDU (ZAIRIAN, B. 1890S), WATERCOLOR ON PAPER, 30 x 40 CM. COLLECTION: ERIC KAWAN.

Cat. 95 THE TRAIN, 1926, BY TSHYELA NTENDU (ZAIRIAN, B. 1890S), WATERCOLOR ON PAPER, 35 x 45 CM. COLLECTION: ERIC KAWAN.

Cat. 96 HUNTER, 1932, BY TSHYELA NTENDU (ZAIRIAN, B. 1890S), WATERCOLOR ON PAPER, 40 x 75 CM. COLLECTION: ERIC KAWAN.

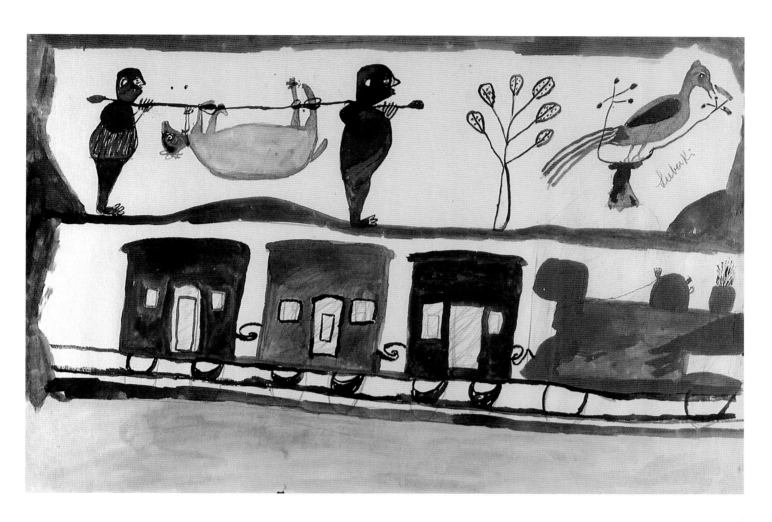

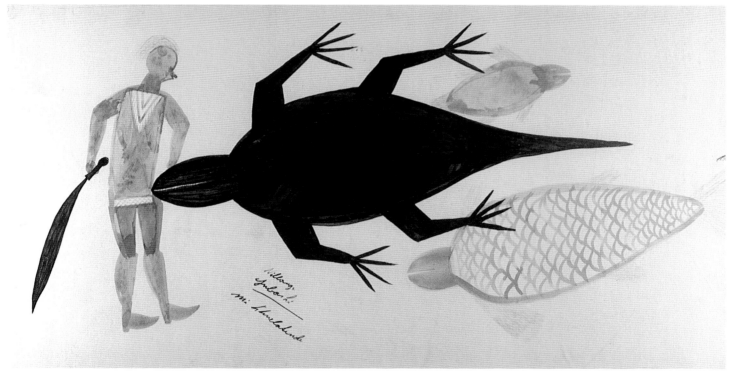

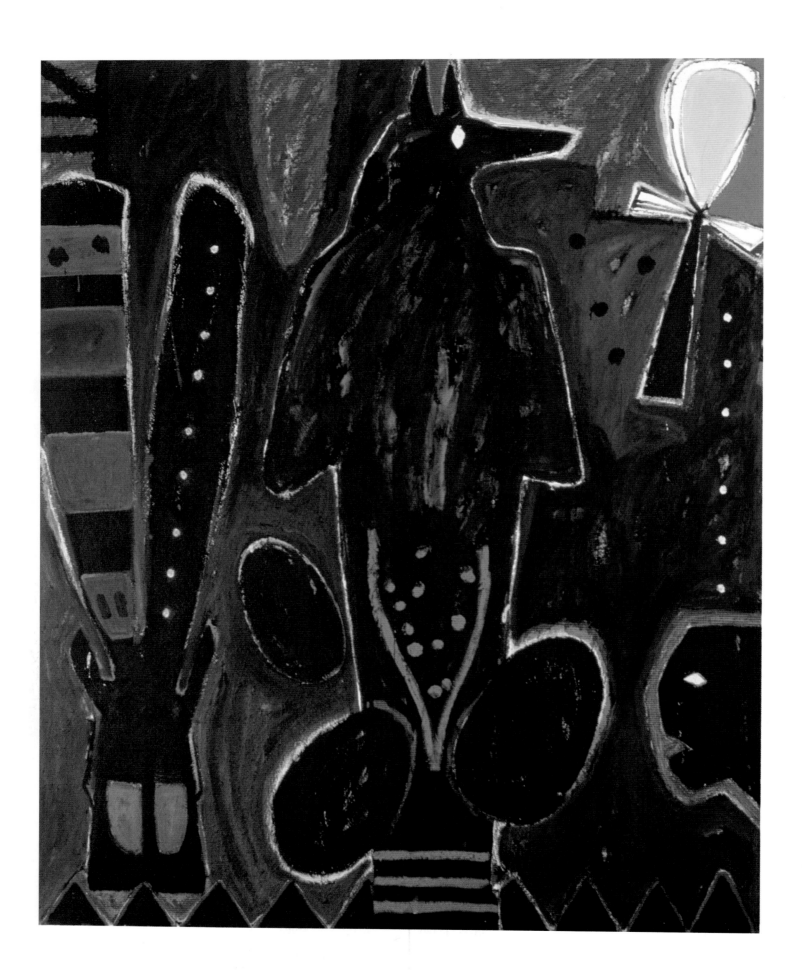

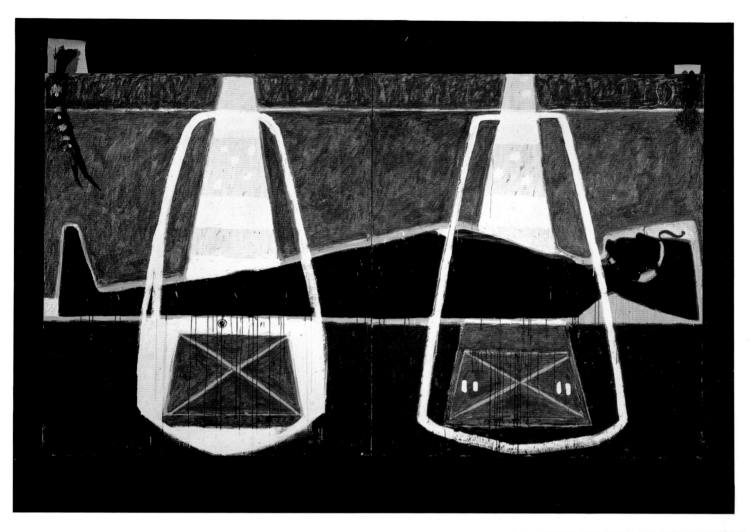

Cat. 97 *THE MESSENGER OF DISORDER*, 1989, BY OUATTARA (IVOIRIAN, B. 1957), ACRYLIC ON WOOD, 200 x 150 CM. COURTESY OF AKIRA IKEDA GALLERY, NAGOYA

Cat. 98 *SAMO THE INITIATED*, 1988, BY OUATTARA (IVOIRIAN, B. 1957), SCULPTURE AND ACRYLIC ON CANVAS, 216 x 360.7 CM. COLLECTION: VREJ BAGHOOMIAN.

Cat. 99 *ZAOULI*, 1987, BY OUATTARA (IVOIRIAN, B. 1957), ACRYLIC AND OIL PASTEL ON PAPER, 66 x 50.8 CM. COLLECTION: CARLA HUBBARD.

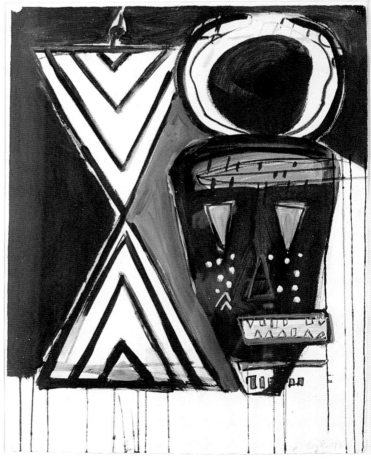

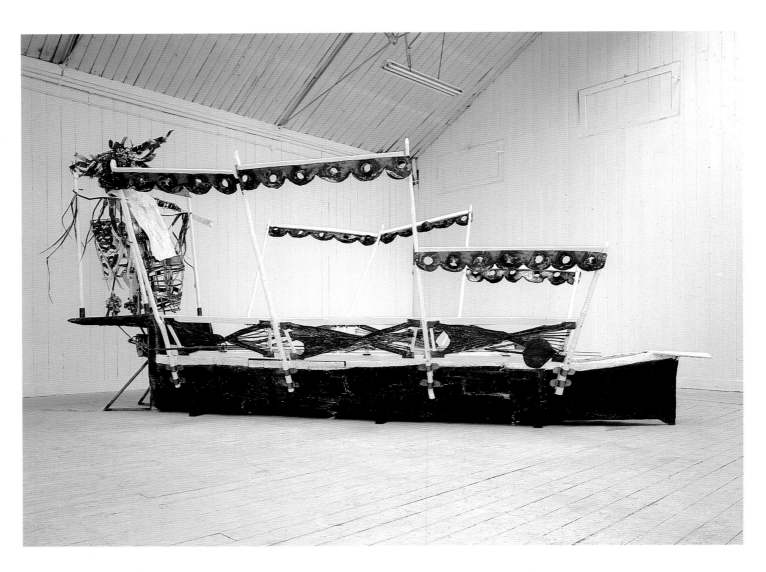

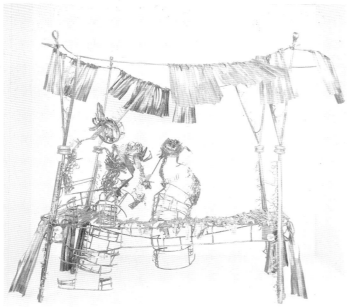

Cat. 100 *ALALI ARU (FESTIVAL BOAT)*, 1986, BY SOKARI DOUGLAS CAMP (NIGERIAN, B. 1958), WELDED METAL, L. 610 CM. COURTESY OF THE ARTIST.

Cat. 101 *CHURCH EDE (DECORATED BED FOR CHRISTIAN WAKE)*, 1984, BY SOKARI DOUGLAS CAMP (NIGERIAN, B. 1958), WELDED METAL, H. 243.8 CM. COURTESY OF THE ARTIST.

Cat. 102 *PARCOURS-TRICOLORE II* (PASSAGE-TRICOLOR II), 1988, BY FODÉ CAMARA (SENEGALESE, B. 1958), OIL ON CANVAS, 210 x 120 CM. COLLECTION: ABDOURAHIM AGNE.

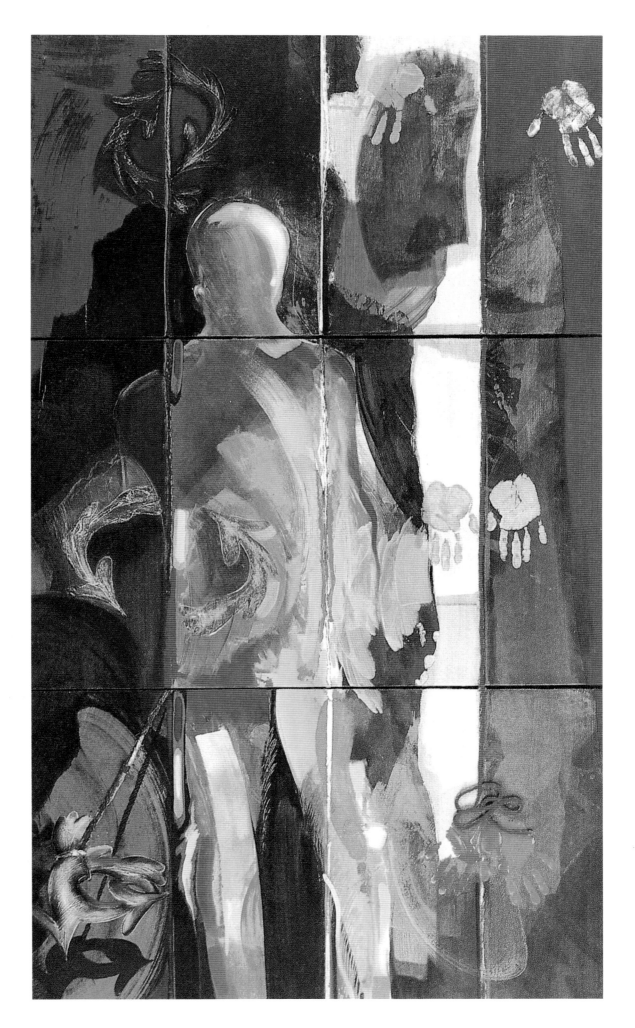

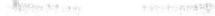

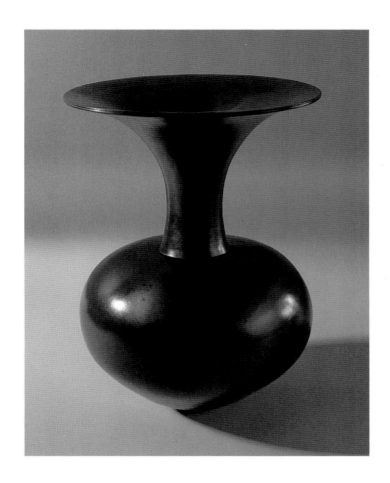

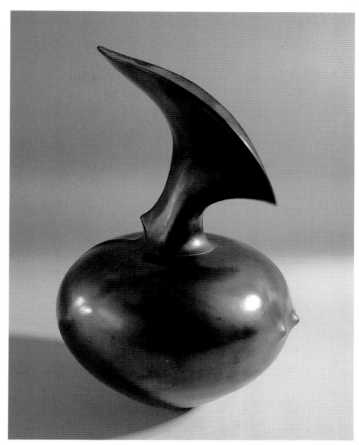

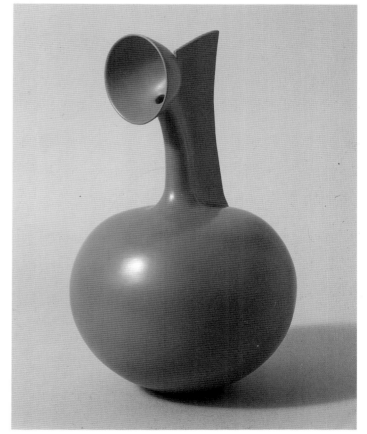

Cat. 103 *PARCOURS I* (Passage I), 1988, by Fodé Camara (Senegalese, b. 1958), collage and oil on canvas, 180 x 200 cm. Collection: Fonds National d'Art Contemporain-Ministère de la Culture, Paris.

Cat. 104 *LE VIEUX NÈGRE, LA MEDAILLE ET LA STATUE* (The old African, the medal, and the statue), 1988, by Fodé Camara (Senegalese, b. 1958), collage and oil on canvas, 120 x 200 cm. Collection: Abdourahim Agne.

Cat. 105 **BLACK SYMMETRICAL FLUTED,** 1990, by Magdalene Odundo (Kenyan, b. 1950), reduced red clay, h. 39.2 cm. Courtesy of Anthony Ralph Gallery, New York.

Cat. 106 **BLACK FLARED TOP WITH NIPPLES,** 1990, by Magdalene Odundo (Kenyan, b. 1950), reduced red clay, h. 43 cm. Courtesy of Anthony Ralph Gallery, New York.

Cat. 107 **ORANGE ROUND NECK,** 1987, by Magdalene Odundo (Kenyan, b. 1950), red clay, h. 36.5 cm. Private collection.

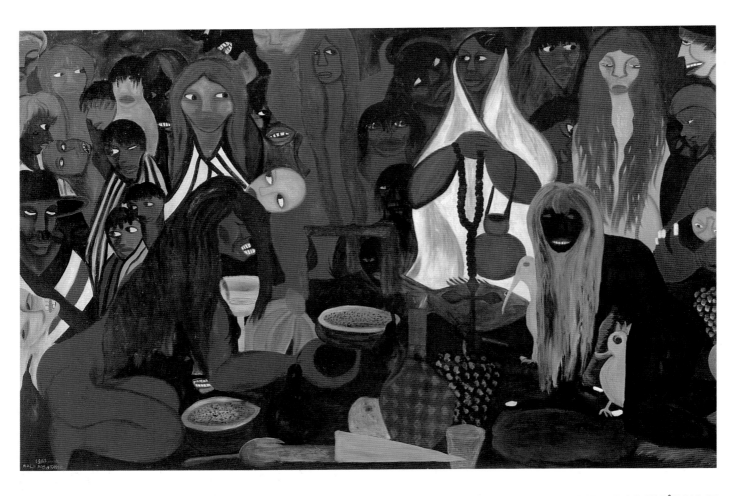

Cat. 108 *PAPA NEGRO E SUA CABAÇA DE INFÂNCIA* (The African pope and his calabash from childhood), 1961, by Malangatana Valente Ngwenya (Mozambican, b. 1936), oil on canvas, 122 x 193 cm. Collection of the artist.

Cat. 109 *E ONDE ESTÁ A MINHA MÃE, OS MEUS IRMÃOS, E TODOS OS OUTROS* (Where are my mother, my brothers, my sisters and all the others?), 1986, by Malangatana Valente Ngwenya (Mozambican, b. 1936), oil on canvas, 232 x 198 cm. Collection of the artist.

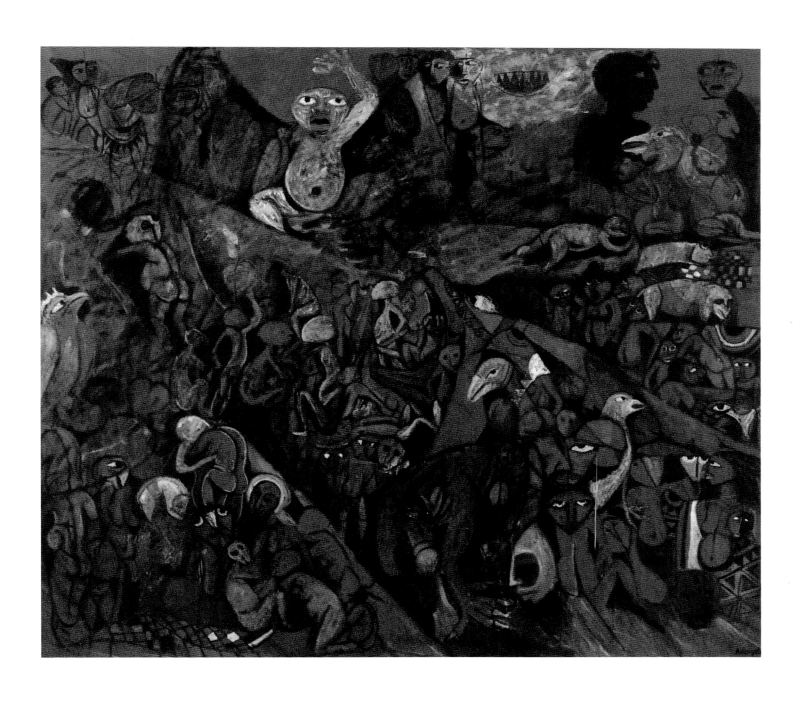

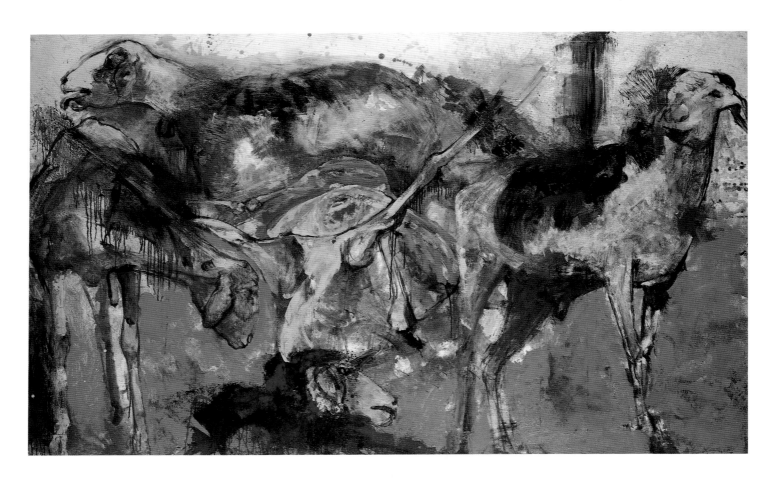

Cat. 110 *LA RONDE À QUI LE TOUR?* (THE ROUND—WHOSE TURN IS IT?), 1970, BY IBA N'DIAYE (SENEGALESE, B. 1928), OIL ON CANVAS, 150 x 200 CM. COLLECTION OF THE ARTIST.

Cat. 111 **DRAWING OF A DAN MASK,** 1978, BY IBA N'DIAYE (SENEGALESE, B. 1928), INK ON PAPER, 20.5 x 15.5 CM. COLLECTION: EBERHARD FISCHER.

Cat. 112 **DRAWING OF AN AFRICAN SCULPTURE,** 1970S, BY IBA N'DIAYE (SENEGALESE, B. 1928), INK ON PAPER, 23 x 16 CM. PRIVATE COLLECTION.

Cat. 113 *JUAN DE PAREJA AGRESSÉ PAR LES CHIENS* (JUAN DE PAREJA MENACED BY DOGS), 1986, BY IBA N'DIAYE (SENEGALESE, B. 1928), OIL ON CANVAS, 130 x 163 CM. COLLECTION: RAOUL LEHUARD.

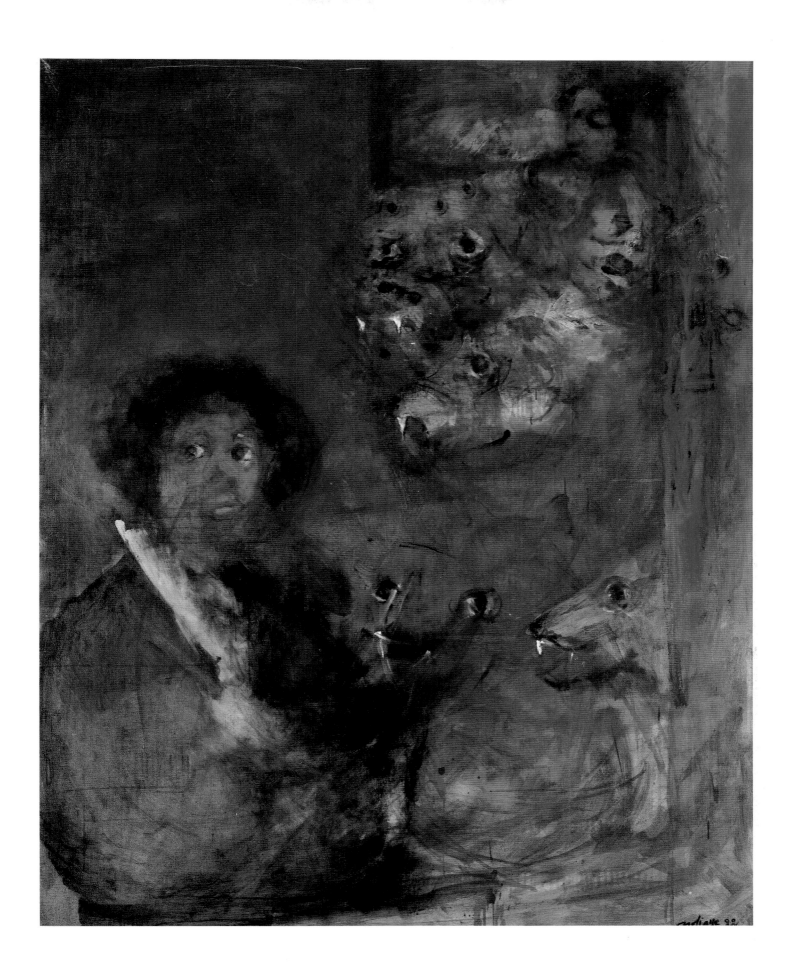

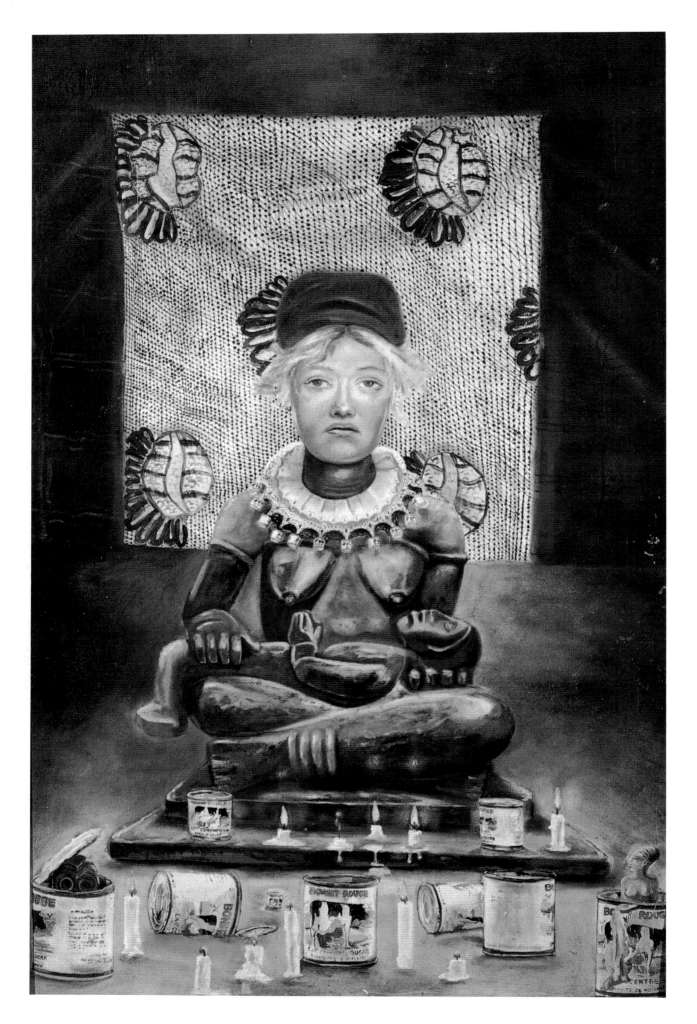

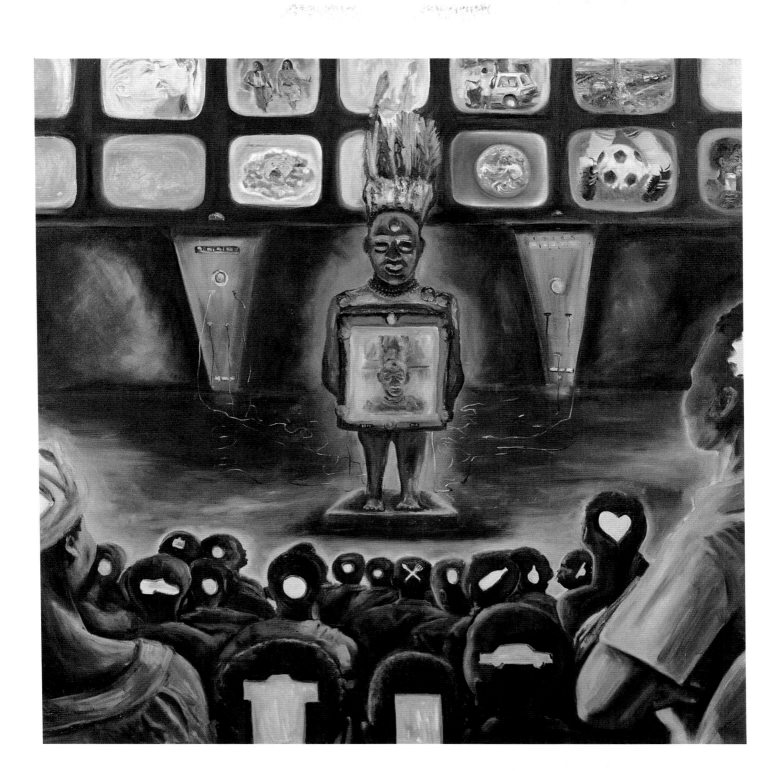

Cat. 114 *MATERNA*, 1984, BY TRIGO PIULA (CONGOLESE, B. 1950s), OIL ON CANVAS, 122 x 88 CM. COURTESY OF THE ARTIST.

Cat. 115 *TA TELE*, 1988, BY TRIGO PIULA (CONGOLESE, B. 1950s), OIL ON CANVAS, 100 x 100 CM. COURTESY OF THE ARTIST.

Cat. 116 *SELF-PORTRAIT*, 1986, BY TRIGO PIULA (CONGOLESE, B. 1950s), OIL ON CANVAS, 60 x 57 CM. COURTESY OF THE ARTIST.

Susan Vogel

Extinct African art is art of the past that has gone on to a sort of second career, looming in the public consciousness as a vehicle of national ideas and symbols. Sometimes this work is more potent and well-known now than it was when it was first produced. It is Africa's celebrated traditional art, no longer made or no longer used for its original purposes, but living on in museums, in reproductions, in imagination and memory. Today many of the objects themselves reside permanently in collections in the West. Some are in African museums; a few may remain in the hands of the original owners or their descendants, as heirlooms or relics of the past. Many actual objects have been lost forever, but the imagined glory of their presence remains. Extinct art has an almost palpable presence in Africa today—its old uses may have atrophied, and the objects may have been exported, but it is as present as ever in the countries where it was born.

Like the other strains of art that we have examined in this book, Extinct art is a conceptual category, not a descriptive one. And it is

INSPIRATION AND BURDEN

not unique to Africa: something like it appears in other parts of the world where great, universally recognized art traditions survive as glorious legacies, both inspiring and burdening artists of succeeding generations. Greece and Mexico are two among a number of countries whose artists must reckon with Extinct art.

Extinct art in our sense is not the re-use of this heritage, but the legacy itself. Not all art that has ceased to serve its original purposes is remembered as Extinct art. Some has willfully been forgotten, and some has merely faded into obscurity, known only to a handful of old initiates, to scattered archaeologists, and to a few scholars. Living traditional art forms may be treated as Extinct and used by artists and designers as neutral forms, as if they had no ethnic or other connotations, when they are actually still in use by a particular ethnic group. The intention is usually to portray them not as part of the present but as part of the past—as quaint or archaic relics.

In Africa, the symbolic meaning of Extinct art objects may be quite unrelated to the meaning intended by their makers and first owners.

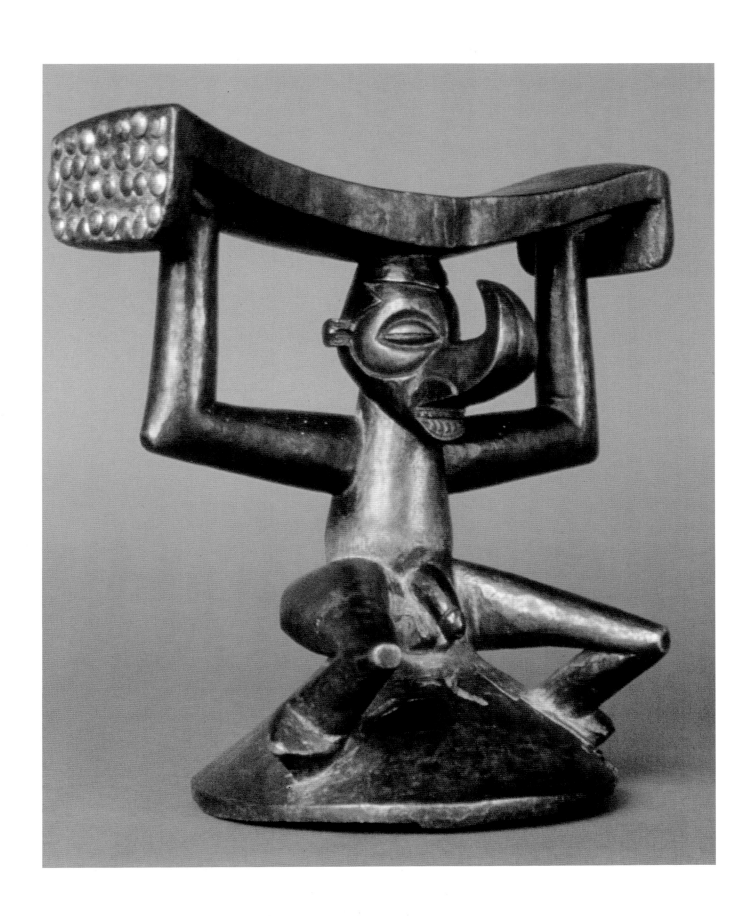

The disappearance or transformation of the objects' original political, religious, or social context often conveniently purges them of their ethnic and political identity, making them available as symbols of national pride and unity. Ironically, African governments have promoted the changes that deprived these works (and the cultures that supported them) of their original force and reason for being. Yet these same governments are often happy to appropriate Extinct art as a national symbol. It is safer as an object of nostalgia and sentiment than it was as an expression of local political power and identity. Examples abound: postage stamps, decorations in public spaces and buildings, bank notes, match boxes, calendars, lottery tickets, posters, the logos of universities, electric companies, airlines, and even more miscellaneous items may be adorned with images of extinct African artworks. Art that is no longer seen as particular to any given ethnic group is available to be "owned" by the whole nation collectively.[1]

The Process of Extinction

The extinction of art types has been a noticeable feature of the twentieth century, but it is not a new phenomenon. In a continual process of renewal and evolution, styles, types, and whole categories of traditional art went out of fashion or favor long before 1900. To all intents and purposes, the art traditions died, even though in some cases the objects themselves survived—the terra-cotta heads of the Nok culture, dating from 500 B.C. to 200 A.D., for example, and the famous Ife bronze heads of the twelfth through the sixteenth centuries. The distinctive styles of the small stone figures made along the Sierra Leone coast in the fourteenth and fifteenth centuries were never again repeated. Their creators seem to have been related to the present Temne, Sherbro, and Bullom peoples, who nevertheless treat these figures as mystical in origin when they find them in the ground. One of the best-known instances of an art form dying while the culture lives on is that of the bronze plaques (cat. 117-119) cast at the court of Benin, Nigeria, in the sixteenth and seventeenth centuries, and then no longer made. The plaques were stored in the palace for two hundred years, but played no further role in the kingdom's artistic life.

These cases can hardly have been unique: similar cessations must have occurred many times in wood-carving traditions, leaving no trace. We have few wooden works collected in Africa before the mid nineteenth century as a reference. Of those, significantly, a majority are in styles unknown today, seemingly because they had died out or had been radically altered by the late nineteenth century. The abandonment of art forms and the invention of new ones must now be seen as lying at the very core of African art history.

It is interesting to consider why particular art forms went out of use. While the power of modern Western art may be seen as inherent, and derived from its status as art, traditional African art supported and supports other powers. Precolonial artworks generally served to uphold structures of spiritual and political authority. They seldom had

◄ Fig. 1. Yaka neckrest from Zaire, wood, 14.6 cm. high. Beautifully carved furniture and useful objects such as bowls, mirrors, doors, pipes, whistles, and so forth have often had shorter lifespans than religious and political art. They virtually never become Extinct art, but pass out of consciousness when they pass out of use. Generally, these utilitarian things simply went out of fashion, and were replaced by imported or undecorated equivalents. They were seldom transformed and modernized like the gourd illustrated in chapter I. Collection: The Virginia Museum, Richmond.

Fig. 2. Bank notes jointly used by most former French colonies (Senegal, Burkina Faso, Côte d'Ivoire, Gabon, and others) use Extinct art as a sign of value. The 10,000-franc note shows a Benin plaque (cat. 117) on the left, a Bwa mask from Burkina Faso on the right. The 5000-franc note shows a panel from a Yoruba door on the left, an Ife head on the right, both from Nigeria. This currency is not used in Nigeria which was a British colony and never formed part of the franc zone. The Nigerian artworks that appear on franc bills, however, are among the oldest and most elaborate known, and have become universal symbols of African heritage.

any independent raison d'être. Works of art were tied to the prestige of moral bodies—such as rulers, associations, or cults dedicated to various spirits. They consequently became vulnerable whenever these key political and religious authorities were challenged by local events, by colonial forces, or by new religions. The Anyi of Sanwi, Côte d'Ivoire, for example, abandoned the tradition of funerary terra-cottas after a Liberian prophet, William Wade Harris, made massive conversions around 1914.[2]

Art traditions rarely survived the dissolution of the institutions to which they were tied except by becoming replicas of themselves, usually devoid of meaning. A pointed illustration of this comes from the royal art of Benin, Nigeria, where before the colonial invasion of

Fig. 3. Commercial building under construction in Ouagadougou, Burkina Faso, designed by a Burkinabe architect. The panels between the balconies duplicate the superstructure of Bwa masks, and terminate in their distinctive upturned crescent (see the right side of the 10,000-franc note in fig. 2). Though these masks are still used by the Bwa in funerals and other rituals, their effectiveness as graphic design has led to their treatment as simple forms —"detribalized," neutralized, and purged of meaning in the collective reservoir of Extinct forms. Photo: Boureima Tiekoroni Diamitani, 1989.

Fig. 4. Liberia's national museum, Monrovia, 1980s. Like many African museum buildings, this one was not designed to look imposing. African museums are often located in structures of historical significance, or in newly constructed buildings which may include elements of traditional architectural style. Displays typically seek to avoid arousing potentially divisive feelings by de-emphasizing ethnicity and by promoting a sense of national pride. Photo: Doran Ross.

1897, works of art in bronze and ivory were the exclusive prerogative of the court. When the British sent the king into exile, these works of art virtually ceased to be made. Seventeen years later his successor was crowned, and court life resumed—whereupon the arts of bronze-casting and ivory-working were revived. But the postconquest arts of Benin, like those of other African courts under colonial domination, reflected the diminished power and status of the ruler. Artworks made after 1914 are smaller and less elaborate than preconquest objects, and the quality of the craftsmanship is uneven. Eventually the king lost exclusive control over the brass-casters and ivory-carvers (formerly known as "servants of the king"), who began to work for commoners and foreigners. Today the bulk of their work is sold to tourists (Ben-Amos 1976:320-322).

The rising and falling fortunes of particular cults have seldom been recorded. A fascinating example that has come down to us, however, is the story of the Long Juju of Arochuku village, in the Igbo area of Nigeria. Here we can see the workings of another process that can lead to the abandonment of an art form. The Long Juju, originally a local tutelary deity, became famous throughout Eastern Nigeria in the mid nineteenth century as a fertility shrine and judging oracle. By the end of the century, however, its judicial power was discredited: word had gotten out that persons believed to have invoked it falsely had not been killed by it—the usual consequence of a powerful "juju's" wrath—but had been sold into slavery in distant parts for the profit of the cult priests. In 1902, aware of the cult's involvement with slaving, the British administration outlawed it and blew up its shrine. "This of course had no effect in itself on its power, which depended on local public opinion, not on government edicts. Its position as tutelary deity of Arochuku had never been challenged and is accepted to this day [the 1930s]. Its power as a fertility spirit had recovered in the 1930s and was expanding again: its power as a judicial 'oracle' had disappeared" (Jones 1984:49-51). By the 1950s, Simon Ottenberg found that the Long Juju once again had judicial power and was quite active for difficult cases.[3]

Art Restaged by Museums and Artists

The transformation that the Extinct artwork undergoes in an African museum differs from what it would suffer in a Western one. African museums usually lack the air of sanctity and reverence that museums have in the West—they serve as fairly straightforward places of display and storage.[4] Unlike Western museums, they seldom occupy former palaces or temples. Many African museum buildings were built specifically as museums. They often include elements of traditional architecture, and their scale is generally modest, or at least not calculated to awe the visitor with its grandeur.

In Africa, the "museumification" of traditional works of art is generally more neutralizing than elevating. The museum context tends to defuse these spiritually charged things, as if the glass in the vitrines were there to protect the visitor from the object rather than

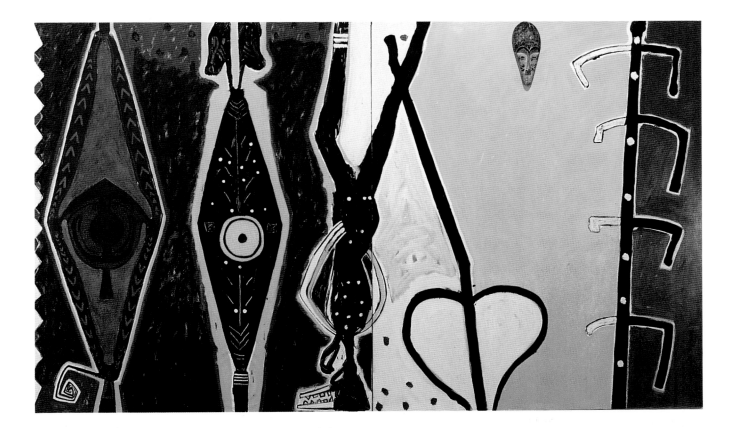

Fig. 5. *Painting of the Soul*, 1988, acrylic on canvas with "fetish," 212 x 355 cm., by Ouattara (Ivoirian, b. 1957). Traditional art appears in Ouattara's work as if it were all Extinct, a storehouse of forms without specific meaning or location. Here the elements from left to right derive from: a shield from the Papuan Gulf in Oceania; paired heads adapted from Ouattara's own Senufo tradition, surmounting a generic shieldlike form; an upside-down stick figure wearing an animal mask, perhaps also Senufo; a heart-shaped form recalling a yam-leaf pattern found in Igbo decoration from Nigeria; an actual mask, probably made in Gabon for export; and an abstracted graphic device suggesting the tops of Dogon *kanaga* masks (cat. 2) from Mali. Ouattara succeeds in making all these forms his own, and in shaping them to fit his own meanings. Photo: courtesy Baghoomian Gallery, New York.

the other way around. "Museumification" provides distance, detaching the object from the emotional intensity and fervor of belief it was made to sustain. (Just the opposite happens in Western art museums, where the object's intensity is heightened by that hallowed space). In the African museum, the object loses the sharpness and specificity of its original meaning. It becomes generic. Oddly repeating the history of the museum which began with sixteenth-century "curiosity cabinets," African museums are often crowded with Africans looking at curiosities that are accompanied by relatively little explanatory information. This may be intentional: by omitting the potentially meaningful names of owners, cults, villages, or artists, the labels in these museums cast a haze of vagueness over the display.[5] Were this information given, at least some of the visitors would recognize that they had had direct personal experience with elements from the objects' lives.

International painters and sculptors have thoroughly mined Extinct art as a rich source of imagery. They virtually never reinterpret it in ways that would add to our understanding of it—but that is not usually their intention.[6] Rather they attribute their own meanings to these formerly meaningful objects, and take care to mix ethnic styles. African artists working in other contemporary modes have shown virtually no interest in Extinct art, which may have little resonance for buyers of Urban art, and may even have negative connotations to patrons of New Functional art, for whom traditional art is in any case more immediately available.

International artists turn to Extinct art knowing that European artists have done so before them, but their attitude to that knowledge

Figs. 6 a,b. Traditional hat-shaped object for funeral display, early 20th century, wood covered with gold leaf, unknown Baule artist, Côte d'Ivoire. Gold and valuables are displayed at Baule funerals, but objects such as this one have been supplanted by modern things such as electronics or cash. This no-longer-practiced art form has not become Extinct, but nevertheless has a later echo. Photo: courtesy Sotheby's. b. Hat carved by Koffi Kouakou (Ivoirian b.1962). He invented his art form at the suggestion of a European who commissioned him to carve a shirt, and his works have been sold only to foreigners. He is essentially a tourist artist, who has been included in this exhibition (as others might have been) because of the intrinsic interest of the objects he makes. His father, Toungbo Koffi, an artist who works in gold in Kongonou village, made objects like the traditional hat. Koffi recognizes the relationship between his work (cat. 84-86) and his father's, but wouldn't consider covering his modern sculptures with gold leaf "because gold-covered things are, and should be, African, not modern" (interview with Jerome Vogel, September 1990). Private collection; photo: Jerry L. Thompson.

Fig. 7. *Carnival Parade*, 1986, oil on canvas, by Viteix (Victor Texeira, Angolan, b. 1940). Viteix's masklike forms are generically African, mediated by a complete familiarity with the African-influenced art of Miró, Klee, and other European artists. He holds a *doctorat de troisième cycle* from Paris, where he lived for over ten years. He is a cosmopolitan man, his eye formed by training and travel in Portugal, Cuba, and Brazil as well as in France. Graphic signs form a border around many of his current works. Collection: CICIBA, Libreville. Photo: Susan Vogel.

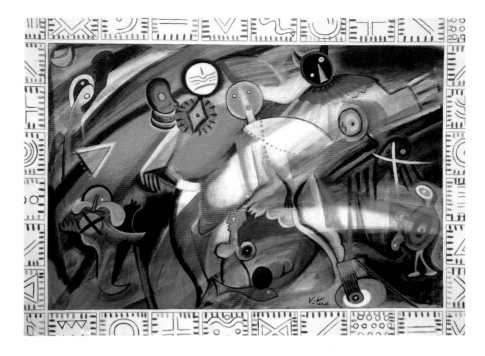

Fig. 8. Male and female figures with mask-like faces, 1988, oil on canvas, by Minkoe Minze (Gabonese, b. after 1940). The face of the female figure is an accurate rendition of a Punu mask from Gabon; the man's face is a more stylized version of a mask, melding elements from several traditional ethnic styles. The artist shifts to a more loosely painted technique for the bodies, which are executed in a different style. Collection: the artist. Photo: Susan Vogel.

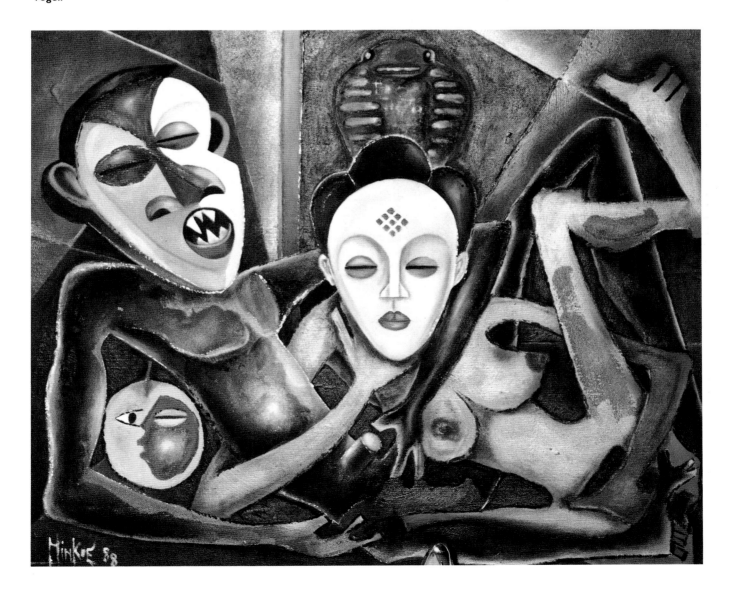

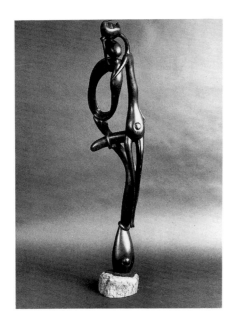

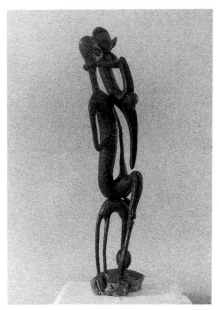

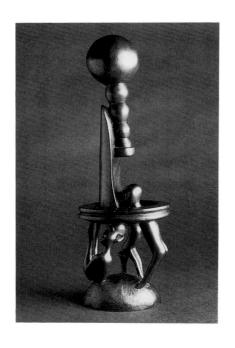

varies greatly. Many feel the presence of Extinct art in a general, nonspecific way, and echo its forms in generic "scary faces," or in geometricized forms that synthesize a number of specific styles. Others paint recognizable objects, or parts of them.[7]

Art Processed for Tourists

Tourist art can be roughly divided into two types: reproductions of traditional art—sometimes horrendously transformed; and souvenirs invented for tourists, such as the fantastical misshapen *shetani* figures carved by the Makonde in Tanzania. Both reproduce stereotypes about "ancient Africa" to suit the tastes and expectations of outsiders. Contemporary tourist art is bought not only by tourists and resident whites, but by Africans, who routinely use it for decorations and gifts, and who now make up a good part of the "tourist" market. Like craft products, tourist items are made in series, and are highly repetitive —often virtually identical.

Close and distant reproductions of traditional styles have been made in ever increasing volume since about the 1940s. By now, literally thousands of tons of bronze and wood objects have poured out of places where artists were traditionally organized in guilds or castes, most conspicuously from Benin, Nigeria; from the Bamana of Mali; and from the Senufo of Côte d'Ivoire. An ersatz style developed in the early 1960s by Makonde carvers in Tanzania, working with an Indian merchant named Mohammet Pereera, has burgeoned into a major export. Unlike most tourist art, it responds to the Western buyer's admiration of uniqueness and authorship: sculptures are all "different," and many are signed.

The weakness of tourist art as a form of artistic expression may lie in its inherent insincerity. Unlike most other African art, it is made to satisfy the expectations of customers who do not share the values or assumptions of its makers.[8] If tourist art is often crude or shoddily made, that is partly in response to foreigners' ideas of what "primitive art" should be like (Richter 1980:71). If, like the Makonde sculptures, these souvenirs portray a world filled with frightening spirits and wild demons, that too is probably in part a response to the tourist's view of Africans as superstitious and spirit-ridden.

Tourist art styles, especially those based on traditional art and those made in the largest volume and over the longest time, don't evolve much. As a constantly changing, unstable population, tourist buyers (but obviously not the local purchasers) do not enter into the same kind of dialogue with the artist as other, local audiences who collaborate in the formation of the work. The lack of change in tourist art may be due to the fact that every day there appears another tourist for whom the work is fresh and new.

Inescapable Heritage

The relationship of contemporary Africa to the most glorious art of its past is of course an enormous subject discussed throughout this book.

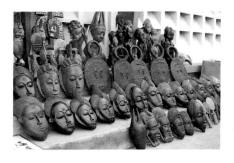

Figs. 9 a-c. Sculptures made in the early 1970s by the Makonde artist Atesi (Tanzanian), whose work is superior to the usual rubbery forms and slick ebony carving of Makonde tourist art—an invented style that does not reproduce.
Makonde carvers fulfill the tourists' definition of art by making every sculpture unique, and by signing their works. Makonde carving has attracted serious admirers, but most art historians and art museums have dismissed it as art because of its enormous volume (many thousands of closely similar though never identical sculptures are produced by a veritable army of sculptors every year, none for their own use), and because of its overwrought forms and repetitious content (genre scenes of traditional life and figures representing a dangerous spirit). Collection: Stuart Wrede; and unknown collection. Photos: Dick Frank.

Fig. 10. Tourist art, mainly reproductions of traditional Baule masks, on the steps of the small train station in Dimbokro, Côte d'Ivoire, 1978. Unlike masks actually used by the Baule, these are a monochromatic dark brown. There is very little difference from one copy to another, though several workshops can be identified here. Photo: Susan Vogel.

The purpose of the current chapter has been to identify this strain of art as a living presence in Africa today. The brooding—or uplifting —ancestral presence of Extinct art provides the elements for a vast cultural collage; it engenders relationships, forces postures, and invites uses. But it does not determine the content of the collage, the attitude to the postures, the tenor of the relationships. It is simply an abiding presence, loved, repudiated, recycled, cynically manipulated, reverently enshrined. Raw material, determining forms, or screen on which to project today's desires, African art in extinction has as potent an effect as ever.

NOTES

1. Traditional black African art forms are quite common in South Africa, for example, where, ironically, they are treated as part of the national heritage.

2. Harris was trained by Methodist missionaries and developed a syncretic Christian cult that he preached as he traveled through southern Côte d'Ivoire in 1913-1914. He preached, baptized converts, destroyed "fetishes," and founded Harrisist churches, many of which still exist (Soppelsa 1982:16).

3. Personal communication, August 1990.

4. Reverence of a different kind, however, may affect it. The museum in Bamako, Mali, was obliged to relocate when Islamic leaders objected that it and the possibly potent "fetishes" it contained were too close to the main mosque, on the other side of the street.

5. During the Biafran war, the Nigerian museums rewrote all their labels to omit ethnic names completely. Only the names of villages were given. The museums had always been careful to present some art from every region.

6. Iba N'Diaye's drawings of traditional sculpture are an exception. Seeking to penetrate the grammar of the forms for his own purpose, he elucidates them for the viewer.

7. Though the style of these works may bear some similarity to European primitivism, the attitude and relationship of the artists to the African sources are so different one cannot call their style African primitivism. For them it is not "primitive," savage, or alien, and it is personally significant. See the sculpture and comments of the modern Fang sculptor Leandro Mbomio Nsue (fig. 2, p. 179), the son and grandson of Fang sculptors, whose works bear a passing resemblance to certain primitivizing European sculptures.

8. The growing importance of African buyers on the tourist market does not seem to have appreciably altered the styles of tourist art, which are in any case well established.

AFROKITSCH

Donald John Cosentino

Evil Imitations?

Do art styles die? Of course they do. Consider the terra-cottas of Nok, or the 150-year-old mosque at Zaria, in Nigeria. An architectural jewel of that medieval Hausa city, the mosque was slated for demolition in the enterprising 1970s by city authorities anxious to express Zaria's progressive character. When protests from nearby Ahmadu Bello University were added to cautious voices from the town, a compromise was reached: the mosque was left standing, but fluorescent lighting and electric fans were fixed to the vaulted ceilings. And the graceful columns and arches were completely encased in a larger pink-stucco shell, and were equipped with amplified speakers for the muezzins. The old mosque remained, but only through suffering this aesthetic mummification. A millennium-old architectural style became a motif: bric-a-brac for a third world moderne structure.[1]

What happens to the corpses of dead traditions? The excavations in Nok and the renovations in Zaria make their fate plain. They get buried, dead and buried—but not necessarily forgotten. Buried things do get dug up and rediscovered—so that advertisers can transform them into beer logos, or politicians can promote them as objects of national veneration, for reasons completely unrelated to the motives of their fabricators. Alternatively, their burial may be more psychic than physical. Traditional forms may persist as cultural memories, material-izing unexpectedly in the works of diverse contemporary artists. Or, like zombies, they can be revived without souls: a model of the old Zaria mosque has been reproduced at the Museum of Traditional Nigerian Art in Jos, part of a museum-cum-amusement complex that includes not only a zoo but a restaurant housed in a mud simulacrum of the Oba's palace in Benin.

Marx's famous observation on the repetition of great historical events seems equally apropos for great artistic traditions: they always occur twice, the first time as tragedy, the second as farce. This essay, then, is dedicated to that reprise called farce or, as the French say, *betise* (folly, or sottishness). Not at all fortuitously, *betise* is the very word borrowed by the Fon to describe their cast-brass miniatures of fantastically posed copulating couples, which are now merchandised as pornographic knickknacks throughout Africa. (I bought mine from a window display in an Indian shop in Nairobi. They were nestled next to a collection of the Amharic crosses now favored by both the Jamaican Rastafarians and American Rasta-wanna-bes.)

The history of *betise* production is murky. The Fon tradition of metal casting is celebrated by an international public in the nineteenth-century wrought-iron statue of Gu, the *vodu* of war, at the Musée de l'Homme in Paris. More pertinently, cast-brass miniatures were created as symbolic ornaments for *asen*, the iron staffs that served as symbolic

altars dedicated to ancestral kings. Similar ornaments were made for the palaces of the Fon aristocracy. These genre figures depicted every aspect of Fon domestic life, and were sometimes arranged into complex tableaux, chiefly processions, involving as many as thirty-six separately cast figures on a wooden base or frame (Crowley 1982:56). These tableaux, reminiscent of baroque Neapolitan crèches, were then presented to commoners and strangers as signs of royal favor.

Early references to these brass *asen* figures were made by F. E. Forbes (1851) and J. A. Skertchly (1874). But there is no established material link between *asen* figures and *betises*. Was this brass pornography created ex nihilo, or does it have historical antecedents? In his discussion of royal Dahomean brass work, William Fagg suggests an answer: "The techniques used in making [royal art] seem to be the result of conscious innovation and importation rather than of natural development—a synthetic tendency which is also found in Ashanti" (Crowley 1982:57). And indeed, in his Akan research, Timothy Garrard locates a likely source for the "synthetic tendency" that created and sustained the manufacture of *betises* (Garrard 1982:60). Examining more than 120,000 gold weights, Garrard discovered five eighteenth-to-nineteenth-century representations of copulating couples, with one pair additionally kissing (surely not a common practice in eighteenth-century Asante). He estimates that among approximately 3,000,000 extant gold weights there may be 100 such erotic couples. For whom were they made? Jaded Akan patrons, or the roué foreigners who had been landing on the Gold Coast since the seventeenth century?

Discussing a very different tradition, the poet Rilke asked, "What is the good of a used-up God?" If we transpose "Art" for "God" (as Matthew Arnold did), the *betises* respond with a lewd laugh. Laughter is used to bushwhack a culture into *terra nova*. Old forms are cut

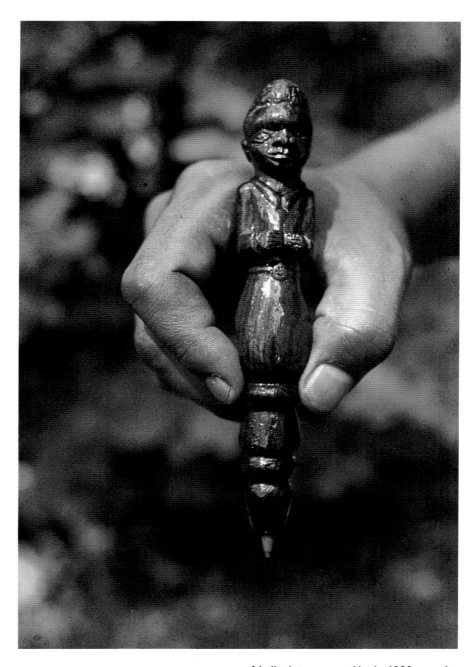

A ballpoint pen carved in the 1980s recycles the traditional wood–carving medium and imagery. Yoruba sculptors used to occasionally carve figures and heads on their tools and other small objects such as combs. Here the forms of stylized Yoruba sculpture have been updated by becoming more organic and naturalistic. In imitation of plastic, the surface is varnished to give the pen a slick, modern look. Photo: Marilyn Houlberg.

loose from their social matrices and reapplied to utterly new contexts. *Betises* stand in relationship to the old Fon brass traditions the way Robert Mapplethorpe's sado-erotic photos do to Praxiteles, or as Andres Serrano's *Piss Christ* (1987) does to Bernini: parodies that mark the extinction of a tradition. These works feed like viruses, dining off a fading host.

In Western art-historical studies, imitations of authentic art are called kitsch. Consider the words of Hermann Bloch, writing shortly after Hitler launched his Kulturkampf: "Kitsch is also a system of imitation. It can resemble the system of

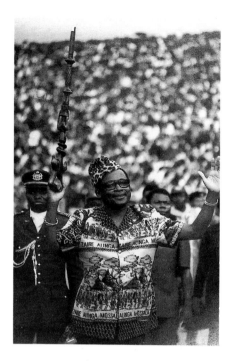

Fig. I. President Mobutu Sese Seko of Zaire, dressed in a leopard-skin cap and a dashiki printed with village scenes, and carrying an ancestor staff made for the tourist trade— all symbols of a generic, romanticized Africa. Photo: Copyright Attar H. Abbas, Éditions du Jaguar/Ed. J.A., Paris.

art in every detail, above all when it is handled by masters. . . . The Kitsch system requires its followers to 'work beautifully,' while the art system issues the ethical order: 'Work well.' Kitsch is the element of evil in the value system of art'' (Dorfles 1969:63). Bloch was writing out of the shambles of Weimar culture, and at the beginnings of the Nazi effort to turn kitsch into a national style. Max Beckmann and George Grosz were being cashed in for a papier-mâché Valhalla decorated with Aryan swastikas. It must have seemed to Bloch as if all of culture had become ersatz, a manufactured copy of a historically dubious past. Totalitarian aesthetics and the manufactured mass cultures of Euro-America have shadowed the term ever since. The Western academy and the educated public continue to understand kitsch as the "evil" imitation Bloch lamented.

Do *betises*, stuccoed mosques, and other examples—political schlock, festival decor, billboard nostalgia, fast-food caryatids—constitute an African variant of kitsch: Afrokitsch? They are all material transformations, and in some cases murders, of traditional African arts. They are all imitations. But are they all "evil"? The curious history of the Akan and Fon brass figures cautions us against such easy classifications. Raucous parody does not necessarily function in the same way as studied replication. All kitsch is imitation, but not all imitation is kitsch. Bloch associated imitation with the death of culture, but in Africa, imitation can also be part of a process of reinvention. *Bricoleurs* move from the village to the city, where the detritus of new emporia restocks tool kits and imaginations.

It is important to recognize the variety of contrary ways in which imitations may be classified in contemporary Africa. Similar complications in their categorization in Western cultures arose during the recent symposium "On Kitsch" at Skidmore College:[2] "[Kitsch is] an imitation of art which aims at getting an unreflective, immediate,

emotional response, [and] its function will either be to promote something—mainly in commercial terms —without contextual restrictions, or, on the other hand, to reinforce identification within a specific and well-defined context, mainly in ideological terms" (Friedlander et al. 1990:203). In this redefinition, Saul Friedlander identifies two kitsch strata: common kitsch, reflected in the daily art of contemporary urban life, especially as it is expressed commercially; and ideological or "uplifting" kitsch, which co-opts traditional symbols and icons to promote political or national agendas. Afrokitsch is manifested in these same categories, which we shall employ to examine imitations of traditional art in two paradigmatic nations: Mali and Nigeria. Finally, we shall decontextualize Afrokitsch in order to see how it operates in an emerging international composite culture.

Kanagas in the Sky with Diamonds: Kitsch in Mali

Nostalgia is the sentiment most common to kitsch: the longing for a safer and better world, expressed in "beautiful" historical recreations. These recreations are an attempt to establish an immediate liaison with the past in order to ennoble or validate a tawdry commercial or political present. Consider Shah Reza Pahlavi setting up silk tents amid the ruins of Persepolis to celebrate the 2,500th anniversary of the Darian conquests with his Aryan friends; or Bokassa of the Central African Empire ordering a replica of Napoleon's carriage fabricated for his Bangui coronation (even though the imported Norman horses would all die quickly from the tsetse fly).

Or consider the polymorphous fate of Soundiata (aka Son Jara, or Sundiata) in the material culture of Mali and the Mande fringe. Soundiata is a thirteenth-century emperor (*mansa*) and culture hero of the Mande. The griots who sing the epics praise his control of vast amounts of *nyama* (occult power),

which make him superior to all other emperors including Mansa Musa, whose ostentatious pilgrimage to Mecca in 1324-1325 caused a dramatic inflation of the Egyptian gold standard. In the griots' songs, material splendor cannot match ultimate mystical powers. John Johnson, in his translation of the epic, remarks of the hero, "His life serves as contemporary role model, not admired but copied, for any person who might choose to pursue an ambitious life's course. Whatever

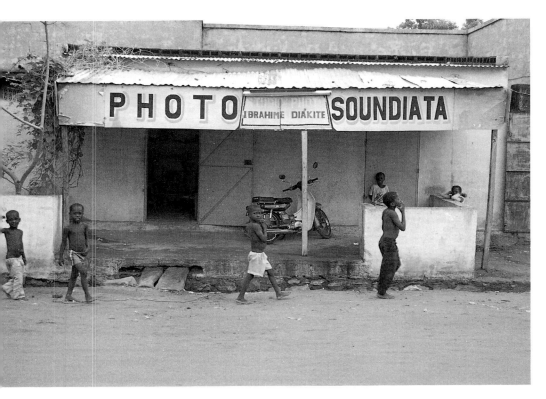

Fig. 2. Photo Soundiata studio. Quartier Lafiabougou, Bamako, Mali, 1990. Photo: Rachel Hoffman.

the narrative may possibly tell us about the past, it can tell us a great deal about the present" (Johnson 1986:7). So too can the very modest Bamako studio Photo Soundiata (fig. 2), where anyone can become associated with the eponymous hero through the *nyama* of a photograph.

The renaming of the French Sudan as "Mali" in 1960 was one example of the nostalgia exploited by emerging political elites. Although the new nation state was not congruous with the old empire, the patina of the epic tradition was too glamorous to resist. The new president, Modibo Keita, asserted direct descent from the ancient Mande aristocracy, even while espousing

"African socialism"—contrary credentials also claimed by other leaders on the Mande fringe (Jackson and Rosberg 1982:188). It is instructive to analyze how those leaders co-opted or suppressed traditional art in their quests for power.

Sekou Touré of Guinea, southwest of Mali, made political capital out of his dubious claim to descent from Samori, the legendary leader of a nineteenth-century jihad (Bohannan and Curtin 1971:327). At the same time, in the name of the new socialist Africa, Sekou Touré constricted the expressions of local ethnicities to such a degree that the coastal Baga ceased to create their Nimba masquerade sculptures, which had been among the most celebrated examples of West African traditional art. According to Frederick Lamp, one of the few scholars to visit Guinea during and after the Sekou Touré Kulturkampf, Nimba lingers in Baga culture as the sugar-sweet memory of a lost era. The nostalgic space her sculptures occupy in Baga consciousness parallels that of the celluloid legacy left to American popular culture by Marilyn Monroe: two queens of popular culture, both undone by encounters with charismatic political figures.[3]

In place of traditional art, Sekou Touré had his image stamped on the face of the same kind of watch used by Walt Disney to propagate Mickey Mouse. In that enterprise, Sekou Touré was certainly not alone. I found President Eyadema wrist watches throughout Togo, where the president's birth, and his escapes from various coup attempts, are celebrated in a series of holidays called *Les Trois Glorieux*. What these politicians have succeeded in creating, of course, are political religions, the natural world of "uplifting kitsch." Friedlander describes the process:

With the demise of traditional religions, the sacred is transferred from its natural settings into a new setting: the political. That is, the religious is devoid of the sacred, and the sacred is transferred to the political domain. Therefore you have

Fig. 3a. Portrait of President Siaka Stevens of Sierra Leone surrounded by masks of female secret societies. Atelier of Lasisi, Fourah Bay area of Freetown, Sierra Leone, 1983. Photo: Donald Cosentino. Fig. 3b. Bronze bust of Stevens with traditional rings of neck fat copied from *suwi* masks. Port Loko, Sierra Leone, 1970s. Photo: Frederick Lamp.

to reconstruct all the symbols, and kitsch is the basis of the act of reconstruction. You take the traditional religious symbols, which were natural in their religious context, and you construct a new religion, a political one. Then you light the torches, set the flags waving in the breeze, set the altar, and appropriate the idea of sacrifice, and of the hero dead and resurrected. You simply imitate what was authentic in its religious context and you enter the realm of political kitsch, with its immediate emotional impact (Friedlander et al. 1990:227).

Siaka Stevens, president of the authoritarian regime in neighboring Sierra Leone, sought to co-opt rather than usurp traditional icons of power. In Freetown his portrait was displayed in an altar arrangement with female masks, including the *suwi* of the Sande society; and in Port Loko a bronze bust of him disclosed prominent rings of neck fat, an aspect of beauty celebrated in the *suwi* masking tradition (figs. 3a and 3b).[4] But Stevens was a most adroit politician, and his lines of power were not parochial. Several Krio and Mende informants told me that the Volkswagen car that slowly revolved as an advertisement on top of one of the Freetown skyscrapers was actually filled with the president's *bofima*, a deadly medicine that assured its owner power over all who encountered its rays.

Bifurcated symbols were also employed by Samuel Doe, the postadolescent sergeant who led the bloody coup against the American/Liberian oligarchy in 1980, and who was himself assassinated a decade later. In the summer of 1983, I saw teenagers in Monrovia and Freetown wear green T-shirts sporting the grim visage of baby-faced Doe, in army fatigues and surrounded by the appropriate revolutionary slogans. But in the market a very different image was being sold on wax prints concocted to celebrate "Redemption Day," when Sergeant Doe promoted himself to president. In the center of that cloth was a

picture of Doe wearing a business suit and striped tie, reading glasses, and a high Afro coif. Circling the yuppified president, however, were clusters of dwarf hippos and generic ancestor statues that looked vaguely Baule or Fang (fig. 4).

Leaders from small ethnic groups, such as Doe's Krahn people, seem to favor these generic representations of traditional power. Contrast the Doe manifestations to the wardrobe of *Le Guide*, President Mobutu Sese Seko of Zaire, another autocrat from a minor ethnic group. For his public appearances Mobutu favors leopard-skin caps, dashikis printed with wistful scenes of grassthatched villages, and the kind of ancestor staff that can be bought from any Hausa trader in front of any Hilton on the continent (fig. 1). Like Doe's, Mobutu's drive for authenticity is true to a generic, romanticized Africa, but is not tied to any pesky and probably disloyal ethnic group. Generic pan-African symbolism seems increasingly the preferred medium for "uplifting kitsch."

But the legend of Soundiata has not been left to be exploited solely by his political heirs and their imitators on the continent. Contemporary adaption of elements from the oral or material media of traditional society usually leads to the "evil imitation" of kitsch, but occasionally an oral or material image gains vigor when used outside its traditional context. Thus Guinea's Ballets Africains has made a moving choreographed drama out of the coming-of-age episode from the Soundiata epic, when the crippled young hero struggles to stand up and walk against the jeers of his mother's enemies.[5] And perhaps the most extraordinary recreation of the Soundiata epic is that of the Malian director Souleymane Cissé, in his movie *Yeelen* (Brightness), which won a special prize at the Cannes Film Festival in 1987.[6]

At the core of the movie is the same struggle between father and son that motivates the epic (and all of human existence, if your view-

point is Freudian). The two finally confront each other in battle at the end of a long quest. And their struggle is expressed through magic, *nyama*, though its agency is utterly transformed. The father thrusts with a gigantic divining rod on which a wild-eyed chicken has been immolated in the opening scene. The son parries with the "Wing of Kore," a wooden plank inset by a blind uncle with a glittering pyramidal prism that looks as if it has come from a New Age boutique. Finally, as earth and sky catch fire in a cleansing holocaust, we realize that Cissé has fixed his epic in a galaxy far far away. Soundiata has met *Star Wars*. The young hero, part Mande prince and part Luke Skywalker, has confronted his evil father (aka Darth Vader). The prism set in the Wing of Kore by the uncle (aka Obi-Wan Kenobi) has transformed it into a light saber. So, in this glorious transposition, Kore, the highest initiation society among the Bamana, becomes the Jedi.

Early in the plot the father says, "To succeed, we must betray." And in a sense that's what Cissé does, "betraying" the epic by introducing deliberate anachronisms. Fulani horsemen thunder in with faces painted in a manner unknown to the Fulani. A seated male sculpture in the initiation grove looks more cinematic than Bamana. And then there's the George Lucas connection. This wholesale transposition, I believe, is precisely what saves *Yeelen* from being kitsch. Cissé did not make a "translation" of the epic, but a new work with only tenuous connections to the old. He succeeded at the same game that prompts Wole Soyinka to reanimate the Yoruba deity (*orisha*) Ogun in a host of poems, plays, and novels. After filming his *Satyricon*, in 1969, Fellini said he had created a rocket ship that went backward. And so did Cissé, a rocket ship that launched the epic of Soundiata into the center of late-twentieth-century cinematic art.

Malian novelist Yambo Ouologuem has also launched a literary rocket into the Soundiata epic, but his is armed with a nuclear warhead. Ouologuem's novel *Le Devoir de Violence* (1971) offers a sweeping account of a West African empire called Nakem from the thirteenth century to 1947. Although no atlas contains Nakem, the contours of the physical and political systems Ouologuem satirizes are clear enough. It is the empire of the epics sung by the griots, and of the *mansa* epitomized by Soundiata. Presiding over this immense pseudohistory like an endless toothache are the Saifs, a royal family whose discretion and sense of honor rival Al Capone's.

The real targets of Ouologuem's mock epic, however, are not the Saifs but those Africans and Europeans who would romanticize them, and, through nostalgia, would curdle the true history of Sudanic cultures into florid kitsch. Ouologuem is playing with African and European pretensions: the negritudinous platitudes of poets and politicians who establish their authority through a supposed descent from the emperor heroes. He is also mocking the European romanticists whose scholarship has equated the epics with history, chief among them Leo Frobenius, who is mercilessly savaged in the novel as the gullible but avaricious ethnologist and art historian Shrobenius:

This salesman and manufacturer of ideology assumed the manner of a sphinx to impose his riddles, to justify his caprices and past turnabouts. And shrewd anthropologist that he was, he sold more than thirteen hundred pieces, deriving from the collection he had purchased from Saif and the carloads his disciples had obtained in Nakem free of charge, to the following purveyors of funds: the Musée de l'Homme, the museums of London, Basel, Munich, Hamburg, and New York. . . . An Africanist school harnessed to the vapors of magico-religious, cosmological, and mythical symbolism had been born: with the result that for three years men flocked to Nakem—and

Fig. 4. Wax print of President Samuel Doe of Liberia surrounded by traditional icons of power. Monrovia, Liberia, 1983. Photo: Donald Cosentino.

Figs. 5a, 5b, 5c. *Chi wara* advertises an art boutique; flies on the tail of an Air Burkina plane in a billboard advertisement; and decorates a beer billboard. Bamako, Mali, 1990. Photos: Rachel Hoffman.

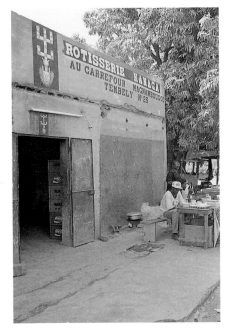

Figs. 6a, 6b. Stylized Dogon *kanaga* advertising Rotisserie Kanaga fast food; and another *kanaga*, this time inverted, on the side wall of the Bank of West Africa—Mali. Bamako, Mali, 1990. Photos: Rachel Hoffman.

what men!—middlemen, adventurers, apprentice bankers, politicians, salesmen, conspirators— supposedly "scientists," but in reality enslaved sentries mounting guard before the "Shrobeniusological" monument of pseudosymbolism.

Already it had become more than difficult to procure old masks, for Shrobenius and the missionaries had had the good fortune to snap them all up. And so Saif—and the practice is still current—had slapdash copies buried by the hundredweight, or sunk into ponds, lakes, marshes, and mud holes, to be exhumed later on and sold at exorbitant prices to unsuspecting curio hunters. These three-year-old masks were said to be *charged with the weight of four centuries of civilization*. To the credulous customer, the seller pointed out the ravages of time, the malignant worms that had gnawed at these masterpieces imperiled since time immemorial, witness their prefabricated poor condition. *Alif lam! Amba, koubo oumo agoum* (Ouologuem 1971:95-96).

Most obviously, Ouologuem is mocking the buyers and sellers at establishments such as Bamako's Maison du Masque Africain, which advertises its wares with kitschy little *chi wara* logos on a billboard shared with the corn merchants (fig. 5a). But the transposition of traditional art images in Bamako is much more eclectic and pervasive than the advertisement of fake art. The *chi wara* resurfaces as the logo for Air Burkina (fig. 5b), and, in a naturalized form, as the mascot for Castel Beer (fig. 5c). Nor should the fate of the *chi wara* be consid-

ered a singular imitation from traditional Malian art. Consider the use of the *kanaga*, the Dogon initiatory emblem, to advertise the Rotisserie Kanaga (fig. 6a), where meat sticks may be consumed under its aegis, or even on the side wall of the BIAO (Bank of West Africa—Mali), which sports a highly stylized set of inverted *kanaga* (fig. 6b). Clearly we are dealing in Mali with a feisty, democratic kitsch, no matter what the intentions of the state and its leaders.[7]

Udoji Culture: Kitsch in Nigeria

There are some events that aesthetically transform an era: the exposition at London's Crystal Palace in 1851, which introduced the industrial arts into Victorian decor. The 1936 Berlin Olympics, which formalized the uplifting variety of kitsch as an international style. Elvis Presley's appearance on *The Ed Sullivan Show* on American television, which created a mass market for rock 'n' roll. The Udoji commission was such an event for Nigeria.

In 1973, General Yakubu Gowon, the Nigerian head of state, established the Udoji Public Service Review Commission to examine the wage structure of the civil service. The commission recommended sweeping bonuses to encourage worker productivity. Flush with optimism from the successful conclusion of a civil war, and with oil monies that seemed limitless, the government adopted the Udoji recommendations with a vengeance. In October 1974, an across-the-board wage increase was decreed, which in some cases more than

doubled existing salaries, and included payment in arrears. A high proportion of the work force in Nigeria is employed by the government, and the country went on a spending spree. Those on foot got bikes. Bikers got motorcycles. Cyclists got Peugeots, bought from motorists now scouting out Mercedes. Leventis Department Stores were immediately stripped of Sanyo appliances and of gold-colored plastic bric-a-brac from Hong Kong. The ever au courant beauty parlors offered the "Udoji Hairstyle" (fig. 7a). The sale of champagne and lace was so extreme that by 1978 the government had to proscribe their import.[8] Even those who didn't make money got a T-shirt to commemorate their misfortune (fig. 7b). Everything became a commodity in this superhot market, including traditional culture and art.

The paradigmatic career in the Udoji economy was that of contractor. Everyone seemed to be building: the government roads, buildings, and schools, and individuals new homes. Udoji nairas, the Nigerian currency, found their way back to ancestral villages, where contractors were employed to construct "villas" and "lodges" for homeboys who had made good in Lagos, Enugu, and Kaduna. Often these houses were built according to the international tropical shoe-box design, but there were also fantastic creations such as the chief's house with flamboyant garrets and elaborate balustrades built near Enugu in Eastern Nigeria (fig. 8). The Igbo contractor may have taken inspiration from the Italian firm he worked for, but Udoji optimism is unmistakable in the design of the house.

New houses for the Udoji "nairanaires" created a new market for interior decoration, which had been only a casual aesthetic concern in traditional housing. The original Udoji surge resulted in anomalies like the parlor in Alhaji Dan Yari's traditional mud compound (*gida*) in Zaria, a room well stocked with technokitsch from the international emporium (fig. 9). But in addition

to the electronics and plastic glitz suddenly affordable from Leventis and the other international importers, a market developed for the kitsch previously created by Nigerian artists for the airport and tourist trade. Carvers now had a domestic market for their imitation Benin gewgaws (fig. 10), as did the Bini artist who carried transposition to higher levels by re-creating the famous bronze head of the Benin queen mother in terra-cotta (fig. 11a) and in king ebony (fig. 11b).[9] At the same time, other Benin artists enjoyed a brisk trade from the mass production of fake bronzes with "modern" themes. Nigerian artists made sure there was no shortage of supplies for the new market in interior decor.

While the Udoji commission fueled the demand for kitsch, the enthusiasm for simulacra had been flourishing since Independence in 1960. Among the Yoruba, that enthusiasm was colored by the same sort of historic nostalgia that propagated the Soundiata legend in Mali. Early in this century, the Yoruba historian Samuel Johnson claimed Egypt as the original homeland of his people. To celebrate that prestigious source, three oddly syncretic Yoruboid pharaohs in bas-relief were placed on Independence Building in Lagos (fig. 12a). But the most profound source for contemporary reinvention, and for Niger-kitsch, was Yoruba folklore and mythology.

In 1953 and 1954, Amos Tutuola published his two nonpareil quest narratives, *The Palm Wine Drinkard* and *My Life in the Bush of Ghosts*. Tutuola's decidedly idiosyncratic use of the English language and his retro-folktale plots (which read to post-Modern audiences like some incredible Yoruba splice of *Night of the Living Dead* and *The Wizard of Oz*[10]) were quickly hailed in Europe and America. Dylan Thomas described *The Palm Wine Drinkard* as "a brief, thronged, grisly and bewitching story," and a *New Yorker* critic wrote, "Mr. Tutuola tells his story as if nothing like it had ever been written down before, and he

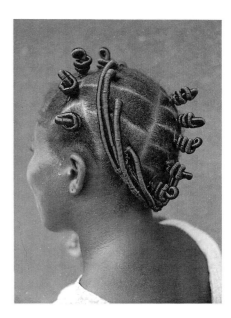

Fig. 7a. "Udoji Hairstyle" worn by Florence Adebanjo. Ikenne, Western Nigeria, mid 1970s. Photo: Marilyn Houlberg. Fig. 7b. A melancholy T-shirt: "Udoji No Reach Me." Western Nigeria, 1975. Photo: Mark Schilz, courtesy Marilyn Houlberg.

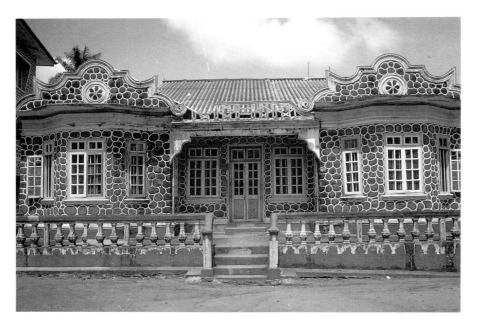

Fig. 8. Igbo chief's home in "high style." Traditional design patterns (*uli*) are echoed in the wavy lines of painted bricks. Enugu district, Eastern Nigeria, 1970s. Photo: Steve Erlich.

gives his themes the pristine quality they must have had when they were the living substance of the cultures that produced them and before they were demoted to the nursery. One catches a glimpse of the very beginning of literature, that moment when writing at last seizes and pins down the myths and legends of an analphabetic culture" (Tutuola 1953: back cover). Despite this international acclaim, Tutuola did not find an immediate audience in Nigeria, and never sold many books there. But the mythic creatures his novels captured resurfaced as characters in Ladipo's "folk opera" based on *The Palm Wine Drinkard*, and as posts in a cement fence at the University of Ibadan,(fig. 12b).

The most celebrated realization of the nostalgia for Yoruba folklore was undoubtedly created by the Oshogbo School of Art, under the patronage of Ulli Beier and Suzanne Wenger. The town of Oshogbo, mythic home of the generous river *orisha* Oshun (and adopted home of the generous Austrian impresario Wenger), became a kind of Yoruba Florence: a town where the old myths were re-created in startling new art forms. Huge representations of spirits from the Yoruba pantheon were constructed in concrete near the river site sacred to Oshun (fig. 12c), and even grouped around the Oshogbo Esso Service

Station (fig. 12d). They were the productions of enormously talented artists—Muraina Oyelami, Jimoh Buraimoh, and especially Twins Seven-Seven (whose work was featured in the 1989 exhibit "*Magiciens de la terre*," at the Centre Georges Pompidou, Paris)—and had become commodities in the international market by the 1970s. But what do these enormous representations of the *orisha* signify in Nigeria? Like Tutuola's characters, they might be seen as the re-creation of mythic figures through individual imaginations fevered by Modernist media. Unlike Tutuola's characters, however, these objects had no native Yoruba impetus for their creation. By their grotesque exaggeration they might be considered comparable to the gargantuan marble saints that dwarf tourists and the odd worshiper in Saint Peter's in Rome, but what do Oshogbo carvings, paintings, and cloth prints signify to the Yoruba minority that still worships the *orisha* exclusively? They cannot signify much, since they do not stand in any ritual continuum. Nor has much of a Nigerian domestic market ever developed for this peculiar Austro-Yoruba style. Even Twins Seven-Seven has never made it into the new interior-design mart of Udoji culture.

Does Oshogbo represent the iconographic revival of a fading religious tradition, or its exhumation and transformation into uplifting kitsch? There can probably be no unitary categorization for creations as complex as those of Oshogbo. To those outside the culture, this style may continue to have the impact of revelation. Within the context of contemporary Nigeria, however, Oshogbo art may seem as ostentatious, and ultimately as alienating, as a Bernini interior, as etic (but fascinating) as Leni Riefenstahl's photographic visions of the Nuba, or as stagy as Wagner's Valhalla deities. In assessing the significance of Oshogbo, I agree with Friedlander that representations more "religious" than those produced by the religion itself are kitsch (Friedlander

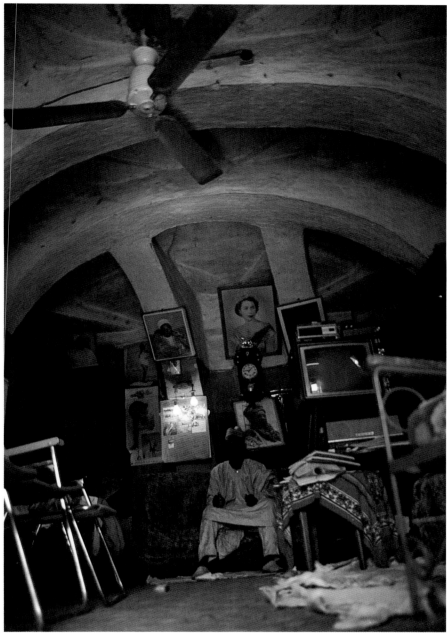

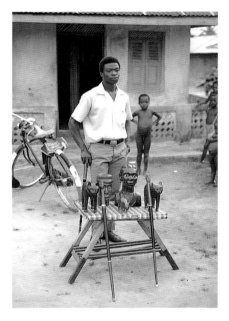

Fig. 9. Modernized interior of the parlor in Alhaji Dan Yari's compound, equipped with TV, aluminum chairs, chime clock, electric fan, and Oriental rug. Zaria, Northern Nigeria, 1970s. Photo: Steve Erlich.

Fig. 10. Udoji knickknacks: Isoko carver with bookends and breakfront busts. Emede, Bendel State, Nigeria, 1970s. Photo: Philip Peek.

et al. 1990:234).[11] He had in mind the Nazi shrines in Nuremberg; I am considering the grove for Oshun in Oshogbo. To be more Catholic than the pope is to be kitsch, and so is being more Yoruba than the Oni of Ife.

The Igbo people around and across the Niger river have also allowed historical nostalgia to shape their contemporary material culture. Belonging for the most part to state-less societies before the colonial

intrusion, the Igbos did not develop the complicated priest-dominated narrative or material mythologies of the Yoruba. No early Igbo historian claimed origins from the East,[12] but the Igbos did rather quickly develop a conscious appreciation of the unique, achievement-driven institutions they had developed. They attempted to express that consciousness politically in the brief and disastrous Biafra war of secession (1967-1970). The war was carried

on with old-fashioned carnage. But Biafran media manipulation ("starving baby" videos distributed through a Swiss agency for American network news broadcasts), and Biafran leader Odumegwu Ojukwu's choice of "Finlandia" as the national anthem, seem strangely post-Modern. Chastened by military defeat, post-Udoji Igbos turned to an older expression of nationalism: the glorification of their own folkways.

Tradition Anyi Noya (Here is our

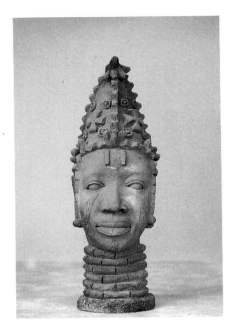

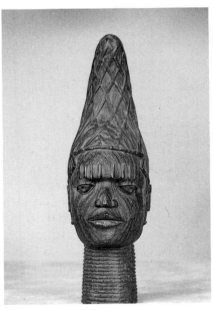

Figs. 11a, 11b. Copies of bronze head of Bini queen mother, in terra-cotta and king ebony, by Rich Amu. Benin City, Nigeria, 1967. Photos: Philip Peek.

culture), a billboard photographed in the late 1980s near the market town of Onitsha, celebrates the taking of the *ozo* title, the highest status a man may achieve in traditional Igbo society (fig. 13).[13] At the center, in a kind of apotheosis, stands the man taking the title. He is in full regalia, supported on his left by a society brother holding an ivory tusk, and underneath by his wife in her ivory anklets. All around the titled trio circle those events and characters that constitute an *ozo* ceremony. For the artist, *ozo* is a paradigm, and the painted tableau a narrative allegory of traditional order.

To the left we see two men on their way to the ceremony. They have consulted the oracle (*agwu*), who promises them "long life, no death" in Igbo. So assured, one brother switches languages and exclaims, "My brother, let us go out from here."[14] To the right are gathered musicians to play for the festivities. Underneath, food is being presented: yams and a fowl by iconographically dwarfed women, and a cow for *ozo* by a man in Hausa dress. The good times have definitely begun. Food is being cooked in the lower left corner, and men are horsing around. Two of them are wrestling while the palm-wine gourd has been tipped over. Another looks on resignedly and exclaims in Igbo-Pidgin, "Today na Today, Okonkwo; it is time for custom."

"Culture" as defined by this billboard is every bit as syncretic and contemporary as the medium that celebrates it. It is a culture constantly shifting language codes between Igbo, English, and Pidgin. With inspired (or unconscious) reflexivity, the onlooker above who invokes "Okonkwo" may be summoning the archetypal tragic culture-hero created by Igbo writer Chinua Achebe in his famous elegiac revocation of the lost past, *Things Fall Apart* (1958). Celebration here is not without chiaroscuro. Another onlooker says of the men horsing around, "They are fighting for nothing," and his friend agrees,

"The strength of palm wine can cause confusion." The sign artist has a very Bakhtinian sense of celebration, and a determination not to be merely "pretty" about tradition. Like other representations that transcend the kitsch sentiments that inspired them (*Yeelen*, *Le Devoir de Violence*), *Tradition Anyi Noya* succeeds in capturing the lost past by securing it firmly in the energy of a messy present.

FESTAC Madness

Udoji culture found expression in personal and ethnic terms, but it also became a national expression in two archetypal events: the All-Africa Games of 1973, and FESTAC in 1977. These twin events should be understood as the quintessence of uplifting kitsch, and, as such, harbingers for other styles of national and international Afrokitsch.

The second All-Africa Games were staged in Lagos from January 7 to 18, 1973, three years after the end of the Nigerian civil war. Billed as a regional Olympics, the games more significantly celebrated the country's *rite de passage* from a horrendous war of ethnic hatreds to a newly won hybrid nationalism. The logo chosen for the games was the famous bronze head of the Oni of Ife (twelfth to fourteenth century) wearing a beaded crown with plume. Though its provenance has been contested, the brass is celebrated enough to be featured on the CFA currency of Francophone Africa, as well as on a Nigerian sixpenny postage stamp that inspired a Cameroon artist to cast a copy, in what must be a singular example of philatelic mimesis (figs. 14a and b; Bascom 1969:106). The 1973 logo likewise inspired its own simulacra. Marilyn Houlberg records the plume-crowned head of the Oni of Ife stenciled on a stylish tote bag (fig. 14c), reproduced on a twelve-inch plastic decal suitable for interior decoration (fig. 14d), and in the trendy coifs of Nigerian women (figs. 14e and f). And the inspiration continues: copies of the Ife brass were prominently for sale at

Figs. 12a, 12b, 12c, 12d. Yoruba myths become industrial decorations. a) Bas-relief of Yoruboid pharaohs. Independence Building, Lagos, Nigeria, 1966. b) "Grisly and bewitching" creatures described by Amos Tutuola dance around air-conditioning unit. Institute for African Studies, University of Ibadan, 1972. c) Mythological figures in concrete along the road to the Oshun shrine. Oshogbo, Nigeria, 1966. d) Gas station with mythological facade in concrete, created by Adebisi Akangi. The main road in Oshogbo, Nigeria, 1966. Photos: Philip Peek.

the 1990 African Market Fair in Los Angeles (fig. 14g). Uplifting kitsch knows no borders, and cannot be anachronistic.

The All-Africa Games and its use of traditional art as a reinforcing national symbol served as prelude to the Festival of African Culture (FESTAC), which followed in 1977. Few contemporary cultural events can have affected the political life of a great nation more dramatically.[15] One of the common reasons given for the downfall of the government of General Gowon, who had successfully seen Nigeria through its civil war, was his failure to keep FESTAC plans on schedule. As the event drew closer, the vibrant Nigerian press began printing countdown clocks in banner headlines: 74 HOURS TIL FESTAC!!!

The event itself was billed as a sequel to the 1964 Festival of Negro Arts in Dakar, an international exposition of art, performance, and drama staged by Senegal President Léopold Sédar Senghor. The intent of the Dakar festival was to manifest "negritude," Senghor's term for the unique contribution of black people to world arts and culture. Perhaps the most famous Nigerian artist, writer and Nobel laureate Wole Soyinka, wary of glorious causes after a harrowing imprisonment for his opposition to the civil war, had earlier expressed his contempt for this sort of cultural posturing by observing, "A tiger doesn't need to proclaim its tigritude." But that was not the mood of the government, the press, or the extraordinary number of Nigerians who

managed to buy or be near a television for the proceedings. A rush on electronics shops, similar to the initial Udoji wipeout of Leventis, assured millions of Nigerians access to the arts show that had brought down one government and caused the next to spend millions of naira.

What Nigerians watched was days of dances and performances, preceded by a march past the TV cameras by troupes of costumed, masked, and masqueraded traditional performers from Africa and from black-diaspora communities throughout the world. This march-past was definitely the most popular of the festival events. Students I was teaching then at Ahmadu Bello University would squeal as each national troupe came on screen in their national gear. The event seemed borrowed from the march of nations at the Olympics. But the efforts of all those performers to please reminded me of the boardwalk competition at the Miss America pageant, and the heterogeneous display of all those styles recalled that classic of kitsch coffee-table photo essays, Edward Steichen's *The Family of Man* (1955). Like Steichen's selection of photos, the TV screen reflected decontextualized, cross-classified, and vaguely labeled groups of happy interchangeable utopians.

To commemorate the event, the International Festival Committee had published its own coffee-table volume, *Festac 77*. Between short scholarly essays, the volume featured studio shots of African art, mostly masks, some of museum quality and some contempokitsch. To support the pan-African festival theme, there were also shots of Haitian dancers, Australian aborigines in ritual dress, and pharaonic tomb tableaux. Almost all the artwork was identified generically, by country and not by ethnic group, so that a Sande *suwi* was labeled a "West African Mask" (*Festac 77*:15). Clearly the art of various ethnic groups was being co-opted to promote a pan-African identity. And over and above all these objects—on

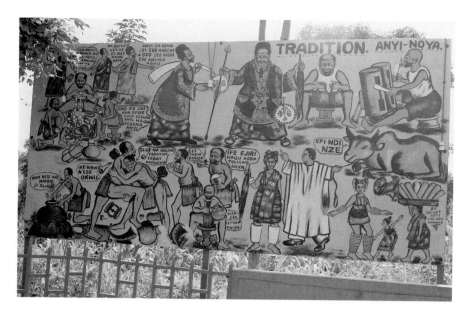

Fig. 13. *Tradition Anyi Noya*, billboard cele-
brating Igbo traditions. Painted by Oye
Agu Agbagana of Jacket Arts, Northern
Igboland, Nigeria, late 1980s. Photo: R.
Reid, working with Herbert Cole.

the glossy cover of *Festac 77*, on
every festival brochure, on mass-
produced T-shirts, on market cloth
used for wrappers—was the festival
emblem: the ivory pectoral mask
stolen from the bed chamber of
Oba Ovonramwen during the 1897
sack of Benin, now ensconced in
the British Museum.

The Nigerians wanted the mask
back for the festival, and of course
the British wouldn't let them have
it. The British Museum pleaded
poor conditions in Nigeria, espe-
cially the lack of humidity control
(never mentioning its eternal fears
of setting a repatriation precedent
for the Elgin Marbles). One wag at
the National Museum in Lagos won-
dered aloud why a mask that had
survived 400 years in the Oba's
palace could not be expected to last
a few more weeks in Nigeria for the
festival.[16] The National Museum
then commissioned a copy of the
mask in ivory, which it displayed
during the festival. The replica was
well done, but unfortunately new
ivory has the translucent quality of
white plastic. The commissioned
mask thus became an unwitting
metaphor for other cultural trans-
formations, visible and ideological,
at FESTAC.

The Benin mask and the Ife head
became symbols of celebration for
nation states far removed from them
in time and concept. They were
co-opted and transformed into what

Larry Nachman has called "rein-
forcing symbols": "Kitsch [comes]
from a world from which tradition
has been banished. . . . What do you
do with those who don't understand
the philosophical basis for a new
society? For those who don't, you
have to introduce something else;
you have to introduce some force
that will bond those who can't un-
derstand what you're making, and
why you're making it. This is the
origin of . . . reinforcing symbols"
(Friedlander et al. 1990:228). Like
images of the Roman fasces, the
Khmer temples at Angkor Wat, or
the walls of Zimbabwe, these
Yoruba and Bini art treasures have
been minted into a new currency.
They have come to valorize new
social orders. The originals are re-
vered in foreign museums, and their
imitations are mass-produced for
domestic consumption. The plastic
decals and arty wax-prints manu-
factured for these festivals confirm
the relationship between kitsch and
new modes of production: "One
trait of kitsch is the lack of any
mistake in the reproduction, the
perfection of it . . . the madonna
reproduced in plastic is much better
than in plaster. You need industrial
production for kitsch" (Friedlander,
in Friedlander et al. 1990:234). The
decal Oni and T-shirt Oba may har-
binger the fate of these other
antique traditions as African art
becomes a commodity in a develop-
ing world-culture emporium.

Afrokitsch International

We may bewail the invisible hand
that is creating this new emporium
for traditional African art and cul-
ture. We may say it's wrong for
Paul Simon to use Ladysmith Black
Mambazo or for David Byrne to
use Celia Cruz in their music (though
by the same token we would need
to tell Hugh Masakela not to imi-
tate Dizzy Gillespie, and King Sunny
Ade to get rid of that Hawaiian
guitar). We may rail against these
adulterations of traditional African
cultures, but if we did so our la-
ments would seem as fatuous as
King Lear raging against the wind.

IFE BRONZE
NIGERIA

PLATE 70. Copy of an Ife (Nigeria) bronze head (9¼"), made by a brass-caster from Cameroun. Collection of

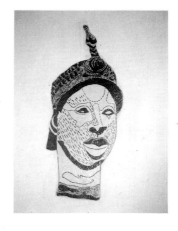

Figs. 14a, 14b, 14c, 14d, 14e, 14f, 14g. Recreating the Ife bronze. a) Nigerian postage stamp with Ife head and b) bronze head cast by a Cameroon artist after the postage-stamp image. Photos: Eugene R. Prince, from Bascom 1969:plates 69 and 70. c) Student's tote bag with Ife logo. Ikenne, Nigeria, 1970s. d) Plastic decal of Ife head from the wall of a house. Ilishan, Nigeria, 1988. e) "Ife Bronze Hairstyle" advertisement, from *Modern Nigeria Hairstyles*, about 1975. f) "All-Africa Games Hairstyle," worn by Bola Olubi. Ikenne, Nigeria, 1973. Photos: Marilyn Houlberg. g) Ife bronze head for sale at African Market Fair. Crenshaw district, Los Angeles, 1990. Photo: Donald Cosentino.

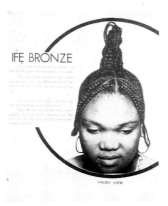

IFE BRONZE

FRONT VIEW

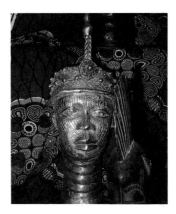

Better to recognize that a composite world culture is taking shape, and that Africa, despite the woeful economic and political statistics of the last decade, is an essential ingredient in that emerging culture. It is time to take stock of composite culture, and of Africa's role in it.

For historical reasons, and for sheer weight of influence, it is best to begin that assessment in Anaheim, California. It is there, in Disneyland, that Afrokitsch International may have been born, and there that it persists in its lowest common form. Jean Baudrillard is correct in asserting that far from being a fantasy, Disneyland is the most real place in Southern California (Baudrillard 1984:262). Los Angeles may be unreal but Disneyland taps the source.[17] A surprising number of African simulacra are scattered through the various Disney "lands," but they must all be read against "Main Street." It is that perihelion of Americokitsch, that bricked street of five-eighths-size

Edwardian shops, frozen, like the body of Walt Disney, in some imagined moment of historical virtue, that determines the value of all other cultures in the theme park.

It is always the last fin de siècle on Main Street. The scramble for Africa has just ended, and the colonies are established. At the gates to Adventureland is an orange-juice ad, "Sunkist I Presume," echoing Stanley's query of Livingstone, mounted under a creditable imitation of the facade of a Hausa house (fig. 15a). Someone here was concerned with verisimilitude. The arresting visuals give way, however, to hokey stereotypes. We may board the *Zambesi Queen* for a Jungleland ride (fig. 15b). Next door, under another thatched roof, is the Big Game Shoot (fig. 15c). Should all this adventure prove too taxing we can retire to a nearby fast-food stand guarded by generic wooden ancestor figures, or we can consume our burgers by a caryatid (fig. 15d) in the Fang-Baule style.

Although the Disney rides keep changing, the ambience remains the same. The Anaheim site was conceived and realized in the 1950s, when the image of Africa was compounded from Johnny Weissmuller and John Huston. So Africa remains frozen at Disneyland, an exotic fossil with an agreeable frisson of danger safely contained by the certainties of Main Street. The message has changed now: it's not *African Queen* but *Gorillas in the Mist*. It's not the tsetse fly but the HIV virus. It's not Tarzan but Paul Simon. So now there is almost a quaint feeling in Anaheim, like walking into a nineteenth-century curio room. But Disney curios are commodities. They sell hamburgers, hot buns, and plastic heads. More important, they sell a "feeling." African images in Adventureland sell an ersatz feeling of excitement for having braved something, having made an experience your own, an experience all the more powerful for never having happened.

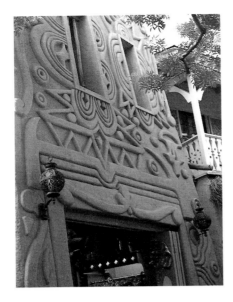

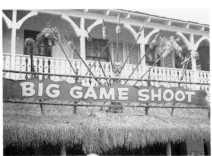

Figs. 15a, 15b, 15c, 15d. African fantasies in Disney's Adventureland. a) Facade of orange-juice stand in Hausa style. b) Jungleland ride recalls *African Queen* scenarios. c) Big Game Shoot offers the thrill of the African

kill. d) Caryatid in generic African style, reminiscent of the Fang-Baule figures on the Doe commemorative cloth (fig. 4), supports fast-food stand. Anaheim, California, 1980. Photos: Donald Cosentino.

This homogenization and commodification of tradition (also apparent in political and national kitsch) are what Dwight MacDonald called "masscult": "Masscult, or mass culture . . . applies to commercial kitsch, and is exemplified by Mickey Mouse and Disneyland. . . . There is a category of kitsch that aims at being accepted all over. Everybody looks at Dallas, all over the world. It simply entertains and 'beautifies' life at the level of the daily and uniform. The uniformity and universality are the criteria of masscult" (Friedlander, in Friedlander et al. 1990:208). Masscult by its nature metastasizes. So Disney spread to Africa soon after Africa surfaced in Anaheim. In the early 1980s I found exact imitations of Donald Duck and Mickey Mouse selling *gelato* in Somalia, and Snow White and her fairy godmother sell-

ing ice cream in Sierra Leone (fig. 16). At about that time, the Sierra Leone government issued a series of Disney commemorative stamps featuring Mickey, Donald, and their little animated friends.[18] These sets of African and American images are congruent. They maintain a dialogue across otherwise staggering cultural, social, and economic divides. Together they represent the lowest common denominator of masscult, a melting pot of images that makes true pluralism impossible.

Masscult exists as the dark side of Afrokitsch International. It should be judged in comparison to the simultaneous development of composite culture. Masscult homogenizes cultures in the name of an ersatz universalism. Composite culture accentuates the differences. The aesthetic aim of masscult is a

false optimism. Composite culture calls into question all previous assumptions about universalism, and scoffs at claims to particular ascendancies. It is in the latter mode that we experience the music of King Sunny Ade, or of the Talking Heads; that we watch for culture clash in the films of Souleymane Cissé and Jonathan Demme; that we appreciate the ironies of *Tradition Anyi Noya* and the parodies of Yambo Ouologuem and the brass-casters of *les betises*.

As this essay began with a consideration of Fon "foolishness" at the end of the nineteenth century, so it ends with a bit of Fon-inspired foolishness at the end of the twentieth. I speak of Legba's phallus enshrined on a temple porch in Oyotunji Village, South Carolina (fig. 17). On the face of it, Oyotunji Village is absurd. An ersatz Yoruba village, a sort of Guinea Coast Vatican, filled with temples dedicated to the Yoruba *orisha*, and the descendant Fon *vodun*, in Beaufort County, South Carolina? With an Oba from Detroit, and subjects from scattered points throughout the diaspora? Yet visiting Oyotunji is not at all like visiting Disneyland. There is none of the false optimism of Anaheim about the place. The day I visited, there was the stench of sacrificed fowl around the shrine to Eshu. And the village was about to celebrate the feast of Oshun Panshaga, the sacred prostitute. And just around the corner was the seven-foot monument to Legba's creativity.

This icon to Legba, the *orisha-vodun-lwa-santo-orixa* of communication, challenges prevalent scholarship on the significance of kitsch. Like Oyotunji Village itself, his phallus demonstrates the creative possibilities open to artists willing to play with tradition. If art may devolve into kitsch, then kitsch may return the favor by generating fresh and tensive images out of old traditions. No Yoruba shrine really looks like this one in Beaufort, South Carolina. So what? Legba is being born again as an African-American deity, and so too his old iconogra-

Fig. 16. Snow White and her Fairy Godmother. From the wall of the Yum Yum Ice Cream Parlor, Freetown, Sierra Leone, 1983. Photo: Donald Cosentino.

Fig. 17. Phallic Legba sculpture with tour guide. Oyotunji Village, Beaufort County, South Carolina, 1989. Photo: Marilyn Houlberg.

phy is being recycled into new artistic expressions.

In this essay we have examined many expropriations of traditional African art for dead-end political and commercial reasons. But we have also seen old traditions get busted apart, and the detritus used to create anew. That seems to be the message inherent in the seven-foot phallus. Do traditions die? Of course they do. But if space remains for Legba, they may also get reborn.

NOTES

1. Compare this Islamic mummification to the encasing of Greco-Roman temples within Catholic churches—Santa Maria Sopra Minerva, for example, in Syracuse, Sicily.

2. Participants in the symposium at Skidmore College, Saratoga Springs, New York, included Saul Friedlander, Susan Sontag, Irving Howe, Larry Nachman, Robert Nozick, and Stanley Kauffman. The proceedings are published in *Salmagundi* 85-86, Winter-Spring 1990 (see bibliography).

3. Frederick Lamp delivered a paper on the fate of Nimba among the Baga at the Triennial Symposium on African Art, Los Angeles, April 1986.

4. Personal communication from Lamp, September 1990.

5. I had the pleasure of seeing this stirring performance by the Ballets Africains during the arts festival of the 1984 Olympics in Pasadena, California.

6. I am indebted to Rachel Hoffman for her excellent review of *Yeelen* in *African Arts* (see bibliography), and to Hoffman, Samuel Sidibé, Cheik Oumar Keita, Yaya Amadou Coulibaly, and Omar Traoré for their intrepid and imaginative documentation of kitsch signage in Bamako. *Mashallah! wa bismillah!*

7. Democratic kitsch ought to be understood against the horrifying possibilities for the regimentation of kitsch demonstrated in Nazi Germany. On May 19, 1933, Hitler's then-new regime produced legislation against kitsch, the "Law for the Protection of National Symbols." The law was accompanied by explanatory guidelines, but since people did not seem to understand the fine distinctions it established, newspapers ran lists of examples illustrating what was forbidden and what was allowed. The forbidden forms of decoration were explicitly characterized as "kitsch." A swastika was all right on a Christmas ornament, but was strictly forbidden on a bratwurst (Friedlander et al. 1990:202-203).

8. A Nigerian president of the Second Republic had his name printed on bottles of champagne. After he was deposed, a single bottle displayed in the Nigerian National Museum was reportedly the most highly attended exhibit in the museum's history. Personal communication from Doran Ross, September 1990.

9. Of Rich Amu's work, Philip Peek remarks, "Have you ever carved in king ebony? And who could afford bronze anyway? Sure that piece is a copy but sure it's different also. And I still think that viewed alone, it's a good carving." Personal communication, September 1990.

10. Those familiar with Tutuola's work were not surprised when avant-pop musicians David Byrne and Brian Eno chose "My Life in the Bush of Ghosts" as the title of a rock album in the 1980s.

11. Evelyn Waugh notes that you can always tell an Anglican from a Roman Catholic cathedral in England because it is the Anglican that will be full of candles, incense, and all the other easily borrowed trappings of Rome. Surfaces are easily replicated and expanded. Deep structures are resistant to imitation.

12. The question of origins, however, is important to Igbos. They have been called "the Jews of West Africa," and seem to enjoy that comparison. There is a widely known and believed emic folk etymology that derives "Igbo" from "Heeboo," and thus maintains that these Eastern Nigerians are the lost tribe of Israel.

13. Henrietta Cosentino suggests translating the Igbo title into Pidgin: "We Tradition: We dey na ya" ("Here we are, right in our tradition"), which captures the locative sense better than an English transliteration.

14. I am indebted to friend and colleague Nkeonye Nwankwo for her translation and narrative hypothesis of this sign. After I queried her about the artist's reason for shifting linguistic codes, Ms. Nwankwo replied with good-natured exasperation, "Perhaps it's because the person who painted this didn't know a folklorist would study it!"

15. The parallels that immediately come to mind are the shameless uses made of Olympic pageantry for domestic political needs by Messrs. Hitler in Berlin (1936), Brezhnev in Moscow (1980), and Reagan in Los Angeles (1984).

16. Personal communication from Marilyn Houlberg, September 1990.

17. If you doubt this assertion, replay the ads of the Republican National Committee for the 1984 presidential campaign. Note the similarity between Reagan's "Morning Again in America" scenario and Disney architecture. Then tally the electoral vote scores: forty-nine states for Reagan, one for Mondale. Reagan knew a thing or two about showbiz and politics.

18. Doran Ross reports seeing Mickey Mouse appearing with the Michelin Man throughout many parts of Africa. Personal communication, September 1990.

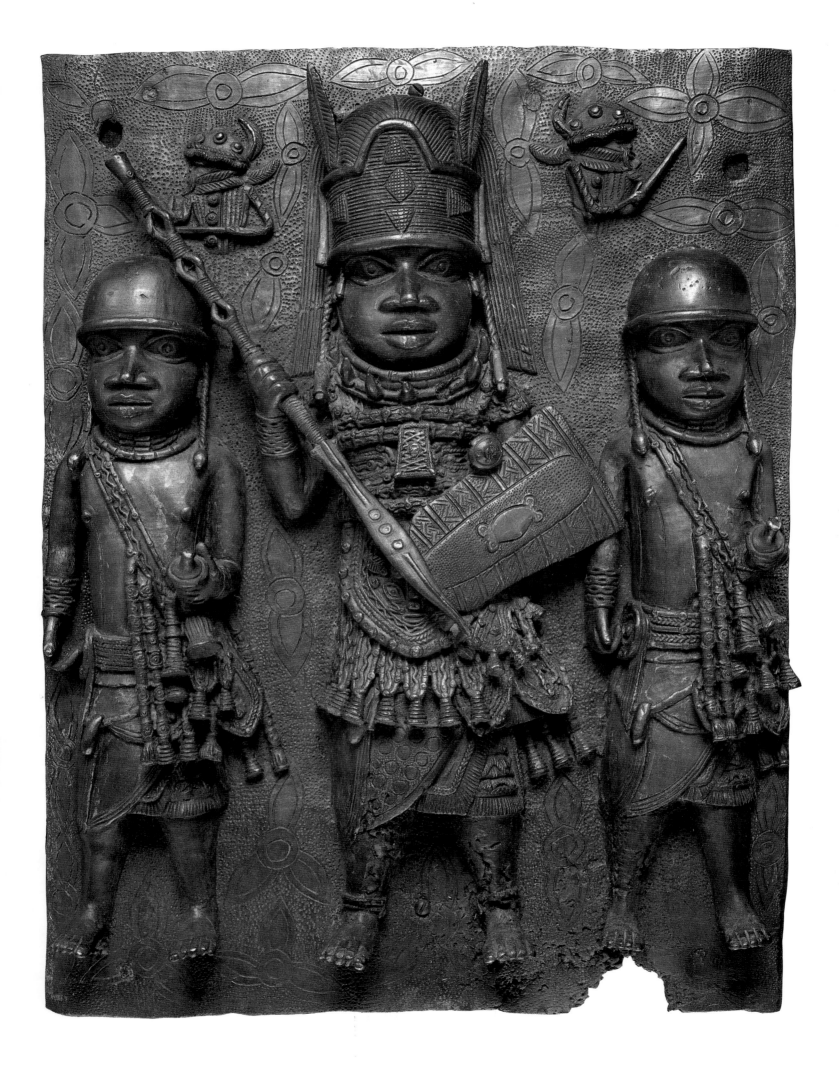

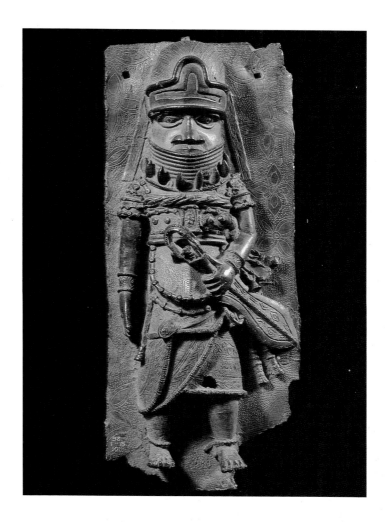

Cat. 117 PLAQUE WITH WARRIOR AND ATTENDANTS, LATE 17TH-EARLY 18TH C., UNKNOWN BINI ARTIST (NIGERIA), BRONZE, H. 49.2 CM. COLLECTION: PEABODY MUSEUM OF ARCHAEOLOGY AND ETHNOLOGY, HARVARD UNIVERSITY.

Cat. 118 PLAQUE WITH WARRIOR, LATE 17TH-EARLY 18TH C., UNKNOWN BINI ARTIST (NIGERIA), BRONZE, H. 42.4 CM. COLLECTION: THE RENEE AND CHAIM GROSS FOUNDATION.

Cat. 119 PLAQUE WITH PRIEST, LATE 17TH-EARLY 18TH C., UNKNOWN BINI ARTIST (NIGERIA), BRONZE, H. 38 CM. COLLECTION: THE RENEE AND CHAIM GROSS FOUNDATION.

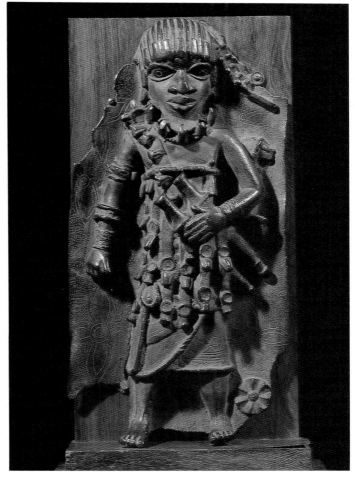

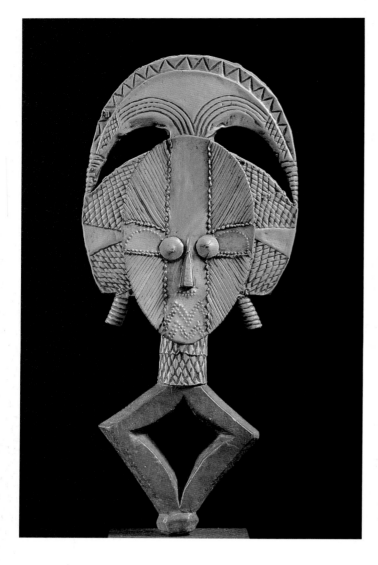

Cat. 120 RELIQUARY GUARDIAN FIGURE, LATE 19TH-EARLY 20TH C., UNKNOWN KOTA ARTIST (GABON), COPPER, BRASS, AND IRON OVER WOOD, H. 41 CM. COLLECTION: JOHN AND NICOLE DINTENFASS.

Cat. 121 RELIQUARY GUARDIAN FIGURE, LATE 19TH-EARLY 20TH C., UNKNOWN KOTA ARTIST (GABON), COPPER AND BRASS OVER WOOD, H. 51 CM. COLLECTION: THE RENEE AND CHAIM GROSS FOUNDATION.

Cat. 122 RELIQUARY GUARDIAN FIGURE, LATE 19TH-EARLY 20TH C., UNKNOWN KOTA ARTIST (GABON), COPPER AND BRASS OVER WOOD, H. 57.5 CM. COLLECTION: THE RENEE AND CHAIM GROSS FOUNDATION.

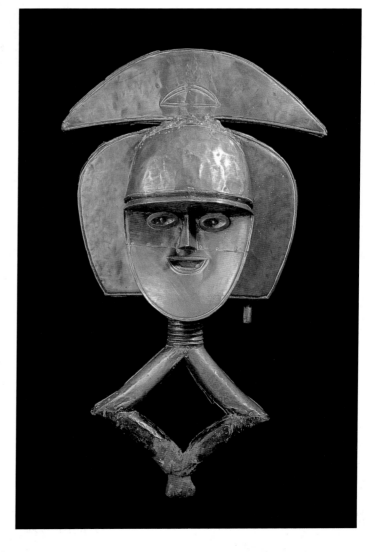

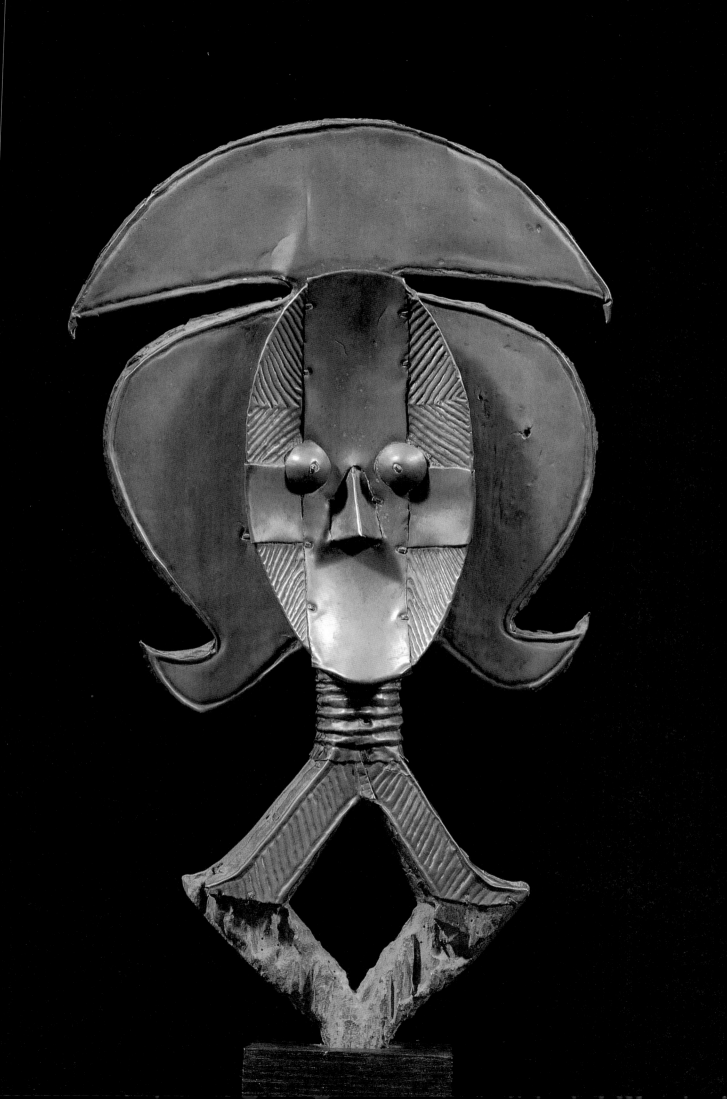

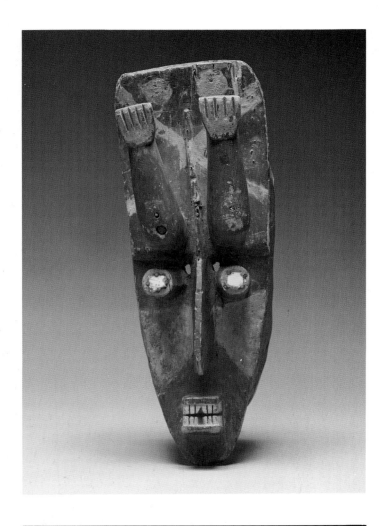

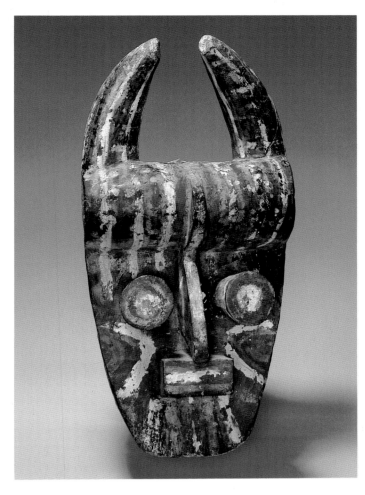

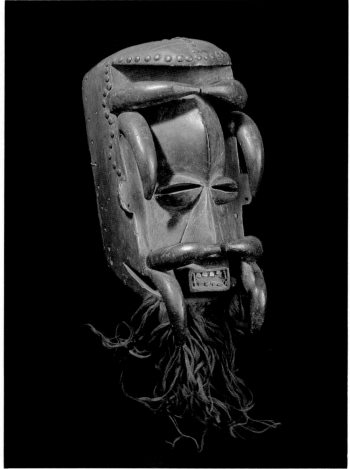

Cat. 123 MASK, EARLY 20TH C., UNKNOWN GREBO ARTIST (CÔTE D'IVOIRE), WOOD AND PAINT, H. 46 CM. COLLECTION: PEABODY MUSEUM OF SALEM.

Cat. 124 MASK, EARLY 20TH C., UNKNOWN GREBO ARTIST (CÔTE D'IVOIRE), WOOD AND PAINT, H. 40 CM. COLLECTION: SEATTLE ART MUSEUM, KATHERINE WHITE COLLECTION.

Cat. 125 MASK, EARLY 20TH C., UNKNOWN BETE ARTIST (CÔTE D'IVOIRE), WOOD, RAFFIA, AND BRASS TACKS, H. 35 CM. COLLECTION: THE RENEE AND CHAIM GROSS FOUNDATION.

Cat. 126 MOTHER AND CHILD FIGURE, LATE 19TH–EARLY 20TH C., UNKNOWN KONGO ARTIST (ZAIRE), WOOD, H. 64.8 CM. PRIVATE COLLECTION.

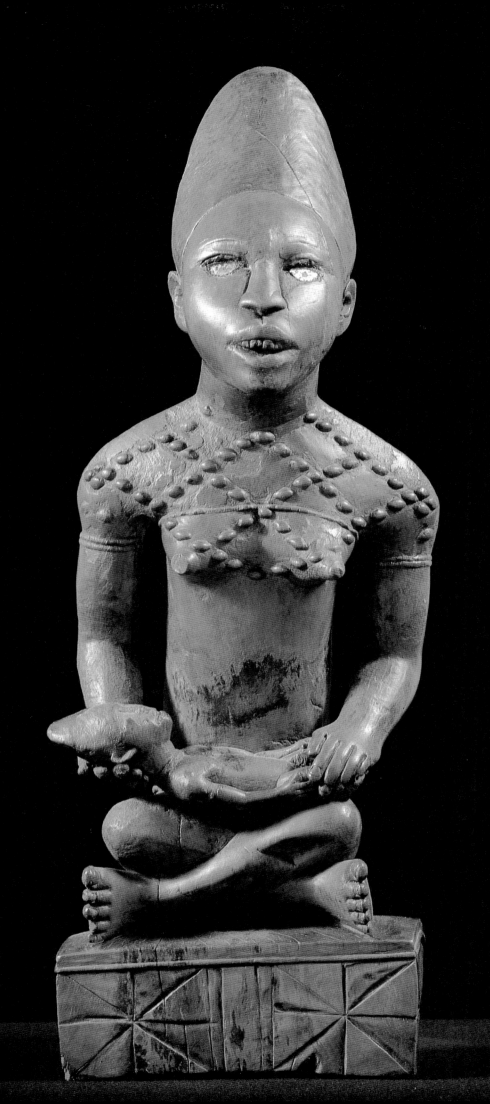

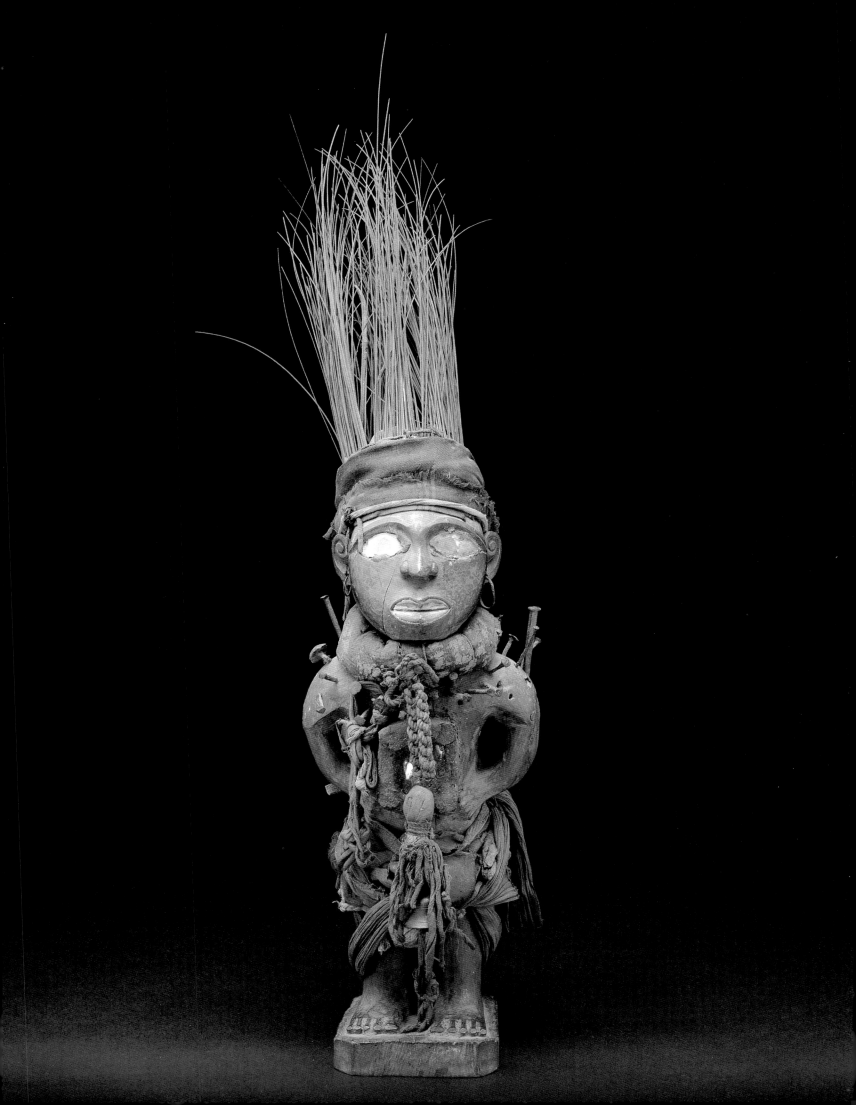

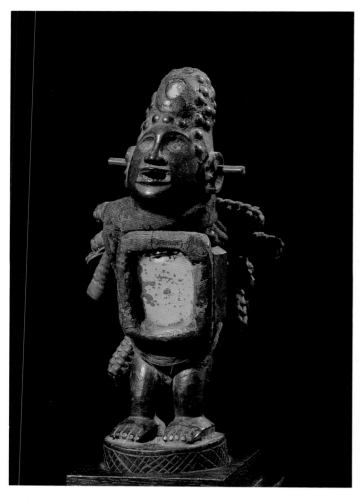

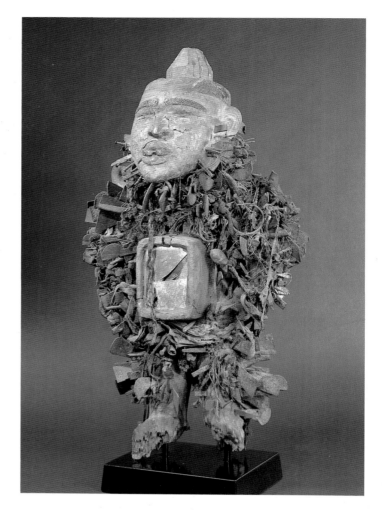

Cat. 127 POWER FIGURE, LATE 19TH-EARLY 20TH C., UNKNOWN
KONGO ARTIST (ZAIRE), WOOD, QUILLS, RESIN, MIRROR, NAILS,
IRON, BELLS, FIBER, COTTON, AND PIGMENT, H. 72.2 CM.
COLLECTION: THE JUSTIN AND ELIZABETH LANG COLLECTION OF
AFRICAN ART, THE AGNES ETHERINGTON ART CENTRE, QUEEN'S
UNIVERSITY, KINGSTON, CANADA.

Cat. 128 POWER FIGURE, LATE 19TH-EARLY 20TH C., UNKNOWN
KONGO ARTIST (ZAIRE), WOOD, GLASS, BEADS, BRASS TACKS, AND
CLOTH, H. 27.2 CM. COLLECTION: THE RENEE AND CHAIM GROSS
FOUNDATION.

Cat. 129 POWER FIGURE, LATE 19TH-EARLY 20TH C., UNKNOWN
KONGO ARTIST (ZAIRE), WOOD, METAL, CLOTH, AND MIRROR, H. 70
CM. COLLECTION: MR. AND MRS. ARMAND ARMAN.

Cat. 130 KNEELING FEMALE FIGURE, LATE 19TH-EARLY 20TH
C., UNKNOWN VILI ARTIST (REP. OF CONGO), WOOD AND GLASS,
H. 17.8 CM. COLLECTION: SAUL AND MARSHA STANOFF.

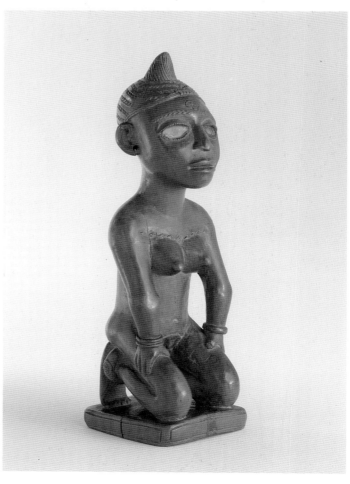

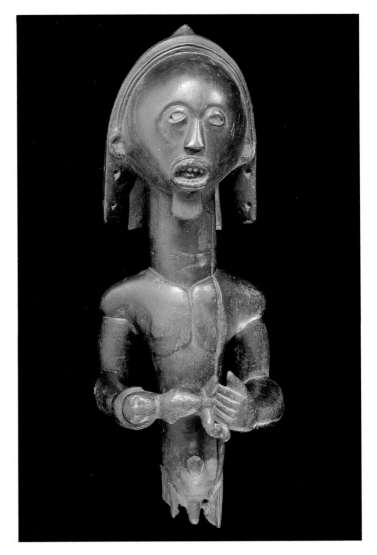

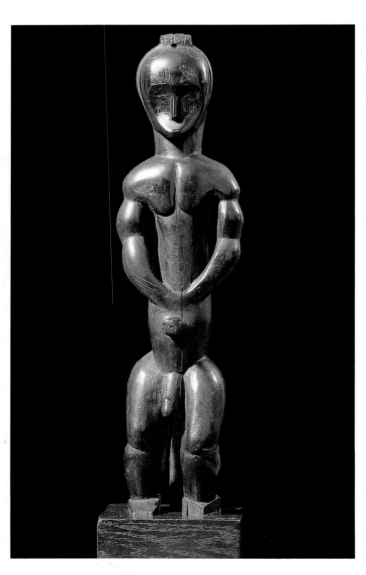

Cat. 131 **MALE RELIQUARY GUARDIAN,** LATE 19TH-EARLY 20TH C., UNKNOWN FANG ARTIST (GABON), WOOD, H. 55.7 CM. COLLECTION: THE RENEE AND CHAIM GROSS FOUNDATION.

Cat. 132 **MALE RELIQUARY GUARDIAN,** BEFORE 1900, UNKNOWN FANG ARTIST (GABON), WOOD, H. 58 CM. COLLECTION: PEABODY MUSEUM OF ARCHAEOLOGY AND ETHNOLOGY, HARVARD UNIVERSITY.

Cat. 133 **FEMALE RELIQUARY GUARDIAN,** BEFORE 1900, UNKNOWN FANG ARTIST (GABON), WOOD, H. 51 CM. COLLECTION: PEABODY MUSEUM OF ARCHAEOLOGY AND ETHNOLOGY, HARVARD UNIVERSITY.

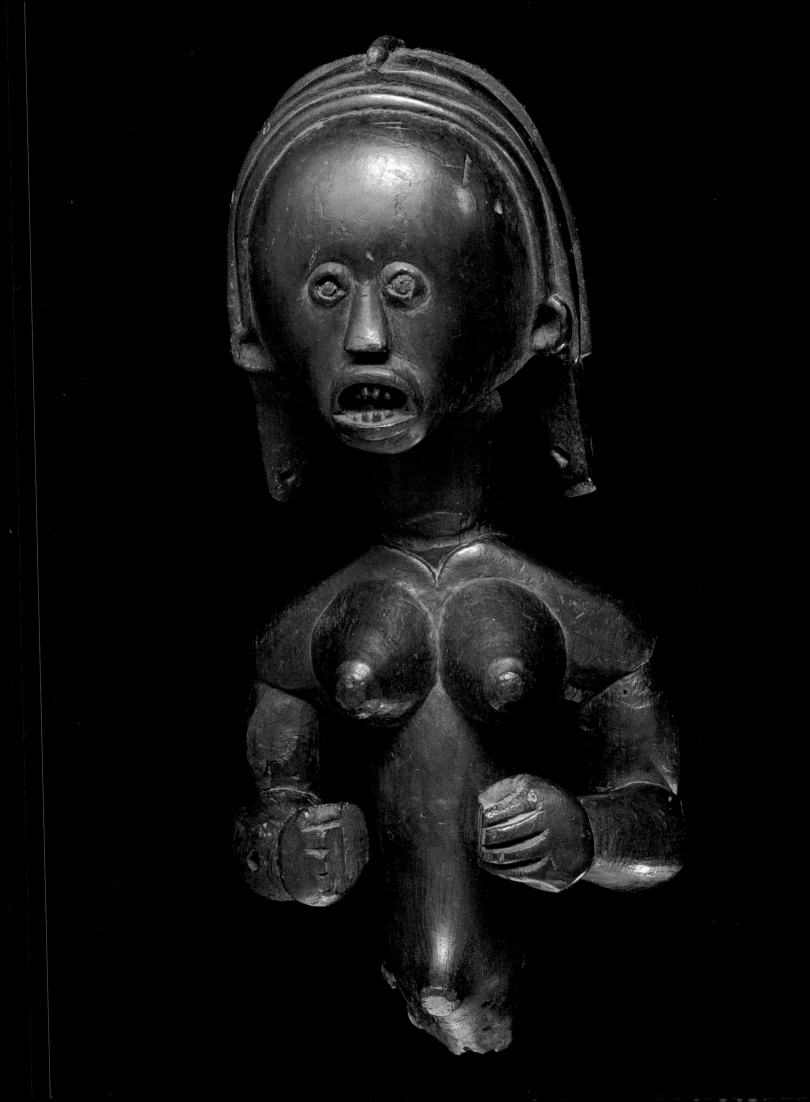

THE SELFHOOD OF THE OTHER

Reflections of a Westerner on the Occasion of an Exhibition of Contemporary Art from Africa

Thomas McEvilley

Plato says somewhere that if you're shipwrecked and washed up on a beach, and you see drawings in the sand showing that people have been studying geometry, you know you're all right: you've landed in civilization.

Carl Trahman, classics professor, remarked in 1966 that if you go somewhere to give a talk, and you sit down to dinner and see that they've put marshmallows in the salad, you know that at last you've arrived in the realm of the other.

Modernism

At the heart of Modernism was a myth of history that was designed to justify colonialism through an idea of progress. The West, as self-appointed vanguard, was to lead the rest of the world, forcefully if necessary, toward a hypothetical utopian future—a great deal of wealth changing hands along the way. The passing of Modernism means the passing of the mentality of the colonial era, and especially of the view of history that was its cover story. "Post-Modern," "post-historical," and "postcolonialist," therefore, are more or less synonymous terms.

In the discourse about contemporary art the term "post-Modern" is often used to describe certain formal developments and aesthetic shifts, without reference to the larger sphere of political, social, and economic history. But the view of art history that is passing, with its teleological emphasis on linear se-

quences of formal change, was merely an aspect of the Modernist myth that justified colonialism. Stated very briefly: Modern art, with its imperative of formal evolution—and above all abstract art, with the claim that it transcended social forces—was an emblem of the master-soul of Euro-Modernism; it provided an exemplary array of evolutionlike developments that were taken to guarantee that history was indeed engaged, under Western leadership, in an adventure of progress.

Post-Modernism in the visual arts is part of the global project of cultural decolonialization. It involves (among other things) an attempt on the part of Western people to get beyond strictly European ideas of aesthetics and its history—ideas heretofore integral to their sense of identity. The project has many dangers, among them what Kumkum Sangari has referred to as "an institutionalized 'third-worldism' . . . [that makes] an attempt to re-annex the colonial subject . . . through the application of recent de-essentializing critical theories pitted against bourgeois, colonial, Enlightenment value systems" (Sangari 1989:4).

Objects

In the colonial period, objects made in non-Western cultures were brought back to the West not just as booty but as evidence. They were understood, at however mute a level, as proof of the superiority of the colonialists—that was the point of calling the colonialized cultures

Fig. 1. The work of Zairian artist Cheri Samba was seen in the landmark exhibition "*Magiciens de la terre*" at the Centre Pompidou, Paris, in 1989. This was the first major exhibition to show contemporary Western art alongside contemporary art from Africa, Oceania, and elsewhere, with an attempt to eliminate projected feelings of hierarchy and centrality. The exhibition, in other words, was a post-Modern attempt at correcting the attitudes that led to colonialism—an attempt to arrive at a post-colonialist, rather than a neocolonialist, exhibition strategy. Samba's work in the exhibition was very popular, and he has since shown in galleries in New York, Paris, and other Western art capitals. He has become, in short, a symbolic figure in the experimental opening of the Western art world. Photo: courtesy Jean-Marc Patras Galerie, Paris.

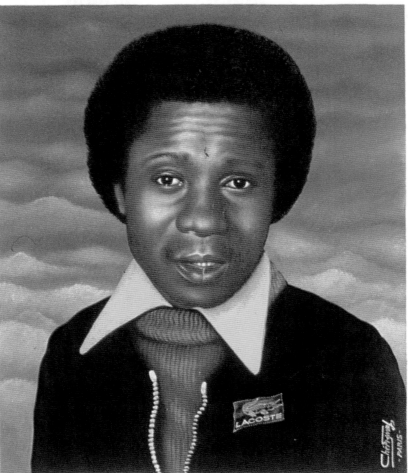

CHERI SAMBA

"primitive." How their objects were treated upon arrival reflected the shifting valuation of the other in the West.

First, the colonialized peoples were regarded as somehow less than human. The sixteenth-century conquistadors, encountering the native peoples of the New World, saw them as without souls—that is, as nonparticipants in the advance of providence and in the Christian doctrine of death, judgment, Heaven, and Hell. They were creatures on the level of, say, parrots, which could be eaten, kept as pets, taught language, or plucked for their feathers. This mode of dealing with other cultures is very ancient. Aristotle, for example, suggested that the Scythians were not human, though they looked like humans. African groups commonly thought

that the first white colonizers were not human either. The European-colonial myth of the nonhumanness of conquered peoples was supported by the claim that these people were outside history—history being the white way of organizing the narrative of communal memory. Their ahistoricity in turn was demonstrated by, among other things, their supposedly unchanging art—its eternal or Edenic stasis negating the dynamic onrush of events among historical peoples.[1] Examples of this preternatural art that found their way to the West were kept alongside elephant tusks and peacock feathers in "curio rooms." They were parts not of culture but of nature; and the project of colonialization would supposedly shift their makers from nature to culture.

Later on in the colonial process

the conquered peoples gradually came to be seen as human after all. At this point their objects began to have a double significance in Western ways of dealing. On the one hand, these things now seemed to be art, the emblem of the soul, and hence to indicate the humanity of their makers. On the other, this art was still perceived as ahistorical, demonstrating that colonial cultures, to be brought into history, still had to stay under the wing of Western tutors. Now the objects were transported from curio rooms to museums, at first of ethnography, then of art.

At about this stage of the process—the early years of the twentieth century—"our" (meaning white Western) artists started making objects like those of "their" (meaning non-white, non-Western) artists.

Fig. 2. Lothar Baumgarten, a German artist, spent six months living among the Yanomami in the Amazon basin. While there, Baumgarten adopted, as far as possible, the Yanomami mode of dress and life-style. Subsequently his artwork has involved references to this experience and materials from the region. The picture shows his feet covered, in the tribal fashion, in red pigment, which Baumgarten brought back with him. Baumgarten's work has involved a ground-breaking attempt to use art as a means of opening communication between cultures. It also suggests a sense of exhaustion in Western ideas of cultural identity, and a desire to incorporate an invigorating otherness. Photo: courtesy the artist.

Fig. 3. The work of Bhikash Bhattacharjee, an Indian painter who lives in Calcutta, is deeply involved with issues surrounding the opening of Indian culture to outside influences. His adoption of Western art materials (oil on canvas) and styles of representation is unambiguous, but his subject matter reveals much ambivalence. *In His Office*, 1981, portrays a new type of Indian, the Westernized businessman who seeks to exploit the wave of the future. It implies that positions of wealth and power in Indian society increasingly fall to those who have most fully capitulated to Western ways. The curtain behind the figure, however, suggests that the unknown future lying in wait for India may contain surprises unforeseeable by the supposedly authoritative figure in the foreground. Bhattacharjee's work is often hopeful about the future of a changed India, but it also expresses anxiety over what is being lost. Photo: courtesy the artist.

These objects, in fact, were the basis of what we call Modern art.[2] That passage of influence reflected an alteration in our habit, but not a sufficiently large one to make "them" seem Modern in "our" regard. For that, another reversal was needed: the moment when the colonialized peoples started making objects like ours would indicate that they had been drawn into history—that they had orphically remembered the true meaning of their identity as human. At that moment the West would begin to call their art "contemporary," a term that does not apply to ahistorical or timeless things, and that previously had been accorded primarily to objects made in Paris or New York.

Geometry or Marshmallows?

When one culture looks at the objects of another, those objects are instantly incorporated into an alien mental framework. Helplessly, they are interpreted through some habit of thought different from the habit of their makers. To regard this as a negative outcome, as a rape of the object or a violation of its essence, is to imply that an artifact, as a thing made by a human, is as ethnically particular as its human maker, and that its ethnicity is contained in it like a kind of soul. The system of

thought of the maker is felt to be alertly present in the object in such a way that the object is abused by regarding it through some other system of thought. Here fetishism and the expression theory of art merge.[3]

Similarly, to see an object in another place than that in which and for which it was made is to see it surrounded with questions: how and why did it get to that new place? Was it stolen by some imperial force? Is its itinerary a record of economic exploitation or violent abuse? The Zuni and some other non-European peoples have sought the return of their objects from Western museums of art and ethnography, on the grounds that the objects' specificity is perturbed by placing them in an alien cultural environment. The government of Greece has long sought the return of the Elgin Marbles from the British Museum in London, again implying that objects are tied to the places of their facture. Yet it is unlikely that a Western European country would seek the return of, say, an old master painting from Japan, or from elsewhere in the non-Western world. Power relationships govern these (as other) feelings. The dissemination of Western cultural objects into non-Western

cultures is seen as an assertion of Western power and influence in a kind of proselytizing mission. But the confinement of non-Western objects in Western museums is seen in quite an opposite way, as a sign of the bondage of this other culture to Western power, of the appropriation of its wealth and indeed its identity by an alien force.

"The Animals"

An emic or culturally inherited world view, in its ideal state, would be that of the members of a cultural group who had no knowledge whatever of other cultural groups and who believed that their own styles of cognition were all that existed—that they were, in effect, the natural and absolute ways of being and knowing. The Witoto, a people of the Amazonian basin currently numbering about 3,000, have traditionally referred to themselves as "the People of the Center of the World," and to other groups as "the People of the Animals"—a distinction parallel to the European one between culture and nature.[4] Any culture that has not relativized its own inherited attitudes by acknowledging the attitudes of other groups is emic. Into such a culture comes the Western anthropologist. Like a god viewing many warring groups from on high, he is aware that there are various approaches to the meanings of things, and he sees the Witoto approach as just one among many. His approach is called etic, meaning that it transcends the level of the emic by a cognitive meta-step.[5]

Western science is widely regarded as possessing the strongest claim at present to an etic position—partly because of its proven effectiveness at intervening in nature, but perhaps also because of a residual persuasiveness in the Modernist myth. The claim of science exerts strong appeal in what Badri Raina has called the "transnational countryside" of the third world (Raina 1989:96). It is expressed, for example, in Sangari's dread of reversion to the emic: "The question which insistently arises . . . is that if we refuse to grant total interpretative value to linear, western, cognitive modes, then what options do we have apart from reactive indigenisms" (Sangari 1989:4).

The elevation of the Western scientist to the role of transcendent arbiter, however, seems possibly only another emic approach, perhaps as un-self-critically projected outward as the world view of the Witoto. The record of anthropological accounts, for example, often shows an entrenched complacency of cultural attitude not altogether different from the conquistadors'. A more genuinely etic attitude might emerge if scientists had relativized their own position as well. (But would that be an attitude or a nonattitude?)

Soul-Vendors

To an etic culture it seems reasonable, even normal, to make goods destined for sale in foreign markets. But to a traditional emic mentality there may be something shocking about making goods for other cultures than one's own. There is indeed something almost impossible about it, because it involves making objects that one does not understand—an alienation of one's labor from one's soul. (My red-and-black-checked flannel jacket with the label "Lumberjack" inside the collar was made in Bangladesh.) Is it one's intention, one's power—one's soul, as it were—that one sends overseas for alien exchange? Does this represent a willful sellout by the native maker to a foreign power? Or an ambiguous confusion and merging of souls into some new and possibly horrible entity?

Jean-Paul Sartre, in his introduction to Frantz Fanon's *The Wretched of the Earth*, wrote of the first members of a conquered culture to adopt the ways of the conquerors (Fanon 1983:7). He saw them as essentially lost beings, who have sold their souls and those of their natural fellows and have in consequence become blanks, soulless, neither one thing nor another. They have betrayed the whole project of identity. But this feeling seems to assume the integrity of the colonized individual before the colonialist overlay has affected his or her livelihood and, hence, personality. It seems a wishful Edenic myth of cultural purity to believe that humans were once psychologically and socially whole, and that it is culture-mixing that destroys this wholeness and creates monsters. Does this then mean that culture-mixing is impossible, or inevitably destructive, and that it can never produce healthy results? There is something misbegotten and puritanical here, like an insistence on ethnic purity.

Sartre's detestation for the colonialized servant's betrayal of his or her race implies that all cultural influence from outside should be rejected or resisted. The popular 1980 movie *The Gods Must Be Crazy* shows a "native" African community rejecting a Coca-Cola bottle (representing "Coca-colonialism," or cultural neocolonialism) the way a living body may reject a surgical implant. The motif relates to the utopian and puritanical idea of returning all objects to their original places. It represents a desire to freeze the world, and to prevent all change in it—ultimately a desire to maintain the emic point of view forever.

This attitude, with its hidden essentialism, assumes something like the Hegelian idea that each culture has a nature or essence. In the metaphysical puritanism of Modernism, to compromise a thing's essence seems perhaps worse than to destroy the thing outright: it is to make it into something that ideologically annihilates it while simultaneously taking over its being. The intrusive force activates the thing's survival in such a way as to betray it at every moment it survives. Its existence is based on a continuing betrayal of its reason for existing. The desire to return objects to their originary places implies that an artifact has an essence that reflects its maker's ethnicity. Since essences do not change, any significant culture-mixing is impossible or, even worse, hideous.

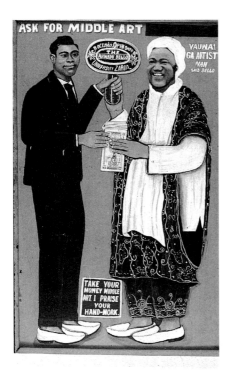

Fig. 4. Middle Art, a Nigerian artist, ad-
dresses issues in the painting *Take your
money Middle Art. I praise your hand-work*
(1962) that are related to those raised by
Cheri Samba in *Pourquoi un contrat?* (Why
a contract?; cat. 81). In that work, Samba
seems to express anxieties about his situa-
tion, which at the same time he seeks to
justify. Middle Art, like Samba, is taking
money for his work, but he is taking it from
an African. Like Samba, he shows himself in
the Western-style garb that has long been
standard in urban Africa, but unlike Samba,
who is pulled in conflicting directions, he
gains an unambiguous African validation
from the traditionally dressed official who
pays him. Photo: courtesy Bildnachweis,
Übersee-Museum, Bremen.

Monster Mash

The servant whom Sartre denounces
is apparently a kind of monster, in
the Greek mythological sense of a
being with the traits of two or more
species at once: a human collage or
pastiche. The point that Sartre may
have missed, viewing these things
from the heart of late Modernism,
is that the process of change works
through such monstrosity: a being
containing part of one era and part
of another at the same time is a
being moving into the future, like
Zeno's arrow occupying two places
at once in its flight. Cultural change
occurs through the interposition of
pastiche, and the ontology of mon-
strosity, collage, and pastiche is ab-
solutely characteristic of the post-
Modern or postcolonial project.
Western artworks by Picasso incor-
porating elements of African or
Oceanic art are pastiche monsters;
so are Indian artworks by Tyeb
Mehta that incorporate elements of
Matisse, and African artworks by
Iba N'Diaye incorporating School
of Paris painterliness. The fecun-
dity of these new hybrid species
offers a cross-fertilization from
which a challenging future might
grow.

The Siren Song

An infrequently asked question is
why one culture would want the
objects of another in the first place.
In some cases, of course, the im-
ported objects may be more efficient
for a practical purpose—say the
advantages of iron over bronze.
Otherwise, a conqueror may wish
to display booty as a sign of con-
quest, or a colonial may see the
objects of the ruling class as status
symbols. Sometimes the desire for
alien objects comes because people
are sick of their own culture and
want a hole through its shell into an
outside. In these cases, the desire
for contact with an alien culture is a
desire for an exotic otherness that
one feels as a new identity. To the
disaffiliated member of a culture,
possessing the alien object is like a
talisman of promised freedom, like
possessing another soul, or a chan-

nel to one (somewhat as the Latin
poet Ennius remarked that he had
three souls because he spoke three
languages). Through appreciating
objects from an alien culture one
may discover the relativity of one's
own inherited tastes. In an emic
situation it is natural to think that
one's taste is inborn and universal.
Only after etic relativizations does
it become clear that taste cannot be
inborn, because judgments of qual-
ity change.

Thus the dialogue that takes place
when goods travel back and forth is
complex. At first, it is often a dia-
logue of exploiter and exploited:
beads are traded for gold. Later it
becomes more two-directional: re-
frigerators for gold. Then popular
imagery spreads, usually from the
center of greater wealth: Coca-
colonialism, Marlboro ads, Marilyn,
Elvis. Finally high imagery flows:
our high art and theirs mutually
merge, in a series of uneven steps.
If one understands art as an expres-
sion of the identity of a culture,
then the artwork might be seen as
an embodiment of the culture's soul.
When different arts flow into one
another it is as if the souls of cul-
tures were merging. The merging
of Sumerian and Egyptian icons in
ancient Near Eastern cultures sub-
ject to influence from both, the
merging of Greek sculptural forms
into Indian Buddhism, the back-
and-forth influences between post-
war American and Japanese cul-
tures— these are examples of that
process.

A Question

This dialogue of objects is a chan-
nel for a type of communication
that was missing in the colonial
period and in the generation or two
of its aftermath. In that era, even
ethnographic writing, for all its in-
tentions of neutrality and objectiv-
ity, was generally uni-ocular: the
gaze went all one way. *We* repre-
sented *them* through *our* ways of
representation. What resulted was
often either Western discourse ap-
plied blindly outside its sphere of
relevance, or, in perhaps the most

sensitive cases, what Clifford Geertz has called "haunted reflections on Otherness" (Geertz 1988:16). James Clifford has written of the need for ethnographic discourse to become a dialogue in which the identities of both observer and observed are in question—that is, in which each party is open to influence, to being changed inwardly, by the other—as opposed to "discourses that portray the cultural realities of other peoples without placing their own reality in jeopardy" (Clifford 1983:133). Will the long-insular world of Western contemporary art receive contemporary art from previously colonialized cultures with such openness? At least the development of such dialogue is finding, after long drought, some advocates among white representatives of Western institutions.

It is a difficult task to find ways into this project, with the cloud of colonial history still lying so dark and heavy over attempts at communication. One exploration is Robert Farris Thompson's study of the responses of African artists to reproductions of Cubist paintings. Another is the present exhibition of contemporary art from Africa, which proposes a dialogue not only of objects but of their makers. These African works come to us in the West carrying within them memories of works of ours that went out to them some years ago, works that themselves carried memories of African works from a yet earlier passage. Insofar as art is an expression of cultural identity, this work critiques our identity through the conflation of elements of us with elements of them. Both the art traditions involved in the dialogue will be abused in the process, torn out of their intended limits, out of their sense of themselves as they thought they knew themselves to be. Both will be used in misconceived or other-conceived juxtapositions that will mock their initial intentions. As art is the symbol of the self, the self will be symbolically torn and distorted in this exchange, made a monstrous pastiche again.

Yet in the articulation of their difference, a sameness emerges too from their conflation in one new monstrous being.

Tell Them about Globalism

In the Modernist period, if a third world artist wanted to become Modern, or international, he or she simply began painting like a member of the School of Paris. This was more or less the course undertaken by the Bombay Progressives, for example, in 1947. Abstract art in the Western Modernist styles became, especially under the force of postwar American hegemony, a signifier for Western culture's claim to universal validity. Perhaps this is why it is still under a special taint of colonial submissiveness in much of the third world, except in such cases as the neotantric abstraction of India, where it attaches itself to native tradition. Post-Modern globalism is less alchemic in its ideology than Modernist internationalism was. Instead of attempting to melt divergent things down into a Prime Matter of School of Paris or New York School homogenization, the post-Modern project is rather to focus one's particularity with as much clarity, wholeness, integrity, and intensity as one can, while still finding a way to inject it into the international discourse: a way, in effect, to make it useful to others, to make it readable or relevant to receptors of other ethnicities. In the process all values—identity, artistic quality, cognitive stance—are reshuffled in a shifting and insubstantial relativization in which all the cards become wild.

Cognitive Baptism

The philosopher Richard Rorty writes, "The desire for a theory of knowledge is a desire to find 'foundations' to which one might cling, frameworks beyond which one must not stray, objects which impose themselves, representations which cannot be gainsaid" (Rorty 1979: 325). Thus a theory of knowledge is apt to be innately imperialistic: it asserts the authority of one's own

representations over those of others. "Philosophy's eternal concern," Rorty argues, "is to be a general theory of representations, a theory which will divide culture up into the areas which represent reality well, those which represent it less well, and those which do not represent it at all (despite their pretence of doing so)" (Rorty 1979:3). A theory of knowledge, then, is a means of making a quality judgment about the truth value of a proposition. And any such judgment extends by implication beyond its stated domain: propositions conflicting with a proposition judged truthful, for example, are apt to receive a contrary judgment. So a value judgment made by a member of a certain group, a group defined by a certain commitment, whether national, religious, or other, is never simply inclusive, but also exclusive. It implies a negative valuation of all groups or individuals whose commitments conflict with it.

In the sixteenth and seventeenth centuries the conquest of non-Western peoples by European armies was justified by Christianity, which posited the mission of baptizing the heathen in order to save them from eternal damnation. (Like Aristotle's denial of the humanness of Scythians, this justification for foreign conquest is very ancient; it goes back to Zoroastrian arguments in support of the Persian Empire in the sixth century B.C.) This archaic reasoning lost plausibility with the secularization of Europe in the eighteenth century but was soon replaced by another, articulated most fully and systematically in Kant's critiques. There one finds the doctrine of the three faculties, the cognitive, the ethical, and the aesthetic, that are said to make up the human as a receptor and processor of information, and the all-important insistence that they have nothing to do with one another. None of them, according to Kant, can confirm or reject the judgments of another. Like senses, each has its proper sphere, in which its judgments are a court of last resort. As one cannot hear

the color red, so one cannot cognitively determine whether an ethical or aesthetic judgment has been properly made, and so on.

Socially, the function of this doctrine was to elevate European judgment-making over the judgment-making practices of other cultures. Without a clear epistemological grounding, one culture cannot claim to be more advanced than another—since how could one tell? In order to assure that European culture was superior to those it conquered, and that it thus had not only the right but the responsibility of conquering them, it was necessary to argue that European judgments were superior to those of other cultures. Kant's description of the three faculties on the lines of the senses was designed to make each exercise of them as direct and incontrovertible as a judgment of one of the senses. Skeptical epistemologists have opined that the only indubitable statements are those to such effects as "I feel cold," or "I seem to see the color red" (Ayer 1977:54-56). No argument or testimony can refute such statements as long as they are sincerely made. Kant, with his recognition of the inaccessibility of the thing in itself, nevertheless tried to fashion a theory of knowledge that would let our apprehensions get as close to it as possible, and fashioned this theory on the model of such sense-based statements. On the basis of Kantian epistemology, Western philosophers developed a feeling that their cognitions were the best that could be attained with human apparatus. This assurance spread complacently through society and was tacitly supportive of the violent progress of nineteenth- and twentieth-century imperialisms.

Kant's theory of knowledge, then, must and does implicitly reject the cognitions of non-Western cultures. The Western judgment on art, for example, was said to be exclusively aesthetic, when properly exercised, with no clouding admixture of social or cognitive concerns. In contrast, the members of traditional societies, in which art is said to exist only in the matrix of religion and communal rite, were thought to experience the aesthetic along with the social and the cognitive. In terms of Kantian theory this was a confused way of receiving artistic experience. This sense of the inadequacy of the perceptions and cognitions of non-Western peoples was akin to the Christian view of their soullessness, and to the view expressed by Hegel that Oriental cultures are "for the most part really unhistorical"—that is, outside the story of the human (Hegel 1956: 106). Yet in Western post-Modernism of the last decade or two, the tripartite approach to art prevalent in pre-Modern cultures, with aesthetic, social, and cognitive elements conflated and interpenetrated, has returned.

Knowledges

One would think that a postcolonial attitude must admit different theories of knowledge. And by admitting a variety of theories of knowledge, one is bound to admit some that imply the falsity of one's own inherited assumptions. One is bound, in other words, to betray one's own specific ethnic inheritance in the attempt to open oneself to the reality of others—"to try to do away with my own presence," as Todorov says, "'for the other's sake'" (Clifford and Marcus 1986: 201). Thus the Western would-be decolonialist enters the same realm of monstrosity inhabited by Sartre's complicit colonial.

Acknowledging a variety of conflicting theories as equal approaches to reality of course distances any attempt at certainty in an objective or universal scale. One gives up truth and its security of self, the very values for which a theory of knowledge was wanted in the first place, and accepts that all such matters are simply parts of what Michel Foucault called the game of truth and falsity (Foucault 1980). So in attempting to get into a post-colonialist (as opposed to neocolonialist) frame of mind, both the European and the African must develop a mental shape-changing ability with which to switch value frameworks and cognitive frameworks at will.

There are common cognitive acts that parallel this. Suppose, for example, that one is presented with a sheet of paper with marks on it, and then questioned about its quality. One will first have to know what the sheet of paper is intended to be, and to be aware of how one's evaluation of it switches with its own shifts of identity. If it is a poem, let's say, it may seem very bad, while as a cartoon it may be very good; if it is regarded as a drawing in the high-art sense it may seem mediocre, as a map abominable, and so on. Similarly a post-Modern epistemology involves a constantly shifting sense of identity such that one could say, If I were a French aristocrat it might be great; a Zulu, no good; an ancient Egyptian, run of the mill; an American entrepreneur, simply boring, and so on. Thus the etic is not a single attitude elevated above others but a compendium of many emicnesses. And who or what is one really, in the midst of this unanchored or rudderless sailing on cognitive seas? This one does not know yet.

Representations

A part of the epistemological imperialism that sustained economic imperialism was the assumption that Western modes of representing, both visual and other, were superior, that is, more objective or true to nature, than those of non-Western cultures. This would seem a simple emic assumption. As the naturalness of the inherited world view seems apparent in the emic situation, so does the naturalness of the inherited representations, visual and verbal, that embody that view. But can there be convincing arguments, other than the emic infatuation with one's own inherited ways, for the objectivity of one mode of representation over another? One Western artist concerned with this issue,

Fig. 5. Fern Shaffer, an American performance artist, in a work of 1986 conceived in collaboration with Othello Anderson. Shaffer operates the Artemisia Gallery in Chicago, a gallery devoted exclusively to the works of women artists. Her work, like Kim Jones's (fig. 6), involves evocations of non-Western or non-Modern identities in a generalized or archetypal way and tends to feature an earth mother or fertility-goddess motif and thus to involve a nostalgia for stages of human development that Modernism has tended to eradicate. The work prominently features concern over the ecology, and expresses a willingness to jettison contemporary Western cultural modes for its sake. Photo: courtesy Fern Shaffer/Othello Anderson.

Fig. 6. Kim Jones, an American performance artist, is shown here in his performance persona of Mud Man. In Jones's neoprimitivist performances he appears, usually unannounced and in public (as in this picture, taken on West Broadway, New York, in 1985), in ordinary Western attire, and proceeds to alter his identity. Undressing, he covers his body with mud and straw. Next he shoulders an apparatus of sticks, which, though it is not based in a direct or scholarly way on any particular non-Western model, embodies for Jones the general archetype of the pre-Modern, with its associated ideas of closeness to the earth and lack of specific definition. The Mud Man persona signifies the prime matter or potentiality from which a new idea of humanity may emerge for the future. His face blanked out by a stocking mask, he stands silently like a reminder, in the midst of Western urban life, of other, unspecified cultural options. Photo: Thomas McEvilley.

Leonardo da Vinci, is said to have used a mirror to ascertain the accuracy of a drawing. Situating the mirror in relation to a still life or figure so it presented him with the same view that he was attempting to draw or paint, he would check to see if such and such a line exited the rectangle of the picture at the same point at which it exited the rectangle of the mirror, and so on. Greek sculptors sometimes employed measuring devices; checking the thickness of an object with calipers, they would make the representation of it the same width. The French artist Yves Klein exhibited body casts of his subjects. There would seem to be, in such methods, some basis to claim the objectivity of the representation—but that does not amount to certainty in the subjective realm. If you say, "This portrait doesn't look like that person to me," then, as with the statement "I feel cold," there is no argument or test that can refute you.

The Modernist assumption that our representations were true to nature, and others' were not, suggested that other peoples were not seeing nature clearly. This reinforced epistemological skepticism about the value of their cognitions. Clearly, it seemed, other peoples were trying to see nature objectively, that is,

the way we did, and we would be doing them a big favor by helping them out. To do this, however, we had to convince them that their own representations were false and shameful. We had to try to turn them against their own ethnicity —that is, to a degree, against themselves. That was the Modernist way. In the post-Modern project of relativization, however, it is not only the others but ourselves who are subverted.

Selves

To enter a dialogue in which one's own world view is on the line, to jettison one's inherited role in the game of truth and falsity, is to give up one's patrimony in the world, which is to say one's selfhood. Insofar as the self is ethnically constituted, the project of fetishizing difference in one's own person is like changing one's unconscious mind. "Ethnicity," as Michael Fischer has written, ". . . is often something quite puzzling to the individual, something over which he or she lacks control." It may reveal itself with "a sense of the buried coming to the surface, and the compulsion of an 'id-like' force." And yet, at the same time, it "is something reinvented and reinterpreted in each generation by each individual," and

Fig. 7. T. F. Chen's *Competition*, a painting of 1978, illustrates the idea of post-Modern pastiche while also making some comments on it. Chen, a Chinese artist resident in New York, shows a female figure derived from Ingres and Titian being serenaded and wooed by a traditional Japanese image and a Western Modernist image. The scenario suggests that one or another will win out, and may seem to allude to Japanese and American economic competition. But at the same time its deliberately blatant mix of images and styles from different periods and cultures indicates the cultural relativism and egalitarianism of the era after the decline of the hierarchical Modernist ideology. Photo: courtesy the artist.

hence is to a degree malleable (Clifford and Marcus 1986:195-196).

One of the common social functions of art has been its role in shaping and sustaining the sense of identity (and hence in changing it). Art presents a set of communally generated and communally received objects that invite a bonding of communal identification around the shared reception of their meaning. Its long association with totemic representation illustrates its function of sustaining a highly focused sense of identity. Yet as an instrument of persuasion, art has the ability to sever as well as to bond, and to rebond in new associations of pastiche.

Sartre's idea of the monstrosity of the converted colonial assumes the existence of an integral self that should not be invaded and remade, should not be violated, by another self. But isn't it perhaps better— more realistic—to be unsure who you are? The Zairian idea of "authenticity" (like the "negritude" idea from Senegal, and other phenomena of postcolonial recovery of balance) expresses an insistence on the self and its endurance. Meanwhile the post-Modern emphasis on the decentering of the self implies an affirmation of cultural pastiche, the self diffused through all

cultures as once the self of the Sorcerer of Trois Frères, portrayed on a Magdalenian cavern wall some 20,000 years ago, diffused itself through all nature, assuming at once the attributes of bird, bear, feline, and horned beast.

Invisible?

"How do we explain the total ignorance about the achievement of non-European artists in the West? Why are they invisible?" asks Rasheed Araeen (1989: 12-13). A theoretical answer based on Hegel might be, Because they're nature, not culture. This part of the Modernist ideology of world mastery is not unlike the Witotos' declaration that all other human groups are the People of the Animals, and it is one of the colonialist dichotomies that is changing most radically in the post-Modern turn. Fredric Jameson defines late capitalism—that is, the age when Modernism gives way to post-Modernism—as the moment when "the last vestiges of Nature which survived on into classical capitalism are at last eliminated: namely the third world and the unconscious" (Foster 1983:207). With ethnicity—a reality somewhere between the personal and the universal—replacing the personal and communal unconsciouses as the upsurging element of surprised self-recognition, the distinction between nature and culture is going fast too. (That distinction, which goes back to the Greek Sophists as a part of the cover story for an earlier colonial period, was based on the assumption that culture could be controlled, nature not; now that situation seems directly reversed.)

In Hegelian terms, when members of non-Western cultures begin to adopt Western styles they are ceasing to be nature and becoming culture. But by the same token, as they become more, supposedly, like us, they become not more controllable but less so. Their situation and ours are both changing out of control. And the search for the other, then, is a search for the newness of one's changing self.

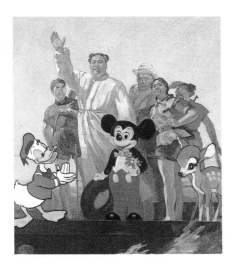

Fig. 8. Alexander Kosolapov is a Russian artist whose works have been dedicated to post-Modern satire of Modernist seriousness, and to the idea of the future as a truly global pluralism. Expressing the era of *glasnost* and *perestroika*, he has, in *Steamboat Mao* (1985), conflated first- and second-world images with a careful sense of indiscriminacy. High and low culture, East and West, mingle comfortably. The apocalyptic tone of this image indicates the idea that a new age of history is at hand, while the ironic distance from that message implicitly denounces it as a residue of Modernist feeling. Photo: courtesy the artist.

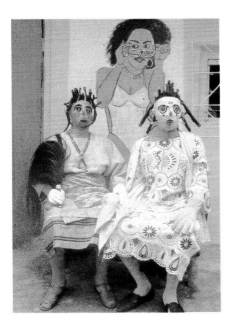

Fig. 9. A street scene from Ilishan, Nigeria in the 1980s. Two traditional Yoruba masqueraders representing the dead appear to be resting during a ritual, or perhaps waiting for it to begin, and have sat down in front of a bar. The picture advertising the bar shows quite another type of African woman, one who has adopted Western ways of deportment, dress and hairstyle. Such Westernisms seem to be attaining something like etic status, at least for the moment, in African capitals. Photo: Marilyn Houlberg.

Talkin' 'bout Us

"The cultures of world peoples need to be constantly rediscovered," write George Marcus and Michael Fischer, "as these peoples reinvent them in changing historical circumstances" (Marcus and Fischer 1986:24). This sentence seems to refer primarily to the others, but it holds for us too, as we seek to know ourselves in the midst of an unexpected and unpredictable change. From the point of view of a Westerner with all the accumulated and interweaving karma of Christianity, imperialism, and Coca-Cola, the distinction between Modernism and post-Modernism seems deeply significant, indeed almost salvific, a feeling traditionally associated with rites of rebirth and other assertions of new selfhood. (That is the danger to the terms Modern and post-Modern—that they may imply too much; but even the numbers of the years are value saturated.) It is in part through our representations, their mergings and borrowings and adaptations, that our identities are shifted into new forms, and this is why the advent of post-Modernism in the West has been experienced prominently as a crisis in our representations.

The crisis of representation (as Marcus and Fischer have observed) is linked to the rupture of decolonialization. In the Modernist period, we in the West thought our representations were more real than others'. We were living in a dream peopled and propped by our representations. Now we wake up—or think we wake up, though we may still be in just another dream, maybe a framing dream or maybe a detail, we can't really tell yet. Anyway, seeming to awaken, we embarrassedly see that our inherited modes of representation were not more real than others' in a general sense, they were only more real to us. They were emic, and like damn fools we thought they were universal. And it was so easy to do that. To think one's representations are etic may be the most characteristic of all emic simplicities. Cut loose

from the anchors of our ignorance, we float rudderless (the rudder was that emic egotist, Modernism) on a sea of the real-without-name. And we call it post-Modernism, a name with the advantage of being a non-name, a concept shaped by negation rather than by position. (Modernism was all about position.)

But is there a nonposition that is not also a position? Is there an etic stance that is not also emic? "They stand firmly because they stand nowhere," says Subhuti, describing the bodhisattvas. We too wish to stand firmly yet stand nowhere, to act as two rather than as one, to incorporate difference into the felt sameness of existence. The crisis of representation, with its correlate of pastiche, seems to offer a mechanism for such a communal rite of passage. The danger is that the crisis of representation might be just another representation, just another device for modeling reality into manageable scale. What is crucial is to realize that, as Paul Rabinow puts it, "representations are social facts" (Clifford and Marcus 1986:234). They are not, in other words, just re-presences, but presences. They are ourselves.

NOTES

1. For a critique of the view of African art as timeless or ahistorical see Susan Vogel's first chapter in this volume.

2. See the exhibition catalogue *"Primitivism" in 20th Century Art: Affinity of the Tribal and the Modern*, ed. William Rubin (New York: The Museum of Modern Art, 1984).

3. The expression theory of art implies that the object, since it is said to express something, is actually a kind of subject, an animate being possessing preferences about what it is taken as expressing. If an artifact or art object is truly inanimate, it would seem that the projection of one thought value or another upon it would be as much a matter of indifference to the object as the way one regards a stone is to the stone.

4. I am indebted to the anthropologist Juan Echeverri for this and other information about the Witoto.

5. My use of the terms emic and etic is based on the discussion by Marvin Harris in *Cultural Materialism*.

"REPRENDRE"

Enunciations and Strategies in Contemporary African Arts

V. Y. Mudimbe

O weaving reeds, may you never be poverty stricken
May you never be taken for sale in the market
May none be ignorant of your maker
May no unworthy man ever tread on you

—Anonymous women's work song, Somalia
(K. Loughran et al. 1986:59)

Introduction

The word *reprendre*—strangely difficult to translate—I intend as an image of the contemporary activity of African art. I mean it first in the sense of taking up an interrupted tradition, not out of a desire for purity, which would testify only to the imaginations of dead ancestors, but in a way that reflects the conditions of today. Secondly, *reprendre* suggests a methical assessment, the artist's labor beginning, in effect, with an evaluation of the tools, means, and projects of art within a social context transformed by colonialism and by later currents, influences, and fashions from abroad. Finally, *reprendre* implies a pause, a meditation, a query on the meaning of the two preceding exercises.

If, however, an African artist does go through these critical phases, consciously or unconsciously, in the creation of art, viewers of the finished work, even some of the most attentive ones, may find themselves looking for traces, for strata and symbols, that might qualify the piece as part of such-and-such trend in the vague domain of "primitive art." Naive, uninformed, sometimes prejudiced, this kind of looking often involves two a priori assumptions, the first concerning the Western notion of art itself and its ambiguous extension to non-Western oeu-

vres, the second supposing the immobility, the stasis, of non-Western arts (see Price 1989). Yet against these assumptions there is a history, or more exactly there are histories, of African arts. In his *Art History in Africa* (1984), Jan Vansina convincingly analyzes the variety of the continent's artistic processes, the readjustments and transformations of methods and techniques there, the dynamics of acculturation and diffusion and their impact on creativity. Furthermore, there is no such thing today as "an" African art. Senegalese trends are different from Nigerian, Tanzanian, or Mozambican, and each is immersed in its own sociohistorical context. Even in traditional masterpieces (see, e.g., Vogel and N'Diaye 1985), the evidence of regional styles and the variety of their histories is clear.

I do not address these historical movements in this study, but try to indicate broad rhythms, tendencies, and discontinuities extending from a recent period of rupture that brought about new types of artistic imaginations. On the whole, I am interested not in causal successions but in new artistic thresholds, displacements of inspiration, and what we may call an "architectonic" system—an underlying order that

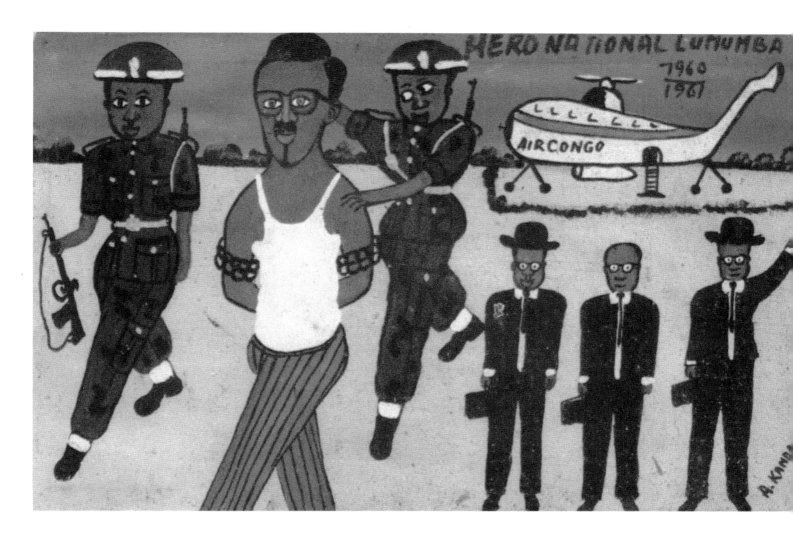

would account for some basic similarities in the amazingly diverse, complex, and conflicting regional styles. This order has led some analysts to suppose a unifying, very ancient "creative complex" in Africa. I have chosen a more sociological approach, which pays attention to history but is principally concerned with incidences of conversion, patterns of discontinuity, and conflicting or complementary influences.

I move from the radical reconversion of African arts in the colonial setting to their subsequent development. A general overview, this description is intended to avoid mystifying technicalities in the discussion of both broad artistic tendencies and particular pieces. It may seem to focus on sculpture and painting, but does so only for purposes of illustration; the analysis can be extended to batiks, ceramics, engravings, paintings on glass, and so on. Finally, I would like to point

out that my approach has a theoretical a priori concerning the status of a work of art: I suggest that we consider African artworks as we do literary texts, that is as linguistic (narrative) phenomena as well as discursive circuits (see Kristeva 1980). I hope my analysis will demonstrate the usefulness of such a position.

The Issue of a "Nilotic" Imagination

"It is," wrote Pierre Romain-Desfossés, "precisely an Asiatic complex that we find in our Katangais painters and which allows us to use the etiquette of Nilotic" (Cornet et al. 1989:68-69). In this amazing statement, which links geography, race, and art, the founder of the Atelier d'Art "Le Hangar" in Elisabethville (now Lubumbashi, Zaire) seeks to explain the originality of his African pupils' artistic imagination. A Frenchman, Romain-Desfossés arrived in the Congo

after the last European war. Seduced by what he considered the country's extraordinary artistic potential, he decided to stay, and was soon organizing an atelier for a few carefully chosen students. His program is summarized in his remark, "We must strongly oppose every method tending toward the abolition of the [African] personality to the advantage of a uniformizing aesthetics of White masters" (Cornet et al. 1989:66).

Romain-Desfossés's project, its missionary zeal giving rise also to a remarkable generosity, united the political and the artistic to constitute a new aesthetic. But he traced this aesthetic, and the creativity of his students in general, back to an "Asiatic complex," a "Nilotic etiquette." His task as he conceived it was to awaken in his students this ancient, unchanging aesthetic memory.

Independently of its technical implications, this concept seems im-

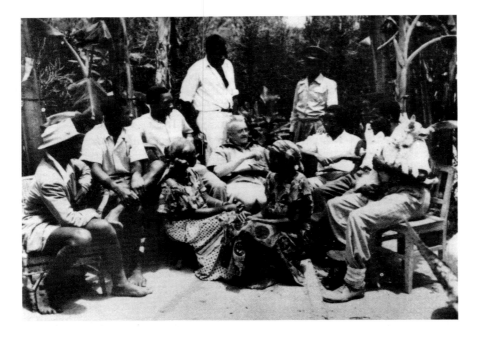

Fig. 2. Pierre Romain-Desfossés, father, master, guide, is seated, his head slightly turned. Around him are his pupil disciples. Three sit at the left and three at the right, forming a half circle. At his feet are two women, again symmetrically, one at the left, one at the right. And behind him stand two men in visual correspondence with the women below, thus establishing a square with the only white figure in the picture at its center. This centrality is emphasized by the students' gazes, which, except for that of the woman to his left, all focus on the "father"; and by the surrounding thick bushy trees, which accentuate the human group by suggesting a tropical forest. Closer to the group are two banana trees, perhaps symbols of human cultivation, one, again, to the left, one to the right. Photo: courtesy Jeune Afrique.

◄ Fig. I. In *Héro National Lumumba*, 1970s, by Tshibumba Kanda-Matulu (Zairian, b. ca. 1950), Patrice Lumumba, the Congolese nationalist, walks to his death. He is followed by two soldiers. To his left are three Katangan officials dressed up in suits and ties and carrying attaché cases, and in the background is a Western-built helicopter representing the universe of foreign interests that decided Lumumba's death. *La Mort historique de Lumumba* (The historic death of Lumumba) (cat. 67) is a dramatic variation of the same theme. The Congolese nationalist is identified with Jesus. Indeed, in the blurred conjunction of the two deaths flows an exclamation. Collection: Bogumil Jewsiewicki.

portant as a reference to a lost configuration interrupted, or at least blurred, by history. It suggests a kind of aesthetic unconscious, common to sub-Saharan Africans, that a patient, sensitive, disciplined search could awaken. In 1957, Frank McEwen, the founder of the National Gallery in Salisbury, Rhodesia (now Harare, Zimbabwe), suggested something similar, by way of a metaphor: "One of the strangest, inexplicable features occurs in the early stages of development through which many of the artists pass, when they appear to reflect conceptually, and even symbolically, but not stylistically, the art of ancient civilization, mainly pre-Columbian. We refer to it as their 'Mexican period,' which evolves finally into a high individualistic style" (McEwen 1970:16). Whether we refer to a "Nilotic etiquette" or to a "Mexican period," the phrase seems to describe something Carl Jung might have called an "archetypal image," "essentially an unconscious content that is altered by becoming conscious and by being perceived, and [that] takes its color from the individual consciousness in which it happens to appear." Jung continues, "The term 'archetype' . . . applies only indirectly to the '*représentations collectives*,' since it designates only those psychic contents which have not yet been submitted to conscious

elaboration and are therefore an immediate datum of psychic experience" (Jung 1980:5).

Romain-Desfossés, however, in his "Nilotic etiquette," was probably thinking of something else—a very ancient datum, something like a lost web, completely forgotten but still alive, well buried in the unconscious. And he was convinced that the works of his best disciples—Bela, Kalela, Mwenze Kibwanga, Pilipili—testified to its existence. But the concept of a primitive "Nilotic" or other complex is very questionable. It might be more prudent to suppose that these young artists invented an *original* texture and style, situated as they were at the intersection of local traditions and the artistic modernity of Romain-Desfossés. On one side of them was the luminous, inescapable influence of village life; on the other, the not-so-neutral gaze and speech of their teacher. Romain-Desfossés played father (he called his students "my children," and attended to both their physical and their emotional well-being), master (he saw his mission as teaching them how "to see"), guide in a new discipline: "painting . . . is in itself a new art that we bring to the black African." As Wim Toebosch writes, he dreamed of creating a new artistic universe: "Rather than giving instructions or imposing criteria or principles, he simply asks his disciples, his children as he calls them, to explore with their eyes, to study the world around them and to try to grasp its totality, but also its essence, without referring to this or that notion of faith—or of superstition" (Toebosch, in Cornet et al. 1989:66). Moreover, Romain-Desfossés had very definite opinions on art history. He was a romantic, celebrating his pupils' creativity as springing from "pure and fresh sources," as opposed to what he called "Western degeneracy," "snobbism," and "folly"—labels escaped only by a few European artists, such as Picasso, Braque, and the like.

A black-and-white photograph of Romain-Desfossés's "family" is the

best illustration of the way he imagined the new artistic world that he was trying to create: the Africans are posed in a subtle arrangement, a kind of square, with himself, the only white in the picture, at its center (fig. 2). The overly well-organized balance between left and right and front and back, the sitters' geometric positioning, the exploitation of nature— everything is calculated to produce a sense of communion, friendship, and love uniting the white "father" and his black "children." The dark forest around the group, and the two cultivated banana trees right next to them, seem meant to establish both a gradual progression from nature to culture and the inverse—a regression of sensibilities from the master and guide, through the young artists almost religiously surrounding him, toward the night of the symbolic unconquered forest. Following Freud, one might refer here to a will to master a psychic topography, and to the cathexis or investment of energy in that pursuit. Finally there is the calm confrontation of looks: the respectful deference in the students' gazes on the master, as if awaiting an oracle; and Romain Desfossés's own eyes, which seem unfocused, as if semiclosed in meditation. Or is he looking at the three students to the left of the group, or at his own, slightly raised right hand? In any case, the most striking feature in his white visage is his enigmatic smile, the father, master, guide holding a secret he will reveal only when he thinks the time is right.

Whoever plotted the photograph succeeded well in picturing the spiritual frame of the Atelier d'Art "Le Hangar" d'Elisabethville, and of its offspring, "*L'École de Lubumbashi*." The photograph is a remarkable representation of the workshop's symbolic intersections between sociocultural conceptions bequeathed to it by colonialism and the new politics of acculturation. For Romain-Desfossés appears here as a paradigm. The artistic constellation he represents crosses the frontiers of at least two traditions, two orders of difference. And the aim of the art he inspired was to bring to light the desire of a new subject, emerging out of a fragile connection between radically different psychic topographies. Romain-Desfossés was not alone in incarnating such an ambition.[1] And all his white colleagues had a number of things in common: they consciously assumed the role and the functions of the father figure; they believed in an innate African artistic imagination, one radically different from that of Europe; and they invited the local artists they considered capable of growth into a discipline that, by digging into blurred or forgotten memories, could bring forth new arguments and ideas, a new, acculturated ground of creativity.

Between Two Traditions
Marshall W. Mount has distinguished four main categories of contemporary African art (Mount 1989). First are survivals of traditional styles, exemplified by such practices as brass-casting in Benin, Nigeria; Ashanti wood-carving in Ghana; and cloth work in Abomey, in the Republic of Benin. Second is the art inspired by the Christian missions. On the west coast and particularly in Central Africa, this kind of work goes back to the first contacts with the Portuguese, in the late fifteenth and early sixteenth centuries; a religious art, it received a boost in the 1950s, when Christian parishes began to sponsor artists' workshops. The art, then, is apologetic, in the sense that it is concerned with the defense and illustration of Christianity, which it adapts to the African context. And the works—crucifixes, sculptures, canvases depicting biblical themes, carved doors, and so on—are generally used to decorate churches, parish buildings, and schools. Third is the souvenir-art category—"tourist" or "airport art" (see Jules-Rosette 1984). This work is made to please Europeans; as an East African carver puts it, "We find out what the [Westerners] like. We make what they like when we are hungry" (Mount 1989:39). And last is an emerging new art requiring "techniques that were unknown or rare in traditional African art." Mount writes, "The representation of this new subject matter is varied in style. There are works that are conservatively and academically rendered as well as abstract paintings that are reminiscent of Abstract Expressionist work. Most of this new African art, however, falls between these two stylistic poles, and as a consequence it avoids a close following of either" (Mount 1989:62-63).

Mount's pedagogical classifications seem useful for a first approach to African arts. Not surprisingly, however, their clarity and apparent coherence cannot account for the complexity of genres, schools of thought, and artistic traditions in Africa. One may wonder, for example, whether to situate the work of Mwenze, Pilipili (disciples of Romain-Desfossés's), and Thomas Mukarobgwa (a student of McEwen's) in the first or the fourth category of Mount's classification. And what about East African batik, or the Senegalese *souwer* or glass-painting tradition? There is also a second problem, and a serious one: in which category should one include "popular art"? This work testifies to emerging trends, yet few of its producers have attended art school, and still fewer have been "recipients of government scholarships in art schools abroad" (Mount 1989:62), like many of the artists in Mount's fourth category. Furthermore, though a number of its creators work with Christian themes, popular art is not strictly speaking inspired by the Christian missions. And no one would deny this art's modernity, which places it, in principle, in Mount's fourth category, yet the motifs of an impressive list of popular artworks are explicitly inspired by traditional objects. What to do?

Mount's classifications may be revised according to a simpler notion: the complementarity of the tradi-

tions in all the categories he separates. The Austrian-born teacher Ulli Beier considered this complementarity one of the most significant signs of the "Afro-European culture contact":

It is no longer possible to look at African art and see nothing but a continuous and rapid process of disintegration. We can now see that African art has responded to the social and political upheavals that have taken place all over the continent. The African artist has refused to be fossilized. New types of artists give expression to new ideas, work for different clients, fulfill new functions. Accepting the challenge of Europe, the African artist does not hesitate to adopt new materials, be inspired by foreign art, look for a different role in society. New forms, new styles and new personalities are emerging everywhere and this contemporary African art is rapidly becoming as rich and as varied as were the more rigid artistic conventions of several generations ago (Beier 1968:14).

We see, then, an aesthetic acculturation between on the one hand the complex of African representations and inspirations, its various discursive circuits displaying their depths and tracing their trajectories; on the other the European, familiar yet strange to the African artist, and at the same time signifying a new starting point. The former belongs to the stubborn local cultural fabric, and reproduces regional Weltanschauungs in demonstrative or decorative, naive or sophisticated fashion. The latter should be posited as a more intellectual and sociological frame.

For the artist trained in colonial-era workshops and art schools, the curriculum there has prescribed powerful reflexes and reflectors. Even in the most conservative institutions, education meant a conversion, or at least an opening, to another cultural tradition. For all these artists, the organic reality of modernity was embodied by the discourses, values, aesthetics, and exchange economy of colonialism. One might in consequence be tempted by Edmund Leach's general system of oppositions between the two traditions, and might hypothesize a discreet competition between them: the more traditional the inspiration for a work of art, the less its general configuration and style would allow a clear assessment of the qualities of its forms, its content, and the maker's technical skills; conversely, the more Westernized an oeuvre, the more easily an observer can make distinctions among these constituent elements. Leach's suggestion is brilliant, but unfortunately it does not address the difficult issue of styles, that is, of "the formal properties of a work of art," which constitute the core specificity of an artistic tradition (see Focillon 1934 and Vansina 1984).

Two sets of criteria—internal (the artwork's style, motifs, theme, and content) and external (the context of its creation, that context's cultural history, the sociological milieu, and the artist's purpose)—should permit the distinction of three main currents (not categories) in contemporary African arts. There is a tradition-inspired trend; a modernist trend; and a popular art. Such orientations as Christian religious art, tourist art, and so on should be situated between the tradition-inspired and the modernist trend.

These two trends aim on the one hand to revitalize the styles, motifs, and themes of yesterday, to bring the past among us, as in the case of the schools founded by Romain-Desfossés, McEwen, and Victor Wallenda; on the other, to search for a new, modern aesthetic, a conscious inscription of a modern cultural setting (as in the case, for example, of the Nigerian Lamidi Fakeye). The two ambitions may seem dissimilar but are actually quite compatible with each other. Recent popular art, made in the years of independence, tends to run parallel to the art of the trend toward modernity. But the art of that trend is more intellectual; it is usually made by educated artists, and their work explores an academic language acquired in art school. Besides its artistic achievement, such work is also monetarily significant, for it is made primarily to be sold. Both the modernist and the tradition-inspired work, in fact, function in African countries as "export goods" for the international market.

The third current, the popular art, is perceived locally as the antithesis of these culminations of aesthetic acculturation. Its artists are generally self-trained, use inexpensive materials, and paint not for export but for ordinary people on the fringes of the local bourgeoisie (like many of the artists themselves). The styles, motifs, and themes of popular art allegorize common-sense perceptions; in a naive formal style, they comment vividly on historical events, social issues, and the cultural struggles of working class and rural peoples (see, e.g., Fabian and Szombati-Fabian 1980). In contrast to a "high" culture sanctioned by international authority and by the respectability of the European art genres, popular art is structured as a number of regional discursive formations whose meanings, codings, status, distribution, and consumption are quite specific to the different places in which they emerge. In short, where modernist and tradition-inspired art reflect the highest cultural values as defined and, supposedly, lived out in the inner circles of acculturated African society, popular art, made at the periphery of the same society, scans, interprets, and occasionally defies such values by confusing their explicitness, challenging their discursivity, and bringing into circulation new readings of founding events, mythologies, and social injustices, as well as popular representations of a history of alienation (see, e.g., Beier 1968 and Jewsiewicki 1989b).

Regrouping

One still remembers the 1983 exhibition of Senegalese tapestries at the Wally Findlay Galleries, New York, and the more recent show "Contemporary African Artists" at New York's Studio Museum in Har-

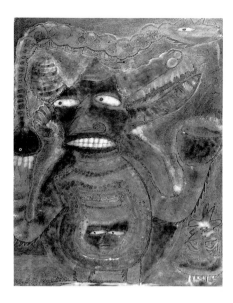

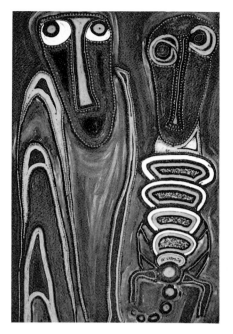

Fig. 3. *The Magical Figure in the Tribe of the Ant-Bird Ghost*, 1970s, by Twins Seven-Seven (Nigerian, b. 1947), ink and gouache on paper and wood. Twins Seven-Seven is one of the best-known artists of the Oshogbo school founded by Ulli Beier in the 1960s. Photo: courtesy Bildnachweis, Übersee-Museum, Bremen.

Fig. 4. *Obatala and the Devil*, 1970s, by Jimoh Buraimoh (Nigerian, b. 1943), beads and oil on hardboard. Buraimoh, a member of the Oshogbo school, is noted for his "bead paintings." In many of his paintings he draws on themes from Yoruba mythology. Photo: courtesy Bildnachweis, Übersee-Museum, Bremen.

lem in 1990.[2] What was striking in both exhibitions was the modernist styles of these collections of works. Introducing the Senegalese pieces, James R. Borynack, president of the Wally Findlay Galleries, observed that "the totality of [works] is immersed in a sort of mythological retrospection which seems to issue from the collective unconscious" (Borynack 1983:4); and the introduction to the catalogue salutes the tapestries as validating "a true African aesthetic" (Borynack 1983:6). As we know, the tapestry technique actually comes from the French École Nationale d'Aubusson, and the execution of the pieces, at least from 1964 to the 1970s, faithfully followed the Aubusson canons. Yet there was a discreet change in the motifs of these works, and it coincided with the introduction, around 1960, of the themes of "negritude." The personal influence of Léopold Sédar Senghor, then president of Senegal, patron of the Manufactures Sénégalaises, and the best-known theorist of negritude, was visible in many of the pieces' celebration of ancient styles. Color, line, and movement fused and broke as if worked by a vibrant rhythm. The work was a grand illustration, in fact, of Senghor's idea of the whole School of Dakar: "an African cultural heritage," an "aesthet-

ics of feeling," "images impregnated with rhythm" (Axt and Babacar Sy 1989:19). A critic might ask whether such pieces, which claim to expose the virtues of an ancient bubbling aesthetic source, qualify as variants of traditional art. The success of the Senegalese tapestries in this regard, and of School of Dakar art in general, is indubitable, responds the artist and writer Issa Samb (Axt and Babacar Sy 1989:129-130). Yet Samb, though reluctant to stem criticism of any kind, fears that the usual critique, emphasizing the work's African heritage rather than the individuality of the artist, "unmasks and misleads simultaneously the system on which the '*École de Dakar*' rests." "It confuses denotation in the sense that the exhibits which have been around the world actually denote Negritude but connote something quite different. And this 'quite different' is principally undefinable, it is the painters' psyche" (Axt and Babacar Sy 1989:130).

The "Contemporary African Artists" exhibition was touched by the same issue: how really "African is modern African art?" (Stanislaus 1990:36). Apart from the self-trained Nicholas Mukomberanwa of Zimbabwe, all the artists in the show— El Anatsui (Ghana), Youssouf Bath (Ivory Coast), Ablade Glover (Ghana), Tapfuma Gutsa (Zimbabwe), Rosemary Karuga (Kenya), Souleymane Keita (Senegal), Mukomberanwa, Henry Munyaradzi (Zimbabwe), and Bruce Onobrakpeya (Nigeria)—were educated at specialized institutions in Africa and overseas; most of them belong to a second generation in the field, and if they consciously relate to earlier African art, they know how to distort it, how to submit it to their own creative process. In fact, they discover in the African past simply art that has preceded them, art both beautiful and ugly. If the past inspires them, it does not bind them. Gutsa, for example, quite consciously distances himself from his Shona culture and conventions by exploring foreign themes (in, for example, *The Guitar*, 1988, in wood,

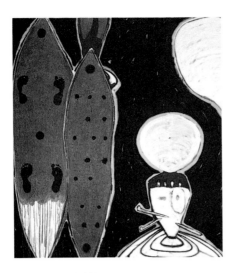

Fig. 5. *Dogon Komo (The Universal Knowledge)*, 1989, by Ouattara (Ivoirian, b. 1957), acrylic on canvas. Ouattara's paintings are infused with symbolism inspired by Senufo and Dogon mythologies. Photo: courtesy Vrej Baghoomian Gallery, New York.

newsprint, and serpentine; and *The Mask, the Dancer*, 1989, in serpentine, steel, and wood). And Mukomberanwa's *Chembere Mukadzi* (1988-1989, serpentine) expresses a contemporary political agenda of women's rights.

The ideological position of the Senegalese artist Iba N'Diaye suggests the attitude of a number of contemporary artists:

I have no desire to be fashionable. Certain Europeans, seeking exotic thrills, expect me to serve them folklore. I refuse to do it—otherwise I would exist only as a function of their segregationist ideas of the African artist (London 1970:8).

N'Diaye invokes a right to a personal subjectivity and individual practice. Why should an artist be condemned to the simple reproduction of other narratives?

N'Diaye's forceful statement, of course, brings to mind the well-known lament of William Fagg: "we are in at the death of all that is best in African art" (London 1970:6). And the era of independence in Africa indeed brought about radical sociocultural transformations and mutations. But why should one a priori decide that the ancient art was best? Ulli Beier writes that Fagg's statement "describes the well-known tragic phenomenon in Africa. All over Africa the carvers down their tools. The rituals that inspired the artist are dying out. The kings who were his patrons have lost their power" (Beier 1968:3). So what? This discontinuity, despite its violence, doesn't necessarily mean the end of African art; it seems, rather, that the ancient models are being richly readapted. Beier himself still finds admirable pieces, evolving "between two worlds," by artists like the traditional Yoruba brass-caster Yemi Bisiri, the Benin wood-carver Ovia Idah, and the Muslim carver Fakeye. And elsewhere he praises the 1960s work of Twins Seven-Seven, Muraina Oyelami, Adebisi Fabunmi, Jacob Afolabi, Rufus Ogundele, and others of the Oshogbo school whose

art—and this was new at the time—was aimed not at the Western market alone. This work reflected a drive to say and illustrate something new, to transcend the crisis of tribal societies and art disorganized by the impact of European culture, and to express the emerging new consciousness. As N'Diaye asserts,

For me painting is an internal necessity, a need to express myself while trying to be clear about my intentions concerning subjects that have affected me—to commit myself concerning vital problems, the problems of our existence (London 1970:8).

The real explodes on N'Diaye's canvases. Sometimes the paintings enunciate an intense narrative of violence—a ritual sacrifice in the series "*Tabaski, sacrifice du mouton*" (Tabaski, sacrifice of the sheep, 1970-1987), or a frightening surprise in *Juan de Pareja agressé par les chiens* (Juan de Pareja menaced by dogs, 1985-1986). Of the artists of the younger generation of painters, Sokari Douglas Camp, of Nigeria, seems fascinated by the everyday life of her people, the Kalabari of the Niger Delta, whose traditions her thrilling compositions show. Fodé Camara, of Senegal, creates complex dances of colors that reflect another game of colors in his native Gorée: the blue of the sea, of Gorée, of voyages, opposed to the red of fear, of violence (Paris 1989:35-39). Gorée, that outpost of the slave trade on the Atlantic ocean! Finally the cosmic conjunctions of Ouattara, from Côte d'Ivoire, reiterate old Senufo and Dogon mythologies in symbolic lines, blocks, and hollows (Baghoomian and Warren 1989). They also make me think of the more peaceful, more domesticated mysticism of another young painter, the Senegalese Ery Camara (Camara n.d.).

This ongoing work and the many masterpieces it has already produced really began in the colonial-era ateliers. New generations have learned from the successes and failures of

those workshops-cum-laboratories, at the same time that they have interrogated their own traditional arts. The artists of the present generation are the children of two traditions, two worlds, both of which they challenge, merging mechanics and masks, machines and the memories of gods.

Popular Art

The term "popular art" has at least three different meanings. First, popular art may simply be the art regarded with favor, sympathy, and approval by a given community; in this sense, the traditional masks of the Dogon of Mali, Pilipili's abstract paintings, and Twins Seven-Seven's figural sculptures are all popular. The phrase may also refer to art that represents the common people: as the Mozambican artist Malangatana puts it, "Art for me is a collective expression that comes from the uses and customs of the people and leads to their social, mental, cultural and political evolution" (Alpers 1988:85). Finally there is a popular art suited to and intended for an ordinary intelligence and a common taste. The description might seem pejorative, yet such art can be highly sophisticated, as in the advertising art designed for the manipulation of the masses.

The term "African popular art" is generally used to refer to this last kind of work. The artists who make it include Anthony Akoto and Ofori Danso of Ghana and Cheri Samba and Kalume of Zaire. Their art is neither a residue of traditional art nor an offshoot of the tradition-inspired and modernist trends in contemporary art. Those trends, as the importance of nonfigurative painting in both of them attests, are less mimetic or representational than symbolic. The meaning of a Tanzanian Makonde mask, for example, or of a canvas by the Nigerian artist Bruce Onobrakpeya or the Zambian Henry Tayali, or of a sculpture by Bernhard Matemera of Zimbabwe, comes from its structuring of signs, signs that combine both with each other and with signs outside

the work to suggest coincidences of values and ideas. Such works are polysemous and symbolic. The art of Akoto, Danso, and Samba, on the other hand, popular by virtue of its media, the texture of its canvases, the narrative sequences it displays, and its populist messages, is fundamentally mimetic and may seem, prima facie, almost monosemous. Works of this kind carry a message, manipulating, arranging, and combining signs so as to make an unambiguous pronouncement. The use of written language—frequent in Samba's paintings (see fig. 6)—is part of this ambition for a militant clarity, a negation of the polysemous, associative, open principles of most works of art. In this sense, popular art seems fundamentally antivisionary and antiimaginative. To what extent, then, does this work really qualify as visual art?

This is the challenge of popular art, which often takes the form of a visual narrative relaying events, phenomena, and issues that the local spectator already knows (see Fabian and Szombati-Fabian 1980). *La Mort historique de Lumumba* (The historic death of Lumumba, 1970s; cat. 67) and *Héro National Lumumba* (1970s; fig. 1), by Tshibumba Kanda-Matulu, or Samba's *Lutte contre les moustiques* (Battle against the mosquitoes, 1989; cat. 77, 82), are simply new versions of events and issues familiar from other means—even from other art. Yet there is something new in these canvases: themes are ritualized, objectified, their complex textures transformed into a neat, transparent, limpid frame. Each of them stands, then, as a closed discourse. This ritualization is of considerable significance insofar as it works out a transmigration of symbols: from the complexity of history, of a real cultural experience, the artist chooses what can speak out the most clearly. The artist essentializes the event, or, perhaps better, symbolizes it—in which case it may have been premature to speak of the monosemy of popular art. Indeed, the message of Patrice Lumumba's walk to death

in *Héro National Lumumba* is ambiguous. The painting's surface clarity does not prevent the viewer from gleaning a variety of meanings from it: the dignity of the nationalist hero, the symbolic link between the Western-built helicopter and the three Katangan officials, the morality of the soldiers serving a state capable of such a crime, the physical absence of the Belgians themselves, and so on. Meanings, suggestions, images emerge from the frame, and history meets symbols in the mind of a "popular" viewer with an efficiency impossible in even the best book.

Popular art is both narrative and art. The grammar of its content, its chromatic logic, and the economy of its compositions escape most of the constraints of academic art. It witnesses something specific: a practice of everyday life. And it does so in an original style—that is, it has "the means of recreating the world according to the values of the man who discovers it" (Merleau-Ponty 1973:59).

An Open Space

Il faudra, avant de revêtir le bleu de chauffe du mécanicien, que nous mettions notre âme en lieu sûr (Before changing back into the mechanic's overalls, we need to put our soul in certainty).
—Cheikh Hamidou Kane, 1961

A traveler, Dorcas MacClintock, a curatorial affiliate at the Peabody Museum of Natural History, Yale University, has a chance meeting with Ugo Mochi, an Italian artist who specializes in the silhouette. An ordinary incident. But then MacClintock discovers Africa, and, eventually, publishes *African Images* (1984), with pictures by Mochi. The book's creators would like it to be a window on African scenery. They introduce it as "a look at animals in Africa"; and the animals are indeed seen fully the way the dictionary defines them, as living, other than human, beings.

Both MacClintock and Mochi seem concerned not with the actuality of African animals but with the im-

pact on the eye of these "beings" in the landscapes that frame them. MacClintock notes,

> Nowhere on earth is beauty of animal form, modeled through time by physical function and environment, so apparent. Hoofed mammals, always watchful for predators, reveal tension in the brightness of an eye, the alert stance, the poise of a head on the curve of neck, the stamp of a forefoot, or the whisk of a tail. Predators, too, are tense as they stalk, wait in ambush, or sprint after their prey. At other times they loll about in the heat of the day. There is beauty of color as well as of form. Patterns have evolved on some animals—stripes, splotches, and spots —that break up body outlines or provide camouflage. Other animals have conspicuous markings on face, ears, or legs that function for recognition among their own kind, emphasize mood or intent or are flaunted in displays of dominance between rivals (MacClintock 1984:xii).

In the vision of this observer, the beauty of a landscape is rearranged according to the criteria of a "natural" art. Yes, MacClintock claims to tell the truth about an order he sees clearly. But what he says nevertheless arises out of a grid of feeling (which is not to say—need I add?—that it is fictitious). In theory, anyone could verify what he has to say. Yet the poetic ensemble he offers is a translation of what he has perceived. Through aesthetic desire, the eye stylizes the perceived, then returns to the observer his own investment.

Natural sceneries might seem to spring from nature but do not: it is in the gaze of the observer that African animals in their spaces are transmuted into aesthetic objects and take on semiotic status, becoming narratives of the natural. In the forest, for example, the appearance and habits of bongo antelopes seem to constitute a discourse: their "body stripes merge with narrow patterns of sunlight to make their antelope outlines almost invisible. . . . Once a bongo scents danger, it freezes.

Then breaking cover, it vanishes as though by magic" (MacClintock 1984:2-3). Duikers, okapis, drills, porcupines, hogs, and other animals have discourses of their own. Along rivers, lakeshores, and rift-valley walls, MacClintock finds variations on the discursive circuits he has found in the forests: dignified baboons socialize in families or walk alone, and small armies of bush pigs raid village crops under the moon; light, elegant, colorful bands of flamingos and pelicans fly or feed. In swamps and marshes one may "read" the activities of sitatungas, colobus monkeys, waterbucks, crocodiles, and hippopotamuses. Is not theirs a *scriptural* activity, asserting a type of existence and the beauty of a kind of narrative? Other discursive texts can be observed in the bush and in the savannas: the movements and social lives of elephants, black rhinoceroses, and warthogs, or of sable and roan antelopes and elands; the grace and majesty of giraffes, the handsomeness of nyalas; and, of course, the jubilation of a remarkable variety of birds.

Can "natural" African landscapes be thought of as texts, as paintings? Do they present themselves to the observer as linguistic and pictorial phenomena to be read, understood, enjoyed; do they constitute an incredible number of delightful discursive styles? One must remember here that the style of a narrative always grows out of a context—that, as Maurice Merleau-Ponty writes, "style cannot be taken as an object since it is still nothing and will become visible only in the work" (1973:59). The "style" of animals living in their natural milieu, then, is obviously not "a means of representation" (how could it be?), but emerges in the exchange between the African landscapes and animals and the eyes of the observer.

In his epilogue, MacClintock daydreams:

> Africa, with its vast skies and far-off horizons, evokes a sense of wildness, freedom, and wonder. It is a

land that echoes the past, where natural order prevails and days are without time. . . .

> In the delicate springlike shade of an acacia, a gerenuk browses, its tail switching, ears batting, and front hoofs propped among the branches. A tiny dik-dik with enormous mouselike eyes ringed in white stares shyly from a thicket. A bull elephant threatens, flaring huge veined ears, brandishing tusks, testing with trunk, and swinging his pendulumlike foreleg sideways (1984:140).

The first paragraph reconstructs (unconsciously?) an old image of Africa; the second consolidates it. The question of the truth of this image seems unimportant, however, since the image credibly represents a possible "natural" African painting or narrative. It is exotic, true, and might then be a fake—an imitation of an ancient figure from some other, extraneous narrative. Even so, however, what it signifies remains pertinent, since it sustains the mimesis of a perception imitating itself in what it stylizes, and succumbing to the beauty it has thus invented.

If, as we have known since Husserl, no forming can transcend its space, its context, its language (Husserl 1970:370-371), we must posit a relation between African styles and their natural context. MacClintock's language shows one such relation—a Franciscan impulse that transmutes every picture into a narrative celebrating the beauty and joy in nature. Another step might be to try to reconstruct the complex interactions between physical and human milieus, and the passage of these interactions into art. Ulli Beier has wonderfully described such an interaction in his discussion of the Mbari Mbayo Club at Oshogbo (1968:101-111). In quite a different vein, Jean-Paul Bourdier and Trin T. Minh-Ha (1985), focusing on vernacular architecture in the Sahel area of Burkina Faso, have shown how the Gurunsi culture has aesthetically domesticated a natural milieu, coherently integrating into it a spatial organization of com-

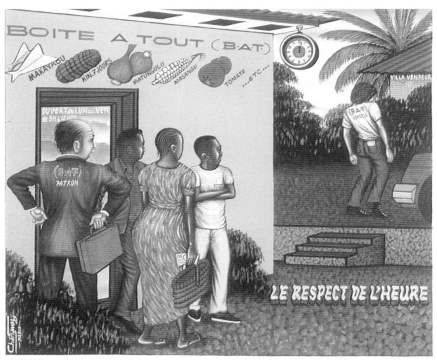

Fig. 6. *Le respect de l'heure* (Punctuality), 1989, by Cheri Samba (Zairian, b. 1956), acrylic on canvas. Samba's painting reads like a commercial; its message is clear, simple, direct. Courtesy Jean-Marc Patras Galerie, Paris. Photo: Tutti.

LE RESPECT DE L'HEURE EST BIEN NORMAL MAIS AVOIR UN PETIT RETARD CE N'EST PAS AUSSI UN PECHE

pounds and the human activities of daily life.

Images of everyday life also appear in the wall paintings of the Ndebele women of Pretoria, where, as Margaret Courtney-Clarke writes, "the traditional abstract designs have merged with representational forms to create a unique, highly stylized art that combines the elements of the past with the realities of the present" (1986:23). If acculturation smacks of necessity in artistic activity such as the Ndebele's, it also sustains the continuity of ancient rituals, techniques, and customs. Furthermore, this art not only inserts itself in a tradition, it also espouses the clear light of the Kwandebele region. Thus a conjunction: space, time, and human tradition interrelate. MacClintock's beautifully stylized animals have their counterparts, their stylistic variations, in, say, such narratives as Pilipili's paintings of fish or crocodiles; the sculptures of elephants, leopards, and birds sold in tourist shops; and even—why not?—in such Malian masterpieces as the Bamana antelope headdress or the Dogon antelope mask (see Vogel and N'Diaye 1985). The Gurunsi compounds illustrate an aesthetic coherence between human and natural milieus; the Ndebele women's murals demonstrate an evolving tradition. We see, then, that the work of art "is not fashioned far from things and in some intimate laboratory to which [the artist] alone possesses the key. This also means that . . . the work is not an arbitrary decree and that it always relates to its world as if the principle of equivalences through which it manifests the world had always been buried in it" (Merleau-Ponty 1973:61). As Michel Leiris has written, in fact, one should, "conceive of the overall approach to African arts less as primarily 'a history of arts and styles' and more as the search for, and the according of spatio-temporal form to, the 'visible products of a certain society's history'" (Perrois 1989: 526).

Conjugating

The Ndebele mural paintings have a sociohistory of their own, but somewhere they become part of the changing permanence of African artistic imaginations, canons, and traditional skills, as witnessed, for example, in the pieces in cat. 117-133, which come from different regions of Central and West Africa and

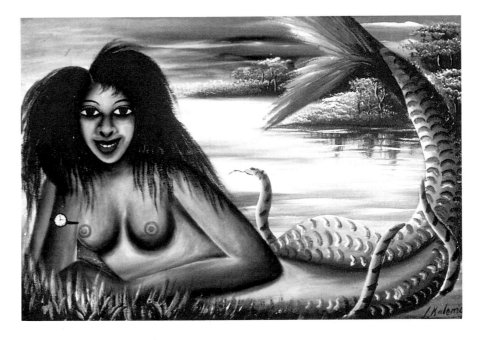

Fig. 7. Representations of Mami Wata, widespread throughout the continent, constitute one of the most significant fictions in African popular art. A mythological aquatic woman, Mami Wata relates to the world by magical powers. Often pictured as half human and half fish, she incarnates a juncture between the real and its other, mysterious side. This painting is by Kalema (Zairian). Photo: Bogumil Jewsiewicki.

were made between the late seventeenth and the early twentieth centuries. Specialists class these pieces in the category of "extinct" art. Of various styles and morphologies, they yet retain loose common features: like most traditional artworks, they were made by anonymous authors, the creator's consciousness being fused, then, with his or her social group; and they can be linked to a number of general cultural canons, trends, and sets of symbols. As an African, I relate to them through a double articulation. On the one hand I find in them a common signifying structure that makes them seem part of a single cultural economy. On the other, I also see regional characteristics in each of them, the Grebo masks from Côte d'Ivoire (cat. 123-124), say, obeying formal customs foreign to those of the Benin plaques (cat. 117-119). The first articulation is highly subjective, and reflects the ideological climate of Africa since the 1960s, a period when the notion of African cultural unity has been promoted in such books as Willy Abraham's *The Mind of Africa* (1966), Cheikh Anta Diop's *L'Unité culturelle de l'Afrique noire* (1960), and in many other places. The second response depends on the findings of anthropologists and art historians, and allows for the exploration of each artist's individuality: the morpho-

logical forms, geometric features, chromatic techniques, and symbolisms particular to his or her vocabulary.

In the dialectic between the two articulations, the extinction of the artistic trends of the past ceases to be a closure. In effect, I can credit the ancient styles with inspirational power, and can examine the more recent pieces for their idiosyncratic patterns and styles. A creative continuity appears, and transcends the objective ruptures described by the laboratory specialists. Mid-twentieth-century Dogon masks from Mali (cat. 2, 4), or early-twentieth-century Makonde masks from Tanzania (cat. 7), appear to me part of the same cultural order. They can be seen and admired not only in their difference, but also as variations mirroring transformations of the archetypes in a basic imagination. And why shouldn't we relate the style of the early-twentieth-century Dogon antelope mask to what appears in the African landscape, which amazed countless African artists before Dorcas MacClintock got to it? This suggestion puts the various forms and styles of African art over time in touch with equivalents in nature.

The practices of traditional artists are of interest, say the specialists, because their works are not realistic yet participate in establishing

the meaning of reality. They provide metonyms and metaphors for real beings, things, events, and natural forces in the world at the same time that they abstract the world. Their perfect insertion in African peoples' ordinary lives has led students of African art to conclude, a bit lazily, that this art is essentially functional. This conclusion erases the complexity of the art's symbolic and allegorical meanings. The mask, for example, a clear objectification of a signifier, refers also to other orders of meanings without which it is useless.

Unlike traditional art, contemporary popular art assumes some of the virtues of realism, advancing its pictures as reflections of a modern culture and its history. Concerned with the politics of the signified, it reinforces its realism with ethical points (as Samba does) or, more generally, with various sociological functions, thus distancing itself from the symbolic and decorative activity typifying atelier and art-school trends since the 1940s.

In Sum

The three trends in current African art—tradition-inspired, modernist, and popular—are recent: the oldest examples date from the first quarter of this century. One might be tempted, then, to relate their genesis to the impact of the colonial era, yet a number of their themes and motifs—reproductions of crucifixes and Madonnas, biblical references, and so on, all along the western coast of the continent—are part of a history of acculturation that goes back to the fifteenth and sixteenth centuries. Viewed in the light of history, the distinction between the tradition-inspired and the modernist trends in contemporary African arts, though useful for the sake of analysis, indicates in the end a kind of enthrallment to traditional art. For these two trends in fact constitute a single current. First, both oeuvres are created mostly in ateliers and art schools, and even when they are made by self-trained artists they illustrate the colonial

acculturation of African societies; second, unlike traditional artworks, both reveal the consciousness, the artistic identity, of their makers; and third, both have as their raison d'être not the imitation of reality but the creation of beauty.

The first of these three shared traits describes the sociocultural context of the new artistic imagination. The second is philosophical, indicating a far-reaching spiritual and intellectual revolution and its new legitimacy in an acculturated social milieu. The third is aesthetic, and brings these two trends into focus: both involve interpretative, symbolic processes of coding what is out there rather than mimetic renderings of reality. And both the tradition-inspired and the modernist impulses often fuse in the work of one artist, for example Malangatana (cat. 108-109), N'Diaye (cat. 110-113), or Twins Seven-Seven.

Popular artworks situate themselves somehow between these two trends. They often relate to a particular region and its history. As narratives, they deconstruct the memory of this history from the perspective of a single individual. In many respects, popular arts, mostly paintings, are structured as "*histoire immédiate*," in Benoît Verhaegen's expression; they are literally a capturing of ordinary, banal stories and events (a market, a drinking party, a political event), of violence and tragedy (a civil war, an assassination), or of mythological motifs, for example Mami Wata (fig. 7). In their extreme manifestations, popular arts come close to publicity and advertisement.

To academic rules of representation and techniques of arriving at "the beautiful," popular artists propose an opposing vision. They want to transmit a clear message; they claim the virtue of sociological and historical truth; and they try to name and unveil even the unnamable and the taboo. Here technical flaws become marks of originality. The artist appears as the "undisciplinable" hero, challenging social institutions, including art practices, particularly

academic ones. Yet this "deviant," who sometimes attacks both a tradition and its modern currents, incarnates clearly the locus of their confrontation. In popular art, the politics of mimesis insert in the "maternal" territory of the tradition a practice that questions both art and history in the name of the subject. This is work that aims to bring together art, the past, and the community's dreams for a better tomorrow.

NOTES

1. The Belgian *frère* Marc Stanislas (Victor Wallenda), for example, founded the School Saint Luc in Gombe-Matadi (Lower Zaire) in 1943. The school moved to Léopoldville (now Kinshasa, Zaire) in 1949, and in 1957 became the Académie des Beaux Arts. A strong believer in the theory of an "innate African aesthetic imagination," Wallenda, during his long tenure as director of the institution, obliged his students to inspire themselves only from "traditional oeuvres." He ensured that they would not be exposed to European art and still less to books on the history of art. Another such figure was Frank McEwen, the founder of a workshop at the Museum of Harare (an offshoot of the Rhodesian National Gallery, opened in 1957). His educational principles were based on a refusal to "corrupt" African artists by exposing them to "the influence of Western art schools" (Mount 1973:119). Sharing the same philosophy were Margaret Trowell, director of the Makerere School of Art in Uganda; and Pierre Lods and Rolf Italiander, at the Poto-Poto School in Brazzaville. One could add the names of Tome Blomfield, who organized a workshop on his farm at Tengenenge (Zimbabwe) for unemployed workers; Cecil Todd, a resolute modernist who, in the 1960s, compulsorily exposed his students at Makerere (Uganda) and later at the University of Benin (Nigeria) to modern European art; and, between the conservativism of Romain-Desfossés and Wallenda and the more recent modernism of Todd, fathers Kevin Carrol and Sean O'Mahoney of the African Mission Society, who, since 1947, have worked among Yoruba craftsmen to promote an art combining "European ideas and African forms" (Mount 1973:32).

2. "Contemporary African Artists" ran at the Studio Museum in Harlem from January to May 1990, at the Afro-American Historical and Cultural Museum, Philadelphia, from July to September 1990, and at the Public Library Cultural Center, Chicago, from January to March 1991.

BIBLIOGRAPHY

Abraham, W.
 1966 *The Mind of Africa*. Chicago.
Achebe, Chinua
 1958 *Things Fall Apart*. London and Ibadan.
Agthe, Johanna
 1990a *Wegzeichen. Signs: Art from East Africa 1974-89*.
 Frankfurt.
 1990b "Signs of the Times: Art from East Africa."
 Unpublished manuscript.
AKA Circle of Exhibiting Artists
 1988 *AKA 88: 3rd Annual Exhibition Catalogue*. Enugu,
 Nsukka, and Lagos.
 1990 *AKA 90: 5th Annual Exhibition Catalogue*. Enugu.
Allainmat Mahine, Basile, and Benoît Arenaut
 1989 *Art contemporain bantu*. Libreville.
Alpers, Edward A.
 1988 "Representation and Historical Consciousness in
 the Art of Modern Mozambique." *Canadian Jour-
 nal of African Studies* 22(1):73-94. Reprinted in
 Jewsiewicki 1989b:72-94.
Ampofo, Oku
 1949 "Neo-African Art in Gold Coast." *Africana: The
 Magazine of the West African Society* 1(3):16-18.
Aniakor, Chike C.
 1988 "Aka: Rhythms of Creativity at the Third Season."
 In AKA Circle of Exhibiting Artists, pp. 6-10.
Antubam, Kofi
 n.d. [ca. 1961] *Ghana Art and Crafts*. Accra.
Araeen, Rasheed
 1989a "Our Bauhaus Others' Mudhouse." *Third Text:
 Third World Perspectives on Contemporary Art and
 Culture* 6:3-14.
 1989b *The Other Story: Afro-Asian Artists in Post-War
 Britain*. London.
Arean, Carlos
 1975 *Leandro Mbomio en la integración de la negritud*.
 Madrid.
Arnold, A. James
 1981 *Modernism and Negritude: The Poetry and Poetics
 of Aimé Césaire*. Cambridge, Mass.
Arnoldi, Mary Jo
 1983 *Puppet Theatre in the Segu Region in Mali*. Unpub-
 lished Ph.D. dissertation, Indiana University.
 1987 "Rethinking Definitions of African Traditional and
 Popular Art." *African Studies Review* 30(3):79-84.
 1988 "Playing the Puppets: Innovation and Rivalry in
 Bamana Youth Theater of Mali." *TDR* 32(2):65-82.
Aronson, Lisa
 1982 *Akwete Weaving: A Study of Change in Response to
 the Palm Oil Trade in the Nineteenth Century*. Un-
 published Ph.D. dissertation, Indiana University.
Axt, Friedrich, and El Hadji Moussa Babacar Sy (eds.)
 1989 *Bildende Kunst der Gegenwart in Senegal*. Frankfurt
 am Main.
Ayer, A. J.
 1977 *The Problem of Knowledge*. New York.
Badi-Banga Ne-Mwine
 1977 *Contribution à l'étude historique de l'art plastique
 zaïrois moderne*. Kinshasa.
 1987 *Art contemporain bantu: deuxième Biennale du* CICIBA
 Kinshasa. Libreville.
Baghoomian, Vrej, and Michael Warren (eds.)
 1989 *Ouattara*. Kyoto.
Bamba Ndombasi Kufimba and Musangi Ntemo
 1987 *Anthologie des sculpteurs et peintres zaïrois
 contemporains*. Paris.

Barber, Karin
 1987 "Popular Arts in Africa." *African Studies Review*
 30(3):1-78, 105-111.
Bascom, William
 1969 "Creativity and Style in African Art." In Biebuyck,
 pp. 98-119.
 1976 "Changing African Art." In Graburn, pp. 303-319.
Bastin, Marie-Louise
 1988 "Hypothèse sur l'origine des découpes chantournées
 de quelques sceptres des Tshokwe (Angola)." In
 Estudos em Homenagem a Ernesto Viega de Oliveira,
 Instituto Nacional de Investigação Científica, Centro
 de Estudos de Etnologia (offprint), pp. 39-54.
 Portugal.
Baudrillard, Jean
 1984 "The Precession of Simulacra." In *Art After Mod-
 ernism: Rethinking Representations*, Brian Wallis
 (ed.). New York.
Bayreuth, Städtische Galerie Regensburg, Iwalewa-Haus
 1985 *Charakter ist Schönheit Afrikanische Kunst heute*.
Beauthéac, N.
 1977 Atelier aujourd'hui Koffi Mouroufié. Paris
Beek, W. E. A. van
 1983 "Harmonie en schaamte bij de Dogon." *Prana*
 32:44-53.
 1990 "The Innocent Sorcerer: Coping with Evil in Two
 African Societies, Kapsiki and Dogon." In *African
 Religions: Experience and Expression*, W. E. A. van
 Beek, D. H. Thompson, and T. Blakely (eds.).
 London.
 1991 "Dogon Restudied. A Field Evaluation of the Work
 of Marcel Griaule." *Current Anthropology*
 (forthcoming).
Beek, W. E. A. van, and P. Banga
 1990 "The Dogon and Their Tree." In *Cultural Under-
 standings of the Environment*, D. Parkin and E.
 Croll (eds.). London.
Beier, Ulli
 1955 "Yoruba Cement Sculpture." *Nigeria* 46:44-153.
 1956 "Ibibio monuments." *Nigeria* 51:318-336.
 1960 *Art in Nigeria*. Cambridge.
 1963 *African Mud Sculpture*. Cambridge.
 1964 "Idah—an Original Bini Artist." *Nigeria* 80:4-16.
 1968 *Contemporary Art in Africa*. New York.
 1971 "Signwriters Art in Nigeria." *African Arts* 4(3):22-27.
 1976 "Middle Art: The Paintings of War." *African Arts*
 9(2):20-23.
Beinart, J.
 1968 "Wall Painting: A Popular Art in Two African
 Communities." *African Arts* 2(1):26-29, 76.
Ben-Amos, Paula
 1976 "À La Recherche du Temps Perdu: On Being an
 Ebony-Carver in Benin." In Graburn, pp. 320-333.
 1977 "Pidgin Languages and Tourist Arts." *Studies in the
 Anthropology of Visual Communication* 4(2):128-139.
Berlin
 1980 *Neue Kunst in Afrika*.
Berlin, Haus der Kulturen der Welt GmbH
 1990 *Middle Art*.
Berlin, *Horizonte '79*, Festival der Weltkulturen.
 1979 *Moderne Kunst aus Afrika*.
Bettelheim, Judith
 1985 "The Lantern Festival in Senegambia." *African
 Arts* 18(2): 50-53, 95-97, 102.
Bhabha, Homi K. (ed.)
 1990 *Nation and Narration*. London.
Biaya, T. K.
 1989 "L'impasse de la crise zaïroise dans la peinture
 populaire urbaine, 1970-1985." In Jewsiewicki
 1989b:95-120.

Biebuyck, Daniel P.
 1969 (Ed.) *Tradition and Creativity in Tribal Art*. Berke-
 ley and Los Angeles.
 1976 "The Decline of Lega Sculptural Art." In Graburn,
 pp. 334-349.
Bohannan, Paul, and Philip Curtin
 1971 *Africa and Africans*. Garden City, New York.
Bonneau, Richard (ed.)
 1973 *Écrivains, Cinéastes & Artistes Ivoiriens*. Abidjan
 and Dakar.
Bope, Nyim-a-Nkwem
 n.d. "La perception kuba de leur histoire à travers l'oeuvre
 de J. Vansina." Unpublished manuscript.
Bordogna, Charles, and Leonard Kahan
 1989 *A Tanzanian Tradition*. Tenafly, N.J.
Borgatti, Jean M.
 1990 "African Portraits." In Jean M. Borgatti and Rich-
 ard Brilliant, *Likeness and Beyond: Portraits from
 Africa and the World*, pp. 29-83. New York.
Borynack, James R.
 1983 *Contemporary Art from the Republic of Senegal*.
 New York.
Bourdier, Jean-Paul, and Trin T. Minh-Ha
 1985 *African Spaces. Designs for Living in Upper Volta*.
 New York.
Brain, Robert
 1980 *Art and Society in Africa*. London and New York.
Bravmann, René A.
 1972 "The Diffusion of Ashanti Political Art." In *African
 Art and Leadership*, Douglas Fraser and Herbert
 M. Cole (eds.). Madison, Wis.
 1973 *Open Frontiers: The Mobility of Art in Black Africa*.
 Seattle and London.
 1974 *Islam and Tribal Art in West Africa*. London.
Breidenbach, P., and Doran Ross
 1978 "The Holy Place: Twelve Apostles Healing Gar-
 dens." *African Arts* 11(4):28-35.
Brenson, Michael
 1990 "Contemporary Works from Africa." *The New York
 Times*, 1 January.
Brett, Guy
 1986 *Through Our Own Eyes: Popular Art and Modern
 History*. London and Philadelphia.
Brink, James T.
 1977 "Bamana Kote-tlon Theatre." *African Arts*
 10(4):36-37, 61-65, 87.
Buchloh, Benjamin H. D., Serge Guilbaut, and David Solkin
 (eds.)
 1983 *Modernism and Modernity: The Vancouver Confer-
 ence Papers*. Halifax.
Burgin, Victor
 1986 *The End of Art Theory: Criticism and Postmodernity*.
 Atlantic Highlands, N.J.
Burns, John F.
 1990 "Johannesburg Journal: It's Mandela's Moment."
 The New York Times, 20 February, p. A4.
Burns, Vivian
 1974 "Travel to Heaven: Fantasy Coffins." *African Arts*
 7(2):24-25.
Butler, V. F.
 1963 "Cement Funeral Sculpture in Eastern Nigeria."
 Nigeria 77.
Calame-Griaule, G.
 1965 *Ethnologie et langage: La Parole chez les Dogon*.
 Paris.
Camara, Ery
 n.d. *Art Animista*. Mexico.
Chambers, Iain
 1990 *Border Dialogues: Journeys in Postmodernity*.
 London.

Chernoff, J. M.
 1977 "Andrews Ofori Danso of Ghana." *African Arts*
 10(3):32-35.
 1979 *African Rhythms and African Sensibility*. Chicago
 and London.
Clifford, James
 1983 "On Ethnographic Authority." *Representations* I(2).
Clifford, James, and G.E. Marcus (eds.)
 1986 *Writing Culture: The Poetics and Politics of Ethnog-
 raphy*. Berkeley.
Cole, Herbert
 1976 "The History of Igbo Mbari Houses: Facts and
 Theories." In *African Images: Essays in African
 Iconology*, Daniel McCall and Edna G. Bay (eds.).
 Boston.
 1988 "The Survival and Impact of Igbo Mbari." *African
 Arts* 21(2):54-65, 96.
Cornet, Joseph-Aurélien
 1975 "African Art and Authenticity." *African Arts*
 9(1):52-55.
 1989 "Précurseurs de la peinture moderne au Zaïre." In
 Cornet et al., pp. 9-57.
Cornet, Joseph-Aurélien, et al.
 1989 *60 ans de peinture au Zaïre*. Brussels.
Cosentino, Donald
 1980 "Lele Gbomba and the Style of Mende Baroque."
 African Arts 13(3):54-55.
Courtney-Clarke, Margaret
 1986 *Ndebele. The Art of an African Tribe*. New York.
Crowley, Daniel
 1969 "Traditional and Contemporary Art in Africa." In
 Expanding Horizons in African Studies, Gwendo-
 lyn M. Carter and Ann Paden (eds.). Evanston.
 1982 "Betises: Fon Brass Genre Figures." *African Arts*
 15(2):56-59.
Dakar, Musée Dynamique
 1975 *Art nègre et civilisation de l'universel*. Proceedings
 of colloquium, "Picasso, Art Nègre et Civilisation
 de l'universel." 1972. Dakar and Abidjan.
 1977 *Iba Ndiaye*. Paris.
Dakar, Société africaine de culture et al.
 1966 *Premier festival mondial des arts nègres*. Souvenir
 book of the festival, Dakar, 1/24 April. Paris.
 1967-1971 *Colloque sur l'art nègre*. 2 vols.
d'Azevedo, Warren L.
 1973 "Sources of Gola Artistry." In *The Traditional Artist
 in African Societies*, Warren L. d'Azevedo (ed.),
 pp. 282–340. Bloomington and London.
Deliss, Clementine
 1989 "Conjuring Tricks." *Artscribe International* 77:48-53.
 1990 *Lotte or the Transformation of the Object*. Graz.
de Rachewiltz, Boris
 1964 *Black Eros*. London.
Desplagnes, L.
 1907 *Le Plateau central nigerien. Une Mission
 archéologique et ethnographique au Soudan français*.
 Paris.
Dewey, William J.
 1986 "Shona Male and Female Artistry." *African Arts*
 19(3):64-67.
Dieterlen, G.
 1989 "Masks and Mythology among the Dogon." *African
 Arts* 22(3):34-43.
 1990 "Mythologie, histoire et masques." *Journal de la
 Société des Africanistes* 59(1/2):7-37.
Dieterlen, G., and J. Rouche
 1971 "Les fêtes soixantenaires chez les Dogon." *Africa*
 41:1-11.
Diop, Cheikh Anta
 1960 *L'Unité culturelle de l'Afrique noire*. Paris.

Domowitz, Susan, and Renzo Mandirola
 1984 "Grave monuments in Ivory Coast." *African Arts* 17(4): 46-52, 96.

Dorfles, Gillo
 1969 *Kitsch: The World of Bad Taste*. New York.

Drewal, Henry J.
 1988 "Mermaids, Mirrors, and Snake Charmers." *African Arts* 21(2):38-45.

Drewal, Henry J., and Margaret Drewal
 1983 *Gelede: Art and Female Power among the Yoruba*. Bloomington.

Eicher, Joanne B., and Tonye V. Erekosima
 1987 "Kalabari Funerals: Celebration and Display." *African Arts* 21(1):38-45, 87-88.

Enwonwu, Ben
 1966 "The African View of Art and Some Problems Facing the African Artist Today." In Dakar, Société africaine de culture et al., pp. 56-67.

Faber, Paul
 1988 "Art from Another World." In Rotterdam, Museum voor Volkenkunde, pp. 9-30.

Fabian, Johannes
 1978 "Popular Culture in Africa: Findings and Conjectures." *Africa* 48(4):315-334.

Fabian, Johannes, and Ilona Szombati-Fabian
 1980 "Folk Art from an Anthropological Perspective." In *Perspectives on American Folk Art*, Ian M. G. Quimby and Scott T. Swank (eds.), pp. 247-291. New York and London.

Fanon, Frantz
 1961 (1983) *The Wretched of the Earth*. Preface by Jean-Paul Sartre. New York. (Reprint)
 1967 *Black Skin White Masks*. New York.

Ferguson, Russell, et al. (eds.)
 1990 *Discourses: Conversations in Postmodern Art and Culture*. New York and Cambridge, Mass.

Fernandez, James W.
 1982 *Bwiti: An Ethnography of the Religious Imagination in Africa*. Princeton.

Festac '77. See London and Lagos, International Festival Committee, et al.

Fischer, Eberhard
 1985 "Guro Art." *Swissair Gazette*, March.

Fischer, Eberhard, and Lorenz Homberger
 1985 *Die Kunst der Guro Elfenbeinkuste*. Zurich.

Focillon, Henri
 1934 *La Vie des formes*. Paris.

Forbes, F. E.
 1851 *Dahomey, and the Dahomans: Being the Journals of Two Missions to the King of Dahomey, and Residence at his Capital, in the Years 1849 and 1850*. London.

Foster, Hal (ed.)
 1983 *The Anti-Aesthetic: Essays on Post-Modern Culture*. Port Townsend, Wash.

Fosu, Kojo
 1986 *20th Century Art of Africa*. Zaria.

Foucault, Michel
 1980 "Truth and Power." In *Power/Knowledge: Selected Interviews and Other Writings, 1972-1977*, C. Gordon (ed.). New York.

Freud, Sigmund
 1927-1931 *The Complete Psychological Works of Sigmund Freud*, J. Strachey (ed.). London.

Friedlander, Saul, et al.
 1990 "On Kitsch." *Salmagundi* 85-86:197-312.

Fry, Jacqueline (ed.)
 1978 *Twenty-Five African Sculptures*. Ottawa.

Gandoulou, J.
 1989 *Au coeur de la sapé. Moeurs et aventures de Congolais à Paris*. Paris.

Garrard, Timothy F.
 1982 "Erotic Akan Goldweights." *African Arts* 15(2):60-63.

Geertz, Clifford
 1988 *Works and Lives: The Anthropologist as Author*. Stanford.

Goldwater, Robert
 1967 *Primitivism in Modern Art*. New York.

Gonçalves, A. C.
 1980 *La Symbolisation politique. Le "prophétisme" Kongo au XVIIIe siècle*. Munich.

Gouard, Caroline
 1989 *Fodé Camara ou L'Oeuvre ouverte: Essai d'approche anthropologique d'une jeune peinture Sénégalaise*. Unpublished Mémoire Maîtrise d'esthétique, Université Paris I—Pantheon Sorbonne.

Graburn, Nelson H. H. (ed.)
 1976 *Ethnic and Tourist Arts: Cultural Expressions from the Fourth World*. Berkeley, Los Angeles, and London.

Griaule, M.
 1938 "Masques Dogons." *Travaux et Mémoires de l'Institut d'Ethnologie* 33. Paris.

Grignon, C., and J.-C. Passeron
 1989 *Le Savant et le populaire*. Paris.

Groupe Bogolan Kasobane
 n.d. [ca. 1988] Statement (ms.). Bamako.

Harris, Marvin
 1980 *Cultural Materialism*. New York.

Harter, Pierre
 1978 "Commemorative Effigy, Seated Chieftain." (Catalogue entry.) In Fry, pp. 123-126.

Hauser, M.
 1982 *Essai sur la poétique de la negritude*. Lille.

Hegel, Georg Wilhelm Friedrich
 1956 *The Philosophy of History*. New York.

Hobsbawm, Eric, and Terence Ranger (eds.)
 1983 *The Invention of Tradition*. Cambridge.

Hoffman, Rachel
 1989 Review of *Yeelen*. *African Arts* 22(2):100-101.

Holas, Bogumil
 1952 "Inscriptions sur véhicules automobiles à Abidjan." *Notes Africaines* (54):46-47.

Horizonte. See Berlin, *Horizonte '79*, Festival der Weltkulturen.

Houlberg, Marilyn
 1973 "Ibeji Images of the Yoruba." *African Arts* 7(1):20-27, 91-92.
 1976 "Collecting the Anthropology of African Art." *African Arts* 9(3):15-19.
 1983 "The Texture of Change: Yoruba Cultural Responses to New Media." *Cultural Survival Quarterly* 7(2).
 1988 "Feed your eyes: Nigerian and Haitian Studio Photography." *Photographic Insight* 1(2-3):3-8.

Huchard, Ousmane Sow
 1989 "The Musée Dynamique." In Axt and Babacar Sy, pp. 52-59.

Husserl, Edmund
 1970 *The Crisis of European Sciences and Transcendental Phenomenology*. Evanston.

Hutcheon, Linda
 1988 *A Poetics of Postmodernism: History, Theory, Fiction*. New York and London.

Imperato, Pascal J.
 1971 "Contemporary Adapted Dances of the Dogon." *African Arts* 5(1):28-33, 68-72, 84.

Irele, Abiola
 1965 "Negritude—Literature and Ideology." *The Journal*

of Modern African Studies 3(4):499-526.

1981 *The African Experience in Literature and Ideology.*
London.

1986 "Contemporary Thought in French Speaking Africa." In *Africa and the West: Legacies of Empire*,
Isaac James Mowoe and Richard Bjornson (eds.).
New York.

Jackson, Robert, and Carl Rosberg

1982 *Personal Rule in Black Africa: Prince, Autocrat,
Prophet, Tyrant.* Berkeley, Los Angeles, and London.

Jacquemin, Jean-Pierre

1990 "Saint Cheri Samba, vie et oeuvres (im)pies." In
Ostend, Provinciaal Museum voor Moderne Kunst,
pp. 9-33.

James, Houra Kadjo and F. Grah Mel

1980 "Les Ficelles de la gloire: Hommage à Christian
Lattier." *Social, Revue d'Études Trimestrielles, publiée
par l'Association Lettres Arts & Societies*, pp. 9-21.

Jegede, Dele

1981 "Patronage and Change in Nigerian Art." Paper
presented at the twenty-fourth annual meeting of
the African Studies Association, Bloomington, 21-24
October.

1983 *Trends in Contemporary Nigerian Art: A Historical
Analysis.* Unpublished Ph.D. dissertation, Indiana
University.

1990 "African Art Today: A Historical Overview." In
New York, The Studio Museum in Harlem, pp.
29-43.

Jewsiewicki, Bogumil

1986a "Collective Memory and the Stakes of Power.
A Reading of Popular Zairean Historical Discourse."
History in Africa 13.

1986b "Collective Memory and Its Images: Popular
Urban Painting in Zaire—A Source of 'Present
Past.' " *History and Anthropology* 2.

1986c "Introduction: One Historiography or Several?
A Requiem for Africanism." In Jewsiewicki and
Newbury, pp. 9-17.

1989a "Présentation: Le Langage politique et les arts
plastiques en Afrique." In Jewsiewicki 1989b:1-10.

1989b (Ed.) *Art and Politics in Black Africa.* Ottawa.

Jewsiewicki, Bogumil, and David Newbury (eds.)

1986 *African Historiographies: What History for Which
Africa?* Beverly Hills.

Jewsiewicki, Bogumil, et al. (eds.)

1990 *Moi, l'autre, nous autres: Vies zaïroises ordinaires,
1930-1980. Dix récits.* Quebec and Paris.

Johnson, John

1986 *The Epic of Son-Jara.* Bloomington.

Johnson, Samuel

1921 *The History of the Yoruba.* London and Lagos.

Jones, G. I.

1984 *The Art of Eastern Nigeria.* Cambridge.

Jules-Rosette, Bennetta

1977 "The Potters and the Painters: Art by and about
Women in Urban Africa." *Studies in the Anthropology of Visual Communication* 4(2):112-127.

1978 "The Myth of Modernity in Popular African Art:
Symbolic Representation in Popular Carving and
Painting." *Qualitative Anthropology*, September.

1979 "Technological Innovation in Popular African Art:
A Case Study of Some Contemporary Art Forms in
Transition." *Journal of Popular Culture* 13(1):116-130.

1984 *The Messages of Tourist Art: An African Semiotic
System in Comparative Perspective.* New York.

1987 "Rethinking the Popular Arts in Africa: Problems
of Interpretation." *African Studies Review*
30(3):91-98.

Jung, C. G.

1980 *The Archetypes and the Collective Unconscious.*
Princeton.

Kankole Muaka-Bilonda and Cheri Samba

1982 "Deux Tintins Zaïrois à Paris." *Actuel* 33-34:128-135,
188-189.

Karp, Ivan

1988 "Laughter at Marriage: Subversion in Performance."
Journal of Folklore Research 15(1-2):35-52.

Kasfir, Sidney L.

1980 "Patronage and Maconde Carvers." *African Arts*
13(3):67-70, 91-92.

1987 "Apprentices and Entrepreneurs: The Workshop
and Style Uniformity in Sub-Saharan Africa." In
Iowa Studies in African Art, Christopher Roy (ed.),
vol. 2, 25-47.

Kecskési, Maria

1987 *African Masterpieces and Selected Works from Munich: The Staatliche Museum für Völkerkunde.* New
York.

Keita, Fallo Baba, and Lucette Albaret

1990 *Bogolan et arts graphiques du Mali.* Paris.

Ki-Zerbo, Joseph

1972 *Histoire de l'Afrique d'hier à demain.* Paris.

1980 *General History of Africa. Vol. 1, Methodology and
African Prehistory.* London.

Koloss, Hans-Joachim

1990 *Art of Central Africa: Masterpieces from the Berlin
Museum für Völkerkunde.* New York.

Kratz, Corinne A.

1990 "'We've Always Done It Like This . . . except for a
Few Details': 'Tradition' and 'Innovation' in Okiek
Ceremonies." Unpublished manuscript.

Kristen, Christine

1980 "Sign-Painting in Ghana." *African Arts* 13 (3):38-41.

Kristeva, Julia

1980 *Desire in Language. A Semiotic Approach to Literature and Art.* New York.

LaCapra, Dominique

1982 *Madame Bovary on Trial.* Ithaca.

Lafayette, University of Southwestern Louisiana, University Art
Museum

1986 *Senegal: Narrative Paintings.*

Lamp, Frederick

1989 "Tradition, Invention, and Modernization." Paper
delivered at the thirty-second annual meeting of the
African Studies Association, Atlanta.

Lane, P.

1988 "Tourism and Social Change among the Dogon."
African Arts 21(4):66-69.

Lawal, Babatunde

1977 "The Search for Identity in Contemporary Nigerian
Art." *Studio International* 193(196):145-150.

1990 "The Study of Contemporary Art in Nigeria: Theory
and Methodology." Paper delivered at the thirty-
third annual meeting of the African Studies
Association, Baltimore.

Leiris, Michel

1948 "La Langue secrète des Dogons de Sanga (Soudan
Français)." *Travaux et Mémoires de l'Institut
d'Ethnologie* 50. Paris.

London, Camden Arts Centre

1970 *Contemporary African Art.*

London, Whitechapel Art Gallery

1986 *From Two Worlds.*

London and Lagos, International Festival Committee et al.

1977 *Festac '77.* Souvenir book of the Second World
Black and African Festival of Arts and Culture,
Lagos, Nigeria, 15 January-12 February.

Loughran, K. S., et al. (eds.)
 1986 *Somalia in Word and Image*. Washington, D.C.
Luanda, UNAP (Uniao Nacional de Artistas Plasticos).
 1987 (Untitled, members' biographies and works).
MacClintock, Dorcas
 1984 *African Images*. Pictures by Ugo Mochi. New York.
Marcus, George, and Michael M. J. Fischer
 1986 *Anthropology as Cultural Critique: An Experimental Moment in the Human Sciences*. Chicago.
Markovitz, Irving Leonard
 1969 *Léopold Sédar Senghor and the Politics of Negritude*. New York.
Martin, Jean-Hubert
 1989 "Préface." In Paris, Centre Georges Pompidou, pp. 8-11.
Mazrui, Ali Al'Amin
 1972 *Cultural Engineering and Nation-Building in East Africa*. Evanston.
M'Bengue, M.S.
 1973 *Cultural Policy in Senegal*. Paris
McEvilley, Thomas
 1989 *Another Reality*. Houston.
McEwen, Frank
 1970 "The Workshop School." In London, Camden Arts Centre, p. 16.
Merleau-Ponty, Maurice
 1973 *The Prose of the World*. Evanston.
Miller, Judith
 1975 *Art in East Africa: A Guide to Contemporary Art*. London and Nairobi.
Morrison, Keith
 1979 "Art Criticism: A Pan-African Point of View." *The New Art Examiner*, February, pp. 4-7.
Mount, Marshall Ward
 1973 (1989) *African Art: The Years Since 1920*. Bloomington and London. (Reprint, with a new introduction, New York.)
Mudimbe, V. Y.
 1988 *The Invention of Africa: Gnosis, Philosophy, and the Order of Knowledge*. Bloomington.
Munich, Staatliches Museum für Völkerkunde
 1987 *Iba N'Diaye*.
Mveng, R. P. Engelbert
 1980 *L'Art et l'artisanat africains*. Yaoundé.
Ndombe wa Ntumba
 1984 "Life Story." In Jewsiewicki et al. (1990).
Neale, Caroline
 1986 "The Idea of Progress in the Revision of African History, 1960-1970." In Jewsiewicki and Newbury, pp. 112-122.
New York, The Studio Museum in Harlem
 1990 *Contemporary African Artists: Changing Tradition*.
Nicklin, Keith
 1976 "Ibibio Metalwork." *African Arts* 10(1):20-23.
Nicklin, Keith, and Jill Salmons
 1977 "S. J. Akpan of Nigeria." *African Arts* 11(1):30-34.
Nsukka, University of Nigeria, Department of Fine & Applied Arts
 1987 *Catalogue: Original Prints from the Third Nsukka Workshop 1987*.
Ntiro, Sam
 1963 "East African Art." *Tanganyika Notes and Records* 61:121-134.
Nunley, John W.
 1982 "Images and Printed Words in Freetown Masquerades." *African Arts* 15(4):42-46, 92.
 1985 "The Lantern Festival in Sierra Leone." *African Arts* 18(2):45-49, 97, 102.
 1987 *Moving with the Face of the Devil: Art and Politics in Urban West Africa*. Urbana and Chicago.
 1988 "Purity and Pollution in Freetown: Masked Performance." *TDR* 32(2):102-122.
Nyang Nyang
 1984 "Life Story." In Jewsiewicki et al. (1990).
Odita, E. Okechukwu
 1983 "Theory and Practice in Contemporary African Art: Modernist or Skokian Aspect." *Journal of Multi-Cultural and Cross-Cultural Research in Art Education* 1(1):43-56.
Olbrechts, Frans M.
 1959 *Les Arts Plastiques du Congo Belge*. Brussels and Anvers-Amsterdam.
Oledzki, Jacek
 1981 "L'Art non-officiel au Senegal." *Ethnologia Polona* 7:81-97.
Olema Debhonvapi
 1984 "Société zaïroise dans le miroir de la chanson populaire." *Canadian Journal of African Studies* 18(1):122-130.
Omibiyi, Mosunmola
 1975 "The Artist in Contemporary Africa." *Pan-African Journal* 8(1):103-113.
Ositola, Kolawole
 1988 "On Ritual Performance: A Practitioner's View." *TDR* 32(2):31-41.
Ostend, Provinciaal Museum voor Moderne Kunst
 1990 *Exposition rétrospective: Chéri Samba—Le peintre populaire du Zaïre*.
Ouologuem, Yambo
 1971 *Bound to Violence*. New York.
Paris, Association Francaise d'Action Artistique
 n.d. [1990] *Art Makonde*.
Paris, Centre Georges Pompidou
 1989 *Magiciens de la terre*.
Paris, International Art Office
 n.d. *Iba Ndiaye*.
Paris, Musée National des Arts Africains et Océaniens
 1985 *Arts Africains: Sculptures d'hier—Peintures d'aujourd'hui*.
 1989 *Revolution française sous les tropiques*.
Patel, Gieve
 1989 "Contemporary Indian Painting." *Dedalus* 118(4): 171-205.
Peek, Philip M.
 1981 "The Power of Words in African Verbal Arts." *Journal of American Folklore* 94(371):19-45.
 1985 "Ovia Idah and Eture Egbede: Traditional Nigerian Artists." *African Arts* 18(2):54-59, 102.
Périer, Gaston-Denys
 1948 *Les Arts Populaires du Congo Belge*. Brussels.
Pern, S., B. Alexander, and W. E. A. van Beek
 1982 *Masked Dancers of West Africa: The Dogon*. Amsterdam.
Perrois, L.
 1989 "Through the Eyes of the White Man. From 'Negro Art' to 'African Arts.'" *Third Text: Third World Perspectives on Contemporary Art and Culture* 6:51.
Poggioli, Renato
 1968 *The Theory of the Avant-Garde*. Cambridge, Mass.
Preston, G.
 1975 "Perseus and Medusa in Africa: Military Art in Fanteland 1834-1972." *African Arts* 8(3):36-41.
Price, Sally
 1989 "Our Art—Their Art." *Third Text: Third World Perspectives on Contemporary Art and Culture* 6:65.
Prussin, Labelle
 1986 *Hatumere, Islamic Design in West Africa*. Berkeley, Los Angeles, and London.

Raina, Badri
　　1989　"The Politics of Development." *Journal of Arts and
　　　　　Ideas* 17-18:91-107.
Renaudeau, Michel and Michèle Strobel
　　1984　*Peinture sous verre du Sénégal*. Paris and Dakar.
Richard, Nelly
　　1987/　"Postmodernism and Periphery." *Third Text: Third
　　88　　*World Perspectives on Contemporary Art and Culture*
　　　　　2:5-12.
Richter, Dolores
　　1980　*Art, Economics and Change: The Kulebele of North-
　　　　　ern Ivory Coast*. La Jolla.
Roberts, Allen
　　1988　"Through the Bamboo Thicket: The Social Process
　　　　　of Tabwa Ritual Performance." *TDR* 32(2):123-138.
Rorty, Richard
　　1979　*Philosophy and the Mirror of Nature*. Princeton.
Rosen, Miriam
　　1990　"Chéri Samba: Griot of Kinshasa and Paris."
　　　　　Artforum 28(7):137-140.
Rosevear, D.
　　1984　"Cross River Tombstones." *African Arts* 18(1):44-47.
Ross, Doran
　　1980　"Cement Lions and Cloth Elephants: Popular Arts
　　　　　of the Fante Asafo." In *5000 Years of Popular
　　　　　Culture: Popular Culture Before Printing*, Fred E.
　　　　　H. Schroder (ed.), pp. 287-317. Bowling Green.
　　1983　(Ed.) *Akan Transformations: Problems in Ghana-
　　　　　ian Art History*. Los Angeles.
Rotterdam, Museum voor Volkenkunde
　　1988　*Art from Another World*.
Roy, Christopher D.
　　1982　"Mossi Chiefs' Figures." *African Arts* 15(4):52-59,
　　　　　90.
Rubin, Arnold
　　1975　"Accumulation: Power and Display in African Sculp-
　　　　　ture." *Artforum* 13(9):35-47.
Rubin, William
　　1984　"Introduction." In *"Primitivism" in 20th Century
　　　　　Art*, vol. 1, pp. 1-81. New York.
Saintes, Musée de L'Echevinage
　　1986　*Iba Ndiaye*.
Salmons, Jill
　　1977　"Mammy Wata." *African Arts* 10(3):8-15, 87-88.
Samb, Issa
　　1989a "Criticism of Representation." In Axt and Babacar
　　　　　Sy, pp. 129-130.
　　1989b "The Social and Economic Situation of the Artists
　　　　　of the 'École de Dakar.' " In Axt and Babacar Sy,
　　　　　pp. 117-120.
Sangari, Kumkum
　　1989　"Representations in History." *Journal of Arts and
　　　　　Ideas* 17-18:3-7.
Schneider, B. [Elizabeth Ann]
　　1972　"Malangatana of Mozambique." *African Arts* 5(2):
　　　　　40-45.
　　1976　"Massinguitana of Mozambique." *African Arts*
　　　　　10(1):24-29.
　　1988　"Malangatana: Artist of the Revolution." *African
　　　　　Arts* 21(3):58-63, 88.
Schildkrout, Enid, and Curtis A. Keim
　　1990　*African Reflections: Art from Northeastern Zaire*.
　　　　　Seattle, London, and New York.
Scohy, André
　　1950　"Peintures congolaises, problèmes d'aujourd'hui."
　　　　　In *L'Art nègre du Congo belge*. Brussels.
Secrétan, Thierry
　　1988　"L'Art de mourir au Ghana." *Geo* (111):78-93.

Senghor, Léopold Sédar
　　1977　*Liberté III: Négritude et Civilisation de l'Universel*.
　　　　　Paris.
　　1989　"Introduction." In Axt and Babacar Sy, pp. 19-20.
Shaw, Thomas M.
　　1986　"Sacred and Profane Aspects of the Popular Image
　　　　　of Sheikh Amadou Bamba." In *Treasures of a
　　　　　Popular Art: Paintings on Glass from Senegal*,
　　　　　Marie-Therese Brincard and Maurice Dedieu (eds.).
　　　　　New York.
Sieber, Roy
　　1973　"Approaches to Non-Western Art." In *The
　　　　　Traditional Artist in African Societies*, Warren L.
　　　　　d'Azevedo (ed.), pp. 425-434. Bloomington and
　　　　　London.
Silverman, Raymond A.
　　1983　"Akan Kuduo: Form and Function." In Ross,
　　　　　pp. 10-29.
Skertchly, J. A.
　　1874　*Dahomey As It Is: Being a Narrative of Eight Months
　　　　　Residence in That Country*. London.
Snead, James A.
　　1990　"Repetition as a Figure of Black Culture." In *Out
　　　　　There: Marginalization and Contemporary Cultures*,
　　　　　Russell Ferguson et al. (eds.). New York.
Soppelsa, Robert T.
　　1982　*Terracotta traditions of the Akan of Southeastern
　　　　　Ivory Coast*. Unpublished Ph.D. dissertation, Ohio
　　　　　State University.
Souillou, J.
　　1985　*Sculptures en ciment du Nigeria de S. J. Akpan et A.
　　　　　O. Akpan*. Calais.
Spanjaard, Helena
　　1988　"Free Art: Academic Painters in Indonesia." In
　　　　　Rotterdam, Museum voor Volkenkunde, pp. 103-132.
Sprague, Stephen F.
　　1978　"Yoruba Photography: How the Yoruba See Them-
　　　　　selves." *African Arts* 12(1):52-59, 107.
Stanislaus, Grace
　　1990　*"Contemporary African Artists: Changing Tradition."*
　　　　　In New York, The Studio Museum in Harlem, pp.
　　　　　20-28.
Stout, J. Anthony
　　1966　*Modern Makonde Sculpture*. Nairobi, Moshi, and
　　　　　Newtonville.
Sy, El Hadji M. B.
　　1989　"The 'Cité of the Artists' and the 'Village of Arts'."
　　　　　In Axt and Babacar Sy, pp. 107-108.
Sy, Kalidou
　　1989　"The School of Fine Arts of Senegal." In Axt and
　　　　　Babacar Sy, pp. 35-39.
Szombati-Fabian, Ilona, and Johannes Fabian
　　1976　"Art, History and Society: Popular Painting in Shaba,
　　　　　Zaire." *Studies in the Anthropology of Visual Com-
　　　　　munication* 3(1):1-21.
Tall, Papa Ibra
　　1975　"Situation de l'artiste negro-africain contemporain."
　　　　　In Dakar, Musée Dynamique, pp. 85-101.
Tati Loutard, J.-B.
　　n.d.　*Malschule Poto-Poto aus Brazzaville*.
　　1989　Text of oral presentation on Congolese art delivered
　　　　　at the opening of the exhibition "The Congo Today,"
　　　　　at the Apex, a Museum of the African-American
　　　　　Experience, Atlanta. Unpublished manuscript.
Thiry, Georges
　　1982　*À la recherche de la peinture nègre*. Liège.
Thompson, Robert Farris, and Joseph-Aurélien Cornet
　　1981　*The Four Moments of the Sun: Kongo Art in Two
　　　　　Worlds*. Washington, D.C.

Tutuola, Amos
 1953 *The Palm Wine Drinkard*. New York.
 1954 *My Life in the Bush of Ghosts*. London.
Udechukwu, Obiora
 1985 "Verschiedene Vorstellungen: Afrikanische Kunst Heute." In Bayreuth, Städtische Galerie Regensburg, Iwalewa-Haus. n.p.
Vansina, Jan
 1978 *The Children of Woot: A History of the Kuba Peoples*. Madison, Wis.
 1984 *Art History in Africa*. London.
Ville de Brive, Musée Ernest Rupin
 1984 *Iba Ndiaye*.
Vogel, Susan
 1990 "African Sculpture: A Primer." In Jerry L. Thompson and Susan Vogel, *Closeup: Lessons in the Art of Seeing African Art*, pp. 75-81. New York.
Vogel, Susan, and Francine N'Diaye
 1985 *African Masterpieces from the Musée de l'Homme*. New York.
Wahlman, Maude
 1974 *Contemporary African Arts*. Chicago.
Wallace, Michele
 1989 "Tim Rollins + K.O.S.: The 'Amerika' Series." In *Tim Rollins + K.O.S.*, pp. 37-48. New York.

Warren, Ben Michael
 1989 *Ouattara*. Kyoto.
Webb, Alex
 1986 *Hot Light/Half-Made Worlds*. New York.
Wemba-Rachid, J. A. R.
 n.d. [1990] "Le Masque et la tradition de la danse masquée." In Paris, Association Française d'Action Artistique, pp. 34-43.
Werman, Marco
 1989 Interview with Idrissa Ouédraogo. *International Herald Tribune*, 25 October:20.
Wheeler, Mortimer
 1964 *Roman Art and Architecture*. New York and Toronto.
Williams, Denis
 1974 *Icon and Image: A Study of Sacred and Secular Forms of African Classical Art*. New York.
Wolfe, Alvin W.
 1955 "Art and the Supernatural in the Ubangi District." *Man* 55:65-67.
Wright, R.
 1975 *The Art of Independence*. New York.

PHOTOGRAPH CREDITS

Photographs used as illustrations for the essays are credited in the captions. Photographs of the objects in the catalogue sections are courtesy of the respective lenders, with the following exceptions: Ken Cohen, cat. no. 129; Susan Dirk, Seattle Art Museum, cat. no. 124; Hillel Burger, cat. nos. 117, 132, 133; Jean-Louis Losi, cat. no. 110; Ivar Pel, Audio-Visual Services, University of Utrecht, cat. nos. 3, 5, 6; Mark Sexton, cat. no. 123; Duane Suter, cat. nos. 17, 18; Jerry L. Thompson, cat. nos. 1, 2, 10, 11, 12, 14, 15, 16, 22, 27, 28, 29, 31, 32, 46, 47, 48, 49, 50, 63, 64, 66, 67, 68, 69, 70, 72, 76, 84, 85, 86, 87, 88, 89, 90, 91, 92, 102, 103, 104, 112, 114, 115, 116, 118, 119, 120, 121, 122, 125, 126, 128, 131; Tutti, cat. nos. 77, 78, 79, 82, 83.

LENDERS TO THE EXHIBITION

Abdourahim Agne
Mr. & Mrs. Armand Arman
Vrej Baghoomian
W. E. A. van Beek
Sokari Douglas Camp
Canal +
Center for Creative Photography, University of Arizona
Centre Internationale des Civilisations Bantu, Libreville
The Chase Manhattan Bank, N.A.
The Denver Art Museum
Des Moines Art Center
M. H. De Young Memorial Museum, The Fine Arts Museums of San Francisco
Drs. John & Nicole Dintenfass
The Agnes Etherington Art Centre, Queen's University, Kingston, Canada
Eberhard Fischer
Fonds National d'Art Contemporain—Ministère de la Culture, Paris
Fowler Museum of Cultural History, University of California, Los Angeles
The Renee and Chaim Gross Foundation
Udo Horstmann
Carla Hubbard
Akira Ikeda Gallery, Nagoya
Iwalewa-Haus, Bayreuth
Bogumil Jewsiewicki
Leonard & Judith Kahan
Eric Kawan
Edward J. Klejman
Mr. & Mrs. James J. Lally
Frederick Lamp
Raymond J. Learsy
Raoul Lehuard
Erle Loran
Malangatana Valente Ngwenya
The Mnuchin Foundation
Musée d'Art Contemporain de Lyon
Museum of International Folk Art, Museum of New Mexico
Museum voor Volkenkunde, Rotterdam
Iba N'Diaye
Annina Nosei Gallery, New York
Jean-Marc Patras Galerie, Paris
Peabody Museum of Archaeology and Ethnology, Harvard University
Peabody Museum of Salem
Jean Pigozzi
Trigo Piula
Anthony Ralph Gallery, New York
Michel Renaudeau
Mr. & Mrs. Robert Billion-Richardson
Mr. & Mrs. Mark Rosenberg
Hans & Betty Schaal
Seattle Art Museum, Katherine White Collection
Maurice W. Shapiro
Saul & Marsha Stanoff
Allan Stone
Mr. & Mrs. Allen Wardwell
Gallery Watatu, Nairobi
and anonymous lenders